PARIS / NEW YORK

PARIS
NEW YORK

DESIGN FASHION CULTURE 1925–1940

MUSEUM OF THE CITY OF NEW YORK

THE MONACELLI PRESS

Published in the United States by The Monacelli Press, a
division of Random House, Inc.

Library of Congress Cataloging-in-Publication Data
Paris-New York : design fashion culture, 1925-1940 /
Donald Albrecht.
p. cm.
Includes bibliographical references and index.
ISBN 978-1-58093-211-0 (hardcover)
1. Arts, French—France—Paris—20th century.
2. Arts, American—New York (State)—New York—
20th century.
3. Paris (France)—Civilization—20th century.
4. New York (N.Y.)—Civilization—20th century.
I. Albrecht, Donald.
NX511.N4P37 2008
700.944'36109042—dc22
2008004091

Design by Pure+Applied | pureandapplied.com

Printed in China

First Edition

CONTENTS

ACKNOWLEDGMENTS

Many people made this exhibition and related catalog possible. Susan Henshaw Jones, president and director of the Museum of the City of New York, was an early supporter. I am grateful to this catalog's essayists for their specific contributions and their deep knowledge, which helped shape my thinking on the subject. Conversations with many people, some of whom made valuable archives available, aided in this research: Avodica Ash, Réjane Bargiel, Illene Berg, Kim Bergen, Melanie Bower, Sandrine Bosser, Emmanuel Bréon, Elizabeth Broman, Lynn Catanese, Carol Cheney, Chris Dierks, Jeff Ferzoco, Nathalie Filser, Sally Forbes, Kirk de Gooyer, Jared Goss, Charles Hobson, Joshua Holdeman, Joan Kahr, Heather Lammers, Marianne Lamonaca, Stephen S. Lash, Cathy Leff, David Garrard Lowe, Floramae McCarron-Cates, Erin McKeen, Agnès Masson, Evelyne Possémé, David Peyceré, Cliff Priess, Alexandre Ragois, Nolwenn Rannou, Jack Rennert, Michel Richard, Adi Shamir, Cindy Trope, Stephen Van Dyk, Gerard Widdershoven, and Eric M. Zafran. It was a pleasure to work with Urshula Barbour, Paul Carlos, and Mimi Jung of Pure+Applied; they designed both this catalog and the exhibition. Within the Museum of the City of New York, I am grateful to Sarah Henry, Jennifer Juzaitis, Susan Madden and her staff, and Thomas Mellins. Liora J. Cobin and Susan Gail Johnson conducted extensive research in the project's early phases, and Elizabeth Compa helped immeasurably in planning an important research trip to Paris, where I was assisted by Rebecca Cavanaugh. Barbara Livenstein masterminded an outstanding press strategy, and Kassy Wilson oversaw the show's installation. Giacomo Mirabella, Aditi Halbe, Abby Lepold, and Shelley Wilson handled the myriad details of shipping objects, and Hakim Hasan oversaw excellent programs. I greatly appreciated the efforts of this book's publisher, the Monacelli Press, where I was pleased to work with Gianfranco Monacelli, Stacee Lawrence, Andrea Monfried, Nicolas Rojas, and Elizabeth White. I also want to thank the international network of scholars and lenders who made *Paris/New York* not only a project *about* international collaboration, but also one achieved *through* collaboration on a global scale.

Natalie W. Shivers edited the book's essays, which greatly benefited from her intelligence and care.

Donald Albrecht

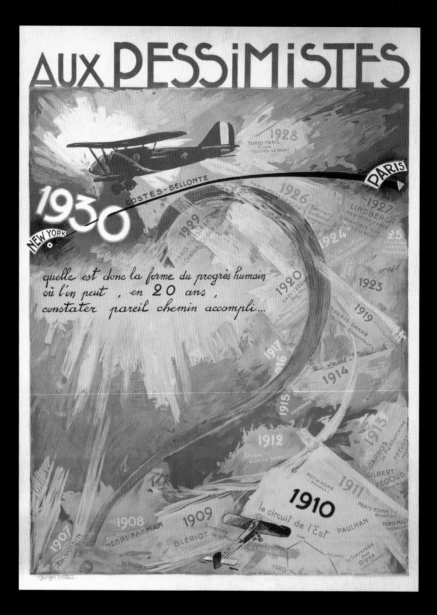

Paris/New York:
Design Fashion Culture, 1925–1940

This exhibition is supported
by a generous grant from the
Florence Gould Foundation.

Major sponsorship is also provided by:
Van Cleef & Arpels

Van Cleef & Arpels

Additional support has been received from:

ELLE and ELLE DECOR Magazines
The Grand Marnier Foundation
Mel Seiden & Janine Luke
Mrs. Stephen M. Kellen
Mr. & Mrs. Jeremy H. Biggs
The New York Design Center
The Pierre and Maria-Gaetana Matisse
Charitable Foundation

ELLE
ELLE DECOR

Grand Marnier Foundation

This exhibition is also made possible
with public funds from:

The New York State Council on the Arts,
a State Agency

NYSCA

PREFACE

The 1920s and '30s witnessed a burst of creative energy in the fields of architecture, design, and fashion. Shaping new styles of buildings and furnishings, redefining contemporary dress, and giving visual form to avant-garde performing arts, architects and designers forged an influential modern aesthetic. The era's most creative figures rarely worked in isolation, preferring instead to participate in international dialogues that linked capital cities in collaborative artistic enterprise. Between the world wars, no two cities engaged in a more fertile conversation than Paris, de facto capital of the nineteenth century, and New York, its twentieth-century rival. Though New York architects and designers suffered feelings of New World inferiority in the face of France's vaunted traditions in the visual arts, the years between the world wars witnessed New York's transformation from a national city to an international capital, one that ultimately equaled Paris in global influence. *Paris/New York: Design Fashion Culture, 1925–1940* explores this remarkable relationship.

The Museum's capacity to realize this project was given a very auspicious launch by trustee Stephen S. Lash, chairman of Christie's Americas, who helped secure important lead funding from the Florence Gould Foundation, and later from Van Cleef & Arpels. Fellow trustee James P. Druckman, president and chief executive of the New York Design Center, also mustered considerable early support by graciously hosting a benefit reception at the Museum enthusiastically attended by many leaders of the New York interior design community. They, along with Friederike Biggs, generously served as Exhibition Co-Chairs. We are also most grateful to ELLE and ELLE DECOR Magazines; the New York State Council on the Arts, a state agency; Mrs. Stephen M. Kellen; the New York Design Center; Mr. and Mrs. Jeremy H. Biggs; and the Pierre and Maria-Gaetana Matisse Charitable Foundation for their meaningful and tangible support of this landmark exhibition.

I also want to thank curator Donald Albrecht, the French and American scholars who wrote for the catalog, the leading organizations who graciously lent to the exhibition, content editor Natalie Shivers, the Monacelli Press, and designers Paul Carlos and Urshula Barbour of Pure+Applied. Through their efforts, we are proud to celebrate a dynamic chapter in the history of Paris and New York, two of the world's great metropolises.

Susan Henshaw Jones
President and Director
Museum of the City of New York

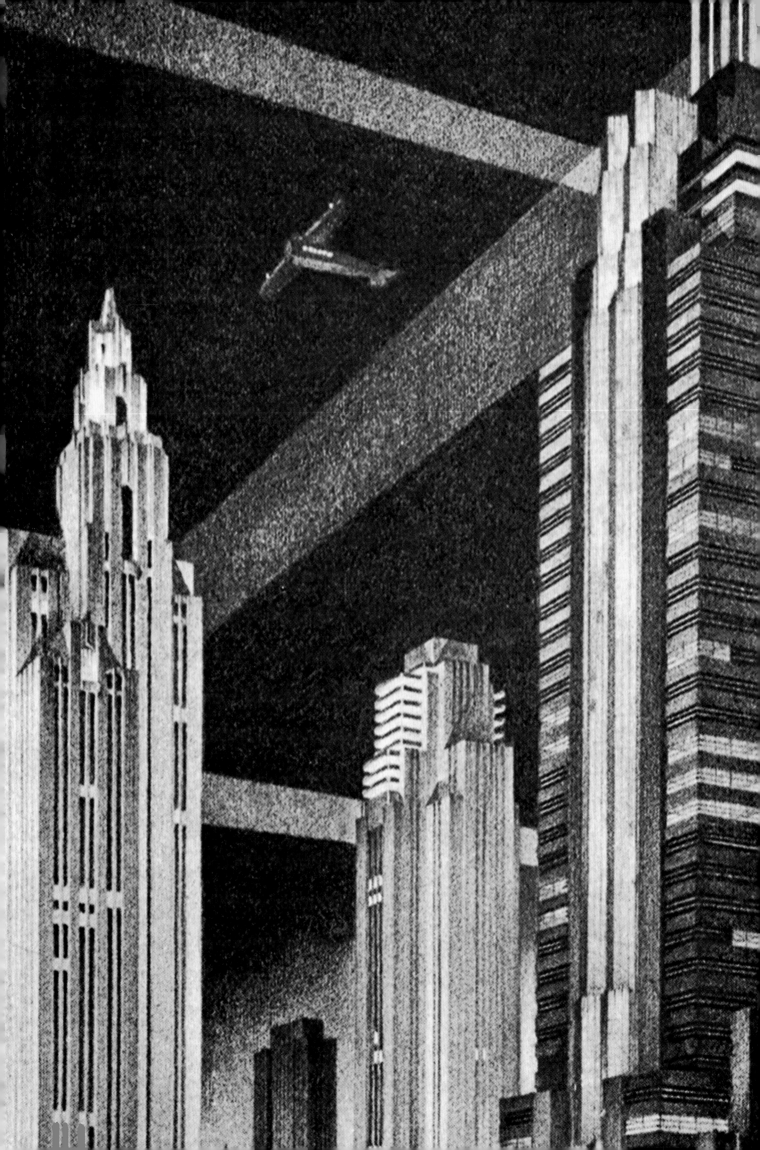

DONALD ALBRECHT

INTRODUCTION

The July 1919 victory march held in Paris to celebrate the end of World War I signaled a seismic shift in French–American relations. Original plans called for the victors to march in alphabetical order, which would have positioned the United States at the rear. But, acknowledging the country's critical role in the conflict, France and her European allies allowed the United States to participate as "America," moving it to the head of the parade.[1] This small but significant gesture recognized both the United States's contribution to the war effort and its new role as the world's leading industrialized nation, as well as the power and prosperity that accompanied this position.

Poster for the 1925
Paris Exposition, designed
by Robert Bonfils

America's featured parade position suggested that the "Old World" was finally considering the upstart nation as a political and cultural partner. This new dynamic reverberated throughout the interwar period as France and America—and especially their financial and cultural capitals, Paris and New York City—developed an increasingly competitive and reciprocal relationship in many arenas that historically had been considered Paris's domain.

Until the end of World War I, Paris had dominated New York in all the fields suggested by the phrase *la belle France.* Paris was the home of *haute couture* and *grande cuisine.* It was the training ground for aspiring American architects and artists throughout the nineteenth century and continued to attract such American expatriates as writer F. Scott Fitzgerald and composer Cole Porter. For them Paris was "a movable feast," as Ernest Hemingway titled the book charting his literary coming-of-age in the city, a place with a long history of supporting artists, which offered them a haven free from American constraints of commercialism and conformity.

Yet Paris's allure wasn't simply as a center of painting, music, and architecture. In the wake of the Industrial Revolution, the French capital's dominance also derived from its unique fusion of art, commerce, and industry that made it to many observers the mythic capital of nineteenth-century Europe.[2] In the decades before World War I, France had turned commerce into an art: Paris's world's fairs of the nineteenth century showcased French talents and wares and offered testimonials to the country's commercial savvy.

Following the devastating world war, Paris was, according to cultural historian Tyler Stovall, in a "state of transition between a vanished past and an uncertain future."[3] New York, on the other hand, was a city of progress and expansion in the 1920s, transformed in a few short decades by waves of immigrants, new corporate business practices, and revolutionary advances in transportation, communications, and building technologies. As the cultural status quo shifted, New York architects and designers in the 1920s and '30s studied the newest ideas emanating from Paris's expositions, studios, and fashion houses but responded with their own "made in New York" versions. As financial magnet and, later, refuge from a second world war, New York also lured a generation of talented Parisian émigrés who revolutionized its fashion magazines, innovated stage design, and transformed American cuisine.

Two international expositions—one held in Paris in 1925 and one in New York in 1939/40—bracket one of the most intense and influential chapters in the love affair between these two world capitals and vividly represent the shifting balance of influence between them. During this period the interchange between Paris and New York was never simple, comprising in equal measure admiration and envy, respect and rivalry. New

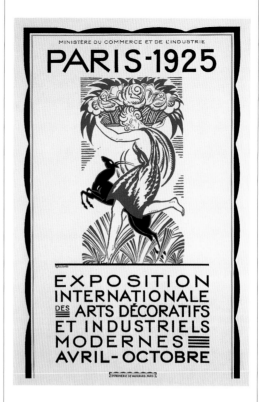

Yorkers began to shed their feelings of New World inferiority in the face of Paris's vaunted cultural traditions, and Paris increasingly looked to New York as the freshly vibrant center of modern culture, best represented by jazz and skyscrapers, whether built of steel and stone or imagined by artists, illustrators, and moviemakers. By the beginning of World War II, New York had created its own fusion of art, commerce, and industry, transforming itself from a city of national stature into an international capital that rivaled—and in some spheres bypassed—Paris in worldwide cultural influence.

PARIS 1925

Throughout the nineteenth century, world's fairs were an important means for Paris to exert its cultural authority. The concept for such international fairs, in fact, grew out of France's national expositions, which concluded with the 1844 French Industrial Exposition in Paris and led to the first truly international fair—the 1851 London Exposition. These fairs enhanced trade between nations and often introduced new technological inventions. The Exposition Universelle of 1889, for example, produced Paris's most famous landmark, the Eiffel Tower, which merged innovative engineering and sculptural form on an unprecedented scale. World's fairs also presented new trends in architecture and design, from the sinuous forms of the Art Nouveau that were ubiquitous at the 1900 Exposition Universelle to the geometric aesthetic of the Art Deco, a term derived from the title of the 1925 Exposition Internationale des Arts Décoratifs et Industriels Modernes.

In the planning stages since shortly before World War I, the 1925 Paris Exposition was meant to counteract the growing influence of new modernist trends emanating from Germany

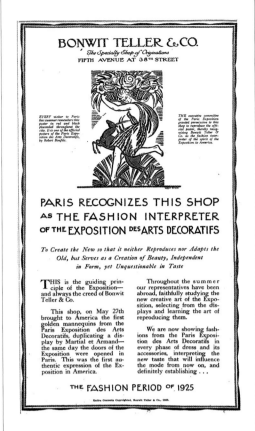

and Austria, which had already begun to challenge French leadership and self-confidence in design. This challenge would continue through the interwar period, with the rise of the Bauhaus in the 1920s and its importation to America in the 1930s. The enormous popular success of the modern German designs exhibited at the annual Paris Salon d'Automne in 1910 spurred French industry to plan an exposition that would reaffirm its own talent for innovation. The outbreak of war, however, forced the project to be shelved until 1922, when France revived its

exposition plan, seeing it as an opportunity to reassert the superiority of its own artistic culture against German influence.

When, after three years of preparation, the exposition opened in April 1925, it was a triumph for its French organizers, a showcase for an extravagant ensemble of buildings and decorative objects that celebrated French design and manufacturing talents. Covering both banks of the Seine in the vicinity of the Alexander III and Invalides Bridges, the exposition comprised numerous pavilions, each sponsored by an attending nation, manufacturer, store, or individual designer. French architecture was represented by a range of styles, from Louis-Hippolyte Boileau's Art Deco pavilion for the premier department store, Au Bon Marché, featuring lavish geometric decoration that strongly influenced commercial architecture in the late 1920s, to the functionalist aesthetic of Le Corbusier's Pavillon de l'Esprit Nouveau, a milestone in the development of the International Style that became popular in the 1930s. There was also furniture by Emile-Jacques Ruhlmann, which revived the forms of eighteenth-century *ébénistes* in exotic materials like ebony and ivory; bracelets of emerald, onyx, and coral by Cartier; and labor-intensive lacquer work by Jean Dunand, all of which exemplified the stylistic sophistication, superb craftsmanship, and Old World luxury of French design.

Most western European countries, as well as the Soviet Union and Japan, were officially represented at the exposition. Two countries, however, were conspicuously absent. Germany, still struggling from the economic aftermath of World War I, was unable to sponsor a pavilion, while American Secretary of State Charles Evans Hughes had declined the organizers' invitation,

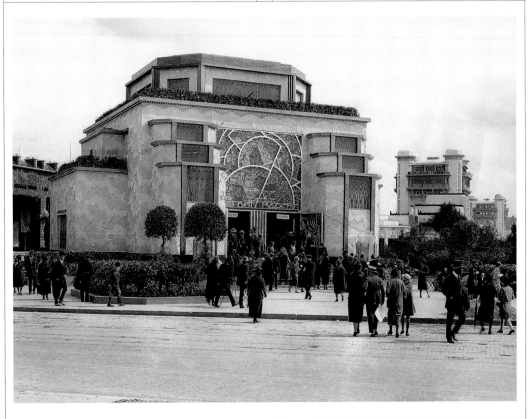

RIGHT
Detail of radiator grille
from the Squibb Building,
New York, designed
by Buchman & Kahn,
photograph by
Sigurd Fischer, c. 1930

BELOW LEFT
Cheney Brothers fabric
based on ironwork design
by Edgar Brandt, silk
and cotton, 1925–29

BELOW RIGHT
Detail of opening
program for Cheney
Brothers showrooms at
the Madison–Belmont
Building, New York,
October 1925

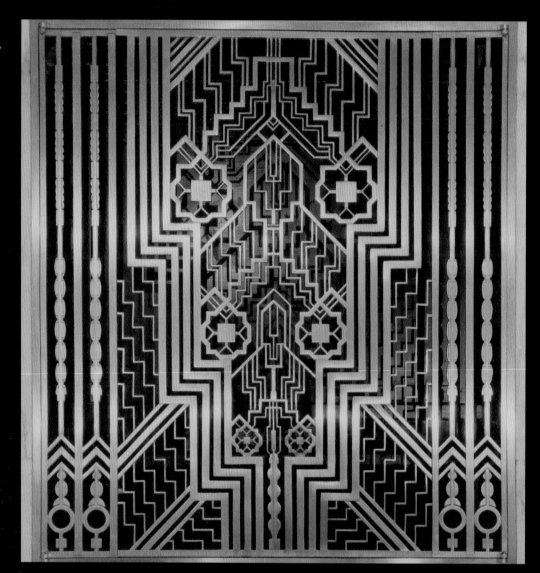

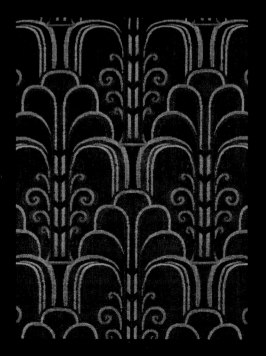

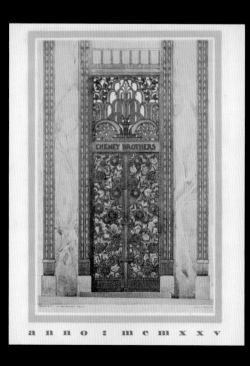

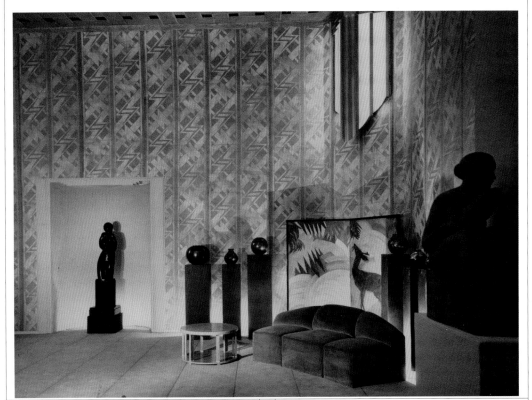

responding that there was not sufficient interest among American manufacturers and trades-people to participate in an exposition that was limited to objects of modern design. The Americans' decision was reached despite France's considerable lobbying efforts. Seeking to counteract German and British propaganda and promote many facets of French life, from culture and the arts to diplomacy and technological advances, the French government had launched a series of initiatives, including the creation of the Official French Information Office in New York City in 1923.[4]

Although the United States didn't participate in the 1925 Paris Exposition, thousands of American tourists visited it during its six-month run, and it was well covered in the American press. There was also an official commission created by Secretary of Commerce Herbert Hoover to inform him of ideas that would be valuable to American manufacturers. In the summer of 1925 three commissioners, including Charles Russell Richards, director of the American Association of Museums, and more than eighty delegates representing various aspects of American arts and architecture went to Paris, taking special tours of the exposition pavilions and visiting the workshops of decorative artists such as Ruhlmann.[5]

The exposition's impact on New York's visual culture was almost immediate. New York architects and designers adopted the fair's angular geometric decorative themes, referred to as Art Deco, to adorn skyscraper masterpieces like the Chrysler Building (1930). The city also openly embraced Parisian designers like French *ferron-nier* Edgar Brandt. Popular hits at the exposition included Brandt's *L'Oasis* screen, which featured stylized natural motifs such as fountains and

leaves, and his decorative grilles at the exposition's Porte d'Honneur, which, according to *Vogue*, announced "that something new surges in front of one."[6] Brandt had designed textiles for the American Cheney Brothers silk company before the Paris exposition, and his sumptuous decoration of the company's new Manhattan headquarters—the Madison-Belmont Building, which opened in October 1925—helped launch New York's infatuation with French Art Deco.[7] In addition to his designs for Cheney textiles, Brandt also worked for another textile manufacturer, F. Schumacher & Co. He provided furnishings to the company's New York showroom, and his wrought-iron fire screen, *La Biche dans la Forêt*, inspired the company's Les Gazelles au Bois fabric, which was featured in the interiors of at least two New York City Art Deco masterpieces: the ballroom of architects Schultz and Weaver's Waldorf-Astoria Hotel (1931) and a dress salon in Ely Jacques Kahn's Bonwit Teller department store (1930) on Fifth Avenue.[8]

The 1925 Paris Exposition's influence was also evident in a series of exhibitions in museums and stores that showcased the work of its leading designers and synthesized modern art and commerce. Impressed with what he saw in Paris, Charles Richards chose approximately 400 objects from the exposition, including work by Brandt, Dunand, and Ruhlmann. An exhibition of these wares opened in Boston in early 1926, then came to New York's Metropolitan Museum of Art, followed by crowd-pleasing visits to six additional cities. On the heels of the Metropolitan Museum's exhibition, in late 1927 Wanamaker's New York store introduced modern designs to its patrons in "Venturus," an exhibition of French designers from the exposition,

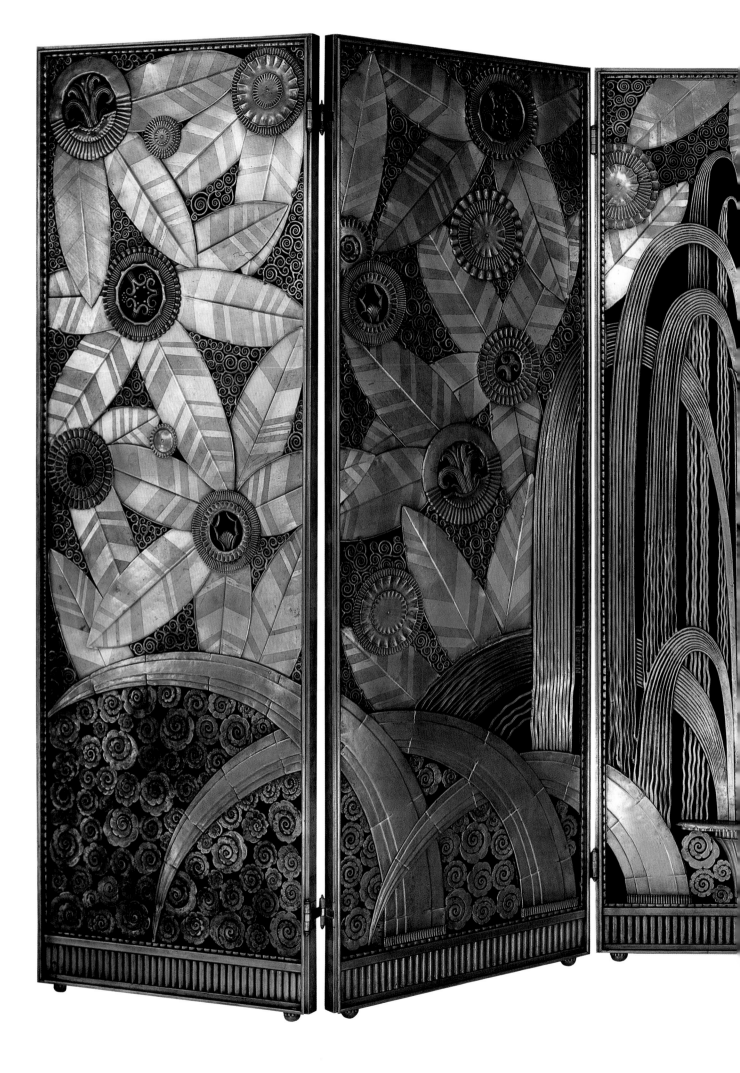

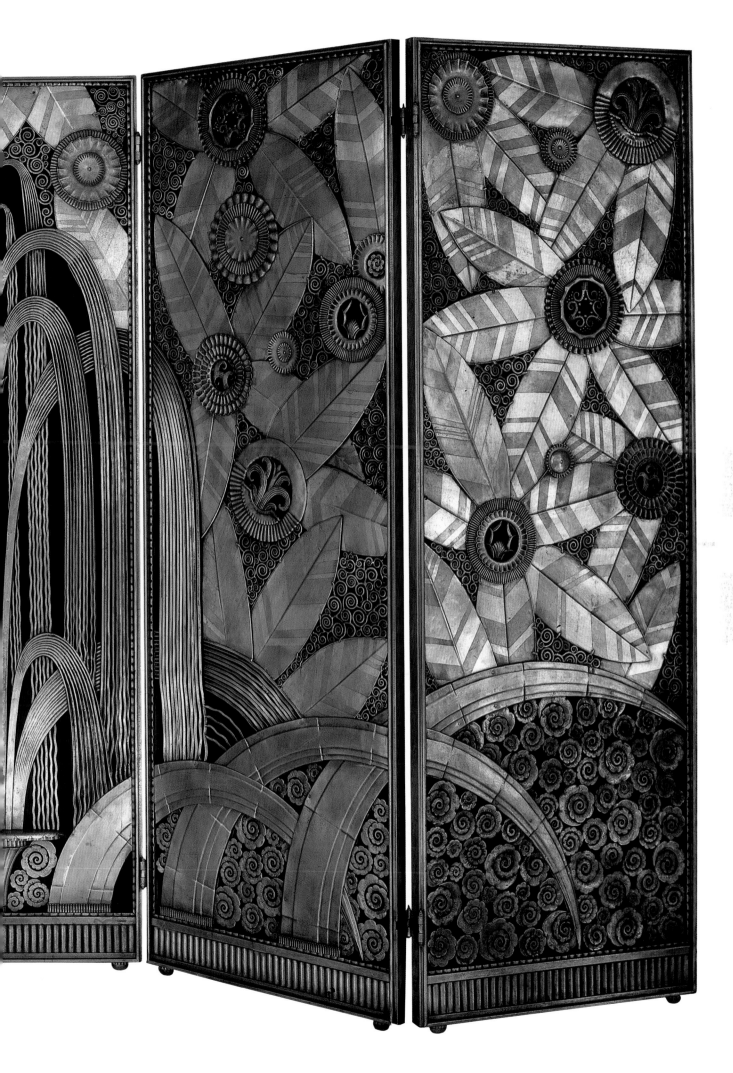

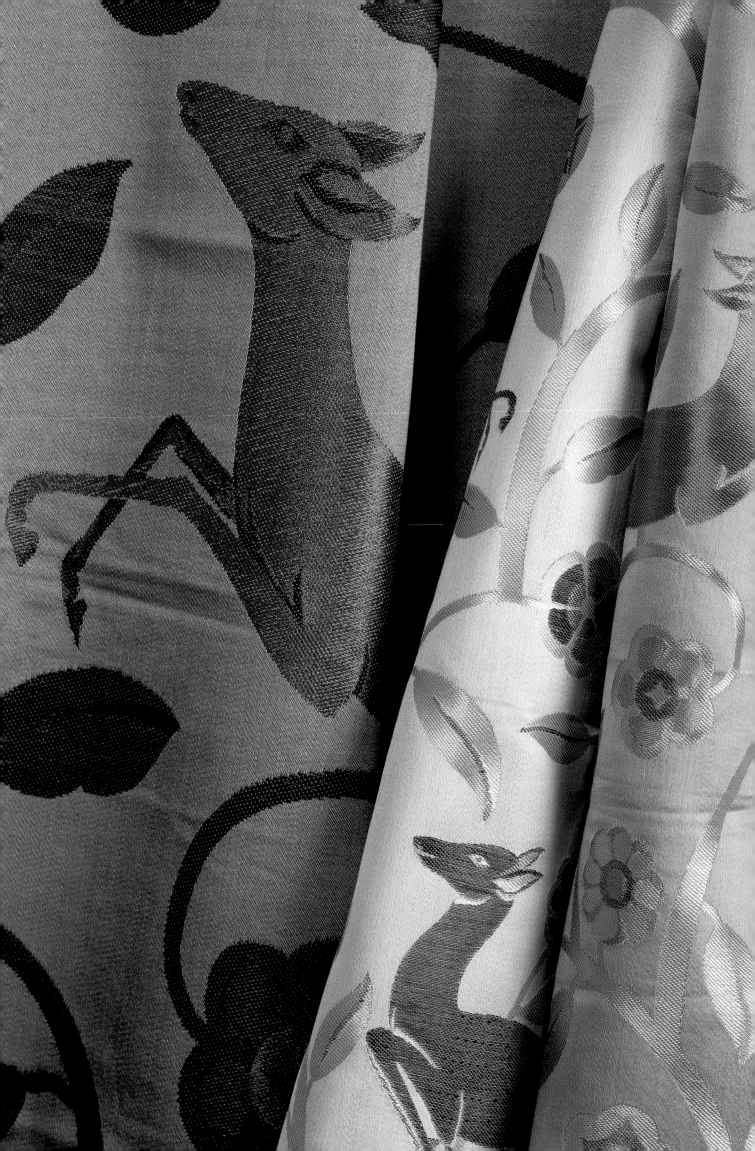

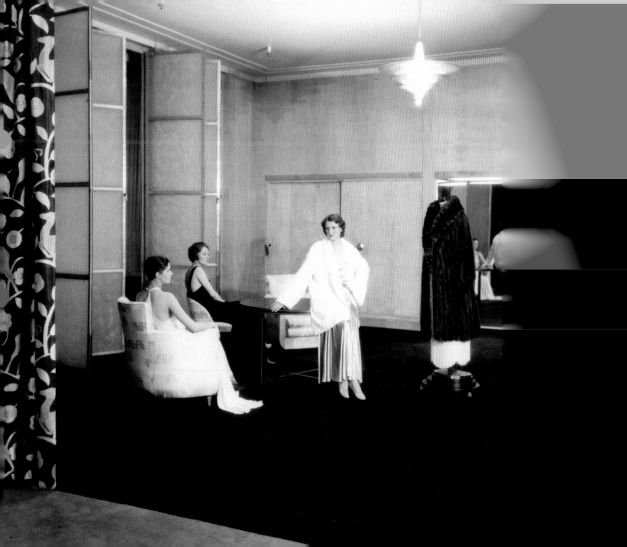

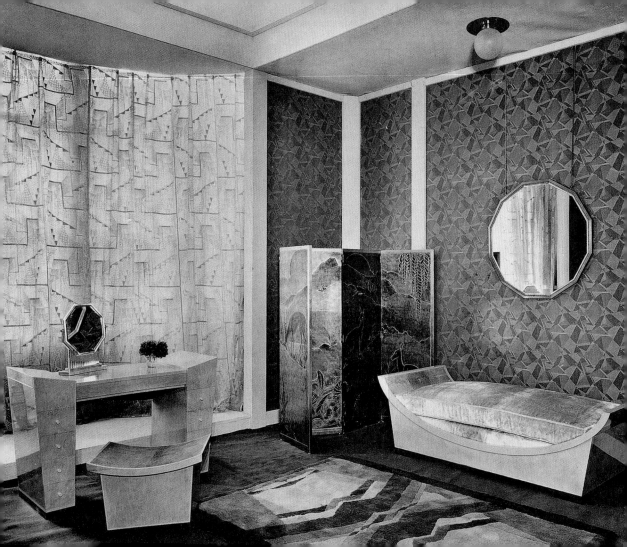

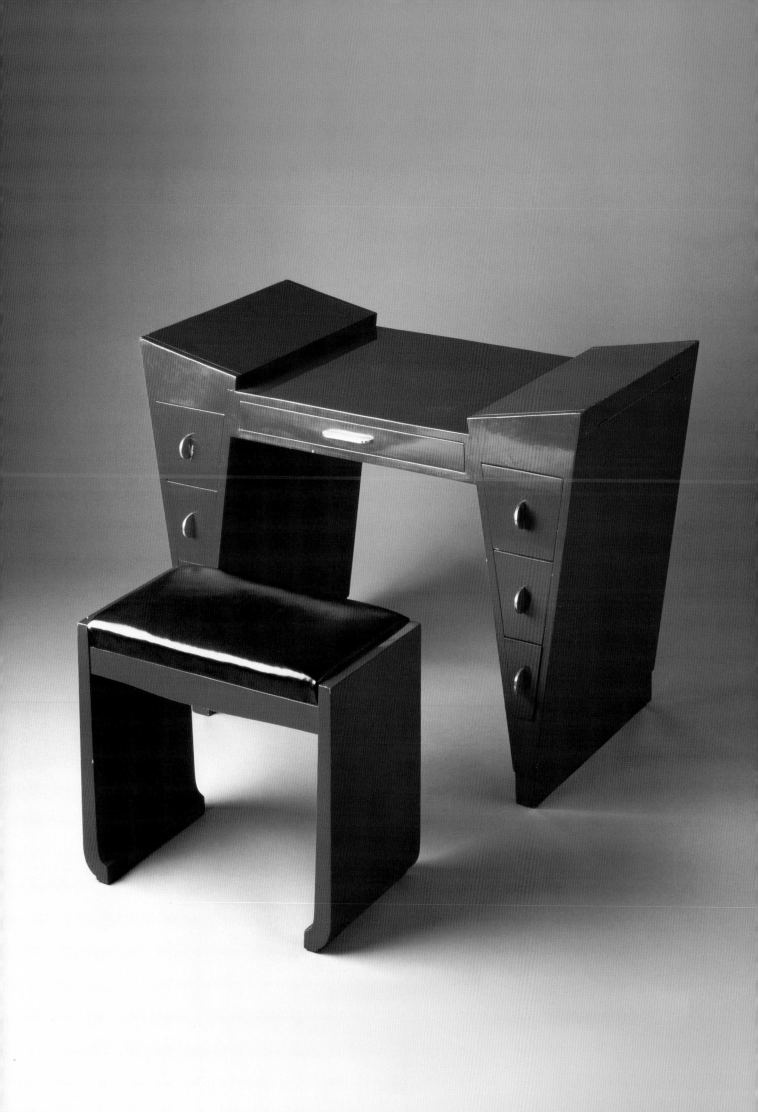

including Jean Luce and Jean Puiforcat, as well as American designers such as Henry Varnum Poor. Wanamaker's efforts coincided with the R. H. Macy & Co. exhibition of three complete rooms of "modernistic" furniture, while in 1928 alone there was a total of five New York City department store exhibitions. One of these was Lord & Taylor's "An Exposition of Modern French Decorative Art," which was organized by the store's Director of Fashion and Decoration, Dorothy Shaver, and featured French ceramics, paintings, glassware, metalwork, sculpture, and textiles, many of which had been displayed at the Paris exposition.[9] Within a short time, Lord & Taylor went beyond just exhibiting French modern design to offering copies of it: among other pieces, customers could purchase a wood dressing table and bench finished in red lacquer instead of the more exotic sharkskin that had covered the original model by Léon Jallot. (The original model was published in the December 1928 issue of *Good Furniture* magazine.)[10]

The influence of these shows would culminate in the Metropolitan Museum of Art's 1929 exhibition, "The Architect & the Industrial Arts," which would give modern design the imprimatur of the nation's leading arts institution. At the same time, as described in Marilyn F. Friedman's essay in this book, "Art Deco to American Modern at the 1929 Metropolitan Museum of Art Industrial Arts Exhibition," this exhibition represented the swan song of the 1925 Paris Exposition's impact on New York decorative arts. While it clearly demonstrated American designers' allegiance to French contemporary design, the exhibition also indicated the infiltration of other European influences as well as American innovations. After years of copying French design, American—and especially New York—designers were ready to step out from France's shadow. In March 1929, a month after the Metropolitan Museum show opened, a new group of New York–based designers called the American Designers' Gallery essentially declared independence from French sources and their emphasis on luxury and rarity by featuring designs that addressed American conditions. Their designs established new criteria for consumer products—simplicity, practicality, comfort, and affordability—that became increasingly important during the Depression, which was set in motion by the stock market crash in October 1929.[11]

NEW YORK 1939

No single event more vividly represented America's new cultural voice than the New York World's Fair of 1939/40. The fair had been in the planning stages since 1935, when the success of Chicago's 1933/34 Century of Progress Exposition convinced New York businessmen to hold their own fair, organized optimistically as a profitable antidote to the Depression. In contrast to the 1925 Paris Exposition's site along the Seine, nestled in the epicenter of France's architectural patrimony, the New York fair was located outside Manhattan and built de novo on a reclaimed ash heap in Flushing Meadows, Queens. While some of the fair's almost 400 buildings evoked the country's colonial past (ostensibly the event celebrated the 150th anniversary of the Constitution and the inauguration of George Washington in New York), the most distinctive buildings and exhibitions represented the fair's pro-technology theme, "The World of Tomorrow."

In another departure from the Paris exposition, where elite decorative artists and *ébénistes* predominated, the New York fair boosted the rise of American industrial designers who had come of age in the 1930s. They had designed mass-produced refrigerators, calculators, and trains whose sleek, machinelike, streamlined styles were intended to stimulate sales that would lift America out of the Depression. These figures included members of the American Designers' Gallery, such as Donald Deskey, as well as Norman Bel Geddes, Russel Wright, Gilbert Rohde, and Raymond Loewy. (Loewy's and Deskey's transition from French Art Deco to American streamlining is the subject of an essay in this volume by David A. Hanks, "From Deco to Streamlined: Donald Deskey and Raymond Loewy.") Many of these designers saw streamlining in nationalist terms. As designer Egmont Arens claimed in a 1934 telegraph to President Franklin D. Roosevelt, "streamlining has captured American imagination to mean modern, efficient, well-organized, sweet, clean, and beautiful." Arens offered to speak on "Streamlining for Recovery" and appealed to the federal government as well as businesses to accept *streamlining* as an important new word in the English language.[12]

American designers at the 1939/40 New York World's Fair created theme pavilions and exhibitions on subjects like food production, as well as

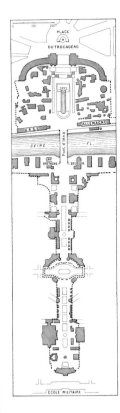
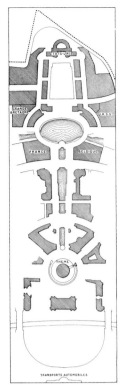

LEFT
Comparative site maps
of the 1937 Paris
Exposition (left) and the
1939/40 New York World's
Fair, reproduced in
L'Illustration, June 10, 1939

BELOW
Model of the Theme
Center at the 1939/40
New York World's Fair;
designed by Wallace K.
Harrison and J. André
Fouilhoux; stainless steel,
wood, and plastic; 1937

buildings that celebrated the country's corporate economy. Most of these structures and interiors adopted streamlined forms in contrast to the elaborately decorative Art Deco style of the 1925 Paris Exposition. The most popular pavilion was Norman Bel Geddes's sweeping General Motors Building, which housed an enormous model of a freeway-covered America circa 1960 that visitors viewed from moving, elevated seats.

Sixty foreign nations also participated in the fair with pavilions located in the "Government Zone." Costing nearly four million dollars, the French Pavilion was created by a collaboration of the architectural firms of Roger Expert and Pierre Patout, designers of elegant public spaces on the great ocean liner the Normandie. As Liora J. Cobin discusses in her essay "The Longest Gangplank," the ship was widely heralded as the ambassador of French taste when it made its maiden voyage to New York in 1935. The Normandie, in the words of its owners, was "France afloat"—but only available to those who could afford it. Expert and Patout's exposition pavilion—its curving forms evoking the Normandie's hull and smokestacks, its outdoor dining terrace serving as a landlocked deck—brought French design to the masses attending the fair. Color renderings of the ship's Grand Salon and the pavilion's main hall make the connection clear: in both drawings slender tuxedoed men promenade with women in evening dresses amid columned spaces of vast proportion, surrounded by decorative murals. On the actual Normandie, the murals were made of gilded glass panels by Jean Dupas, and depicted mythological subjects.

In contrast to the futuristic automobiles and other consumer wares shown by the Americans, the French looked back to their cultural heritage and devoted their pavilion to the country's

artistic treasures, from Gobelin tapestries to Sèvres porcelain; luxury goods such as laces, silks, and perfumes, all for sale; and, on the building's top floor, a first-class restaurant that brought *haute cuisine* to New York and would prove to be the training ground for the city's renowned post–World War II French restaurateurs. The most distinctive aspects of the colonnaded pavilion were its huge curving windows and open-air, rooftop dining terrace. Both of these features offered uninterrupted views of the Lagoon of Nations, around which the foreign pavilions were arranged.[13]

Here nightly fireworks displays took place in a spectacle encompassing 3,000 water nozzles, gas jets, colored drum lamps, giant spotlights, and firework guns, all choreographed to music played by a nearby live symphonic orchestra and piped in via amplifiers at the lagoon. This water display was inspired by Chicago's 1933/34 Century of Progress Exposition, as well as a more recent fair, Paris's 1937 Exposition Internationale des Arts et Techniques dans la Vie Moderne. Although not as influential as the 1925 Paris Exposition—by then New York designers had developed their own voice—the impact of the 1937 Paris Exposition was nonetheless evident in the 1939/40 New York World's Fair's axial Beaux-Arts planning, as well as in Surrealist exhibitions by designers like Gilbert Rohde and Russel Wright. It was, however, the 1937 fair's elaborate light and water shows that drew the most attention from American critics and the most careful study by the fair's organizers. Since the New York fair was largely underwritten by private corporations, its organizers were especially interested in reports that attendance in Paris was highest on summer evenings during these spectacles.[14]

As symbols of international harmony, the popular and festive Lagoon of Nations spectacles masked rising fears of war on both sides of the Atlantic. Hopes for peace were suddenly shattered

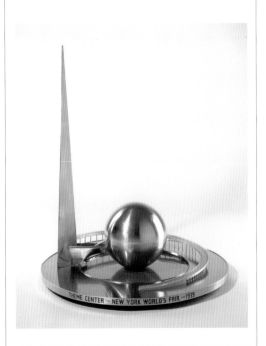

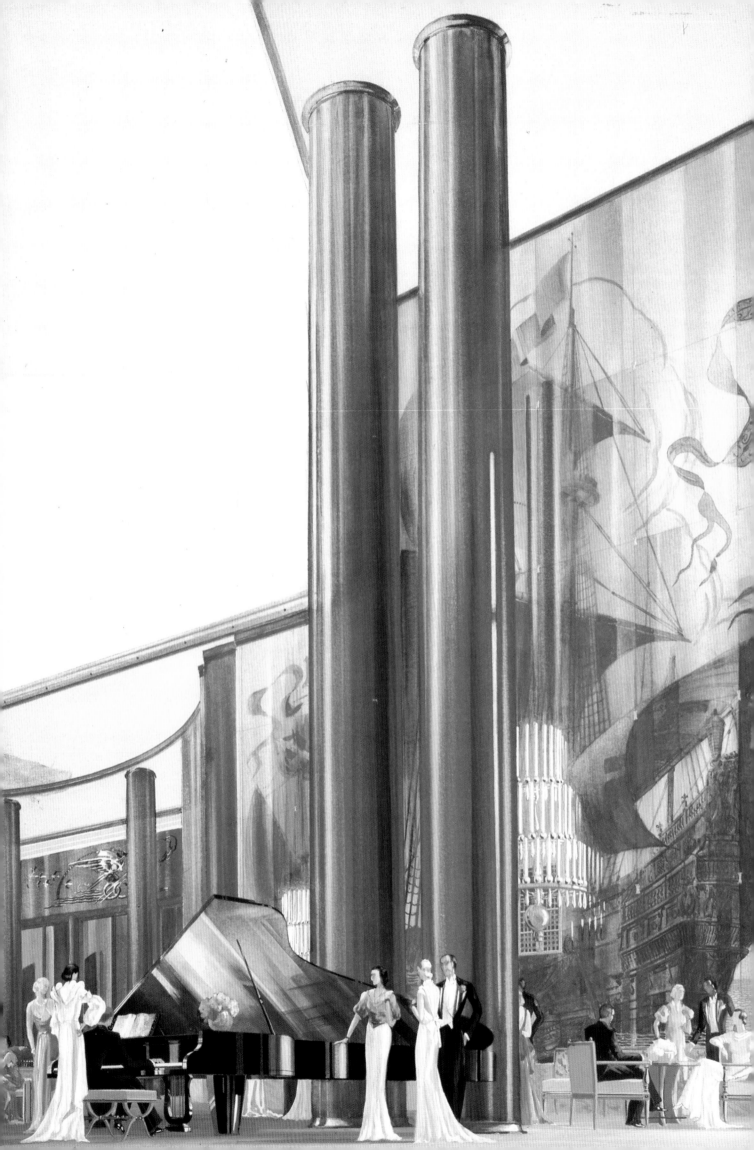

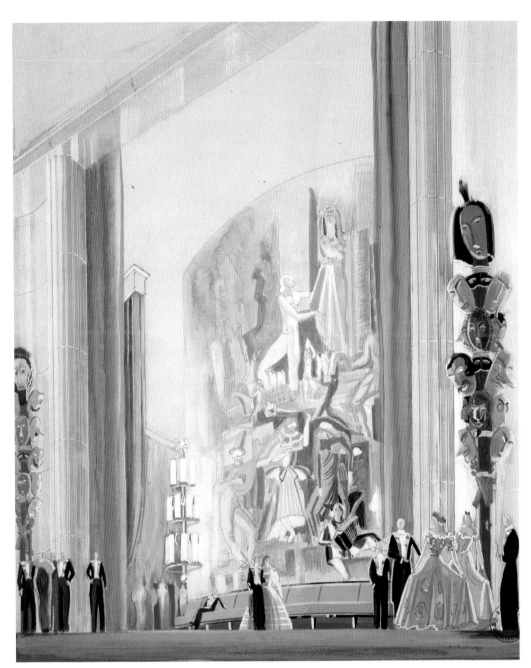

on September 1, 1939, when the Nazis invaded Poland. By August of 1940 Paris was in Nazi hands, and the close links between Paris and New York were severed. The military and cultural ascension of the United States would soon follow. Although it would not officially enter the war until December of 1941, the relationship between America and France, New York and Paris, had already shifted into a new phase as Paris's role in world political and cultural affairs diminished and New York's expanded.

The essays in this book and the artifacts featured in the exhibition it accompanies trace key aspects of the complex relationship between Paris and New York during the important—and still influential—interwar period. At this time, ideas about urbanism, architecture, decorative arts, fashion, art, jazz, and gastronomy crisscrossed

the Atlantic. Charismatic personalities like jazz performer Josephine Baker, cosmetics magnate Helena Rubinstein, architect Ely Jacques Kahn, restaurant impresario Henri Soulé, and artist Pavel Tchelitchew acted as ambassadors between the two cultural capitals, ushering new ideas back and forth across the ocean, irrevocably changing the cultural dynamic between two of the world's greatest cities.

URBANISM

It was in the arena of urbanism that New York most clearly demonstrated its aspiration to catch up with Paris and become a great city. It intended to achieve greatness by fusing art, commerce, and industry into a dynamic twentieth century metropolis that drew on—but varied from—Paris's historic model in significant ways. Evidence of this intention can be found in the second volume of Thomas Adams's *Regional Plan of New York and Its Environs* published in 1931 (first volume issued in 1929) which, even as the Depression descended on New York, audaciously suggested that the city could equal Paris as a grand world capital through bold urban planning. "Paris is the Mecca of hundreds of thousands of Americans because of its beauty," the report noted at the beginning of a section devoted to the French capital's architecture and urban planning, in contrast to only occasional mentions of other European cities like Berlin and Vienna.[15] While the report celebrated New York's monumental train stations and Art Deco skyscrapers that showed, respectively, the influence of the Ecole des Beaux-Arts and the 1925 Paris Exposition and bemoaned recent architecture in Paris, there was still much to learn from the Old World capital as New York sought comparable civic grandeur. Decrying New York City's wanton destruction of many great buildings in its rush to grow and modernize, the 1931

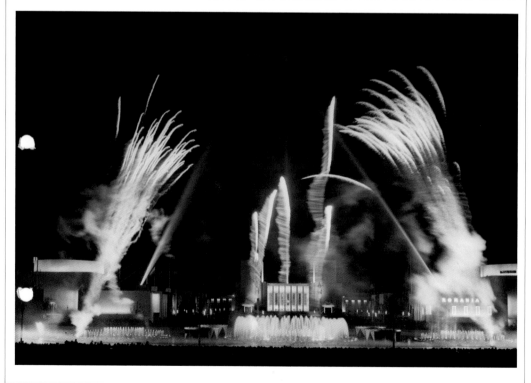

book recommended that New York copy Paris in its preservation of historic structures and whole districts (something New York would not do until the 1960s). The plan also advised the city's leaders to learn from the Parisian tradition of governmental involvement in setting monumental buildings within grand surroundings—such as Louis XIV's role in the development of the Tuileries and the Place de la Concorde, among other sites—as well as the spacious boulevards created in the nineteenth century under Baron Haussmann. Applying this model to New York, the city could create its own monumental art center, depicted in the report by a romantic rendering of set-back skyscrapers surrounding a broad plaza with an obelisk, and its own version of Paris's landscaped esplanade, given a distinctly New York character with the inclusion of dramatic and widely spaced towers. "[New York's] mountain ranges of buildings proclaim what [artist and author] Joseph Pennell once described as the 'art atmosphere' of America," the report proclaimed, "an atmosphere in which these mighty cliffs express boldness, individuality, enterprise and dominance. It is an art atmosphere as symbolic of America as the somber domestic architecture of Edinburgh and the charm of Paris are symbolic of their places."[16] New York City, the report boldly asserted, would soon be elevated from a beehive of commerce to a great metropolis like Paris—a center of art, but also itself a work of civic art.

The genesis, realization, and result of Adams's plan and its relationship to a comparable one for Paris, Henri Prost's Paris Region Plan of 1934, are the subjects of this book's first essay, Jean-Louis Cohen's "Metropolis in the Mirror." Cohen notes that between the two world wars, New York and Paris were not only incubators of architectural modernism—the subject of two other essays in this book, by Richard Guy Wilson and Isabelle Gournay—but also were laboratories for urban experiments at an unprecedented regional scale. Both plans explored industrial production—Paris and New York were leading manufacturing centers at the time—as well as strategies for modernizing their central cores and creating networks of transportation systems and public parks. Cohen examines how Paris and New York envisioned their metropolitan futures in urban plans that were conceived by looking over each others' shoulders for inspiration. They also involved a wide range of participants, some of whom worked in both cities, including technical managers, city planners, engineers, architects, and landscape architects, as well as financiers and political figures. Both plans also drew on precedents from the United States and France, as well as Germany, Italy, and England.

Cohen notes key differences between the plans that derived from each city's economic and political situations. The most significant contrast was the cities' forecasts for their own growth. In Paris concerns over the Russian and German

Drawing of the proposed Chrystie–Forsyth Parkway by Maxwell Fry, reproduced in Thomas Adams's *Regional Plan of New York and Its Environs*, 1931

revolutions precipitated conflicts between the conservative city of Paris and the socialist and communist suburban belt, precluding the creation of a Greater Paris like the expansive Greater New York that grew from the city's consolidation in 1898. Thus the Paris plan, created in the wake of the Depression and only willing to look forward to 1950, saw the roughly 1,500-square-mile region's population frozen at its existing size of 6.3 million. Adams's plan, on the other hand, optimistically predicted a New York region of more than 5,500 square miles with a population that would balloon from 9 million people in 1929 to 21 million in 1965. Even if New York would never equal Paris in civic grandeur, it seemed sure to surpass it in scope and civic ambition.

ARCHITECTURE

Richard Guy Wilson and Isabelle Gournay examine the architectural dynamic between Paris and New York in their essays in this book, "Modernity and Tradition in Beaux-Arts New York" and "Beyond Metaphor: Skyscrapers Through Parisian Eyes," respectively. Wilson discusses the surprisingly enduring influence of Paris's venerable Ecole des Beaux-Arts on New York architecture. Gournay explores the French magazines, newspapers, and books that charted the change in Parisian attitudes toward the modern New York skyscraper, which represented everything the French loved and disdained about America, as well as the skyscraper's effect on architecture in and around the French capital.

Paris enjoyed a centuries-long lead in producing great architecture; New York entered the architectural history books later but debuted

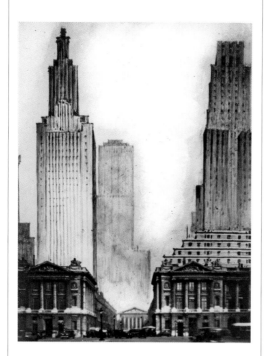

spectacularly with its skyscrapers. Between the 1870s and the start of the Depression, New York City architects and builders constructed the world's most daring examples. The most famous of these, the Empire State Building, would surpass Paris's Eiffel Tower as the world's tallest structure upon its completion in 1931.

The design of early skyscrapers featured technological innovations that allowed ever larger and more profitable use of Manhattan's valuable land. In 1870 the city, still composed of low-rise, walk-up buildings, witnessed the construction of the Equitable Life Assurance Building in Lower Manhattan, the first office building to take full advantage of a passenger elevator. Although only five stories tall, the Equitable had unusually high floors, thus rising to a height almost twice that of the city's average building.[17] With the introduction of steel-frame construction in the 1880s, the stage was set for an extraordinary building boom of structures rising to ever increasing heights. The impulse to build unfettered by any consideration other than profit culminated in a second Equitable Building in 1915, a forty-story behemoth that cast its financial-district neighbors in dark, all-enveloping shadow and would be scorned by both American and European critics as a startling but brutish example of American capitalism run amok.

After the passage of the 1916 Zoning Ordinance, however, New York skyscrapers were reshaped into gently tapering set-back silhouettes to allow sunlight to penetrate the canyons between the towers. The set-back form characterized the well-received Shelton Hotel (1924) and American Radiator Building (1925) and reached its peak in the late 1920s in such structures as the Chanin Building (1929) and Chrysler Building (1930). One of the leaders of New York's commercial architecture was Ely Jacques Kahn, who visited the 1925 Paris Exposition and adapted its decorative aesthetic to such buildings as the new Squibb

Building (1930) and Bonwit Teller department store (1930), bestowing sophisticated Parisian elegance on such utilitarian features as elevator doors, mailboxes, and mechanical grilles.

French disdain for structures like the Equitable Building was replaced by praise for the new Art Deco skyscrapers. While Le Corbusier's Plan Voisin of 1925 proposed cruciform skyscrapers for historic Paris, nearly all the participants in two important competitions—in 1930 for the Porte Maillot and in 1931 for the Voie Triomphale (Triumphal Way) west of Paris—proposed New York–style set-back skyscrapers. Architect Louis Bonnier also created studies for skyscrapers near Notre Dame and the Place de la Concorde. Although the French capital did not actually construct any skyscrapers in this period, Parisians were enthralled by the new structures coming out of New York City. Building forms such as architect James Gamble Rogers's Columbia-Presbyterian Medical Center (1928), which rose nearly 500 feet above the Hudson River and whose picturesque set-back silhouette had been illustrated in the popular French magazine *L'Illustration*, were exported to the Parisian region, appearing in, for instance, France's first high-rise hospital, the Hôpital Beaujon built in Clichy in the mid-1930s.

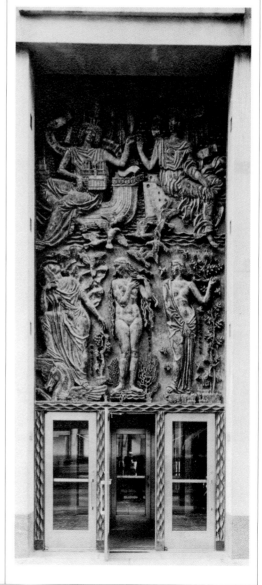

At the same time that skyscrapers were captivating Parisians' imaginations, the influence of Paris's Ecole des Beaux-Arts continued to prevail in America. Traditional Beaux-Arts principles of planning and form making were used for grand residences and civic buildings as well as commercial structures in this period. Many New York architects working in both traditional and modern styles studied at the Ecole, and its alumni included skyscraper designer Ely Jacques Kahn, as well as William Van Alen, architect of the Chrysler Building, and Raymond Hood, architect of the American Radiator Building and Rockefeller Center.

Rockefeller Center, constructed throughout the 1930s, exemplified the advantageous integration of Beaux-Arts and skyscraper traditions. Widely admired by both French and American critics, the complex's emphasis on symmetry and clear organization and its grand processional walkways, underground shopping arcades, and elegant rooftop and street-level gardens fused Beaux-Arts principles with New York's skyscraper aesthetic. The project endeared itself to French observers not only for its well-ordered urbanism, but also because it was developed by Francophile John D. Rockefeller, Jr., and involved Parisian sculptors such as Alfred Auguste Janniot and Ecole

de Beaux-Arts–trained American artists, such as architectural sculptor René Paul Chambellan. Textile designer Ruth Reeves, who had studied with Fernand Léger, provided wall fabrics for the center's Radio City Music Hall. (The complex also included La Maison Française, a building conceived to attract French tenants, as American ones were increasingly scarce during the Depression.)[18] In its fusion of modern and Beaux-Arts planning and forms, Rockefeller Center represented a model for the reciprocal relationship between French and American architectural influences between the wars.

JAZZ

If, as Isabelle Gournay writes in her essay, the New York skyscraper was in French eyes the "New World's architectural savage," then American jazz was its musical counterpart. Jody Blake's essay, "Africa on the Spiral: Jazz in New York and Paris Between the Wars," examines the path of jazz as a "giant spiral," a term she takes from American-composer-in-Paris George Antheil. Antheil, Blake writes, noted that "the shortest route—musically, at least—from the Congo, the heart of France's colonial empire in Africa, to Paris was through New York, cultural capital of the Negro, or Harlem, Renaissance." As a waystation for people migrating from the rural South to the industrial North in America, New York was the locus of another aspect of the diaspora that brought Africans from the Congo to France.

The conflation of African American jazz and "modern" American skyscrapers in the 1920s animated the transatlantic dialogue between Paris and New York. For Parisians skyscrapers and jazz represented new ways of art and life that could reinvigorate their own culture in the enervating wake of World War I. Parisians connected jazz's emphasis on syncopation and complex polyrhythms not only to tribal Africa but to the visual and aural cacophony of New York's dizzying skyscrapers and blaring automobile traffic. The significance of this conflation was underscored in a debate not between jazz musicians or skyscraper architects but between literary eminences: New Yorker Edmund Wilson and Parisian Jean Cocteau. Essentially, the debate acknowledged that cultural influence had reversed and now flowed from New York to Paris. For sophisticates on both sides of the Atlantic, jazz represented a new and dynamic means of expression in a quickly changing mechanized world. At the end of World War I, Cocteau had praised American machines, skyscrapers, and black messengers of jazz as "the beginning of a new, excellent direction." In turn, Wilson, while noting that American skyscrapers were "manifestations of force" and that the nation's entertainments were "terrifically alive," also urged the French against debasing their exalted culture with the rough syncopations of jazz and the crude Americanization of French art and literature. Let the "barbarous" and "harsh" be American, Wilson said. "Our genius is adapted to it."[19]

Original atelier plaster mock-up of a detail from the bronze relief by Alfred Auguste Janniot for La Maison Française, New York, c. 1930

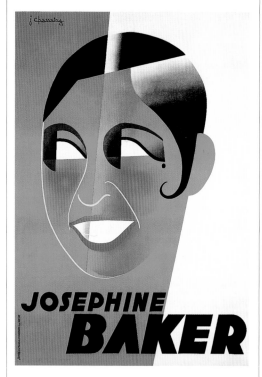

RIGHT
Poster depicting
Josephine Baker, designed
by Jean Chassaing, 1931

BELOW
Lacquer panel of
Josephine Baker, designed
by Jean Dunand and
Jean Lambert–Rucki, 1926

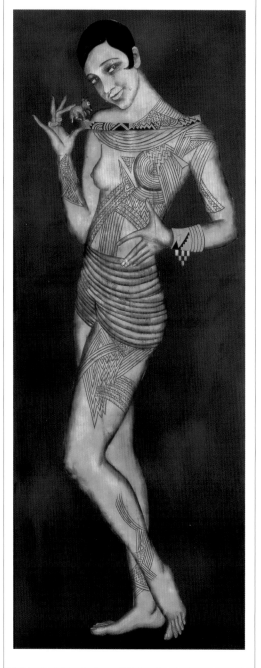

Originating in New Orleans at the beginning of the twentieth century, jazz grew out of West African and Western musical traditions and spread into various musical forms in the 1920s. Parisians had first encountered jazz when all-black regiments, preeminent among them the unit led by Manhattan's leading black jazz orchestra leader James Europe, arrived in the city in 1918 after the United States entered World War I. With surprising confidence, they brought American popular culture to Europe. A lively Parisian jazz culture of nightclubs, performances, and writings, as well as cross-Atlantic influences, developed in the ensuing decade. Black New York poets and artists went to Paris to write and paint. For them, American jazz music heard in Parisian clubs was an important ancestral art alongside the Baule masks and Fang figures shown in shops and galleries. Similarly, Paris's embrace of jazz validated it as an art form for Americans, enhancing its acceptance back in the United States.

Preeminent among the American jazz musicians who mesmerized both Parisians and American expatriates was Josephine Baker. A recent émigrée from the New York Broadway stage, Baker made her sensational European debut in Paris's *La Revue nègre* in 1925 at the Théâtre des Champs-Elysées and quickly became an icon of Parisian musical and visual culture. Jean Dunand, one of Paris's most elite designers at the 1925 Paris Exposition, created elaborate lacquer panels with Baker's image, and Jean Chassaing designed Cubist-inspired posters. Pol Rab's drawings for Stéphane Manier's novel *Sous le signe du jazz* (Under the Sign of Jazz) depicted Baker's naked skin, Blake writes, "superimposed on the facade of a skyscraper, as if the grid of industrial windows was some sort of tribal scarification pattern." It was a knowing metaphor for Baker, who was, in the imaginations of Parisians, "simultaneously the primordial Black Venus and the quintessential modern flapper." Through jazz stars like Baker in the 1920s and James Europe before her, New York and a newly powerful and confident America launched the exportation of its popular culture.

FASHION

While members of Paris's Ecole des Beaux-Arts upheld French standards in the spheres of architecture and art, France's leadership in couture was established and advanced by the Syndicat de la Couture, a tight-knit group of designers, seamstresses, and accessory makers who clothed a small coterie of the world's wealthiest and most-copied women. Throughout the nineteenth century, New York society was dressed by French couturiers, most prominently Charles Frederick Worth. In New York, however, there were no couturiers. After the end of the Civil War, the American fashion industry had tremendous manufacturing capacity and soon was proficient in retailing and marketing as well. The city's garment industry, however, remained

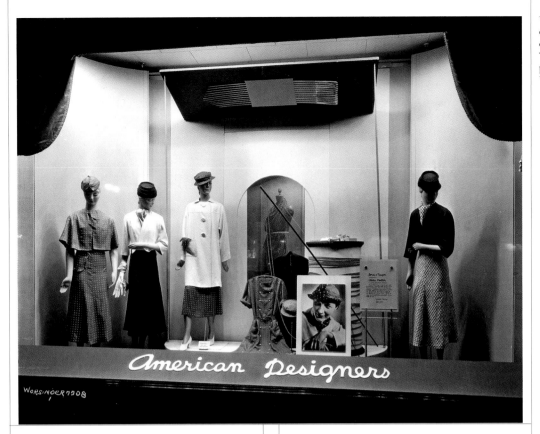

Window display
devoted to American
designers at Lord &
Taylor, New York,
photograph by
Worsinger, 1933

deficient in a key area where Paris was preeminent—an area that would be vital to the establishment of a fashion industry of any standing: designers with recognizable names and styles that could be identified as distinctly "American" in the way that Parisian couturiers were recognized as international ambassadors of French culture. In her essay, "Fashion Showdown," Phyllis Magidson charts the story of New York–based fashion design during the pivotal 1920s and '30s, when the city staged all-out war on Paris's historic fashion dominance, proposing clothing that replaced French couture with more practical ready-to-wear fashions. It was a trajectory akin to that of furnishings and decorative arts— from the 1925 Paris Exposition to the American streamlined products of the 1939/40 New York World's Fair.

Although fashion publications, prestigious stores, and an exclusive coterie of socialites like Mrs. Harrison Williams remained committed to the sophistication and selling power of Parisian goods, there were many signs that French couture was succumbing to a long-overdue American challenge in the period. The formation of a dedicated garment district along Seventh Avenue in the 1920s (many housed in Art Deco loft buildings designed by Ely Jacques Kahn's firm) was critical because it consolidated the industry in safe and spacious quarters that included showrooms and manufacturing workrooms. Here commercial machine manufacturing would make mass-produced, ready-to-wear clothes, in contrast to the elite, handmade couture that was regarded in France as an art. Garment District clothing became all the more popular in the Depression, when trade relations between France and the United States

declined, the Syndicat de la Couture refused to lower its standards in response, and American women clamored for affordable clothing that was also comfortable and practical.

At the same time, a small group of New York–based couturiers emerged, including Mrs. George Schlee, who, as "Valentina" in the 1930s and '40s, designed for a small group of society women and stage stars. She also created her own clothes, and "Mrs. George Schlee dressed by Valentina" became a celebrity mannequin when she appeared at countless nightclubs and Broadway openings. Equally important was Chicago-born Mainbocher, who opened the first couture house in Paris operated by an American and designed for such celebrities as the Duchess of Windsor. With the start of World War II and the fall of France in 1940, many Paris couture houses closed and Mainbocher returned to America, opening up a salon in Manhattan and thereby elevating the fashion sensibility of his native country.

Finally, specialty shops and department stores were influential in creating a market for New York–based designers. At Lord & Taylor, Dorothy Shaver, who had been an innovative promoter of the 1925 Paris Exposition's decorative arts, was an early booster of New York designers through all-American shows and in-house shops. Hattie Carnegie was another important retailer who by 1918 had established herself as a tastemaker known for high-quality specialty design. Ironically, it was Carnegie who may have given the biggest impetus to the post–World War II New York fashion industry by employing creative designers without crediting them. Chafing under her yoke, young talents such as Norman Norell and Claire McCardell broke off

with the coming of the war and started their own firms identified with their own names. *Vogue* had already acknowledged this shift when it published its first Americana issue in 1938. During the war, New York designers established their own award, the Coty. Although Paris reasserted its centuries-long dominance of the fashion field after World War II via Christian Dior's famous "New Look" collection (1947), it did so alongside a participant that hadn't been there before the war: a New York–based fashion industry with its own distinctive, American style.

CUISINE

Another area where France clearly dominated New York before World War II was cuisine. Here, however, America did not challenge France's hegemony. Instead it embraced French gastronomic culture wholesale—beginning with the French pavilion at the 1939/40 New York World's Fair and followed by the establishment of New York's classic French restaurants, which were run by restaurateurs who trained at France's World's Fair pavilion and their progeny. This Franco-American culinary tradition is the subject of Amy Azzarito's essay in this book, "New York Haute Cuisine."

In 1938 the scion of a leading French restaurant family, Jean Drouant, enlisted Henri Soulé to become the *maître d'hôtel* under his direction at Le Restaurant du Pavillon de France, popularly known simply as the French Restaurant, at the 1939/40 New York World's Fair. Soulé had already gained his reputation as one of Paris's youngest captains of waiters at age twenty-three and was later manager and chief of staff at the Café de Paris. Traveling on the Normandie with a staff of almost one hundred, Drouant, Soulé, and Marius Isnard, the restaurant's *chef de cuisine,* launched the enormously successful World's Fair restaurant on May 9, 1939, with a menu that featured such French specialties as *chateaubriand, poularde froide à l'estragon*, and *rognons sautés Carvalho*.[20] After the fair closed—and with France at war—Drouant and Soulé attracted funding from prestigious underwriters and launched a new restaurant in Manhattan, Le Pavillon, in the fall of 1941. Due to its high-quality food and impeccable service, Le Pavillon would be proclaimed by many as the finest restaurant in New York and by some as better than any restaurant in France. By the mid-1960s, Soulé had gone on to create the equally celebrated La Côte Basque, while no less than thirteen other Manhattan restaurants—from the still-functioning Four Seasons and La Grenouille, to La Caravelle, Lutèce, and El Morocco—were owned or staffed by Le Pavillon-trained captains, waiters, *sauciers*, and *poissoniers*.[21]

While it's easy to understand how Soulé and his protégés could successfully translate their elite Gallic cuisine into upscale Manhattan restaurants and more than a half dozen outside Manhattan as far away as Miami, their most surprising achievement was infiltrating two of America's most successful mass-market food enterprises: the Howard Johnson Company and the Campbell Soup Company. By the mid-1960s, when the former boasted more than 1,000 restaurants and motor hotels from coast to coast and the latter had been immortalized by Andy Warhol as a symbol of commercial America, a total of ten Soulé protégés, including soon-to-be-famous chefs Pierre Franey and Jacques Pépin, worked for these companies in such capacities as research chef, production chef, and vice president of quality control. In similar roles, members of Soulé's extended family tree would influence American cuisine when Howard Johnson sought to attract well-heeled corporate travelers on expense accounts by creating a chain of upscale steakhouses called Red Coach Grills. Though these grills did not generate the company's hoped-for profits, Soulé and company helped spread the art of *haute cuisine* into the commercial heartland of the United States. Americans were prepared for the next assault. The first season of Julia Child's *The French Chef* premiered on television around this time, and a new chapter of Franco-American culinary relations ensued.[22]

FURNISHINGS AND INTERIOR DESIGN

The relationship between Paris and New York in the fields of furnishings and interior design was held together by many strands in the period between the wars. Essays in this book by Marilyn F. Friedman and David A. Hanks, "Art Deco to American Modern at the 1929 Metropolitan Museum of Art Industrial Arts Exhibition" and "From Deco to Streamlined: Donald Deskey and Raymond Loewy," respectively, trace the arc of French-derived styles such as Art Deco from the rarefied world of the 1925 Paris Exposition to their decline in the face of consumer-driven American streamlining that culminated at the 1939/40 New York World's Fair.

The triumph of American-made streamlining, however, hardly meant the total embargo of French and European design by New Yorkers. The minimalist International Style modernism coming from Germany, Holland, and, in the case of France, Le Corbusier, would gain in popularity throughout the 1930s. It eclipsed the Art Deco style, largely due to the efforts of advocates such as Chick Austin, dynamic director of the Wadsworth Atheneum in Hartford, Connecticut; Alfred H. Barr, Jr., and Philip Johnson at the Museum of Modern Art (MoMA) in New York; and leading universities such as Harvard, which in the late 1930s hired Bauhaus founder Walter Gropius to head its department of architecture. Throughout the 1930s, architects adopted the International Style for buildings like the McGraw-Hill headquarters by Raymond Hood and MoMA by Philip Goodwin and Edward Durell Stone. Even the leading practitioner of French-inspired Art Deco skyscrapers, Ely Jacques Kahn,

would adopt the new International Style of straight lines and ribbon windows in his first post-war skyscrapers.

In contrast to the severity of the International Style, there was another furniture and interior design mode emanating from Paris that blended modern and historical references for effects that were decorative and romantic, sometimes to the point of fantasy. Designers such as André Arbus and Jules Leleu picked up the mantle of Ruhlmann, who had died in 1933, and created a new French Neoclassicism—in full flower on the Normandie—of subtly curving forms, majestic proportions, and sumptuous materials. Others, like Diego Giacometti and architect Emilio Terry, developed a Surrealist baroque style of whimsical, often bizarre shapes, sometimes drawn from nature.

Nelson Rockefeller's Fifth Avenue duplex, completed in 1937, transplanted the new French style to New York in spectacular form. Designed by Jean-Michel Frank, one of the era's most influential figures, and architect Wallace K. Harrison, it was conceived, Rockefeller noted, "in the style of Louis XV, with its excitement and beauty, but done in a modern way." Spacious and elegantly proportioned rooms, often indirectly illuminated via ceiling coves, provided a setting to lavishly entertain and display works of high-quality fine and decorative arts. In addition to custom furniture by Frank, the apartment featured Aubusson tapestry carpets and upholstery fabrics by Christian Bérard, exotic furnishings by Diego Giacometti and his brother Alberto, and fireplace murals by Pierre Matisse and Fernand Léger.[23]

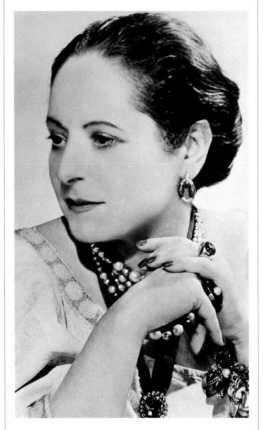

While Rockefeller's apartment emphasized the calm and elegance of the new French style, with only hints of Surrealist baroque, Helena Rubinstein's Fifth Avenue salon, completed about the same time, embraced the style's fantastic and theatrical side. Rubinstein, the diminutive yet imperious cosmetics magnate, was one of the

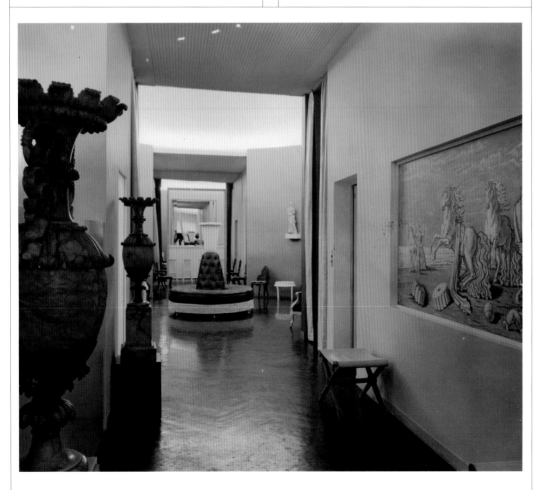

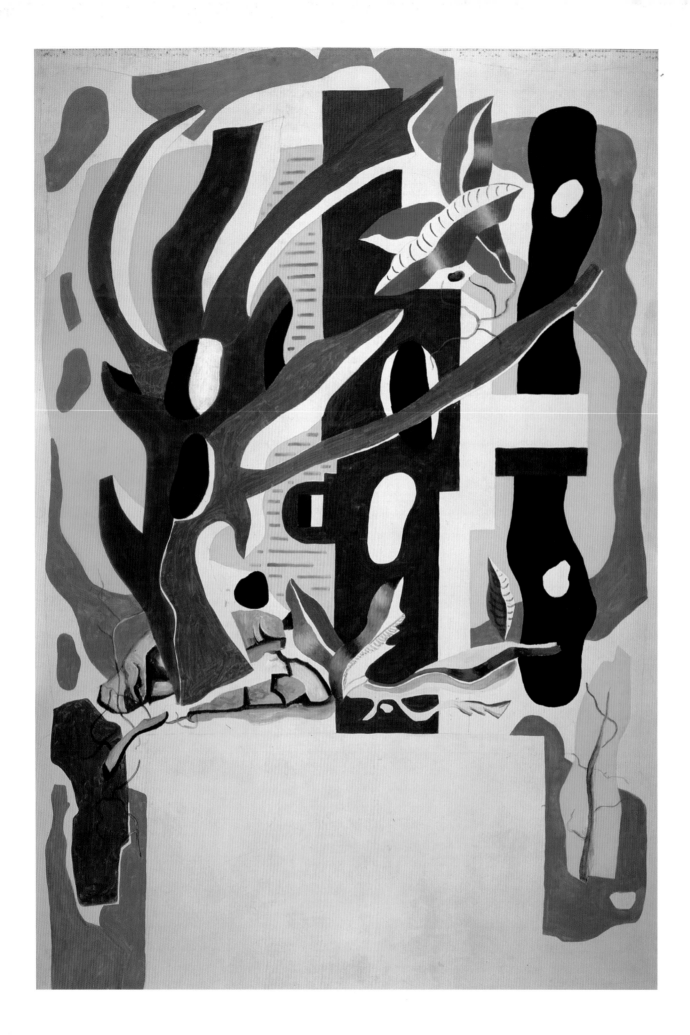

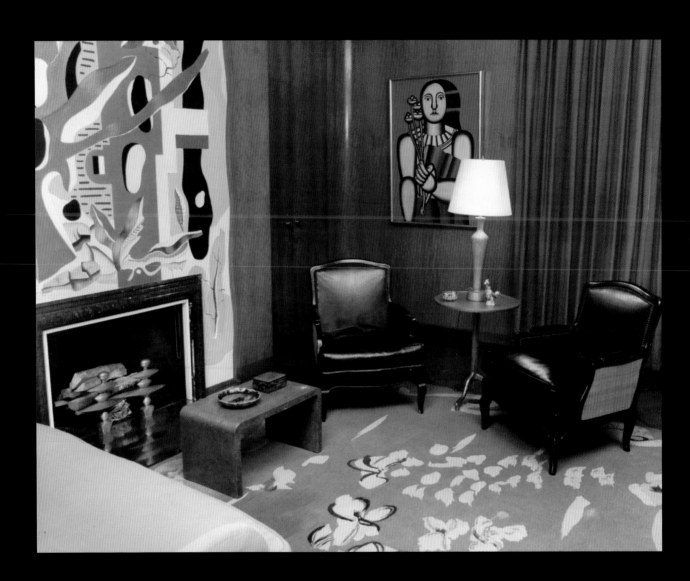

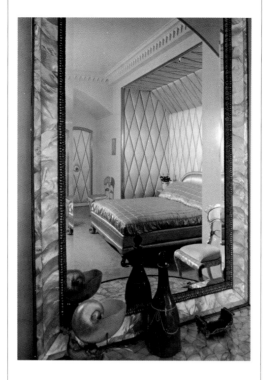

Master bedroom
in Helena Rubinstein's
Paris apartment, designed
by Maison Jansen,
photograph by
F. S. Lincoln, c. 1937

era's most visible ambassadors between Paris and New York. She had commissioned apartments and salons in both cities from an eclectic roster that included New Yorker Donald Deskey and the Parisian Maison Jansen. Her houses were filled with African sculpture, Surrealist paintings, and Venetian rococo settees, and she slept in a bed covered in gold satin and set within a niche of ivory quilted satin. Rubinstein's Fifth Avenue salon, with interior design by Ladislas Medgyes and Martine Kane, featured oak-and-leather stools by Frank, a rug inspired by Léger, and a portrait of herself by Pavel Tchelitchew, a leading artist discussed by Kenneth E. Silver in his essay, "Neo-romantics." The setting for these disparate elements was a baroque environment of huge mirrors, swag draperies, overscaled plaster work, and startling contrasts of light and dark surfaces that would influence a generation of American hotel and retail designers from Dorothy Draper to Morris Lapidus.

The interior design aesthetic of Rubinstein owed a debt to Surrealism, which had emerged as an avant-garde political and literary movement in the 1920s and had by the 1930s migrated into the visual arts, including interior design and fashion. Employing a visual language of strange and shocking juxtapositions, dreamy landscapes, and irregular, biomorphic forms, Surrealists mined the unconscious to liberate themselves and their audiences from what they decried as the twentieth century's increasingly rational and technological constraints.

Within this context of Surrealist art and its commercialization, Phyllis Ross explores the work of Gilbert Rohde in "A Bridge to Postwar American Design: Gilbert Rohde and the 1937 Paris Exposition." Best known for his introduction of modern design to the Herman Miller Furniture Company, Rohde designed exhibitions and furniture that took a dramatic new turn toward

luxury and fantasy after his visit to the 1937 Paris Exposition. The Pavillon de l'Elégance, for example, influenced Rohde's Anthracite Industries exhibit at the 1939/40 New York World's Fair by using Surrealist elements in white plaster to dramatize the exhibit's message. Rohde also pioneered the application of the movement's biomorphic forms to interiors and mass-produced furniture, which, in contrast to the custom-designed French tradition of Frank and Rubinstein, moved Surrealism into the American mainstream. Ross's essay thus sheds light on a less well known but nonetheless distinguished member of the Paris-New York axis.

ART AND BALLET

While New Yorkers on the eve of World War I were not strangers to French art—visitors to the Metropolitan Museum of Art could have seen French paintings, and Alfred Stieglitz's *Camera Work* magazine had started to publish the work of Henri Matisse and Pablo Picasso in 1907—nothing had prepared them for the explosion that occurred in February 1913 when the "International Exhibition of Modern Art" opened to the public at the 69th Infantry Regiment Armory on Lexington Avenue. Immortalized as simply the Armory Show, it featured approximately 1,250 paintings, sculptures, and decorative objects by some 300 artists, both European and American, including French artists from Paul Cézanne to Georges Braque and Henri Matisse. Amid all the controversy and derision that greeted the show's unconventional work, Marcel Duchamp's *Nude Descending a Staircase, No. 2* took center stage, with its Cubist depiction of a woman recalling, according to a *New York Herald* critic, nothing more artistic than "a cyclone in a shingle factory."[24] The fuss produced many commercial applications of modern art, including Wanamaker's department store windows that promoted "Cubist" dresses—an early indication that contemporary art could increase sales.[25]

Whether mocked or revered, the Armory Show nonetheless served as a catalyst to the acceptance of modern art in New York City and America. From the exhibition, the Metropolitan Museum purchased Cézanne's *View of the Domaine Saint-Joseph*, the artist's first work to enter a U.S. museum. New York itself would soon become the subject of French Cubist art when Parisian artist Albert Gleizes, who was living in New York during World War I, represented the cacophonous metropolis in two paintings, *Le Jazz* and *Broadway* (both 1915). Five years later, artists Katherine Dreier, Marcel Duchamp, and Man Ray founded their Société Anonyme, which, as the country's first "experimental museum" devoted to contemporary art, produced programs, exhibitions, and publications that laid the groundwork for the most significant event in modernism's development in the United States: the founding in 1929 of the Museum of Modern Art. [26]

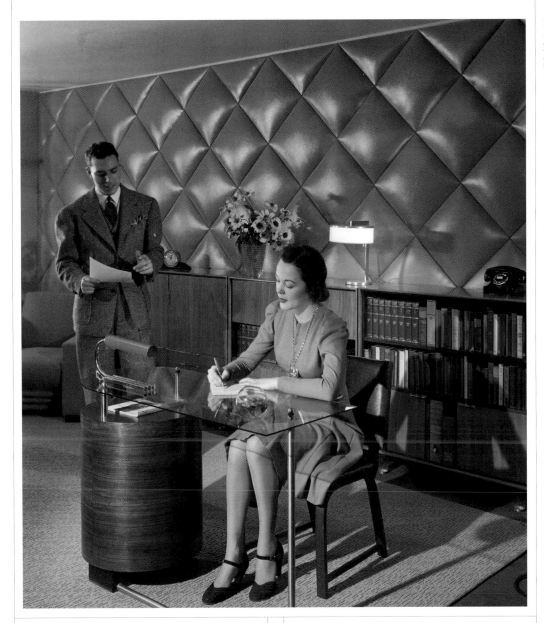

Herman Miller showroom,
Chicago, designed
by Gilbert Rohde,
photograph by
Hedrich Blessing, 1939

Under the leadership of its brilliant director, Alfred H. Barr, Jr., the museum would advance modernism in America in the twentieth century. In its first decades the museum would mount landmark exhibitions of modern art, architecture, and design, featuring the work of artists such as Pablo Picasso and Jean Arp, as well as architects Ludwig Mies van der Rohe and Le Corbusier, whose first trip to the United States was sponsored by the museum.

Alongside its interest in International Style modernism, the museum also promoted Surrealism as well as Neo-romanticism. Led by a group of artists such as Pavel Tchelitchew, Eugene Berman, and Christian Bérard, who had had their Paris artistic debut in 1926 and would later emigrate to New York, Neo-romanticism was a gentler, more decorative cousin of Surrealism, focused on representing the body, especially through portraiture, and conveying emotions in mysterious landscapes of solitary people, wind-blown draperies, and classical ruins.

Kenneth E. Silver's essay, "Neo-romantics," explores the role of Tchelitchew, Berman, and others, a group of French artists to move to New York starting in 1934. The chic of Neo-romantic artists in New York paved the way for their migration into other art forms. Like Surrealist artist Salvador Dalí, who traveled from Paris to New York in the mid-1930s to create the Dream of Venus pavilion at the 1939/40 New York World's Fair, ballet sets for the Ballet Russe de Monte Carlo, and surreal advertisements for hosiery companies, the Neo-romantics were no stranger to the commercial focus of the New World. Almost all created illustrations and designs for fashion publications such as *Vogue* into the 1950s, and Tchelitchew created murals for the New York salon of the perfume line Prince Matchabelli. The Neo-romantics were also popular as ballet set designers, especially for George Balanchine's early experiments in America and the formation of what would become a postwar New York City institution, the New York City Ballet.

Silver also describes the Neo-romantics' role in turning New York into the world's leading city for a young generation of artists to work and exhibit after World War II, replacing Paris in this role. Barr's catalog essay for his 1936 MoMA exhibition "Cubism and Abstract Art" elucidates

how the Neo-romantic sensibility helped pave the way for such postwar Abstract Expressionist artists as Jackson Pollock. In the essay, Barr defined two different modern art trends. The first trend, at that time dominant and international, grew out of Seurat and Cézanne and continued through Cubism. The second trend traced its roots to Gauguin and encompassed Matisse and the prewar "Abstract Expressionist" paintings of Kandinsky. This second, newly ascendant trend was, Barr noted, in contrast to the first: "intuitive and emotional rather than intellectual; organic and biomorphic rather than geometrical in its form; curvilinear rather than rectilinear; decorative rather than structural; and romantic rather than classical in its exaltation of the mystical, the spontaneous and the irrational." Many of these attributes could be ascribed to the work of the Neo-romantics. But they also heralded the aesthetics of the postwar Abstract Expressionists, who, after 1945, painted and promoted themselves in New York, becoming the first American artists not only to be honored in Paris but, even more important, to be copied there.[27]

CONCLUSION

This essay began with a historical moment set in Paris—the American-led Armistice parade through the Arc de Triomphe in 1919—and ends with an equally significant moment in New York in 1942: the destruction of the Normandie. Berthed in New York harbor when the Nazis invaded Poland in 1939, the Normandie had been prevented from returning to France and was seized by the American government days after the Japanese bombed Pearl Harbor in December 1941. While being outfitted as a troop ship in February 1942, it caught fire. Images of the destroyed and partially submerged wonder that

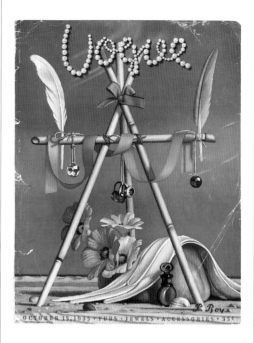

had brought the best of contemporary French decorative arts to New York while transporting the likes of Josephine Baker, Salvador Dalí, and Henri Soulé were published around the world as a poignant symbol of an occupied France. Three years later, as World War II concluded, America was all-powerful, its mainland physically unscathed and its economy revved up by massive military spending. New York City, with Paris as inspiration and catalyst, had become the capital of this new world power.

The dialogue between Paris and New York in the 1920s and '30s continues to shape each city even today. New York remains a center of dance, gastronomy, and modern art, largely as a result of pre–World War II Parisian émigrés, with a dynamic fashion industry that rose in spirited response

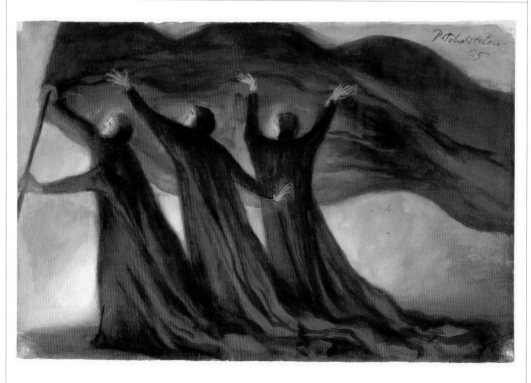

Dream of Venus pavilion at the 1939/40 New York's World's Fair, designed by Salvador Dalí, photograph by Carl Van Vechten, June 1939

to Parisian couture—itself still thriving as luxury brands sold in stylish boutiques throughout New York. The skyscrapers of La Défense, which were built on the outskirts of Paris starting in the 1960s, have Manhattanized the City of Light. The impact of American popular culture, initiated by the invasion of jazz during World War I, remains strong. Paris and New York, as well as France and the United States, confront the ramifications of what composer George Antheil called the "giant spiral" that unites them as multiethnic cities and nations. Yet, as much as Paris and New York gained individually, it is the intensity and velocity of the interwar dialogue between them that remains a compelling model for international collaborations in a global culture.

Donald Albrecht is the Museum of the City of New York's Curator of Architecture and Design. His exhibitions at the Museum include *The High Style of Dorothy Draper* and *The Mythic City: Photographs of New York by Samuel H. Gottscho, 1925–1940*. As an independent curator he has organized traveling retrospectives of architect Eero Saarinen and designers Charles and Ray Eames. He is also the curator of an exhibition about architect Moshe Safdie.

JEAN-LOUIS COHEN

METROPOLIS

IN THE

MIRROR:

PLANNING REGIONAL

NEW YORK AND PARIS

Between the two world wars, New York and Paris were not only theaters of architectural modernization, they were laboratories for urban experiments at an unprecedented scale. Grand designs were conceived in both cities in order to control and direct a demographic growth that was considered an opportunity as well as a threat, with the ambition to consider not only the central areas but the entire metropolitan regions shared by politicians, business leaders, and urban planners. Thomas Adams's Regional Plan of New York, completed in 1929, and Henri Prost's Paris Region Plan, completed in 1934, demonstrate how officials in the two cities envisioned their futures at the scale of vast territories,

TOP LEFT
Diagram showing
functional subdivisions
of the New York region,
reproduced in *Regional
Plan of New York and Its
Environs*, 1929

TOP RIGHT
Diagram of industrial
areas, reproduced in
*Regional Plan of New York
and Its Environs*, 1929

CENTER
Aerial view of the
New York region, painted
by Jules Guerin and
reproduced in *Regional
Plan of New York and Its
Environs*, 1929

BOTTOM
Manhattan waterfront
development studies by
Maxwell Fry, reproduced
in *Regional Plan of New
York and Its Environs*, 1931

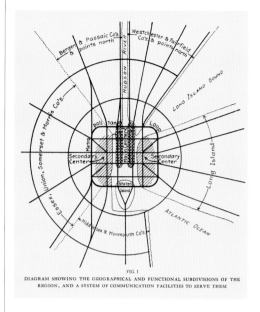

FIG. 1
DIAGRAM SHOWING THE GEOGRAPHICAL AND FUNCTIONAL SUBDIVISIONS OF THE
REGION, AND A SYSTEM OF COMMUNICATION FACILITIES TO SERVE THEM

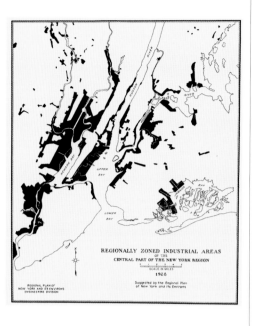

REGIONALLY ZONED INDUSTRIAL AREAS
OF THE
CENTRAL PART OF THE NEW YORK REGION
1926

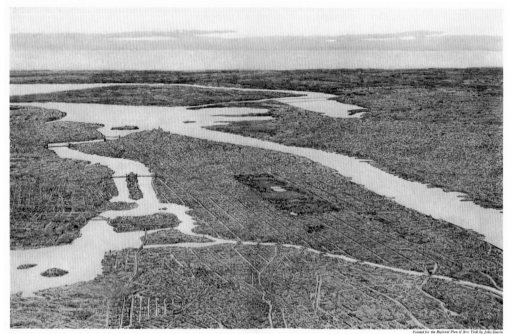

NEW YORK—LOOKING SOUTHWEST ACROSS THE CENTER OF THE REGION

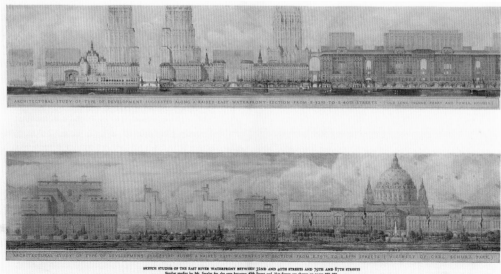

SKETCH STUDIES OF THE EAST RIVER WATERFRONT BETWEEN 32ND AND 40TH STREETS AND 79TH AND 87TH STREETS

adapting for the growth of their industries; making way for mass transit, automobiles, and public parks; and reshaping their historic townscapes. Beyond the dissimilarities of topography and proposed architectural language, the plans suggested comparable strategies for the control of urban growth. Also, they were conceived in a process of mutual observation, as both cities learned from each others' efforts.[1]

Approved within five years of each other, these plans had no real precedents. For the first time in the history of both cities, the issue was no longer mere control of building production in a dense city, which was the focus of New York's 1916 Zoning Ordinance, designed by the architect George Burdett Ford and the lawyer Edward M. Bassett, and the 1902 urban regulation for the municipality of Paris, designed by the architect Louis Bonnier, who had sketched a first schematic extension plan in 1913.[2] What was at stake in both cases was the destiny of regions extending far beyond the borders of the existing centers and the first belt of suburbs.

The main sponsors and experts who were engaged in both processes had been involved with the most interesting planning experiences of the times. New York's 1929 Regional Plan was initiated by banker Charles Dyer Norton, who had been one of the patrons of Burnham and Bennett's 1909 plan for Chicago and wanted to use their plan as a model to mobilize New York's urban elite in favor of a general coordination of urban development.[3] After Norton's death in 1923, his role was taken over by the engineer Frederic Delano, Franklin D. Roosevelt's uncle. One of the main figures in defining strategic options in the plan's early stages was again Ford, who had studied at the Ecole des Beaux-Arts, and acquired firsthand knowledge of European planning practices, first in Germany around 1910 and then in France in 1917–20 as an adviser to the Renaissance des Cités association for the rebuilding of war-damaged cities. Ford's plan for Rheims remained a model for French *urbanistes* throughout the 1920s.[4] The role of plan coordinator was taken over in 1923 by Thomas Adams, who had previously been active in Canada, had served as secretary of the British Garden Cities Association, and was responsible for the planning of the Letchworth Garden City. The architect Harvey Wiley Corbett and many other progressive professionals were also engaged in the planning studies coordinated by Adams.

France's plan was directed by Henri Prost, an experienced planner who, like Ford, trained at Paris's Ecole des Beaux-Arts and who had worked from 1914 to 1923 in France's Moroccan protectorate. There he had introduced town planning regulations derived from German precedents, using functional zoning for the first time in the context of French law.[5] Like many of his contemporaries, such as Léon Jaussely, winner of the 1919 competition for the extension plan of Paris, Prost knew well the developments of city planning

in the United States, partly through the propaganda effort of Ford, who had published a small book on the subject in Paris.[6] The main backers of the Paris plan were not bankers like New York's sponsors, but rather politicians. These included the conservative Paris senator Louis Dausset, who was already engaged in planning programs before 1914 and presided over the plan's committee, and socialist mayor of Suresnes Henri Sellier, a major figure in the shaping of Paris's social housing programs and a future minister of health in the 1936 Popular Front government. Sellier had published a moving tribute to Charles Dyer Norton upon his death, celebrating his New York plan as a "vast building site."[7] Institutions also pushing for a plan for Paris, which was understood as a strategy for the containment of the revolutionary threat, were the Musée Social and the Ligue Urbaine.[8]

Both plans benefited from the contribution of expert technicians and managers of transportation networks. On the New York side of the Atlantic, the former planner of Grand Central Station, engineer William Wilgus, was enlisted to conceive the new infrastructure. On the French side, the engineer Raoul Dautry, who had rebuilt the Northern railways after World War I and had introduced "scientific management" in their workshops, was in charge of the technical aspects of the plan. Parallels could also be drawn between the work done by landscape designer Frederick Law Olmsted, Jr., in defining new regional parks and parkways for New York and the ideas put forward by the Paris gardener and urbanist Jean Claude Nicolas Forestier, who had introduced the French to the concept of the park system developed by Olmsted, Sr., and had proposed parkways for Paris in the early 1910s.[9] Forestier's studies remained the basis of Prost's earliest schemes.

The social and economic investigations and projections that formed the basis of the New York plan, however, reached a depth and a level of sophistication unknown in Paris. Contained in eight volumes of analysis and two volumes of propositions published between 1929 and 1931, the enterprise was funded by the Russell Sage Foundation, which had built the Forest Hills garden suburb before the war and which had allocated one million dollars to the comprehensive study of the metropolitan condition.[10] The planners pragmatically included Bassett, who had written the 1916 Zoning Ordinance, thus guaranteeing the economic realism of the plan's schemes.

In contrast to the essentially private backing of the American project, the French plan was conceived under the aegis of a committee created in 1928 that included representatives of the municipality of Paris, the state, and the Département de la Seine, the territorial authority that included Paris and the first belt of suburbs. Also, rather than the two-foot-thick pile of books and reports published in New York, the main output of the French planners would be a special issue of the journal *Urbanisme* released in 1935.[11] No major mass-communication effort

Zoning and infrastructure
of the Paris region,
Paris Region Plan, 1934

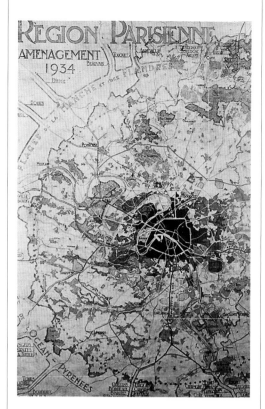

was undertaken, except the publication of a special magazine on the occasion of the 1937 Paris Exposition.[12] Still, the work of Prost was related to the contemporary studies developed at the Institut d'Urbanisme of the University of Paris and to the reformist policies of Sellier. Sellier was very receptive to current developments in Europe and urged the architects of the garden cities he sponsored in Le Plessis-Robinson and Châtenay-Malabry to study the housing schemes built in Holland and Weimar, Germany.[13]

Whereas the New York plan proposed the framework of a much more powerful urban construction capable of accommodating the ambitious growth of population, production, and commerce, the Paris plan remained focused on the improvement of the existing metropolis by creating a new infrastructure and remodeling existing areas. At the time, New York and Paris were the most populated cities in the world, along with London and well ahead of Berlin and Moscow. The area earmarked in 1920 for the Regional Plan of New York encompassed 5,527 square miles and 9 million inhabitants. As defined in 1928, the Paris region accommodated 6.3 million inhabitants within a 35-kilometer circle around Notre Dame, corresponding to an area of roughly 1,486 square miles. But no "Grand Paris" existed comparable to the Greater New York area created in 1898. Political conflict between the conservative city of Paris and the suburban "red belt" prevented the creation of a single authority, which would have inevitably been controlled by the left parties. In addition to the major differences in area and governance, the time horizons of the plans varied significantly. The Regional Plan of New York was intended to plan for the city's development until 1965, whereas the Paris Region Plan was meant, much more conservatively, to shape a

framework until 1950, as if long-term projections were too dangerous.

American and French planners were interested in each others' experience. New York was intensely considered in the Paris discussions, thanks to books such as L'Avenir de Paris, published in 1929 by Albert Guérard, a French professor at Stanford who specifically commented on the Adams plan and publications on American planning.[14] This mutual interest was also evident in the New York plan's references to Parisian precedents, focusing on historical aspects of the French capital, including the works of Baron Haussmann. The New York plan also looked at contemporary Parisian developments, such as the replacement of the city's belt of historic fortifications by low-cost housing starting in 1919 following a plan by Bonnier and Forestier. Demonstrating New York's interest in Parisian planning, Norton himself traveled to London and Paris in 1922, met with Sellier, and visited the Bureau de l'Extension at the Préfecture de la Seine. Writing to Frederic Delano, Norton noted:

The outstanding thing in Paris is the study now going on of the area encircling Paris now dedicated to fortifications . . . Monsieur Bonnier and his very able and enthusiastic group of architects, engineers and artists are studying this huge windfall of new land with zeal and high intelligence . . . Two things interested us most: the fine spirit of group effort which was shown; and the skill and beauty with which their schemes are 'rendered.' They have an instinct for showing their plans well. I asked them why they gave so much thought to that phase of it. They said frankly they were trying to interest the city fathers who decide what shall be done and who control the purse.[15]

In the center of the planners' attention were the problems of industrial production and of suburban development. Since Paris and New York were the main manufacturing centers of their countries at the time, both plans dealt with the issue of industry in the metropolis. But, while Paris desperately tried to become a seaport by widening the lower course of the Seine and building docking facilities in Gennevilliers, New York's role in the transfer of freight between America and the world was well-established. New York's plan suggested decentralization of the port facilities within the region, proposing the transfer of many of Manhattan's harbor facilities to the outer boroughs in order to ease the considerable congestion created in the streets by ferrying activities. In the Paris plan the specter of the Russian and German revolutions led to the idea of gradually decentralizing the main plants, such as the Renault Boulogne-Billancourt factory, removing them from the region, and concentrating new factories to the northeast.

The two cities' planning teams had different expectations of growth. The New York plan optimistically envisioned growth of the regional

LEFT
Plan for the rebuilding
of Rheims, designed by
George Burdett Ford, 1920

BELOW
Competition entry for the
extension of Paris, designed
by Léon Jaussely, 1919

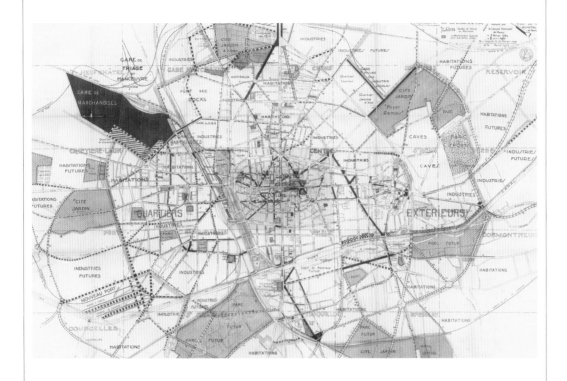

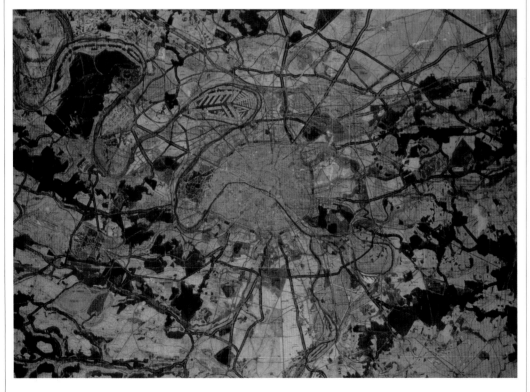

Competition entries for
Paris's Voie Triomphale
(Triumphal Way),
designed by Jacques Carlu
(above) and André Granet
(below), 1931

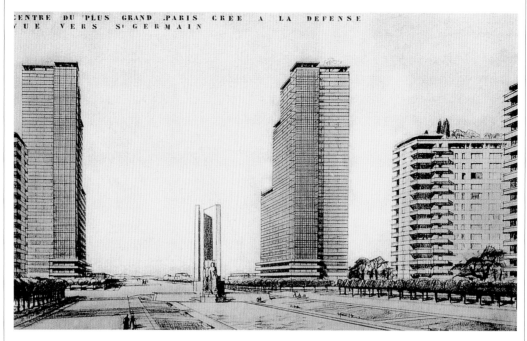

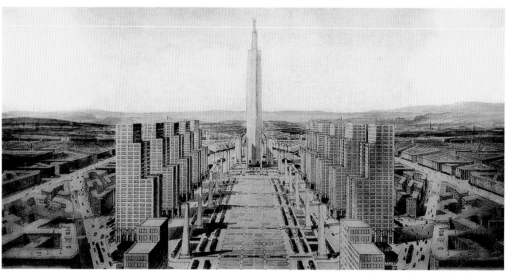

population from 9 million in 1929 to 21 million in 1965, as well as development of industrial production in the outer boroughs and the surrounding areas of the metropolis. In contrast, the Paris plan was based on a Malthusian concept: freezing the population of the region at its then-current level. Undoubtedly, factors in these forecasts were the economic conditions of the two countries. Adams's forecasts predated the Wall Street crash, and the French studies took place after the Depression had hit Europe. More broadly, the Paris plan was developed in the context of ambivalence toward the great city, where the "dangerous" classes needed to be curbed. Also, planners were daunted by the "chaos" created by the uncontrolled proliferation of subdivisions with miserable single-family housing known as the "lotissements." Hence the plan specified the limits of the areas to be developed in every municipality in an attempt to contain the "tentacular" city, a term of loathing coined by poet Emile Verhaeren.[16]

Conceptually, the new plans defined a framework for modernization. The previous plans

of both Paris and New York had focused on rail transportation, and the new plans' initial schemes maintained this perspective. Wilgus conceived an elaborate system of two belt railways connecting the twelve trunk lines converging toward Manhattan, but the railway networks' owners rejected a project that, in their opinion, interfered with their interests. In 1924 the Département de la Seine also started planning for a regional metro, and a competition held the same year for a "new town" in the north of Paris connected urbanization and rail transportation.[17] In the end, however, highways replaced the planned rail links. In both cities the structure of the metropolitan region was reshaped to accommodate new networks of roads for the transportation of goods and people, reflecting the extension of Fordism; that is, the mass-production of affordable automobiles and other industrial objects at an urban scale. Precedents for the highways could be found in the early parkways developed in New York, as well as the *autostrade* built in Italy in the 1920s. Yet the systems were not conceived in

the same manner. The Paris system was based on radial "autoroutes" connecting Paris and the French regions, intersected by a circular beltway located far from the center. The New York model combined a grid with a system of belt roads, shaping a denser gridded network of connections.

Both plans considered the alternatives of preserving the urban fabric's density and continuity of built space throughout the region versus creating a network of garden cities outside the central areas. At the time, most urban planners in Europe and North America were interested in the planning concept of secondary nuclei and satellite towns. At one point in the development of the New York plan, the contribution of British garden-cities pioneer Raymond Unwin was sought. Unwin wrote a rather critical contribution, pleading for the curbing of the automobile and the creation of a crown of new suburbs or garden cities.[18] But Thomas Adams rejected the garden-city experience he had acquired in Letchworth and Welwyn and proposed a "diffused recentralization."[19] This lack of utopian vision was criticized by Lewis Mumford, who saw in Adams's plan a "badly conceived pudding," disagreeing with its "colossal highway schemes."[20]

On the other side of the Atlantic, Prost's plan was based on an explicit rejection of all the "fantasies" of "urban theoreticians," and simply aimed at "vertebrating" the existing metropolis; that is, facilitating the development of its structural skeleton without changing its basic structure |or envisioning massive growth as New York's plan did. One of the Paris plan's original features was its attention to natural sites and historic landscapes such as the Versailles Palace and Park,

Saint-Germain, Meudon, and others, proposing specific zoning devised for their protection. A policy for the preservation of historic sites was not proposed for New York, where no sites of such historicity existed.

The plans diverged widely in two important aspects. One was the question of the social organization of the city. Clarence A. Perry, an economist working on the Regional Plan of New York, developed the notion of "neighborhood unit," the lowest level of urban organization considered in the planning process, after the "regional community" and the "village, county or city community." Its scale was adjusted, without specifying any density, at "that population for which one elementary school is ordinarily required."[21] This cellular vision of the city was developed from the research of Chicago urban sociologists and would be the basis of post–World War II planning throughout Europe. Yet the French planners were far from imagining similar standards, despite the writings of sociologist Maurice Halbwachs on "social morphology," because the discourse of social research didn't reach the political and technical spheres.

Another significant difference, primarily based in politics, was the way each plan addressed the modernization of the central areas. Adams's plan for New York incorporated a series of architectural schemes focused on the area surrounding City Hall and on both shores of Manhattan, as illustrated by Maxwell Fry and Francis Swales. In the Paris plan the political conflict between the Left-controlled red belt, i.e. the suburban territories controlled by left-wing parties, and the conservative center, which corresponded to the municipality of Paris, led to a complete schizophrenia

Axonometric view of the central area of the Plan Voisin for Paris, designed by Le Corbusier, ink on paper, 1925

RIGHT
Wood model of the
Rocquencourt Triangle
interchange built to
the west of Paris starting
in 1936, designed by
Robert Danis

BELOW
Aerial view of planned
automobile highways
outside Paris, designed for
Paris Region Plan, 1928

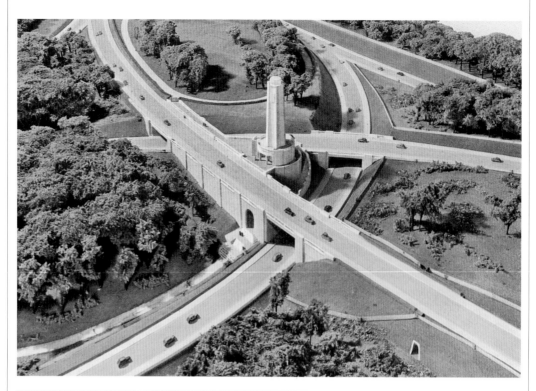

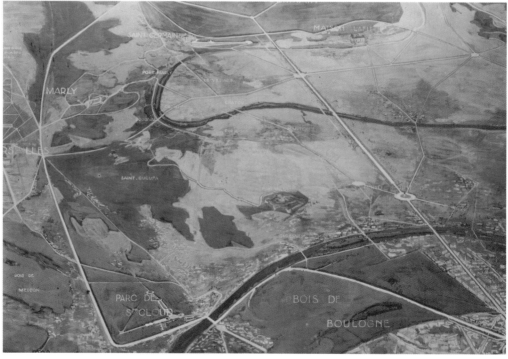

between propositions for the external areas of the region and for the city of Paris itself. The city of Paris remained a black hole in the regional plan, although many projects were discussed in the 1920s and early 1930s. After Le Corbusier's scandalous Plan Voisin of 1925, in which he envisioned the almost complete destruction of the historical center, ideas for the transformation of the Les Halles area were considered. Also, two important competitions took place—for the Porte Maillot in 1930 and for the Voie Triomphale (Triumphal Way) west of Paris in 1931—in which American-inspired skyscrapers were proposed by nearly all participants, offering an early vision of what La Défense would become in the 1960s. As head of the technical committee for the Voie Triomphale competition, Prost must have been aware of the submitted proposals.[22] Yet, since he never worked on specific architectural solutions that materialized his plan, his knowledge of the high-rise solutions proposed by the competitors was never put to use.

The fates of the Paris and New York plans varied. Albeit an unofficial venture, the plan for New York would have lasting effects on the definition of metropolitan infrastructure in the Robert Moses era, thanks to New Deal funding and long-term strategies for the harbor and industrial production, which were eventually decentralized to the outer areas according to the plan's recommendations.[23] In Paris, however, the official plan would have only localized effects on the zoning of suburban areas and would lead to early freeway construction, such as the "Autoroute de l'ouest," with interchanges designed by the architect Robert Danis and built before the war. Significantly, Westchester County's parkways created in the 1920s were models for both plans. Adams, who considered these parkways to be "one of the most significant undertakings, from an economic point of view, that has been carried out in New York and its environs,"[24] inserted no fewer than thirty-nine parkways in his plan. These parkways were also a model for some of Prost's concepts for automobile promenades around Paris.

Both plans had significant displays devoted to urban problems in the 1937 Paris Exposition and the 1939/40 New York World's Fair. These displays included films written by the Paris historian Marcel Poëte and by the American writer Lewis Mumford that documented in similar terms the dire condition of the cities and the bright future promised by the new plans.[25]

But on the grounds that the plans' impacts were mostly invisible, the brochure published in 1942 by the Regional Plan Association under the title *From Plan to Reality* could only map the extension of low-density housing throughout the entire region, despite the plan's attempts to modulate its use.[26] And the Paris plan's proposal to curb industrial growth in the metropolitan region failed until the late 1940s. In fact, both plans were meant to remain guidelines for the management of the regions for several decades. Approved with much effort in 1939 and revised in 1956, the Plan d'Aménagement de la Région Parisienne, as it would officially be called, became an instrument of technocratic management rather than a document controlled by the elected body. It was superseded in 1960 by the ill-prepared PADOG or Plan d'Organisation Générale, which would be rapidly scrapped in favor of a more ambitious design, although the local provisions of Prost were still in effect in some suburban areas until the mid-1970s.[27] In New York the next Regional Plan would not be completed until 1968, but in the meantime, the policies of Robert Moses had shaped the region with implicit reference to the work done in the 1920s.

In summary, while the destinies of both cities in the last third of the twentieth century were shaped in the imaginations of many professionals and citizens by the visions of Adams's and Prost's teams, the hope for social harmony on a metropolitan scale evaporated in the face of the realities of real estate and traffic. More than programs for real action, both plans seem in retrospect to have been mere reflections of aspirations and projections that failed to be shared by the actual players on the urban scene.

Jean-Louis Cohen is an architect and professor of architectural history at New York University's Institute of Fine Arts. He has organized numerous exhibitions at Paris's Centre Pompidou and Pavillon de l'Arsenal, as well as the exhibition and book *Scenes of the World to Come* for the Canadian Centre for Architecture. Among his other books on urbanism is *Des Fortifs au périf: Paris, les seuils de la ville*, written with André Lortie.

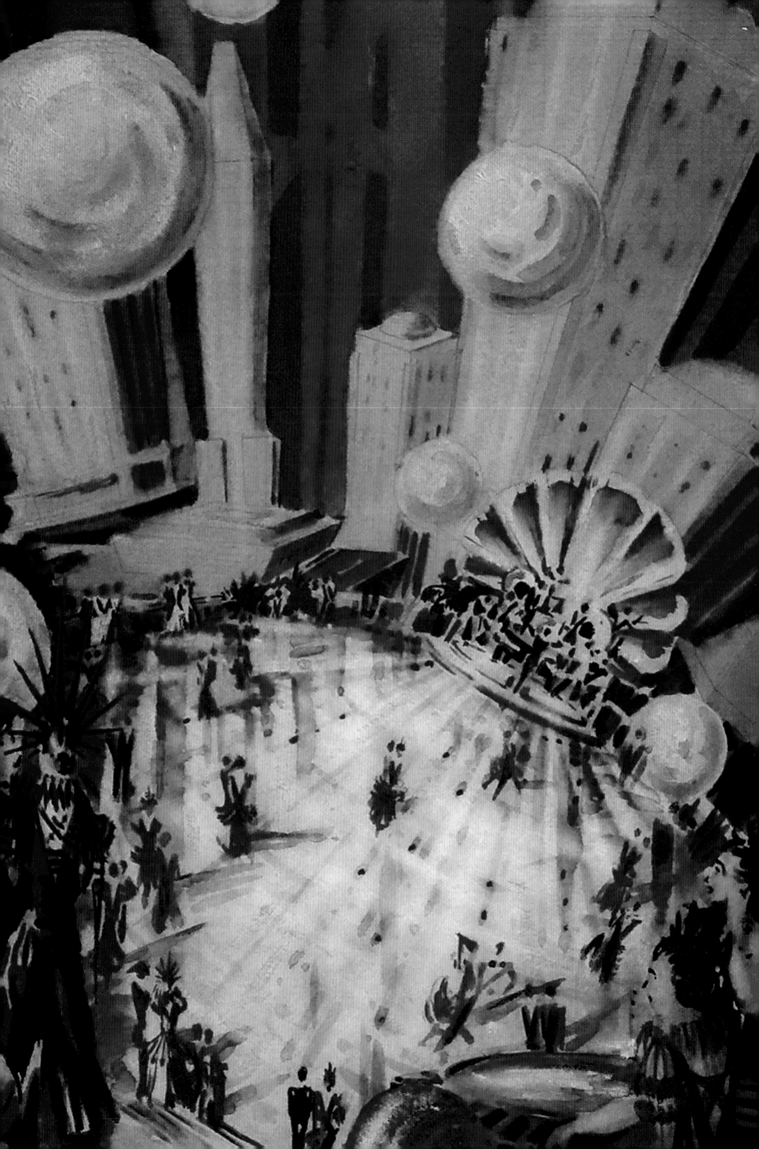

RICHARD GUY WILSON

MODERNITY

AND

TRADITION

IN

BEAUX-ARTS
NEW YORK

A two-way "gangplank" connected Paris and New York architects and critics during the 1920s and 1930s. New York's skyscrapers, elevated trains, and industrial buildings fascinated the Parisians, and Paris offered New York architects the new modernist styles as well as being the home of the Ecole des Beaux-Arts, where many of them had trained. For most architects in New York, and indeed in the entire United States, the principles of the Beaux-Arts retained great authority, even in the face of new styles.

From Paris and the 1925 Exposition Internationale des Arts Décoratifs et Industriels Modernes emanated a new expression called variously "moderne," "modernism," "modernistic," and "Art Deco." This new style consisted of abstracted and lavish decoration applied to conventional forms. It caught the American architectural imagination and could be seen in countless department store windows and displays, along with major structures such as the Daily News, Chrysler, Empire State, and Rockefeller Center buildings. Also out of Paris, though making more of an impact in the 1930s, came the more functionalist, or purist, approach as in the Pavillon de l'Esprit Nouveau by Le Corbusier and his cousin, Pierre Jeanneret, also on display at the 1925 Paris Exposition. This approach was heavily promoted by critics such as Henry-Russell Hitchcock and Philip Johnson as the "International Style." New York finally got its functionalist monument with the Museum of Modern

Art in 1939, yet even that showed the influence of the Beaux-Arts in its facade.

For Parisians the attraction of New York lay primarily in its image as a new industrial civilization. Le Corbusier's *Vers une architecture* (1923) appeared in English as *Towards a New Architecture* (1927) and had as its frontispiece a view of the East River with a tugboat in the foreground; looming behind it was the recently constructed New York Telephone Company headquarters (also known as the Barclay-Vesey Building, 1923–27) designed by Ralph Walker of McKenzie, Voorhees & Gmelin. Given Le Corbusier's purist stance, this cover image was an ironic choice, since Walker's building is frequently cited as New York's first Art Deco skyscraper because of its set-back form and lavish ornament.[1]

However, the city possessed another attraction, as indicated by Le Corbusier's reaction during his 1935 visit to the city. After viewing Grand Central

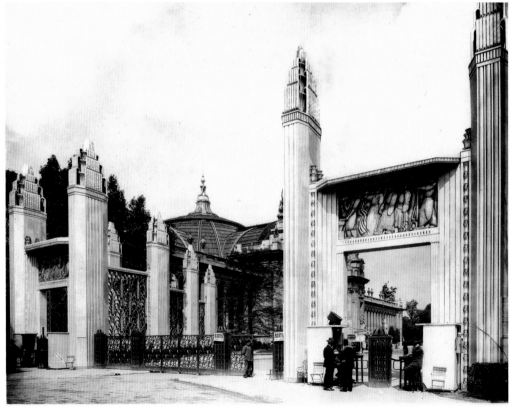

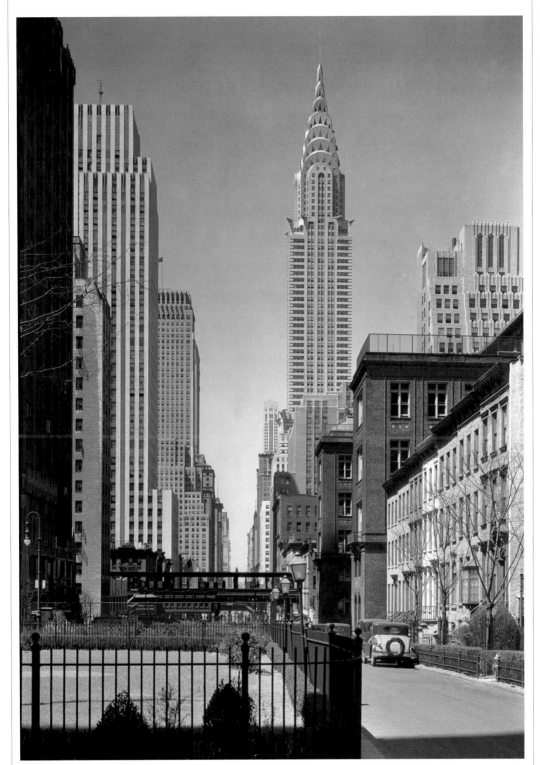

View down Forty-second Street with Chrysler Building, New York, designed by William Van Alen, photograph by Samuel H. Gottscho, 1932

Station and the University Club, he exclaimed: "In New York, then, I learn to appreciate the Italian Renaissance." He went on to say, it was "so well done that you could believe it to be genuine. It even has a strange new firmness which is not Italian, but American!"[2]

Behind Le Corbusier's observation and, indeed, underlying the buildings noted above and many others lay a deep-seated Beaux-Arts orientation. Beaux-Arts architecture in the United States is typically portrayed as an issue of style, exemplified by the grand classical buildings erected in the period prior to World War I, such as the University Club, the New York Public Library, and Grand Central

Station. After the war a new period of modern architecture emerged that was dominated by the Art Deco style up to the early 1930s and then followed by a more straightlaced or functionalist modernism known as the International Style. Typified by its rectilinear character and avoidance of applied ornament, the International Style opposed both the decorative modernism of the Art Deco and the historicism of the Beaux-Arts. The old guard of the Beaux-Arts disappeared into the history books, only to be rediscovered with Postmodernism in the 1970s and, ironically, by the Museum of Modern Art's exhibition of 1975–76. Sometimes acknowledged are Beaux-Arts survivals built in the 1930s, such as

Washington, D.C.'s Federal Triangle, Supreme Court building, and National Gallery of Art (all primarily designed by New York architects), but New York was viewed as the center of modernity by then. Such exclusivist interpretations of history usually have another side and, in the case of New York, the impact of the Beaux-Arts continued well into the decades of the 1920s and '30s and beyond, though critics and scholars have largely ignored it.

The term "Beaux-Arts" as applied to architecture encompasses several elements. On one level is the physical school of architecture, painting, and sculpture located on the Left Bank in Paris whose roots go back to Louis XIV and the construction of Versailles. Reconstituted in the early nineteenth century, the Beaux-Arts became the premier school of architecture in Europe. "Beaux-Arts" also meant an approach to architecture. Officially, the Ecole des Beaux-Arts in Paris did not teach a style of architecture; rather, it taught a logical, rational system of design based upon good judgment and certain rules. Classicism, with its heritage of books beginning with Vitruvius and reinvigorated by Alberti, Vignola, and Blondel, tended to dominate, but in actuality style at the Beaux-Arts depended on the project at hand. Throughout the nineteenth century a spirited debate took place over the appropriateness of different styles, with constant calls for a "modern" style.

Although differences abounded between architects, the Beaux-Arts did teach an approach to architecture that emphasized the plan and the resultant volumes as forming the exterior massing. In theory, the exterior should reflect the interior. Axiality and balance were stressed when the site would allow it and, although students addressed residential and commercial problems, the emphasis lay on grand public buildings. The result was normally in some classical style that could span Greek, Roman, Renaissance, Georgian, or other varieties. Students were taught to draw fast and frequently with time limits on the length of study (*en loge*). A compelling and elegant presentation drawing was an important means of communication about design. Another element of the Ecole's system was the method of instruction. Students took a series of formal lectures on the history of architecture, geometry, construction, and other subjects. They also enrolled in studios (*ateliers*) run by a master (*patron*) where they learned design though competitions (*concours*), which were first criticized by the master and then at the end by a jury.[3]

The first American to attend the Ecole—Richard Morris Hunt, who became one of New York's leading architects—studied there between 1847 and 1854 and set in motion a wave of Americans, such as H. H. Richardson, Charles McKim, Ernest Flagg, and John Russell Pope, who traveled to Paris to attend the Ecole. Between 1892 and 1900, 700 students were admitted to the Ecole, and 124 were Americans.[4] This figure

THE
BULLETIN
OF THE
BEAUX-ARTS
INSTITUTE
OF
DESIGN
JANUARY
1932

does not include an equal number of Americans who either failed to gain admission or just studied in studios (*ateliers*) without attending classes. For most American and especially New York architects, attendance at the Ecole provided training and a cachet that enabled them to succeed. When American schools of architecture were set up after the Civil War, they—with minor exceptions (e.g., the University of Illinois)—followed the French system, even to the point of importing French instructors. In 1865 MIT, whose first classes were held in 1867, established the first American outpost of the Ecole, followed by many other institutions—including Columbia University, which inaugurated an architecture program in 1881.

The debt American architecture owed to the Ecole's system was evident in its buildings constructed between the 1850s and the 1940s and was constantly commented on in the architectural press.[5] In 1887 a group of New York–based designers—Hunt, McKim, Thomas Hastings, and the Chicagoan Louis Sullivan—established the Prix de Reconnaissance des Architectes Américains, an award by Americans to a French student, signifying the American "obligation" to the Ecole.[6] The prize was awarded again in 1893, in New York, and also sponsored by some of the same individuals (McKim, Hunt), the establishment of the American School of Architecture in Rome (which became the American Academy), and the Beaux-Arts Society of Architects. The intention of the Beaux-Arts Society was "to cultivate and perpetrate the associations and principles of the Ecole des Beaux-Arts of Paris and to found an Academy of Architecture" in the United States.[7] The Society sponsored competitions in American architecture schools and gave awards such as the Paris Prize, which sent an American student to the to the Ecole to study. Over the years other prizes and awards were added. The growth of the educational

mission of the Beaux-Arts Society led the members in 1916 to create a spin-off: the Beaux-Arts Institute of Design. Its purpose was to give "instruction . . . by methods similar to those in use at the Ecole des Beaux-Arts in Paris"[8] in architecture, sculpture, painting, and the decorative arts.

With World War I, American attendance at the Ecole dropped off, never to recover. Another cause for the decline was the growing number (28 by 1916, 45 by 1930) of American schools of architecture, most of which followed the Beaux-Arts system as promulgated by the Institute in New York through its competitions and textbooks.[9] In 1929–30, 2,466 students from 44 architectural schools across the country submitted 9,622 drawings to the annual competitions sponsored by the Institute.[10] Projects published in the annual yearbook illustrate many traditional Beaux-Arts buildings, but also many student schemes that incorporated new, modernistic elements. In 1923 the Beaux-Arts Institute, under the direction of Whitney Warren, established the Fontainebleau School of Fine Arts in France and took about 70 American students abroad every year.[11]

The Society and the Institute published an annual yearbook that contained the names of many important New York architects: Raymond Hood (atelier Duquesne, 1905), Ely Jacques Kahn (atelier Redon, 1907), William Adams Delano (atelier Laloux, 1899), William Van Alen (atelier Laloux, 1909), William Lamb (atelier Deglane, 1907), and Wallace K. Harrison (atelier Umbdenstock, 1920). In 1929 there were 216 full members, 72 associate members, and a separate membership that contained at least 70 more architects, such as Ralph Walker, who had attended MIT. The Society and the Institute were also social organizations, and every year they held a Beaux-Arts Ball whose costumes and posters became renowned and were frequently pictured in the society pages of New York newspapers.

The Institute's new headquarters, completed in 1928 at 304 East Forty-fourth Street, illuminates the juncture of the Beaux-Arts and the Art Deco styles. The architects were Ethan Allen Dennison (atelier Laloux, 1902) and Frederic C. Hirons (atelier Laloux, 1904), who won the commission in a competition held among many of the Society's and Institute's members on the afternoon of November 17, 1927. Among those who participated were Hood, Walker, and Van Alen.[12] Hirons, who was the main designer, was well-known for his drawing ability, and the firm designed a number of bank buildings (including skyscrapers) that were erected on the east coast.[13] Hirons's five-story, buff-brick facade incorporated abstract vertical pilasters topped with flattened and stylized Ionic capitals. Above was a wide, plain cornice or parapet that contained at the ends two large figural sculptural blocks that made a bow to the past. Overall, the ornamental scheme incorporated historical and modernistic elements and might be termed "Greco-Deco." René Paul Chambellan, a leading architectural sculptor, provided the models for the three large, highly colored panels: the central one depicted the Ecole in Paris, flanked by the Parthenon in Athens and Saint Peter's in Rome. The Atlantic Terra Cotta Company produced the colorful entrance surrounds, the panels, the abstracted capitals, and the large block sans serif lettering.[14]

This New York brand of modernistic architecture owed a great debt to the 1925 Paris Exposition (and other European movements, such as Secessionism), but it also contained several home-grown elements. One source lay in the ornamental work of Frank Lloyd Wright, though he was seldom acknowledged by New York architects in those years. Another source, and much closer to home, was the New York–based architect Bertram Grosvenor Goodhue. Goodhue never attended architecture school, and his initial architectural orientation—in partnership with Ralph Adams Cram—lay with the Gothic; in fact, he outspokenly opposed the Beaux-Arts. However, his later work (he died in 1924 at the age of fifty-four), such as the National Academy of Sciences (1919–24) in Washington, D.C. and the Nebraska State Capitol (1920–32), incorporated abstracted classical elements. Goodhue's highly praised 1921 proposal for a convention skyscraper became the prototype for the Barclay-Vesey, Chrysler, and Empire State buildings. Organized with a series of rhythmical setbacks that reflected the 1916 New York Zoning Ordinance, Goodhue's skyscraper illustrated how classical and medieval elements might be merged into a new expression.[15]

Raymond Hood had worked with Goodhue and Cram prior to his Ecole years; his work (i.e. the American Radiator Building) exemplifies the new, modernistic interpretation of the Beaux-Arts merger with the Gothic. The symmetry, organization, and processional nature of his plans, whether at the building scale or the block scale (such as Rockefeller Center), owed much to his Beaux-Arts

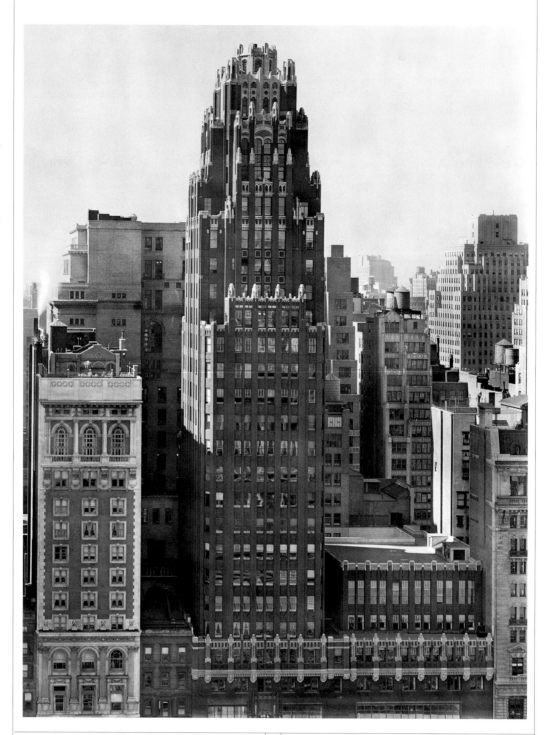

background. With Kenneth M. Murchison, Hood designed the Beaux-Arts Apartments (1929–30) located adjacent to the Beaux-Arts Institute on either side of East Forty-fourth Street. Consisting of 648 units, the twin sixteen-story buildings contained modernist flourishes such as a horizontal window pattern and lavish decoration in the lobbies. But overall the setback form, the courts in front, and the symmetry and general massing were Beaux-Arts.

Traditionally seen as opposed to the lavish decoration of the modernistic or Art Deco buildings by Hood or Hirons is the more purist and undecorated expression known in the United States as the International Style. Indebted to the work of Le Corbusier as well as German and Dutch architects, the International Style was promoted by the new Museum of Modern Art

(MoMA), founded in 1929, and three scholar/critics connected to it, Alfred H. Barr, Jr. (director), Henry-Russell Hitchcock, and Philip Johnson. Through articles, an exhibition, and books (including *The International Style*, 1932), a new defining aesthetic of architecture was proposed based on three principles: regularity rather than symmetry, volume rather than mass, and avoidance of applied decoration. This, the MoMA group proclaimed, guided all new architecture and was, of course, directly opposed to the Beaux-Arts-oriented modernistic approach.[16] MoMA's new building (1938–39) erected on West Fifty-third Street was to embody these new principles. Although Philip L. Goodwin was the head architect of the project, the main designer was Edward Durell Stone. Goodwin (atelier Umbdenstock, 1912) was a very active member of the Beaux-Arts

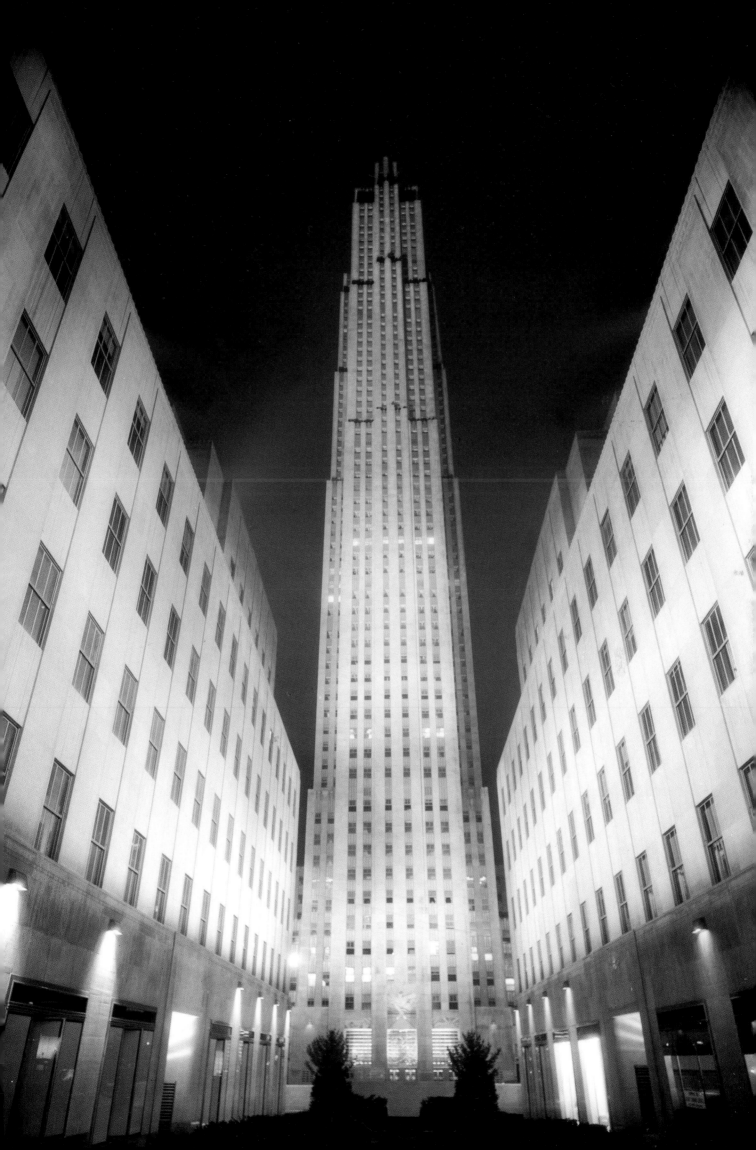

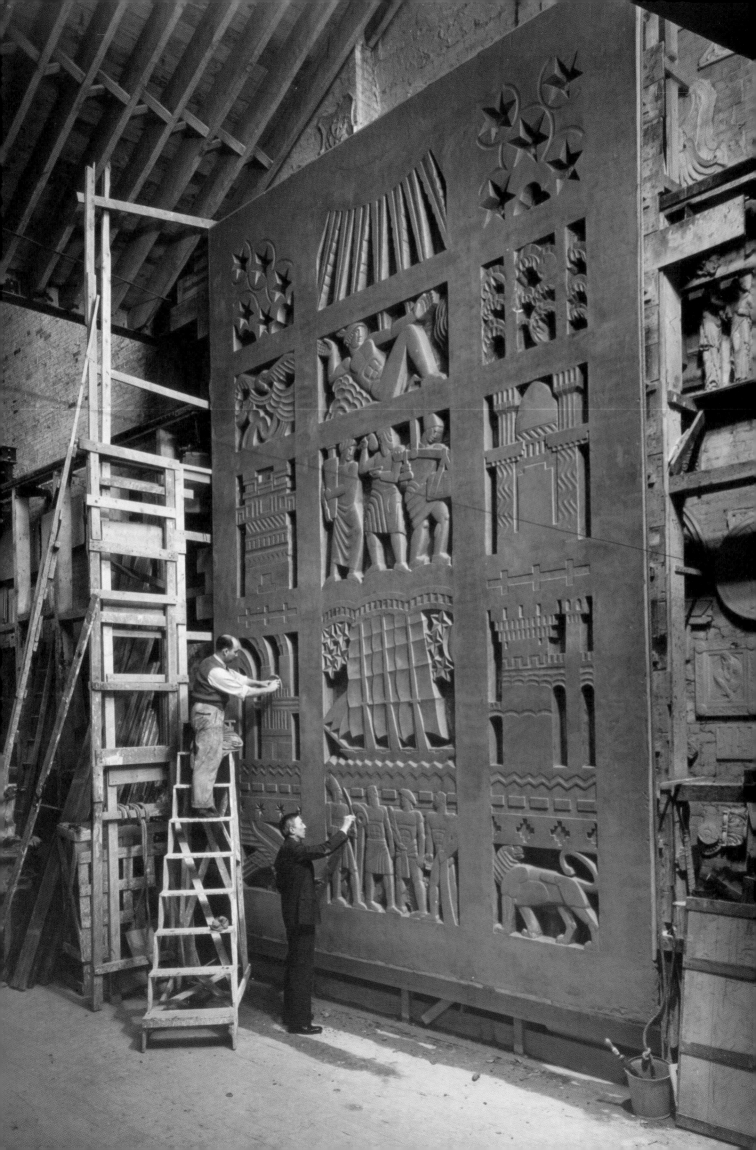

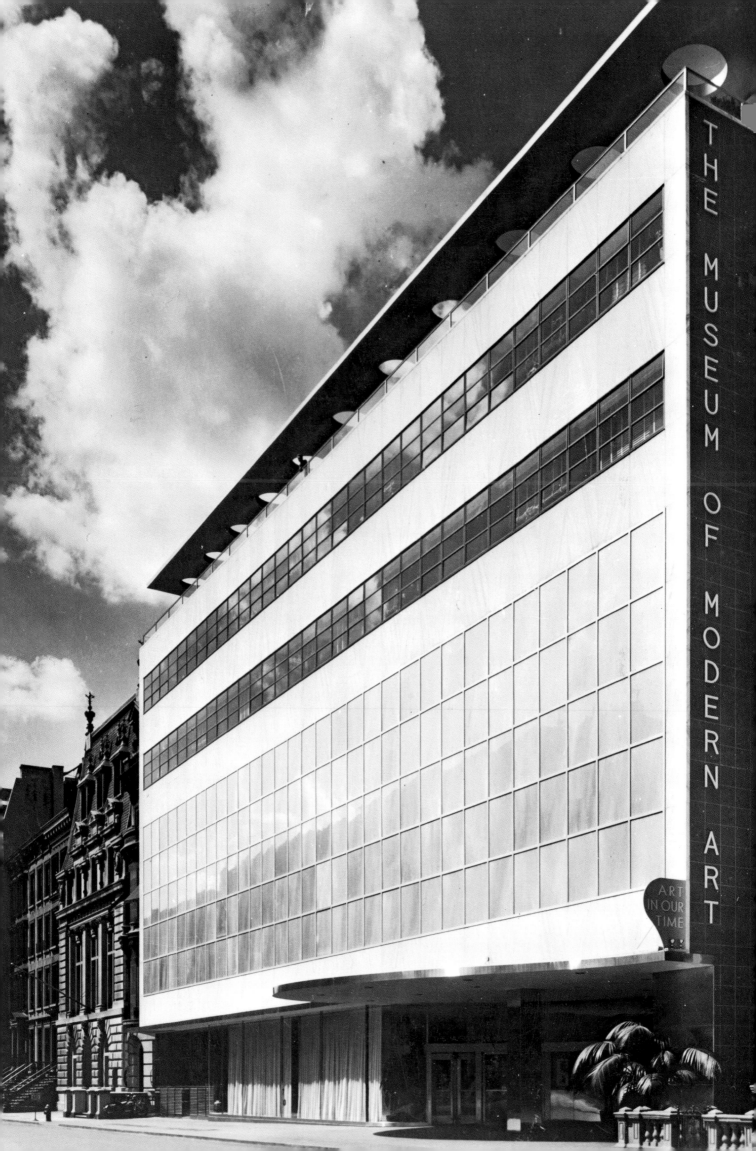

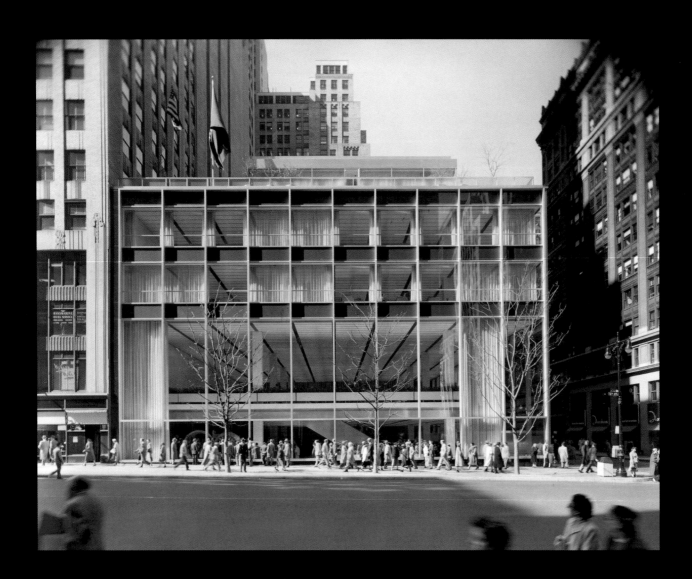

Institute of Design, serving as a trustee and vice chairman. Stone never attended the Ecole, but his training at Harvard and MIT followed the Beaux-Arts system, and he served on the Beaux-Arts Institute's committee of architecture in 1940–41. Stone won a traveling European scholarship and, in spite of designing one of the earliest east coast International Style houses (the Richard Mandel house in Bedford Hills, New York), he had a strong traditionalist streak. Several projects were developed for the facade of MoMA, but the one that was erected bore a strong Beaux-Arts orientation. The entrance was off-center, but the main facade was a standard tripartite organization: overall it was an abstracted Italian Renaissance palazzo with large thermolux panels representing the piano nobile.[17]

Beginning in the late 1920s and continuing into the 1930s, American students (and some faculty) chafed at the strictures of the Beaux-Arts system. During the Depression, calls for reform in almost every area of American culture, as well as new architectural ideas out of Europe—led by Walter Gropius at Harvard and Ludwig Mies van der Rohe at the Illinois Institute of Technology —made the Beaux-Arts appear outmoded. Some American schools tried new methods,[18] and membership in the Beaux-Arts Society and Institute declined. However, into the 1950s annual competitions continued to be held, and students from across the country continued to submit designs.[19] Faced with extinction, the Beaux-Arts Institute reestablished itself as the National Institute for Architectural Education in 1956, and in 1996 it was renamed the Van Alen Institute after the designer of the Chrysler Building.

The impact of the Beaux-Arts could be seen well into the 1950s in two New York projects: the

OPPOSITE
Manufacturers Hanover Bank, New York, designed by Gordon Bunshaft/ Skidmore, Owings & Merrill, photograph by Ezra Stoller, 1954

LEFT
Gallery of Modern Art, New York, designed by Edward Durell Stone, photograph by Ezra Stoller, 1964

Manufacturers Hanover Bank on Fifth Avenue designed by Gordon Bunshaft of Skidmore, Owings & Merrill and the Gallery of Modern Art designed by Edward Durell Stone. Bunshaft was trained at MIT in the Beaux-Arts manner and had been employed by Stone in the 1930s. The bank eschewed ornament and displayed its structure in its glass box enclosure; as form, however, it was pure classicism. Stone's building for Huntington Hartford at Columbus Circle openly recalled Venetian palazzos with its form and tripartite massing. And, indeed, if one examines much American architecture from the 1950s and 1960s, the materials were different and "new" and ornament was gone, but the underlying principles of the Beaux-Arts were present everywhere.

Richard Guy Wilson is Commonwealth Professor of Architectural History at the University of Virginia. He has been the curator and author for major museum exhibitions such as *The American Renaissance, 1876–1917*; *The Art That Is Life: The Arts and Crafts Movement in America*; and *The Machine Age in America, 1918–1941*.

ISABELLE GOURNAY

BEYOND METAPHOR:
SKYSCRAPERS
THROUGH
PARISIAN EYES

For the French, the skyscraper—the New World's architectural savage—has always been a challenging emblem of modernity, the ideal channel for their mix of disdain and envy toward all things American. Prior to 1925, Parisians scorned New York's tall buildings as "mediocre" artifacts, devoid of any "artistic cachet" that would "elevate them beyond their functional significance."[1] However, between 1925 and 1940 their views of New York's skyscrapers expanded and, generally, admiration replaced condescension, as skyscraper design itself evolved into an elegant orderly urbanism that was more pleasing to French taste.[2] Popular media and writings by members of Paris's financial, literary,

UN GRATTE-CIEL DE 400 MÈTRES A NEW-YORK

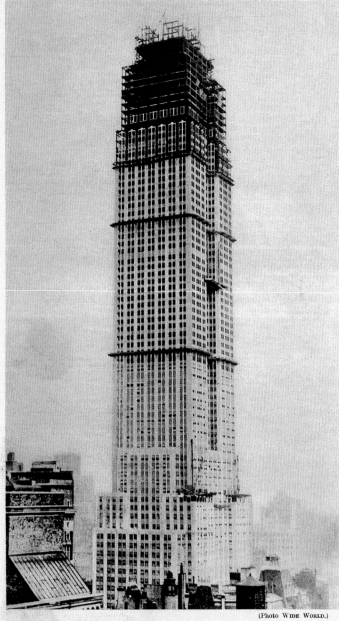

(Photo WIDE WORLD.)

L'EMPIRE STATE BUILDING

Cet immeuble portera au sommet un mât d'amarrage pour dirigeables.

(Photo PACIFIC ET ATLANTIC.)

DES HOMMES QUI IGNORENT LE VERTIGE

Situation plus que périlleuse d'un ouvrier à 400 mètres du sol.

Quo NON ASCENDAM? Telle semble être la devise des gratte-ciel de New-York. Sans cesse, les architectes s'ingénient à accumuler étages sur étages. A peine recevons-nous des photographies du plus haut immeuble du monde qu'on nous envoie des documents sur la construction de celui qui sera encore plus élevé. C'est un sport coûteux, que nous ne comprenons guère, mais qui, paraît-il, est indispensable à la vie américaine. Ce qu'on ne peut prendre en largeur, évidemment, il faut l'occuper en hauteur, mais encore est-il admissible qu'il y ait des limites qu'on ne saurait dépasser! Aux États-Unis, ces limites sont inconnues : les immeubles s'obstinent à grandir et à mépriser ceux qui n'ont que 200 ou 300 mètres de haut.

L'Empire Stade Building, que l'on est en train de terminer, entre ses bases et son sommet, aura plus de 400 mètres. Souhaitons à ses locataires de ne jamais avoir de panne d'ascenseur ou même de ne rien oublier à leur bureau, s'ils habitent le dernier étage.

Ce géant, qui menace les nues, s'élève au coin de la 5e Avenue et de la 34e Rue. Il comporte toutes les installations les plus modernes. Il possède même, sur son toit un mât d'amarrage pour permettre aux dirigeables qui passent de venir s'accrocher, afin sans doute de faire descendre les voya-

(Photo PACIFIC ET ATLANTIC.)

UNE GYMNASTIQUE NORMALE

Pour ces ouvriers, le danger est le travail quotidien.

geurs et de traiter une affaire avec eux sans perdre de temps. Voici une situation brillante — et élevée, ô combien! — pour gens oisifs : gardien du mât d'amarrage de l'Empire State Building.

Ce nouveau gratte-ciel a été construit sur l'emplacement de l'ancien Waldorf Astoria. Il forme avec le Chrysler Building et le Chanin Building un groupe de colosses, qui semblent jouer le rôle de sentinelles veillant sur le sort de New-York et regardant au loin, du haut de leur taille imposante, s'ils ne voient rien venir.

Nous avons dit que cette folie des grandeurs était devenue un sport, mais il y a d'autres sportifs en l'occurrence : ce sont les ouvriers, manœuvres et divers qui travaillent à la construction de semblables édifices. S'imagine-t-on le sang-froid et le coup d'œil que doivent avoir les charpentiers obligés d'évoluer à 400 mètres au-dessus du sol et d'aller d'une poutre à l'autre en n'ayant jamais que le vide sous eux? Certains sont des virtuoses que nul vertige ne saurait atteindre, mais il faut reconnaître que les victimes sont fréquentes. Ce n'est pas impunément que l'on transporte sur son épaule des fermes de fer pesantes en n'ayant, pour assurer ses pas, qu'un espace insignifiant. Voilà les vrais martyrs des gratte-ciel... Il est vrai qu'en tombant d'un cinquième étage!

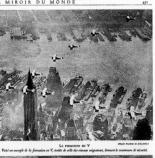

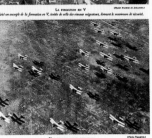

OPPOSITE
Le Miroir du monde, with construction photographs of New York's Empire State Building, December 6, 1930

LEFT
Le Miroir du monde, with photos of New York's Chrysler Building and airplanes over Manhattan, June 7, 1930

and artistic elite charted this evolution, demonstrating how the changing attitude toward New York skyscrapers affected architecture in and around Paris.

Before the mid-1920s, French journalists and writers liked to refer metaphorically to forests, mountains, or cathedrals to describe New York's skyscrapers. They gave an anecdotal, even fantastical, twist to technical features, regaling Parisian readers used to slow and unreliable machinery with narrations of hair-raising elevator rides. Long before 1925, when Le Corbusier's *Urbanisme* formalized his diatribe against the concentration of tall buildings in Lower Manhattan, this district had appeared to French travelers like a "gigantic Capernaum" in need of restructuring.[3] The Woolworth Building (1913) displeased Parisian aesthetes: its set-back profile was "banal and ineffective" with Gothic ornamentation neither "in harmony with its shape, nor proportionate to its bulk."[4] To journalist Jules Huret, Manhattan's "*maisons géantes*" appeared odd and "ugly" unless they were transfigured by electric lighting. His popular account in *L'Amérique moderne* (1910) offered evidence of this nocturnal beauty in full-page photographs, anticipating a rejuvenated, visually oriented attraction toward American culture."[5]

Throughout Jazz-Age Europe, New York–based photographic agencies supplied iconic views both of familiar sites in Lower Manhattan and of the latest tall buildings that were reproduced and commented upon by writers of various backgrounds and ideological leanings. Particularly popular in the early and mid-1920s were photographs of the Equitable Building (1915) dwarfing Trinity Church. In addition to their stunning visual power, they were interpreted as signs of a new value system, placing "caravansaries of commerce" above traditional "temples of faith."[6] In addition to familiar clifflike streetscapes inspiring an "upside-down kind of giddiness," new spectacles—aerial photographs and airplanes flying amidst skyscrapers—fed French imaginations.[7]

Manhattan skyscrapers inspired a mixture of awe and admiration, the key tenet of the Sublime. Their photographs (generally exterior views from a distance) instituted a parallel discourse that eclipsed literary metaphors and sometimes contradicted the text they accompanied; they inspired sections of *New-York*, a best-selling travelogue written in 1930 by fashionable writer Paul Morand, at least to the same extent as direct observation of the buildings themselves.[8] Editors of Parisian art and culture magazines realized that reproducing photos of Manhattan skyscrapers, including those by Charles Sheeler, was in their best commercial interest and sold issues.[9] In the 1930s escapist imagery would even overcome reservations about the mores of corporate America and the overall validity of capitalist rivalry triggered by the downfall of the U.S. economy. For instance, *L'Illustration*, a widely circulated conservative news weekly, used photographs of daredevil riveters to boost enthusiasm for the erection of the Empire State Building (1931) instead of regarding it as a manifestation of inconsiderate hubris.[10]

Perceptions of Manhattan skyscrapers as ugly, chaotic, and insalubrious were challenged by the new generation of towers topped by a cascade of horizontal setbacks, as prescribed by the 1916 New York Zoning Ordinance, and by Rockefeller Center, whose towering 30 Rockefeller Plaza was completed in 1933. Writings on these two topics were numerous and diverse enough to reach a broad spectrum of France's middle class. The architectural and building press was the first to take up the more positive tone. Beginning in 1925, *La Construction moderne* and *L'Architecte*, which borrowed information on the salutary effect of New York's 1916 Zoning Ordinance from their U.S. counterparts, produced enthusiastic pieces on the Shelton Hotel (1924), a minimally decorated brick design, and the American Radiator Building (1924), whose dark, sharply contoured, stepped-back silhouette highlighted by gilded decorative accents allied "beauty" with "brutality."[11] Their

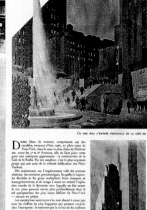

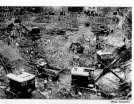

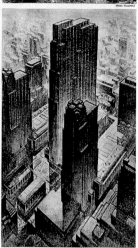

Une fenêtre du « Rainbow Room », restaurant situé au 65ᵉ étage du « Radio Building »,
le plus élevé du Centre Rockefeller, d'où l'on embrasse la féerie lumineuse du New York nocturne

final verdict was that "order had emerged, and, thanks to it, a style."[12] Newspapers and magazines followed suit. In 1926 the daily *L'Intransigeant* stated that the new skyscrapers were "picturesque, logical and beautiful" and deemed the Shelton a "masterpiece" equal to "any spiritual creation." *Lectures pour tous,* France's *Reader's Digest*, depicted Hugh Ferriss's setback fantasies. Stunning images in *L'Illustration* included street scenes by New York artist Vernon Howe Bailey, a youthful Philippe de Rothschild wrote enthusiastically about the Chrysler Building (1930), and the Empire State Building was deemed "an aesthetic triumph" for anyone accepting "the necessity for

our era to conceive canons of beauty adapted to its mechanistic needs."[13] Writer André Maurois, a frequent guest to American universities, was categorical in his approval: "The old skyscraper was . . . a hideous compromise between the cathedral and the barracks. Over the last ten years, builders have changed all of that. Sometimes they treat the first twenty stories like a mountain . . . Other times the entire structure narrows down from base to top, through a succession of terraces . . . The Frenchman admires the infinite variety of forms and their greatness."[14]

The Parisian media's interest in set-back skyscrapers broadened in scope by 1930, and

their coverage ranged from detailed accounts of steel framing to reports on residences for working women, like the Panhellenic Tower (1928). This "skyscraper club" was described as "a common occurrence in New York" and as presenting "major benefits": "isolation in the sky procures quiet and rest, interior design in such structures provides optimum comfort."[15] Le Corbusier's repeated use of skyscraper images he found in the Parisian popular press—as counter-demonstrations to his own urban theories—indicates another measure of their potent iconicity. For instance, the Franco-Swiss modernist master scorned the Shelton as the "*gratte-ciel des Académies*" (the skyscraper of the Academies) and identified Ferriss's drawings as an "American line" of "bristling chaos,"[16] in contrast to his own Ville Contemporaine (1922) and Plan Voisin (1925), projects which featured diagrammatic, evenly spaced, flat-roofed, cruciform towers of equal bulk and height.

Accompanied by spectacular renderings of Rockefeller Center's sunken plaza and roof terraces, the earliest French reference to this new urban complex was probably the December 1931 issue of *Je sais tout*. The article encapsulated themes that other popular and cultural magazines would also exploit, often using promotional material provided by American and French sponsors of this project. Press reports intensified with the creation of the Maison Française Corporation in the spring of 1932. Created to recruit official and commercial French tenants for the center, this U.S. syndicate was represented by a "spotless front man," Senator Jean Philip, and gained support from influential Paris-based politicians, including Prime Minister Edouard Herriot.[17] "Radio-City" was "the metropolis of science and technique," a "realm of art," a "city of leisure and pleasure."[18] For the first time, a "*composition urbaniste*" with an elaborate underground network, a group of buildings where "every available space [would] be covered with lawns, clipped trees, bushes framing fountains, cascades and large pools" had prevailed in Manhattan.[19] Rockefeller Center brought "unity" and "discipline" to buildings previously ruled by "the assertion of the colossal."[20] Once characterized somewhat negatively as "romantic," New York was on its way to becoming "ordered, symmetrical."[21] *L'Architecture d'aujourd'hui*, the organ of modernists, praised the promenade and sunken plaza as "an expansive, sunny and well ventilated space."[22] For journalist Pierre Lyautey, 30 Rockefeller Plaza had allowed America to gain "an awareness of itself and its new beauty."[23]

Far from being forced upon Parisian opinion makers, domestic beliefs and concerns helped trigger this enthusiasm for set-back towers and for Rockefeller Center. The works of former students at the Paris Ecole des Beaux-Arts—Harvey Wiley Corbett, Wallace K. Harrison, Raymond Hood, John Mead Howells, Lloyd Morgan, and Benjamin Wistar Morris, to name a few—these skyscrapers nurtured national pride.[24] Similarly, John D. Rockefeller, Jr.'s gifts to restore French monuments and expand the Paris Cité Universitaire helped to minimize criticisms of his megalomania.[25] Also, enjoying skyscrapers, like jazz music, had come to represent the *esprit du temps* as affluent Parisians warmed up to new artistic expressions and to corporate culture and its architectural manifestations.

At the same time, although catering to much taller structures, New York's 1916 Zoning Ordinance

City Garden Club exhibition and the fountain in the sunken plaza in front of 30 Rockefeller Plaza, New York, photograph by Samuel H. Gottscho, 1934

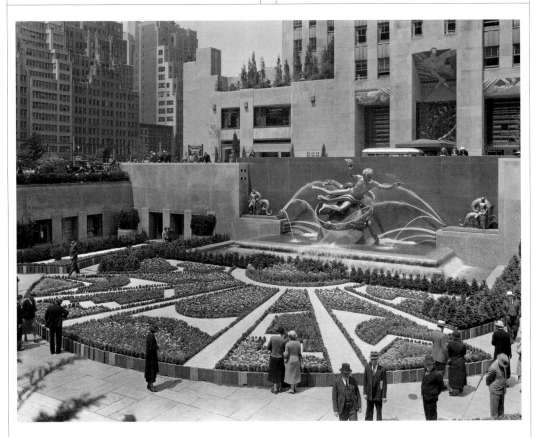

was not fundamentally different from Parisian height regulations implemented in 1902, which prescribed a setback envelope above a 60-foot elevation. In both cities architects were encouraged to devise monumental and picturesque effects in massing and ornamentation for required setbacks. Projects for pyramid superblocks, which Henri Sauvage envisioned along the Seine River's Quais d'Orsay and de Passy in the late 1920s and that magazines like *L'Illustration* enjoyed discussing, were as spectacular as Hugh Ferriss's utopian renderings for Manhattan.[26] Parisians appreciated that in Manhattan "an urban regulation had been more crucial to the renewal and diversification of skyscraper design than was the ingenuity of architects" and that the pure geometry and "dynamic" beauty of set-back towers was derived from "organic necessity" as opposed to "preconceived formal ideas."[27] Indeed, it was this direction—giving precedence to principles of high-rise urbanism over design originality—which two of their best-known and most-respected designers had already adopted: Auguste Perret, in his 1922 project to connect Neuilly to La Défense with identical skyscrapers looking like sliced-off versions of Manhattan's Municipal Building (1907–14), and Le Corbusier in his Plan Voisin for the rebuilding of Central Paris.[28]

In the late 1920s and early 1930s, a number of projects produced designs on the model of the New York skyscraper. For architects less prominent than Sauvage, Perret, and Le Corbusier, the temptation was great to draw inspiration from media coverage of Manhattan skyscrapers. Examples included Viret's and Marmorat's slender setback towers proposed for two hypothetical and highly publicized urban design competitions for the exits from and immediate suburbs of Paris. These competitions included a small, privately sponsored contest for the Porte Maillot, published in 1930, which required that towers frame the Arc de Triomphe, and a larger "idea competition" sponsored by the City of Paris in 1931 to systematize the Voie Triomphale (Triumphal Way) between the Place de l'Etoile and Rond-Point de La Défense, which elicited nearly ubiquitous proposals for tall buildings, although they were not required from participants.[29]

Both Paris and New York media reported on multiple (and always controversial) skyscraper plans for Paris.[30] Aware of its readers' interest in American influence abroad, the *New York Times* took note of these plans, even when they received modest domestic coverage. For instance, in 1926 the *Times* mentioned that the French government, which did not have to comply with existing height regulations, considered building a tower behind the Ecole Militaire and selling its *hôtels particuliers* in the Faubourg Saint-Germain. However, plans for a high-rise counterpart to Washington's Federal Triangle in the shadow of the Eiffel Tower remained on paper.[31] As evidenced by contemporary photomontages, the prospect of a Manhattan

on the Seine was far-fetched.[32] Even enthusiastic visitors to Manhattan seemed to be unanimously against the plan: while New York was a "magnificent high-relief which no additional volume could alter," François Porché noted, Paris was "a delicate drawing which could be ruined by barbarians."[33] Morand, the epitome of the cosmopolitan globe-trotter, preferred his city to be "frankly outmoded" like London, rather than "a failed New York like Berlin or Moscow."[34]

However, Paris was Manhattanized in less obvious but nonetheless lasting ways. Mammoth commercial structures—dubbed "buildings" because no existing French word seemed to properly allude to their scale and commercial intent—rose in the Right Bank's central districts. Some encompassed a full block. A particularly spectacular example housed the offices of the New York City Bank (c. 1930) along the Champs-Elysées.[35] It featured a luxury shopping arcade, a club for bank employees, and a roof garden with a penthouse dining room for bank executives and their VIP clients. In the boardroom the renowned *ébéniste* and interior designer Emile-Jacques Ruhlmann was commissioned to design panels framing large photos of Manhattan.[36] Large New York–scale apartment buildings also began to appear. Like rich Manhattanites, wealthy Parisians (those most likely to have visited New York) were moving away from private townhouses for fiscal and practical reasons. Located in the sixteenth arrondissement, as well as along the Avenue Montaigne and the Quai d'Orsay, their new apartment buildings featured, like their New York counterparts, duplex and penthouse units as well as landscaped courtyards, set-back balconies, and panoramic terraces.[37] Seen from the Seine River, the residential blocks lining the Rue Raynouard on the Passy hill looked taller than twenty stories. In *Architectural Forum*, Beaux-Arts architect and New York socialite Kenneth M. Murchison raved about the castlelike group designed and developed by architect Jean Walter overlooking the Bois de Boulogne on the site of the old fortifications.[38] Most elegant was the apartment building commissioned by Antoine on the Place du Trocadéro, where this "czar of hair dressing" (who regularly visited his Saks Fifth Avenue subsidiary) retained the top floor suite.[39]

Outside the limits Baron Haussmann had set for Paris in 1860, height regulations were not as stringent. Clichy hosted France's first high-rise hospital, an 1100-bed, twelve-story, comb-shaped structure reminiscent of New York's Columbia-Presbyterian Medical Center, whose highly photogenic silhouette had already appeared in *L'Illustration*.[40] Commenting on this new "*gratte-ciel de la souffrance*" (skyscraper of suffering), this magazine contended that, far from being a "servile copy" of American precedents, it had a "strictly French" scale and feeling for measure and separated more efficiently outpatient from hospitalization services.[41] Slender towers were built by the Département de la Seine public housing office.

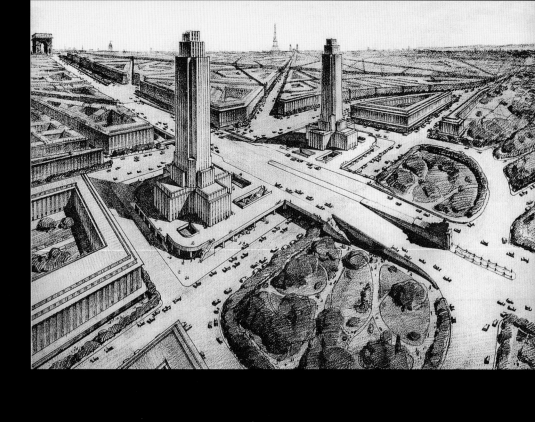

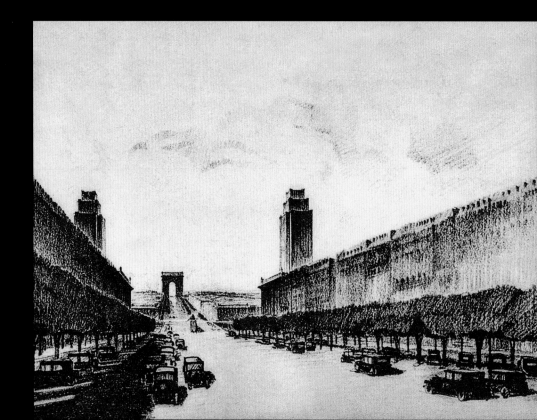

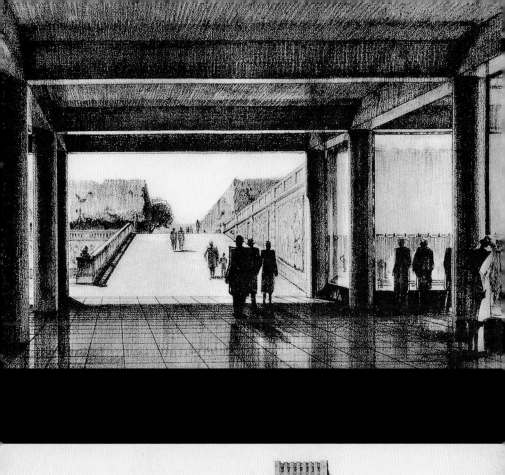

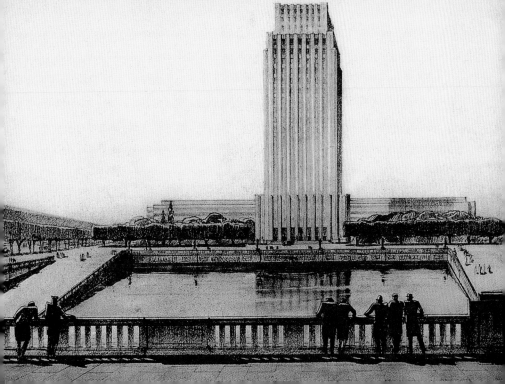

Photomontage of
skyscrapers adjacent
to the Cathedral of
Notre Dame in Paris,
designed by
Louis Bonnier,
c. 1928

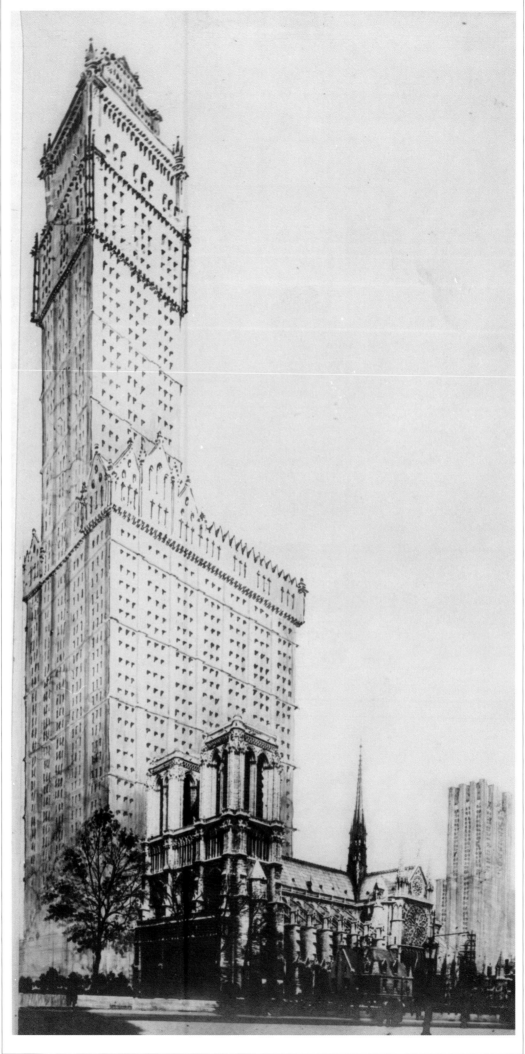

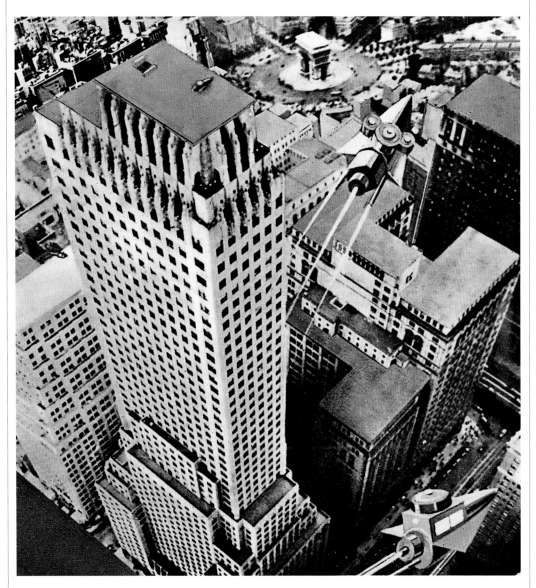

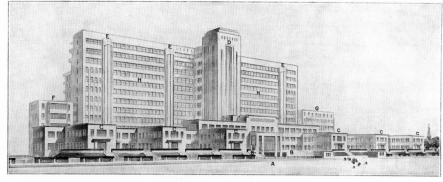

Façade principale du futur hôpital.

A : entrée de l'avenue souterraine de 30 mètres de largeur réservée au personnel et aux visiteurs et permettant d'arriver en voiture jusqu'aux ascenseurs.
B : entrée des malades (à pied ou en ambulance). — C : consultations spécialisées. — D : tour des ascenseurs. — E : escaliers de secours. — F : salles d'opérations septiques.
G : salles d'opérations aseptiques. — H : service des étages, salles de pansement et laboratoires.

aux hospitalisés — trouvant, il est vrai, une compensation légitime dans la cote que leur situation établit auprès de la clientèle — se montreraient sans doute peu disposés à traiter à prix réduit des hospitalisés « supérieurs ». Le régime des consultations payantes, inauguré avant guerre et qui, au fond, est antiréglementaire, n'a été accepté qu'en vue d'enrayer la facilité, parfois excusable, avec laquelle des personnes relativement aisées abusaient de la consultation gratuite. La question, en apparence très simple, est, comme on le voit, fort délicate. La Ville de Paris pourrait, peut-être, la résoudre en créant une clinique spéciale séparée des établissements hospitaliers et non soumise au régime normal de l'Assistance publique.

Quoi qu'il en soit, et sauf cette amélioration spéciale, qui peut être combattue par les champions de la démocratie intégrale mais que souhaitent beaucoup de Parisiens moyens et que justifierait la rigueur des temps, la Ville de Paris possédera enfin un hôpital moderne dont l'organisation, oubliant les formules du passé, fera grand honneur à l'initiative de l'administration et de son chef, le Dr Louis Mourier, qui l'ont conçue.

F. HONORÉ.

Façade sud sur le parc.

A : salles de 14 lits exposées est-ouest. — B : chambres d'isolés. — C : solaria des salles de malades. — D : étage des tuberculeux hommes. — E : étage des tuberculeux femmes. — F : services des salles d'opération (chaque étage comporte un service *complet* de chirurgie ou de médecine absolument indépendant des autres services).

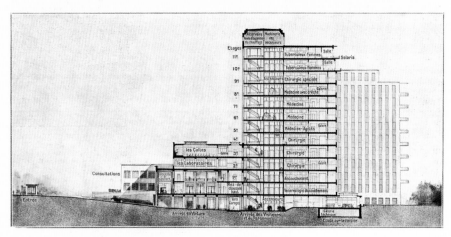

MAQUETTES DU FUTUR HOPITAL BEAUJON A CLICHY. — Coupe suivant l'axe transversal.
(Architectes : L. Plousey, U. Cassan et J. Walter. — Architectes conseils : Patouillart et Lemaresquier.)

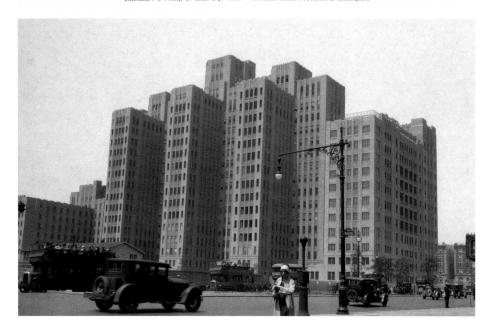

Hairdresser Antoine's
apartment on Avenue
Paul Doumer, Paris,
photograph by
Willy Maywald, c. 1937

The first one was erected in 1932 in the beautifully planned Cité-Jardin de la Butte Rouge in Chatenay-Malabry. It was intended by its sponsor, Senator Henri Sellier, to compose "a picture with its surrounding low building" in the manner of a cathedral.[42] Five other towers interspersed with lower blocks were completed in 1934 in Drancy-la-Muette. *Le Miroir du monde* photographed them in a manner to inspire "the same impression of power as when, from a New York City street, one directs [one's] attention to the top of the most recent buildings."[43]

Starting in the late 1950s, towers housing corporate or government offices, apartment units, American-style hotel rooms, and even facilities for a university sprouted in and around the City of Light, made possible by Gallic counterparts to North American zoning variances and loopholes.[44] By the mid-1970s, La Défense had become, in the words of Ada Louise Huxtable, "a concentration of skyscrapers that dwarfs comparable new construction in American cities." The influential *New York Times* critic was offended by what she saw as the antithesis of "the French tradition of restrained, homogeneous architectural elegance."[45] The district she dismissed as the "Houston of Paris," however, reflected in its planning and architectural history an enduring love-hate relationship between Manhattan and the Parisian public.

Isabelle Gournay is an associate professor of architecture at the University of Maryland. She co–edited *Paris on the Potomac: The French Influence on The Architecture and Art of Washington, D.C.* (2007) and has written numerous essays on the relationship between French and American architecture, including Jacques Gréber's *L'Architecture aux Etats–Unis* and Levitt's communities around Paris.

JODY BLAKE

AFRICA
ON THE
SPIRAL:

JAZZ IN NEW YORK
AND PARIS
BETWEEN THE WARS

George Antheil, an American composer in Paris in the 1920s and '30s, described the historical trajectory of jazz as a "giant spiral" from Africa to the Americas and Europe. According to Antheil, the shortest route—musically at least—from the Congo, the heart of France's colonial empire in Africa, to Paris was through New York, cultural capital of the Negro, or Harlem, Renaissance.[1] Jazz, a unique blending of African and European musical traditions, did, in fact, complete the final leg of this voyage across the "black Atlantic" from Africa to Europe via America toward the end of World War I. In a manifestation of newfound self-confidence and influence, America began

OPPOSITE

Lt. James Reese Europe
and his band, the
Hellfighters of the 369th
New York Regiment,
in Paris, 1918

exporting its popular culture from New York, including the energetic and irreverent music recently christened "jass" or "jazz." Amid the questioning of values following the Armistice, Parisians, in turn, rejected the melodic chansons of the leisurely *café concert* in favor of the breakneck rhythms of the discordant jazz band. As one French journalist explained: "To uproot us from the past despite the shackles that hold us back, that is not the least of the merits of this revelation of modern times: jazz."[2]

Antheil, who wrote the jazz-influenced opera *Transatlantic* while living in the French capital, might have added that the spiral that brought jazz from New York to Paris also reversed its course across the Atlantic. In New York jazz's Parisian sojourn was decisive in making this musical idiom available to the visual, literary, and performing arts, both as a quintessentially American art form and as an expression of African American cultural heritage. Parisians may have been thumbing their Gallic noses at tradition, but Americans, both white and black, still looked up to them for artistic validation. Beginning with the composers of "Les Six," the French used jazz as the basis for a new school of classical music. Indeed, in Paris *art nègre*, or "black art," including African sculpture and American jazz, was credited with saving French art, literature, and music from extinction. The influential art dealer Paul Guillaume affirmed this: "One may almost say that there was a form of feeling, an architecture of thought, a subtle expression of the most profound forces of life, which have been extracted from negro civilization."[3]

As Antheil suggested, to write about jazz in New York and Paris is also to address, at least figuratively, interactions between Harlem and the Congo. In Paris black musicians and dancers from New York, who were embraced as cultural heroes, mediated understanding of African artistic traditions suppressed under French colonial rule. Conversely, Paris, the meeting place for Francophone intellectuals from Africa and the Caribbean, provided American blacks with links to their own African heritage disrupted during slavery. In the years between the two world wars, which opened with racist violence in New York City in 1919 and closed with anti-imperialist protests in Paris in 1931, this Jazz Age cultural interchange had social and political implications deeper than popular entertainment might suggest. A French critic observed, "The route towards the equality of the races has been opened by the dancers and players of jazz."[4]

Jazz had swept into Paris in 1918 in the wake of the American Expeditionary Force. Indeed, disseminating the new music seemed as crucial to the mission of the United States Army's all-black regiments as defeating the Germans. The most famous U.S. Army band in Paris was the Hellfighters of the 369th New York Regiment, conducted by Lt. James Reese Europe. As organizer of the Clef and Tempo Clubs and director of the Society

Orchestra, Europe had gained a reputation as New York City's preeminent black bandleader. His orchestras drew audiences to Carnegie Hall as well as the Manhattan Casino in Harlem and, accompanying the dance team of Irene and Vernon Castle, made an impact on Tin Pan Alley and Broadway. In France, when the Hellfighters were not manning artillery at the front, they entertained soldiers and civilians with instrumental ragtime standards, as well as with wartime novelties in which they used instruments to reenact the sounds of war, as in "No Man's Land," which opened with the line, "There's a minnenwerfer coming—look out—(bang!)." French critics described jazz as a musical counterstrike to "the crackling of the machine gun, the roar of the cannons, and the whistling of the shells."[5] Whether as cause or effect, Parisians associated jazz with an upheaval in artistic, social, and political values, an upheaval in which the new music's associations with Africa as well as America were crucial factors.[6]

Black Americans believed their patriotic sacrifice in what the French called *la Grande Guerre* would lead to fuller citizenship, and the Hellfighters proudly marched up Fifth Avenue in the 1919 homecoming parade. In Paris representatives to the First and Second Pan-African Congresses of 1919 and 1921, including the African American civil rights activist, sociologist, and writer W. E. B. DuBois and his French counterparts, called for the end to racial oppression and exploitation in Africa and the Americas. James Europe believed that the Hellfighters had achieved an artistic as well as a military victory for blacks: "We won France by playing music which was ours and not a pale imitation of others, and if we are to develop in America we must develop along our own lines."[7] Upon their return to New York, the Hellfighters' drum major, Sgt. Noble Sissle, took this lesson to heart. Working with his longtime collaborator, the composer Eubie Blake, Sissle wrote the lyrics to *Shuffle Along*, the landmark all-black musical of 1921 that won a place for African Americans on Broadway.[8]

Word of the Hellfighters' success in Paris traveled back to New York, and commercial jazz musicians followed them across the Atlantic, seeking personal as well as professional opportunities in a city that prided itself on being color-blind. Buddy Gilmore, a standout in James Europe's prewar Society Orchestra, arrived in Paris in 1921. In a period when Parisians equated jazz with noisemaking percussion instruments, the drummer was an iconic figure. Gilmore became a mainstay at Le Grand Duc and other jazz clubs that transformed the entertainment district of Montmartre, once known for the cancan, into a veritable Parisian Harlem.[9] When compared with New York's Small's Paradise on 135th Street and the other jazz clubs that were drawing white patrons to Harlem, Le Grand Duc with its dozen tables and three-piece band was definitely Parisian in scale, but its after-hour jam sessions and soul food were pure Harlem. Le Grand Duc was a favorite hangout of

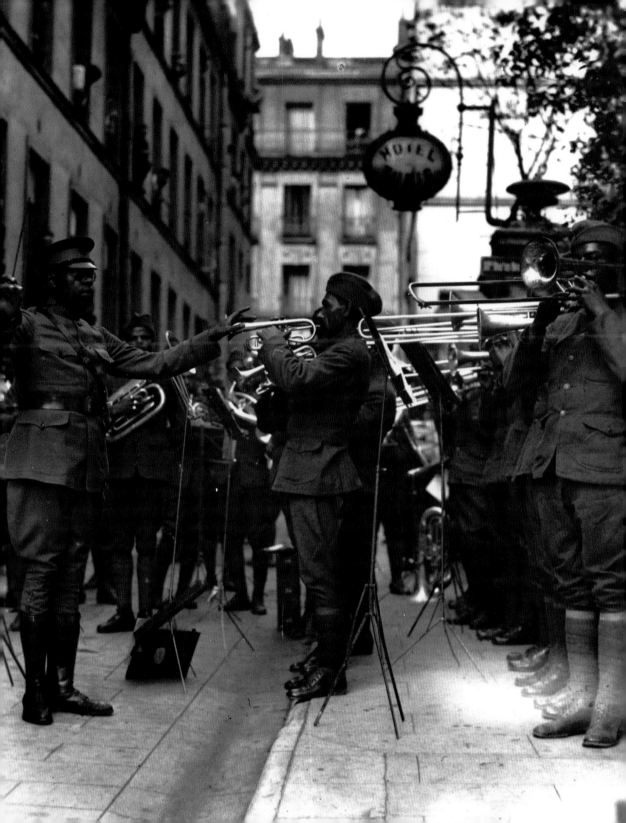

RIGHT
Hellfighters of the
369th New York
Regiment, marching in
New York, photograph
by Underwood and
Underwood, 1919

BELOW
Buddy Gilmore at Zellie's,
Paris, photograph by
Berenice Abbott, 1926

OPPOSITE
Illustration of *La
Revue nègre* by Pol Rab,
reproduced in the novel
Sous le signe du jazz (Under
the Sign of Jazz) by
Stéphane Manier, 1926

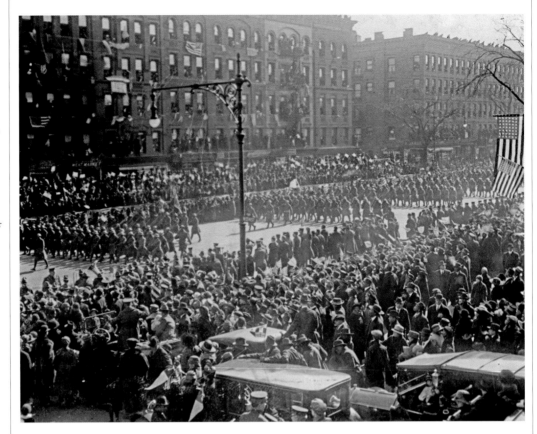

artists and writers associated with the Dada and Surrealist movements, including the poet Philippe Soupault, who paid tribute to its artists in his novel *Le Nègre* and his essays in *Terpsichore*.

New York poet Langston Hughes, who financed his stay in Paris by washing dishes at Le Grand Duc, also described and drew inspiration from the after-hours gatherings: "The cream of the Negro musicians then in France . . . would weave out music that would almost make your heart stand still at dawn in a Paris night club in the rue Pigalle."[10] On his return to New York, Hughes contributed "Jazzonia" and "Nude Young Dancer" to *The New Negro*, the 1925 anthology that was a manifesto of the Harlem Renaissance, the efflorescence of African American culture that was centered in the Manhattan neighborhood of Harlem in the 1920s and 1930s. He also published his first volume of poetry, *The Weary Blues*, embodying his belief that jazz was a stepping stone for artists and writers to free themselves from white middle-class prejudices and scale—what he called "the Racial Mountain."[11]

For black Americans Paris was decisive in identifying jazz music as an ancestral art, comparable to the Fang figures and Baule masks from Gabon and Ivory Coast in the curio shops and art galleries of the French capital. Harlem Renaissance artists, writers, and musicians who visited Paris played a crucial role in establishing jazz as a touchstone for creativity in other fields. They also left records of Paris jazz observed from a distinctively African American point of view. In his 1929 painting *Jockey Club*, for example, Archibald Motley, Jr. depicted the scene outside the Montparnasse club known for its murals of cowboys and Indians as well as recorded and live jazz. Using the red-uniformed figure of the black doorman as a surrogate, Motley directed a socially critical eye at Le Jockey's trendy and all-white clientele, subtly referencing clichés of Paris as the home of *liberté*, *égalité*, and *fraternité*. A second painter, Palmer Hayden, quickly discovered that he received better treatment as an American than his Paris neighbors from Guadeloupe and Martinique. They introduced him to Le Bal Nègre and other establishments where Francophone blacks gathered to dance the beguine and drink white rum, as well as to enjoy Jazz Age imports from New York.[12]

These jazz bands and nightclubs prepared the way for the single event that has become synonymous with jazz in Paris: *La Revue nègre* of 1925. With songs by Spencer Williams, choreography by Louis Douglas, and music by the Claude Hopkins Orchestra, the revue was, to paraphrase one critic, the fullest representation of black American musical talent the French capital had experienced. The Théâtre des Champs-Elysées promised a show straight from New York City's "black quarter" that would be "raw without touchups" and would contrast with Parisian "candy shop" revues.[13] The show, which was, in fact, "cooked up" by white New Yorkers familiar with Parisian audiences, more than met expectations. Caroline

Dudley, Gertrude Stein's neighbor on the Rue de Fleurus in Montmartre, produced the show, and Carl Van Vechten, Stein's friend, fellow writer, and a frequent visitor to Paris, wrote the scenario. The revue's tableaux were staged in front of backdrops by Van Vechten's protégé, the Mexican-born artist Miguel Covarrubias, presenting clichéd images of black American life from Dixie to Harlem.

Thanks to Van Vechten, whose literary portrayals of Harlem were criticized as stereotypical by many black New Yorkers, the show also gave life to canonical images believed to represent African American culture. Indeed, one of the show's Parisian producers enthused that, "it is all our readings that parade before our ravished imagination."[14] The dizzying kaleidoscope of images from South to North and Africa to America signified what we would now call the "cultural hybridity" of jazz music and dance. The "Mississippi River Boat Race" featured stern-wheelers with the exotic names of Memphis and Natchez. In the "Louisiana Camp Meeting" Maude de Forest sang a religious shout, "Same Train," and in the "New York Skyline" Sidney Bechet serenaded Florence Mills with the "Tin Roof Blues." Josephine Baker and Joe Alex performed their "Savage Dance" amid giant tropical fruit in the "Charleston Cabaret." After the opening night of this all-black music and dance review from New York, both fans and critics acknowledged that Paris was "under the sign of jazz," in reference to the title of Stéphane Manier's emblematic 1926 novel, *Sous le signe du jazz* (Under the Sign of Jazz).

The revelation of *La Revue nègre* was the talented and charismatic Baker, who was transformed from a cross-eyed Broadway chorus girl into a glamorous Parisian star rivaling the famed follies star Mistinguette. Naked except for a girdle of feathers (to be replaced in later productions by her signature bananas), she danced the Charleston in the show-stopping "Savage Dance," one of the most notorious *pas de deux* in the history of dance. According to Gustave Fréjaville, a leading Paris music critic, this number in which Baker was partnered with Joe Alex was a "savage dance of an extraordinary audacity . . . expressing with an intensity that is almost unbearable, tragically shameful, the obscure force of desire."[15]

"La Baker" was at the center of Pol Rab's illustrations for Manier's *Sous le signe du jazz*, which contained a fictional account of the show and the absolute enthusiasm and repugnance it inspired.[16] The language of Cubist and Futurist *simultanéité* evident in the overlapping images in Rab's drawing was highly significant. Baker's bare flesh was superimposed on the facade of the skyscraper, as if the grid of industrial windows was some sort of tribal scarification pattern. This was an apt metaphor for Baker, who was, in Parisian imaginations, simultaneously the primordial Black Venus and the quintessential modern flapper. Baker danced the Charleston in the shadow of Manhattan skyscrapers at the Folies Bergère in 1926. The cover of

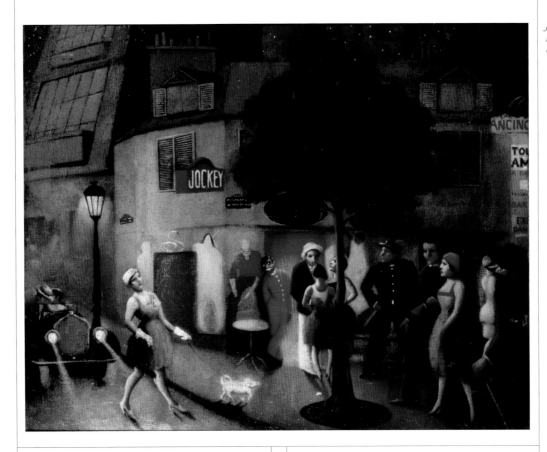

Jockey Club by
Archibald Motley, Jr.,
oil on canvas, 1929

Baker's 1931 biography, *Voyages et aventures de Joséphine Baker,* compared the dancer's pose with the stance of a West African sculpture. Recalling Pablo Picasso's proto-Cubist "Negro period," journalists likened Baker to a "black idol." Yet commentators also used metaphors reminiscent of the Italian Futurists' human machines, describing Baker as a "copper-plated Venus."[17] Paris's leading dance critic, André Levinson, a proponent of Russian classicism and a begrudging admirer of Baker and other black dancers, articulated this apparent contradiction: "As the basis of the negro dance today, we find an elementary and blind release of this rhythmic instinct, the shock of bare feet on the ground . . . The movement of the dancer is no more than a function of this musical continuity, like the drive and recoil of a piston under pressure."[18]

The seemingly paradoxical pairings of jazz with "modern" American skyscrapers and "primitive" African totems were central to the transatlantic debate over jazz initiated after World War I by two critics in New York and Paris, Edmund Wilson and Jean Cocteau. In a 1921 article in *Vanity Fair*, "The Influence of Jazz in Paris and the Americanization of French Literature and Art," Wilson cautioned the French: "Our skyscrapers may be monstrous but they are at least manifestations of force; our entertainments may be vulgar but they are at least terrifically alive . . . Your attempts at the barbarous and the harsh are the most horrible things imaginable. Leave that sort of thing to us: our genius is adapted to it."[19] An expert on modern French poets such as Arthur Rimbaud and Paul Verlaine, long-standing models for modern American writers, Wilson was well placed to notice that the direction of cultural influence between Paris and New York had reversed after World War I.

Wilson's article was prompted by two books, *Le Coq et l'arlequin* (1918) and *Carte blanche* (1920), in which Jean Cocteau staked his claim as a proponent of American popular culture. In an allusion to Hannibal the Barbarian crossing the Alps, Cocteau had stated: "Machines, skyscrapers, ocean liners, negroes, were certainly the beginning of a new, excellent direction. They marched over Capua like an army of elephants."[20] Frances Poulenc and Georges Auric, members of Les Six, a group of composers championed by Cocteau, wrote *Rhapsodie nègre* and *Adieu New York*, respectively, precursors to more extended musical works influenced by jazz. Paris Dadaists also appropriated jazz in their poems, paintings, and performance art, anticipating American expatriate Man Ray's film *Emak-Bakia* (1926) and Philippe Soupault's poems "Georgia" and "Stumbling" (1926), examples of visual and literary Surrealism. As exemplified by the place names and blues repetitions of Soupault's verses and the strumming banjo and rhythmic ruptures of Man Ray's montage, all used jazz and other aspects of American popular culture to impart an irreverent vitality to their work.

Parisians had been admiring New York City's architecture and entertainment since before World War I, sending back reports of the Woolworth Building, the world's tallest building at the time, and *Darktown Follies*, the hit show from Harlem that popularized the instrumental ragtime preceding jazz. After the outbreak of hostilities in Europe, French artists sought

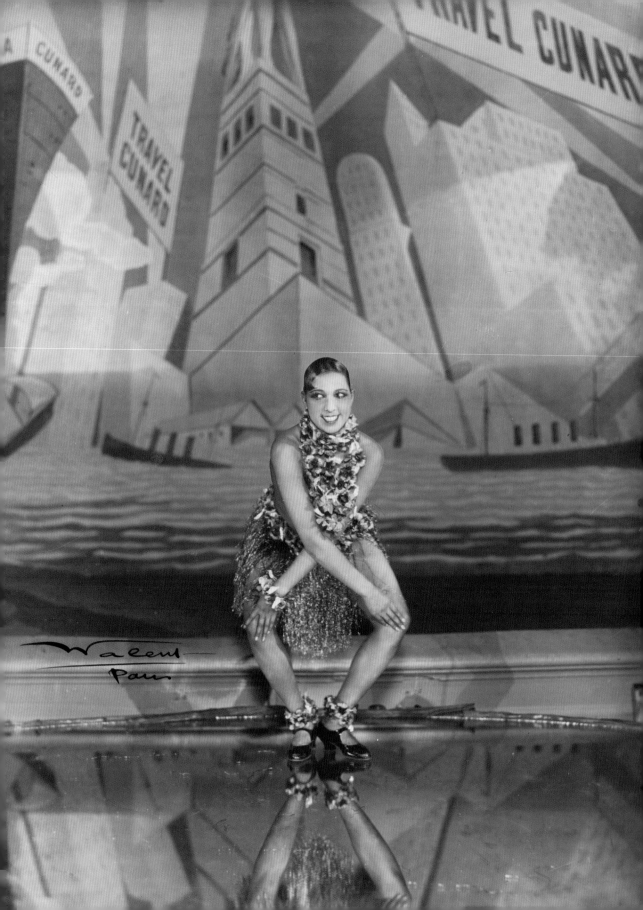

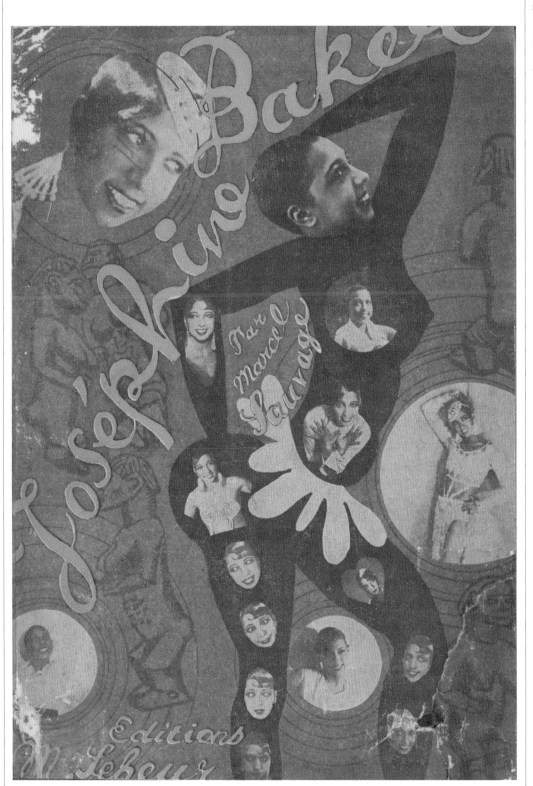

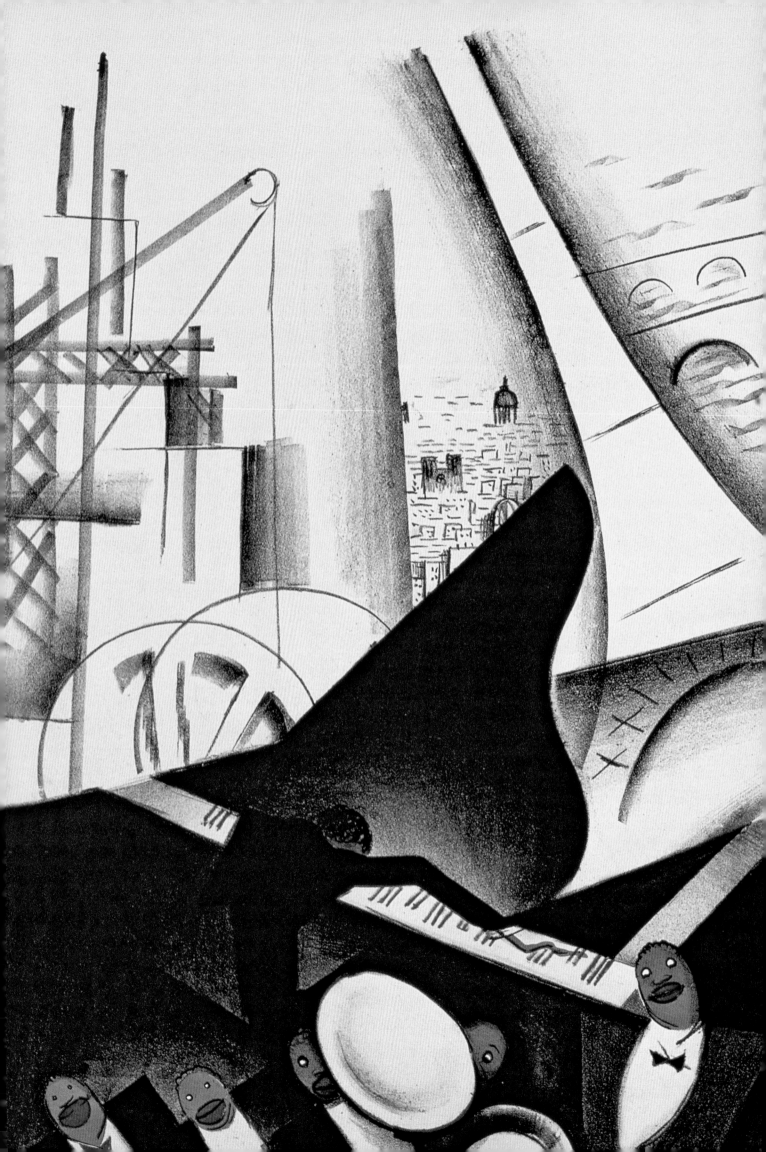

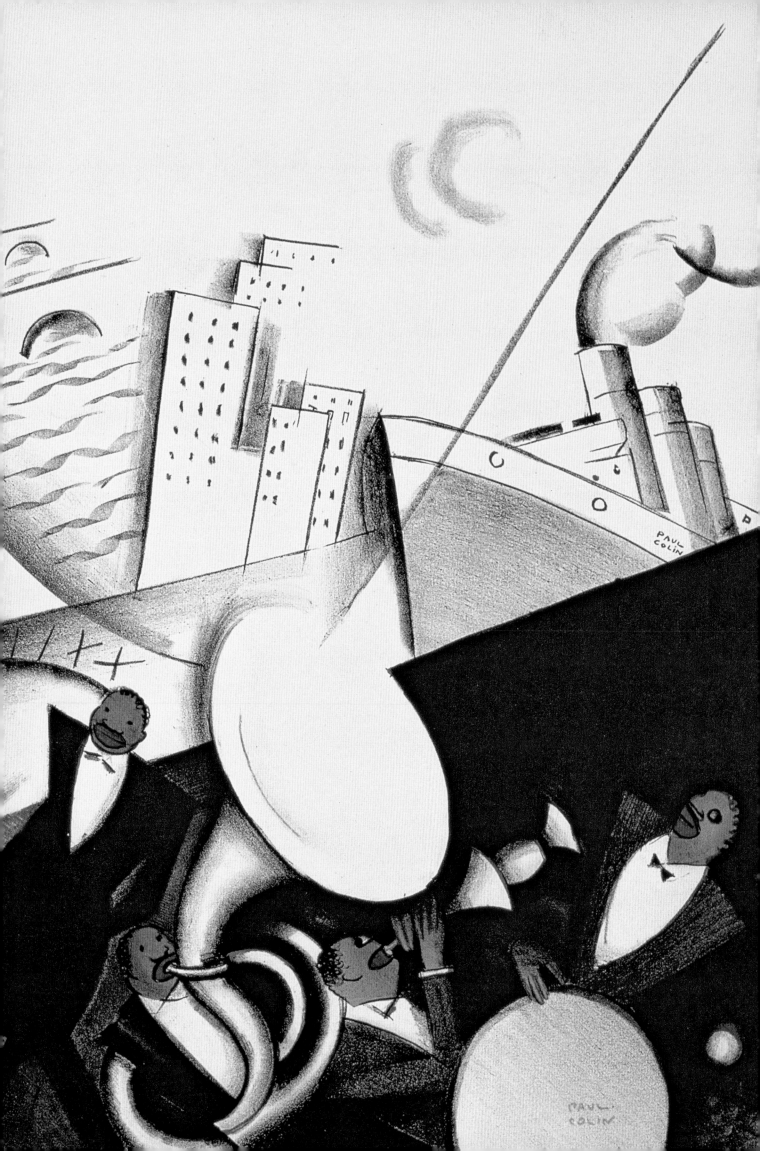

refuge in New York, experiencing skyscrapers and black music firsthand. Albert Gleizes, who had served as a conscript in the French Army, recorded his impressions of New York in paintings such as *Le Jazz* and *Broadway*, both produced in 1915. Gleizes used the visual language of Cubo-Futurism to evoke being jostled in traffic and carried away by a black band, experiences he suggested were symbolic of the modern age.[21] Dada painter Francis Picabia, who had visited New York at the time of the Armory Show in 1913 and returned in 1915 to avoid military service, also depicted skyscrapers and black musicians. Picabia believed that America, which had "bypassed all the old schools," expressed "modern thought in its architecture, its life, its spirit."[22]

In their fascination with Manhattan's skyscrapers and jazz, these Parisian visitors were undoubtedly influenced by New York's modernist circles. During the previous decade, critics and painters had aimed to counteract the influence of French art by seeking inspiration in American vernacular culture, its architecture, advertising, movies, and music. Alfred Stieglitz's 291 gallery and art periodical, *Camera Work*, and Robert Cody's Washington Square gallery were among the vehicles for this approach. Painters who had studied in France and been influenced by Cubism gave their modernist paintings an American stamp with imagery of skyscrapers and, later, of jazz. After his return home from Paris in 1910, John Marin took New York's landmarks as his subject, notably skyscrapers such as the Woolworth Building, which embodied the "great music" of dynamic forces at play in the city. In the 1920s Marin began to identify that "great music" of New York City with jazz. Stuart Davis listened to "hot" records by Louis Armstrong, Cab Calloway, Earl Hines, and others while painting, and appropriately, he painted murals referencing jazz instruments and sounds for New York City's public radio station WNYC in 1939.[23]

While in New York, Gleizes and Picabia shared their enthusiasms with Cocteau and other friends back in Paris, even sending copies of sheet music by Irving Berlin and other popularizers of ragtime. One notable result was *Parade*, the landmark 1917 ballet with a scenario by Cocteau, music by Erik Satie, and set and costume designs by Pablo Picasso. *Parade* was produced by Serge Diaghilev's Paris-based Ballets Russes, which transformed theater by engaging avant-garde musicians, writers, and artists. Known initially for Eastern exoticism, Diaghilev embraced more contemporary themes beginning with *Parade*, a tribute to—and send-up of—American popular culture. For the character of the American Stage Manager, Picasso created a ten-foot-tall, Cubo-Futurist costume in the form of a New York skyscraper. The Negro Stage Manager (eventually eliminated from the production) assumed the guise of a puppet astride the back of a two-person circus horse. The puppet's costume referenced minstrel stereo-

types, and the horse's head was modeled after masks by the Baule or Senufo peoples of West Africa. Satie quoted American ragtime in his score, especially in the "Ragtime du paquebot" (Steamship Rag).[24] Anticipating the antics of early jazz bands, his score utilized roaring motors, blaring sirens, and even pistol shots. When *Parade* was revived in 1919 amid the arrival of American bands, Parisian critics began to identify Satie as a founder of the French school of jazz music.

In the 1920s and '30s, jazz ballets in the tradition of *Parade* continued to demonstrate how inextricably linked New York and Paris were between the world wars. The ocean liners celebrated in Satie's "Steamship Rag" created a transatlantic community of French and American artists who exerted a reciprocal influence on one another. Diaghilev and his rival, Rolf de Maré of the Ballets Suédois, drew on this talent in productions slated for performance not only in Paris, but also in New York, where they inspired imitation. Not surprisingly, the New Yorkers and the Parisians created ballets that were often as different as Picasso's stage managers in *Parade*, the brash American with a loudspeaker and the suave Frenchman with a pipe. Like the American and African American stage managers, characterized respectively by a skyscraper and a tribal mask, the ballets also continued to address the dual identity of jazz.

The dichotomy between the pre-industrial and the modern, the agrarian and the urban, was subject to both progressive and regressive interpretations, raising important issues during a period of technological and social change on both sides of the Atlantic. World War I had stimulated the migration of American blacks from the rural agricultural South to the urban industrial North in search of greater opportunity. France's postwar policy of *mise en valeur*, or maximization of the resources of its colonies, encouraged the influx of Francophone blacks from Africa and the Caribbean into France. Simultaneously, both New York and Paris were being transformed by new technologies, resulting in an accelerated pace and greater complexity of daily life. These developments were symbolized by jazz, a blending of sources including field work songs and brass band music, whose rhythms were associated with oarsmen ferrying goods on the Congo River and assembly lines manufacturing automobiles in America. In the words of a French critic: "These blues and Charlestons come to us intact from across the Atlantic with this mixture of mechanical hyperesthesia and primitive African verve."[25]

In 1923 Les Ballets Suédois produced the first of these transatlantic ballets, *Within the Quota*, a spoof of the nascent Roaring Twenties by two Americans who enjoyed being cultural exotics in France. Gerald Murphy, who had arrived in Paris with no formal artistic training, impressed the French with his billboardlike paintings of ocean liners and safety razors. Cole Porter, who had departed New York after a flop on Broadway, would return home from Paris with hit songs in

Composition
(for *Le Jazz*) by
Albert Gleizes,
gouache on
cardboard, 1915

the American vernacular such as "Let's Do It (Let's Fall in Love)." Parisian audiences were delighted by *Within the Quota* which, as the title suggests, focused on the experiences of an immigrant in America, a character modeled on Charlie Chaplin. The device of the wide-eyed newcomer provided a pretext for referencing clichés of American popular culture, including Wild West cowboys, silent movie heroines, and black (and blackface) vaudevillians. The ballet's sets and publicity materials, with their newspaper headlines and photographs, reinforced the media's role in constructing Parisians' imaginary view of New York as a city of jazz and skyscrapers. The references to Cubist and Dadaist collage also underscored the influence of popular culture exports from New York on Paris modernists. No one realized this better than Murphy and Porter, who made an impact in France as much through their American lifestyles of jazz records and gin cocktails as through their art forms.[26]

For a second 1923 ballet, *La Création du monde* (The Creation of the World), Rolf de Maré turned to three Frenchmen: the poet Blaise Cendrars, the Cubist painter Fernand Léger, and the composer Darius Milhaud, a member of Les Six. In contrast to *Within the Quota*, with its lighthearted American theme, *La Création du monde* emphasized the African side of jazz. Based on the creation myths that Cendrars had compiled in *Anthologie nègre*, *La Création du monde* also had serious artistic pretensions. Milhaud composed an Africanizing score influenced by the jazz bands he had heard on a 1922 trip to New York and compared to well-oiled machines.[27] Léger designed sets where African totems towered over animals and humans, explaining that "Man becomes a mechanism like everything else."[28] In the dance of desire giving rise to the human race, Man and Woman wore costumes evoking primitive idols and futuristic robots.[29] Both Léger and Milhaud were participants in Purism, an interdisciplinary modern art movement dedicated to creating an *esprit nouveau* in postwar France. These aspirations, and the belief that this "new spirit" was represented by machines and jazz, were embodied by the architect Le Corbusier. A personal and professional admirer of Josephine Baker, Le Corbusier was also an admirer (although not uncritically) of Manhattan, which he described as "hot jazz in stone and steel" after a 1935 visit.[30]

Ever since the performance of *Parade* in 1917, Diaghilev had received proposals for jazz-themed works. In 1923 Diaghilev finally approached John Alden Carpenter, an American composer visiting Paris whose previous venture in this genre was

Poster design for
Within the Quota
by Gerald Murphy,
watercolor and
gouache on paper
with collage, 1923

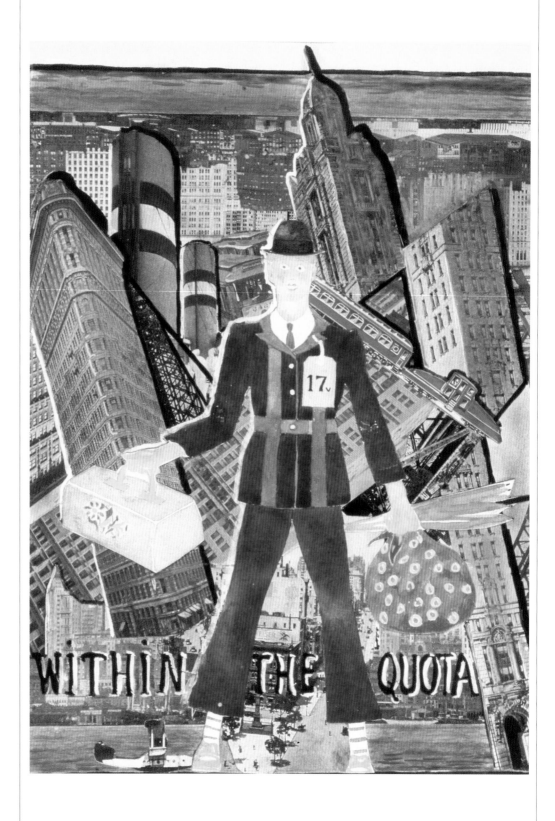

Krazy Kat, a ballet based on George Herriman's cartoon strip. However, Diaghilev did not follow through on the project, and Carpenter and his collaborator, designer Robert Edmond Jones, took *Skyscrapers* back to New York and the Metropolitan Opera, where it premiered in 1926. Carpenter "jazzed up" the pit orchestra, engaged a Harlem chorus directed by Frank Wilson, and enlisted Broadway choreographer Sammy Lee. Jones, a pioneer of what was known as "the New Stagecraft," drew upon the Jazz Age vocabulary of Cubo-Futurism for sets that were also a departure for the venerable opera house. *Skyscrapers* belonged to the genre of the "portrait of a day in the life of a city" popular in the 1920s and 1930s. Musically, Carpenter contrasted rhythms of work and play represented by Manhattan skyscrapers and Coney Island amusements. Similarly, Jones created an "urban jungle" where dark steel skyscraper girders were juxtaposed with brightly colored amusement rides. Although the ballet's ominous undertones disturbed some viewers, the production was praised for developing a "specifically American art form" out of the "common and even vulgar sights and sounds of the life in an American city."[31]

After Diaghilev's death in 1929, veterans of the Ballets Russes made their way to New York and embraced another original American art form in addition to jazz: the Broadway musical. Choreographer George Balanchine and composer Vernon Duke (born Vladimir Dukelsky) collaborated on *Cabin in the Sky* in 1940. African American folklore was as exotic to Balanchine, Duke, and their fellow Russian costume and set designer Boris Aronson as the Slavic tales introduced to Americans by the Ballets Russes tours. As the United States emerged from the Depression and pondered entry into World War II, *Cabin in the Sky,* with its contest between virtue and vice, set "Somewhere in the South" was welcomed as escapist entertainment by New York audiences and critics.[32] The racially demeaning and historically regressive southern stereotypes of, for example, the shiftless Little Joe (Dooley Wilson) and his God-fearing wife, Petunia (Ethel Waters), were perceived as affronts to black Americans in the context of the advancements symbolized by the Harlem Renaissance.[33]

In his 1940 memoir Langston Hughes traced the beginning of "Manhattan's Black Renaissance" to Sissle and Blake's 1921 *Shuffle Along.*[34] *Skyscrapers*, *Cabin in the Sky*, and other productions, such as *The Green Pasture* and *Porgy and Bess,* attested to the vogue for representations of African American culture in musical theater. Unlike *Shuffle Along*, however, *Skyscrapers* and *Cabin in the Sky* were conceived and produced by predominately white creative teams (which complicated their relationship with the Harlem Renaissance).[35] There were, however, notable exceptions in both productions. Frank Wilson, an actor-playwright whose credits included the title role in the dramatic version of *Porgy* and Moses in *The Green Pastures*, directed the choir in *Skyscrapers*, the first time that African Americans performed at the Metropolitan Opera. Katherine Dunham, a dancer-choreographer known for fusing classical training with anthropological research (notably in Haiti), was the uncredited co-choreographer with Balanchine on the numbers that she and the Dunham Dancers performed in *Cabin in the Sky*.

In *Skyscrapers* and *Cabin in the Sky* Wilson and Dunham made their greatest impact on dream or fantasy sequences emphasizing the African side of jazz. In *Skyscrapers*, White Wings—a dancer in blackface whose name derived from his janitor's

Costume drawing for animals in *La Création du monde* by Fernand Léger, gouache and ink on paper, c. 1923

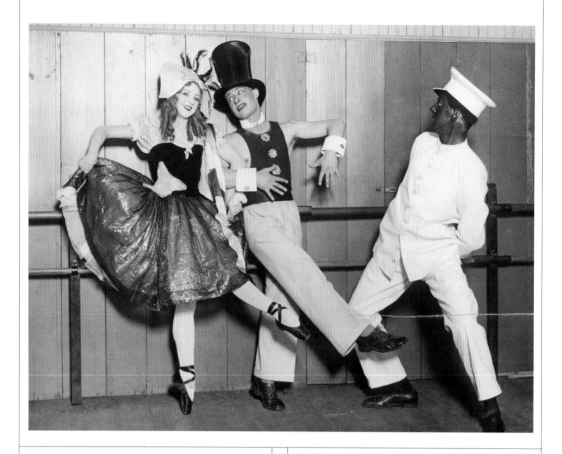

uniform—fell asleep during the night shift at Coney Island. In his exhaustion White Wings envisioned blacks toiling on a southern plantation, their misery suggested by references to American spirituals or African work songs chanted by the members of Wilson's chorus. In *Cabin in the Sky* the sympathetic but good-for-nothing Little Joe took a nap in his back yard. As he drowsed, Little Joe, who had vowed to follow the straight and narrow, was seduced by the temptress Georgia Brown in the guise of the Egyptian Queen Nefertiti. In this number, "My Old Virginia Home on the River Nile," Katherine Dunham employed stylized dance movements inspired by Egyptian tomb paintings to, in her words, "take us out of the stereotype of 'My Old Virginia Home' and connect back with Africa."[36]

Significantly, the White Wings sequence in *Skyscrapers* and the Egyptian number in *Cabin in the Sky* resonated in major paintings of the Harlem Renaissance, *The Ascent of Ethiopia* (1932) by Lois Mailou Jones and *Aspects of Negro Life: Song of the Towers* (1934) by Aaron Douglas. Both artists claimed New York skyscrapers for black America. In Jones's painting the tall buildings were heirs to the Egyptian pyramids. In Douglas's painting skyscrapers rose against the sky like ebony ancestor figures. An African aesthetic informed not only New York, but also its inhabitants, depicted by Jones and Douglas with references to Pharaonic tomb sculpture and West African ancestor masks. Music was both the pulse of the city and its pinnacle, represented by the "classical" pianist and singer in Jones's painting and the "popular" saxophone player in Douglas's.

The figures rose upward to freedom, to sunburst rays and the Statue of Liberty. However, both painters included reminders of slavery—in the form of servants carrying burdens in the *Ascent of Ethiopia* and workers on a cogwheel ensnared by smoke in *Song of the Towers*. In these paintings the struggle was not only historical but also contemporary, as black Americans of the great migration sought success in an urban, industrial, Jazz Age society.

Jones painted *The Ascent of Ethiopia* on the eve of her departure for Paris, where her interest shifted from the art of ancient Egypt to that of sub-Saharan Africa. Although Douglas never traveled to Paris, he benefited from the "discovery" of black African sculpture by Parisian artists, writers, and collectors while he was a student at the Barnes Foundation. *The New Negro* featured drawings by Douglas and African masks from the Barnes Collection. Hughes's "Jazzonia" (also included in the volume) evokes a scene in a Harlem cabaret where "six long-headed jazzers play" and a "dancing girl . . . lifts high a dress of silken gold" and inquires: "Were Eve's eyes/In the first garden/Just a bit too bold?/Was Cleopatra gorgeous/In a gown of gold?"[37] These questions seemed purely rhetorical in the era of Josephine Baker in *La Revue nègre* and Katherine Dunham in "My Old Virginia Home on the River Nile." The thread that wove painting, sculpture, poetry, fiction, music, and dance together in *The New Negro* and in the Harlem Renaissance was the belief articulated by the anthology's editor. In his essay "The Legacy of the Ancestral Arts," Alain Locke advocated reclaiming black America's rich cultural heritage from the degradations

of slavery and Jim Crow segregation as a route to racial progress.[38]

Nowhere did this strategy of "artistic revindication" resonate more strongly than in Paris among the intellectuals from French Africa and the Caribbean who were introduced to the Harlem Renaissance by Pan-African publications in the 1920s and founded the Négritude movement in the late 1930s. Proponents of Négritude (best translated as "Blackness"), a term coined by Martiniquan poet Aimé Césaire, believed that fostering cultural pride and solidarity among Francophone blacks on both sides of the Atlantic was the way to combat French dominance. Critics questioned the economic, social, and political efficacy of this emphasis on the arts in both the Harlem Renaissance and the Négritude movement. It is notable, however, that one of the architects of Négritude, the poet Léopold Senghor, who was an admirer of jazz and a friend of black American intellectuals,

RIGHT
The Ascent of Ethiopia by
Lois Mailou Jones, oil on
canvas, 1932

BELOW
*Aspects of Negro Life:
Song of the Towers* by
Aaron Douglas, oil on
canvas, 1934

AUTHOR! AUTHOR!

Lynn Root, actor, playwright and scenarist, is credited with the original story for "Cabin in the Sky." He wrote it in his cabin half-way up a California mountainside during vacations from the grimly serious business of writing comedies for the movies. He hails from Minnesota and was destined for the ministry before his sense of humor sidetracked his pulpit aspirations. That mad bit of theatrical pugilistics, entitled "The Milky Way," was his initial contribution to the gaiety of Broadway and it won him a film writing contract that has had him brightening the nation's screens ever since. "Cabin in the Sky," filled with the geniality and fun characteristic of his play writing, is his first solo work.

Staged by GEORGE BALANCHINE

Now that everyone has accepted George Balanchine as "the boy wonder of the ballet," he is making a new name for himself—as a stage director. "Cabin in the Sky" represents his debut as supervisor not only of the dances, but of the entire production. His reputation rests firmly on his association with the Ballet Russe and on this country's foremost dance troupe, the American Ballet, which he helped organize. In the commercial theatre he made ballerinas and choreography bywords through his dance direction for "On Your Toes," "Babes In Arms" and "I Married An Angel." He has, however, crowded much more than the dance into the short space of his thirty-odd years. He has been an actor, ballet master and director of experimental stage productions.

Settings by BORIS ARONSON

Not only an artisan of the theatre but also a painter of considerable reputation, Boris Aronson has done his finest work for "Cabin in the Sky." Commentators have called upon the immortal Currier and Ives to provide standards of Americana with which his Southland backgrounds might be compared. His settings have provided the atmosphere for Eva Le Gallienne's production of "2x2=5," for "Walk a Little Faster," in which Beatrice Lillie starred, for "Three Men On A Horse," for turbulent dramas by Clifford Odets and for such theatrical whimsies as a Saroyan ballet.

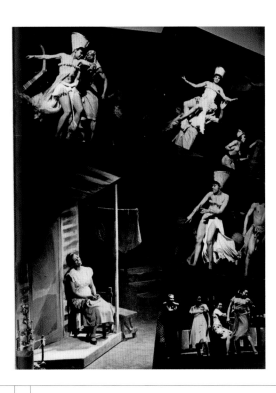

went on to become the first president of his native Sénégal after independence.[39]

At the time of *La Revue nègre*, a critic in the Paris daily *Le Figaro* famously proclaimed that Josephine Baker was dancing on *la table rase*, or a clean slate, kicking up around her the dust of the Old World.[40] In both New York and Paris, the rhythmic dislocations of jazz perfectly expressed the upheavals of the period in aesthetic values, social conventions, class structures, and race relations. Jazz also symbolized the radical change in the relationship between the United States and France as transatlantic allies and rivals and between American and Francophone blacks linked by shared but contrasting experiences of the African diaspora. For France, which prided itself on its "civilizing mission" in the world, jazz proposed a serious challenge to its culture.[41] A newspaper headline on the curtain of the ballet *Within the Quota* announced: "Unknown [American] Banker Buys Atlantic." In the preface to Paul Colin's collection of Jazz Age lithographs, *Le Tumulte noir*, Josephine Baker remarked that "Paris is getting darker and darker."[42] The direction of cultural influence had reversed between Old Europe and the New World and, in the racially loaded language of this contentious period, between the Home of the Enlightenment and the "Dark Continent." A century later these issues still reverberate on both sides of the Atlantic, in the volatile relationship between New York and Paris, as America and France grapple with their national identities as multiethnic nations in a global world.

Jody Blake is Curator of the Tobin Collection of Theatre Arts at the McNay Art Museum in San Antonio, Texas. She authored the book *Le Tumulte noir: Modernist Art and Popular Entertainment in Jazz-Age Paris, 1900–1930* and contributed a major essay to the book *High Drama*, which explored Surrealism and ballet in Paris and New York.

PHYLLIS MAGIDSON

FASHION SHOWDOWN:

NEW YORK

VERSUS

PARIS

1914–1941

It wasn't until America's runway triumph at the Palace of Versailles in 1973 that Paris finally acknowledged the fashion prowess of its neophyte competitor. A full half century after American fashion had taken its modern form in New York's Garment District, Paris stood up and cheered the collections of five singular New York designers—Stephen Burrows, Geoffrey Beene, Oscar de la Renta, Halston, and Anne Klein. Although America's fashion industry had flourished during World War II in the vacuum created by Paris's forced wartime hiatus, Paris stood ready to reclaim its position of couture primacy when the war ended. America, on the other hand, had come out of the war naively confident that it had

exorcised its second-class stigma. Although briefly stymied by the 1947 premiere of Christian Dior's influential "New Look" in Paris, the resolute spirit that propelled New York's fashion industry through the lean times of the Depression and wartime restrictions strengthened its conviction that France might always be *chic*, but it could never again be the exclusive option. Not only could New York outwit Paris when it came to practical dress solutions, but its own couture and custom ateliers had also produced distinctive American spins on glamour. For the twenty-five years following Dior's triumph, the two fashion capitals maintained a separate-but-equal status, that culminated in Paris's ultimate compliment: unqualified acceptance of American fashion in 1973.

New York's achievement of this turnaround was all the more surprising given its total reliance on Paris for creative leadership in fashion trends well into the early twentieth century. Until the early 1930s, there was no question that Paris was *the* sole arbiter of style: infallible, eternal, sacrosanct. American fashion was the impatient kid brother: cunning, adaptable, frequently smart . . . but never *chic*. It was widely acknowledged that New York was proficient in the technical aspects of clothing fabrication, but not in the creative design of "fashion." The city had manufactured clothes for widespread distribution since the end of the Civil War and became a retailing center with the emergence of the Ladies' Mile district a few years later. However, unlike Paris, which had identifiable design personalities such as Charles Frederick Worth, Madame Paquin, and Paul Poiret, New York's fashion industry employed largely anonymous dressmakers who mostly interpreted Paris fashions until the early 1930s. As a result, New York's fashion industry was relegated to second-class status in the eyes of the style conscious.

Paris's fashion dominance into the twentieth century was rooted in the industrial and commercial renaissance masterminded by Louis XIV and his ministers in the mid-seventeenth century and secured by the courtly splendors of the eighteenth century. At the end of that century, the French Revolution effected a shift in fashion from regal excess to populist simplicity, which was reversed in the middle of the nineteenth century with the ascension of Emperor Napoleon III and his establishment of the Second Empire. The motivating force in this transformation was Charles Frederick Worth, Empress Eugenie's designer of choice. From the onset of Worth's aesthetic reign during the 1860s, his artistic alchemy and arrogance bestowed upon France its modern identity as fashion arbiter. Forging the *haute couture* tradition of individual models from which customized garments were meticulously fabricated by hand for a small and elite clientele, Worth secured divine status for the country's artistry, deeming French the language of sartorial elegance.

Maison Worth's illustrious American clientele included upward-striving Gilded Age society figures like Mrs. William K. Vanderbilt and Mrs. C. Oliver Iselin, who turned to Paris for their elegant look rather than to New York's embryonic Ladies' Mile shopping district. Capitalizing on the allure of the Parisian houses, however, dressmaking establishments in New York borrowed from the French to invent such picturesque labels as Madame H. Keily, Mme. Epstein & Co., C & D Macdonald Modes, and Maison Maurice. Still, some ingenious women appropriated real French labels for their American-made clothing. One 1908 commentator reported, "The lengths to which women will go in their desire to appear in the fashion even if they are not, is shown by the business which a lady in New York is said to have founded. According to accounts, she deals in nothing but discarded Paris waistbands—that is to say, those which bear names of well-known dressmakers. Women, in plenty in New York,

will buy these little strips of silk in order to have them stitched into their own dresses, to give their friends the impression that their garments were made in the French capital."[1]

The year 1914 marked the beginning of a shift of interest to American fashion. It was then that Edna Woolman Chase, editor of *Vogue*, then a stalwart advocate of French couture, sought to mitigate the potential disappearance of French fashion—and magazine advertising—during the escalating First World War by staging a "Fashion Fête," organized for the Committee of Mercy to Relieve the Women and Children left Destitute by the War. It took place in November of that year with the blessing of the city's social register, including Mrs. Stuyvesant Fish, Mrs. Vincent Astor, Mrs. August Belmont, and Miss Elsie de Wolfe, the former fashionable actress who was establishing herself as New York's premier interior designer and tastemaker. As outlined in the evening's program, the Fête's mission was to "encourage the New York designer to stand boldly behind their own work . . . The hope of the Fashion Fête is by no means to erase from the signs of New York's smart dressmakers the word 'Importer,' but to put by its side, in equal size and brilliancy, the words '–and Designer.' "[2]

Staged in the ballroom of the Ritz-Carlton Hotel, the Fashion Fête program was effectively a "coming out" for American talent, debuting the formidable technical, and occasionally creative, prowess of New York's fashion industry. Introducing *Vogue's* fifteen-page coverage of the event, Emily Post voiced the skepticism of many of the audience members that greeted the prologue tableau: "and where will they come from, these fashions of yours? Here, from New York. Impossible. There is not a decent frock in the whole town." She concluded, however, that "the dressmaking houses of New York had personality," and that the Fête had "given the New York dressmakers renewed confidence in themselves" and "inspired all who looked upon their work with fresh confidence in them."[3] As elaborately illustrated, the clothes displayed a rugged functionalism, sporting unpicturesque names such as "Country Costume" (Grande Maison de Blanc), "Polo Girl" (P. Nardi), and "Useful" (Stein and Blaine), all displaying youthful lines with an "appealing slenderness." Deficient in artistry and sophistication, these clothes seemed to lack the talent or ambition to change America's immature image and stigma of provincialism, in spite of Emily Post's encouraging words.

The 1914 Fashion Fête presumed to broach an American-Parisian face-off, but it never truly dreamt of challenging the Old Guard's near-religious devotion to Parisian couture, as the magazine demonstrated in its Fashion Fête the next year. Always editorially mindful of the rarefied appetites of his upper-crust readership, *Vogue* publisher Condé Nast sponsored the 1915 Paris Fashion Fête, which reiterated *Vogue's* allegiance to Parisian couture, albeit in a modified, modern

Coat designed by Paul Poiret, Rodier perllaine wool, 1921

form. Sponsoring both American and French fêtes and featuring the products of America for the first time, *Vogue* juxtaposed the new French aesthetic of wartime economy and function with New York models that had long espoused those qualities as quintessentially American.

While the New York–focused Fashion Fête of 1914 had baptized American fashion, it was the completion of two new buildings on Seventh Avenue in 1921 that signaled the development and consolidation of a New York–based fashion industry. After a series of disasters, most famously the Triangle Shirtwaist fire in 1911, and pressures from the International Ladies Garment Workers Union, a group of real estate investors established a new state-of-the-art garment district with fireproof buildings customized to house manufacturing facilities as well as design studios and showrooms for ready-to-wear clothing. They selected Seventh Avenue between Thirty-sixth and Thirty-eighth Streets as the location of this new garment center; the first two buildings, at 498 and 500 Seventh Avenue, contained a total of 1.5 million square feet at a cost of about $20 million for the land and buildings. The Garment District quickly transformed American fashion into a streamlined and vital industry. As *Vogue* described the role of American design in 1923, it was fused with Parisian design into a "great international organization, the members of which fall naturally into three distinct groups: the creators of modes, the great houses of Paris . . . the disseminators—also to some extent creators, though almost invariably along lines previously determined by Paris—of whom the great New York houses are the most notable examples; and the popularizers, the great ready-to-wear houses whose frocks and coats and

FASHION FÊTE

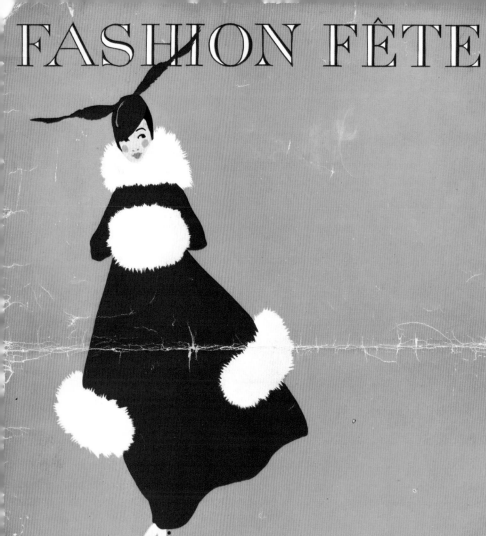

Programme
Twenty-five cents

tailored suits are sold in every shop in the country, who design to some extent along the lines of the prevailing mode and who reproduce in quantity the models created by the great houses of Paris and of New York."[4]

The garment industry continued to grow throughout the 1920s, and by 1931 it had transformed New York's notorious Tenderloin district into the largest concentration of apparel manufacturers in the world, sprawling from Thirty-fourth to Fortieth Streets between Sixth and Ninth Avenues in the heart of Manhattan. This development wielded an unexpected blow to dress imports while augmenting the supply of well priced and well crafted garments for the working woman. A marked shift in international buying patterns was reflected in a 1931 *New York Times* cable report: "The tendency of the American woman to accept a standardized fashion of dress has become a serious danger to the French dressmaking trade, according to President Gerber of the French couturiers' syndicate." Gerber's figures indicated that French dress exports in 1926 were valued at $80,000,000 but that they fell to $55,640,000 in 1930. Yet, the *Times* reported that Gerber, even in the face of this economic challenge to Paris's fashion dominance, "warned the French not to adopt standardized methods," reminding his compatriots that, "where the French excel is in creating deluxe models, in making a dress to suit the woman who wants her dress original and unique . . . Instead of entering mass competition, we must continue our traditional methods and combat the idea that the well dressed woman can accept a cheap standardized costume of vulgar taste."[5]

LEFT
Garment Center
Capitol (1921) at 498
Seventh Avenue, designed
by Walter M. Mason,
photograph by
F. S. Lincoln, c. 1940
(after facade renovation
by Ely Jacques Kahn)

BELOW
Workroom of the
Joseph J. Kaiser Co. in
the Garment District,
New York, photograph by
Byron Co., 1920

In addition to the creation of the cohesive Garment District, there were other signs that New York was maturing as a fashion capital. Non-French designers sought to trump Paris—from Valentina, who successfully launched a couture atelier in New York in the late 1920s, to Mainbocher, the first American couturier to be embraced by the French fashion establishment on their own soil. At the same time, New York's retailers like Lord & Taylor started to energetically market New York–based designers. In December 1933 *Fortune* magazine reported that in March of the previous year, "the Manhattan

retail establishment of Lord & Taylor made history. It bought and paid cash for space in the daily papers to advertise fine dresses designed in America."[6] Significantly, these designers were named on labels, rather than subsumed under manufacturers' names. Each designer was tied to a distinctive personal style and proclaimed as an avatar of a newly self-confident American fashion attuned to the nation's active lifestyle.

AMERICAN COUTURE DIVAS

At the same time, however, fashionable social-ites continued to maintain their devotion to Paris fashion. Avidly covered in the New York press, the Parisian tastes of Mrs. Harrison Williams and Mrs. George Blumenthal ignited American interest in couture. Their demeanors, lifestyles, and spending habits represented the height of glamour, and their trajectories paralleled the arc of French fashion at the time. Mona Williams—extraordinarily rich, spendthrift, and blessed with a blue-blooded, model-perfect body—was extolled and photographed by Cecil Beaton, *Vogue* photographer, illustrator, and editor. Beaton noted her French affinity in 1938: "It is fitting that she should have a cigarette case, the box of finely chased gold, diamonds and emeralds that Louis XIV gave to his father."[7] Cole Porter literally sang her praises, inserting her name into more than one lyric. From the time of her marriage in 1926 to Harrison Charles Williams, purportedly the richest man in America, Mona frequented the houses of Chanel, Vionnet, Balenciaga, Hermès, and Cartier, and she continued her patronage well beyond the 1929 market crash that destroyed her husband's fortune. After Nazi Germany invaded Poland in 1939, she left Paris with the iconic red, white, and blue organza gown from Chanel's last collection, a poignant finale to her 1930s couture frenzy.

Mrs. George Blumenthal's devotion to the sumptuous fashions of Paris was similarly persistent, though not as highly publicized. While she favored the houses of Vionnet and Paquin for her resplendent day and evening attire, the opulence of her shoe wardrobe surpassed her magnificent gowns. Crafted by André Perugia, the premier Parisian shoe concern launched with Poiret's assistance after World War I, the artistry of each pair afforded her high, but subtle, visibility. Prominently positioned as wife of the president of the Metropolitan Museum of Art during the 1930s, Mary Ann Blumenthal amassed a prodigious Parisian wardrobe throughout the decade and, with an eye on posterity, gave a sampling of her holdings to the embryonic Museum of the City of New York's costume collection in 1938.[8]

The very public lifestyles of this rarefied breed of New York–based style leaders afforded them frequent photographic opportunities to model their Parisian trophies. As socialites whose marriages cushioned them from the financial travails of the times, their diversionary appeal met readers' needs for vicarious dream fulfillment.

Vogue's wistful "Eye View of the Mode" spoke for the larger population of fashion-starved women: "This has turned out to be an Age of Economy, ours not to reason why, ours but to decide what we will economize on."[9] Celebrated in full-page portraits by Baron de Meyer, Arnold Genthe, Edward Steichen, and Cecil Beaton, these "couture divas" captivated readers on both sides of the Atlantic who revered their clothing and lifestyles.

NEW YORK RETAILERS

Even while New York's society matrons maintained loyalty to Paris, New York was continuing its development as a fashion capital in its own right. Key to this rise were retailers, from custom shops to department stores providing salon services, each with their own distinctive design style. They imported Parisian couture models directly from French designers, which they accurately replicated for individual clients. They also interpreted these models in less expensive versions, and they employed in-house talent who created their own original designs. Both the interpretive versions and the in-house originals could be customized to individual tastes or purchased "ready to wear," the American innovation of manufacturing in standard sizes and selling off the rack.[10]

Offering all these services, Hattie Carnegie (her name pirated from Gilded Age mogul Andrew Carnegie), who branded her identity into America's consciousness during the mid-1920s, was perhaps the best-known of America's fashion retailers at the time. Originally an importer/creator recognized for her "correct Interpretation of *the* Mode"[11] and for providing "the filtered-out-best of French-taste-for-America,"[12] Carnegie had established herself as the country's foremost tastemaker by 1930. According to *A Shopping Guide to New York* published that year, "They have a way of telling you in the West that a gown is from Hattie Carnegie with more reverence than if they were mentioning Patou and Vionnet rolled into one."[13] Supplementing her collections of French imports and original designs, Carnegie inaugurated her ready-to-wear department in 1933, premiering both street and dinner costumes. A full-page *Vogue* advertisement heralded the expansion of her line: "Every woman loves a label . . . one that can be flung over the back of a chair with the greatest of éclat to impress a watching world. A gesture of the utmost satisfaction when it does not deplete one financially. Hattie Carnegie, THE Hattie Carnegie, has inaugurated a ready-to-wear department with Carnegie clothes at prices that start at $45 . . . 42 East 49th Street, New York."[14] By 1937 Hattie Carnegie had attained international acknowledgement as "New York's number one couturier."[15] Ironically, it was Hattie Carnegie's willingness to bank on the potential of her handpicked talent but refusal to acknowledge designers individually that made her atelier a spawning ground for the next generation

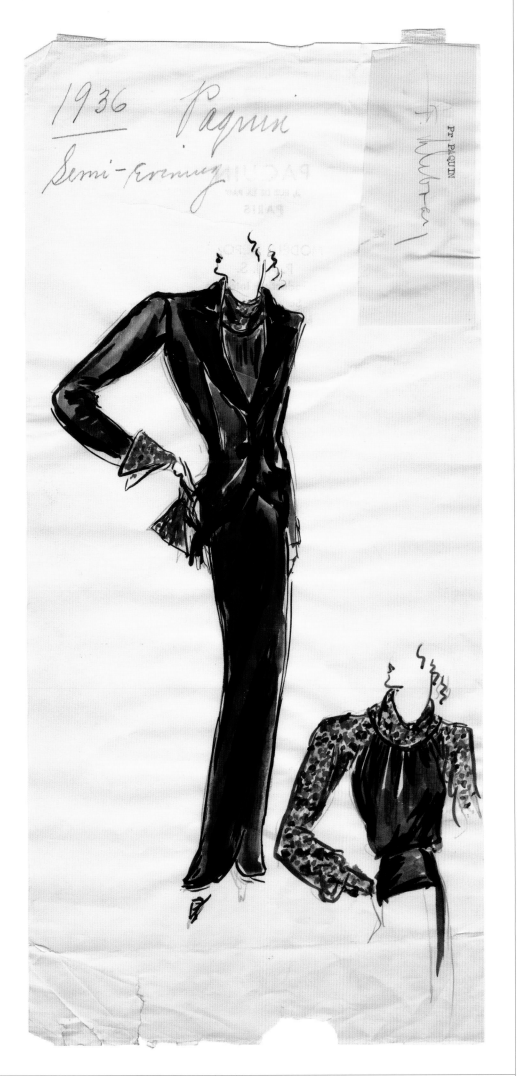

Croquis of semi–evening
ensemble designed by
Paquin Paris for Mrs.
George Blumenthal,
pencil and watercolor on
paper, 1936

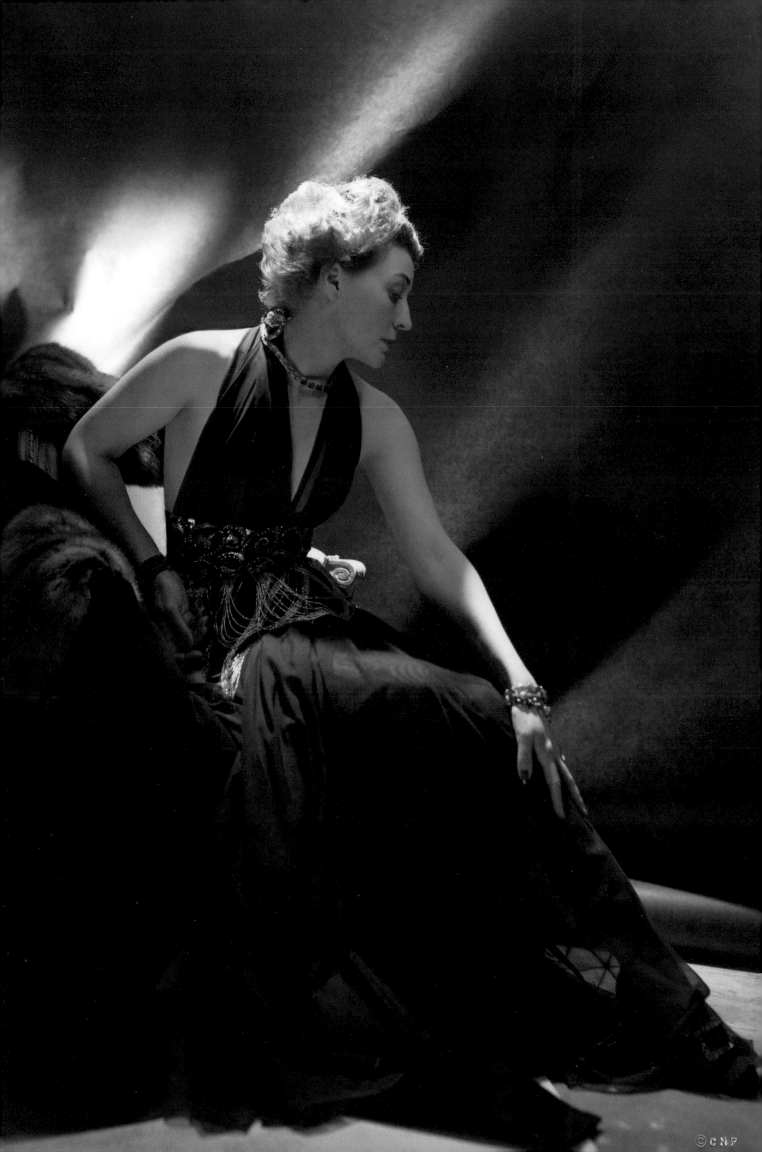

Little diamond brooches to clip on a hat or gown

White gold, sapphire and diamond vanity case

A jade, lapis, baguette diamond and sapphire cigarette case

Photograph frame of jade, coral, onyx, gold and emerald

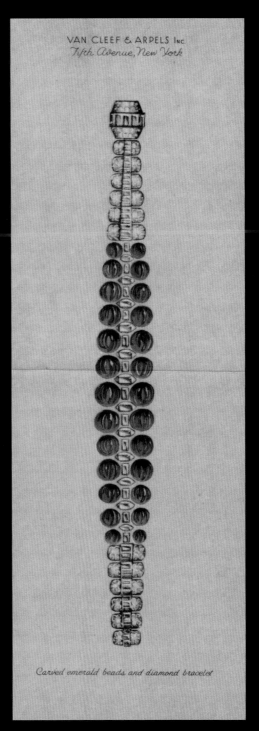

Carved emerald beads and diamond bracelet

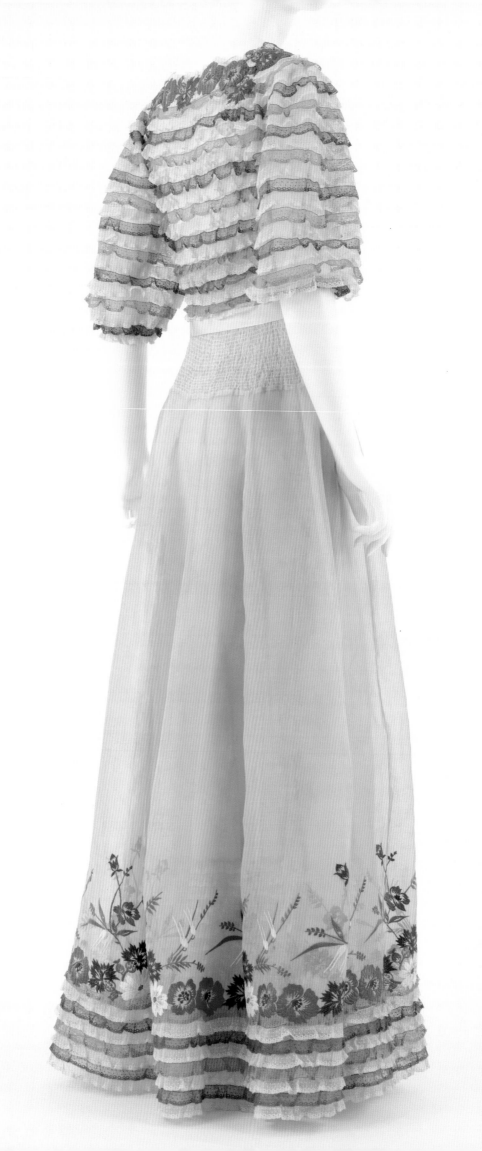

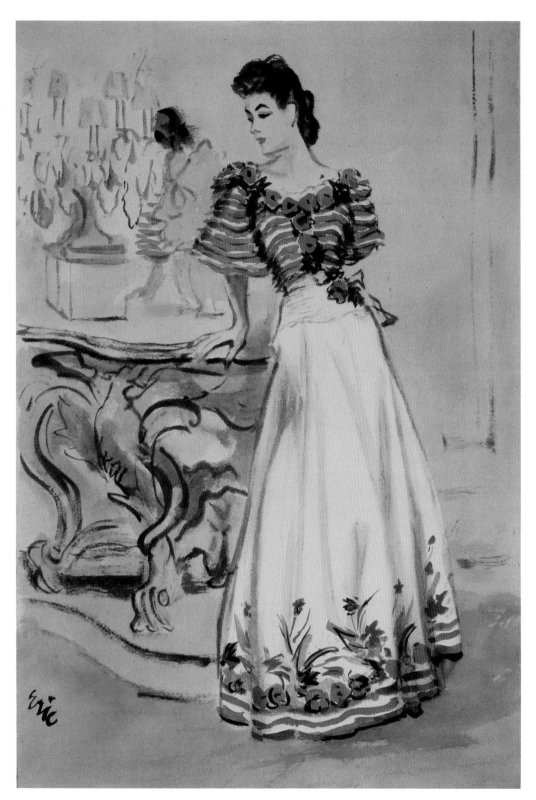

OPPOSITE
"Tricolour" gown
designed by Gabrielle
Chanel and worn by
Mona Williams,
embroidered silk
organdie, 1939

LEFT
Watercolor of "Tricolour"
gown designed by
Gabrielle Chanel for
Mona Williams, drawn by
Eric, reproduced in *Vogue*,
July 1, 1939

BELOW
Bracelet made by Cartier
for Mona Williams;
sugarloaf-cut Burma
sapphire, Ceylon
sapphires, pearls, and
platinum; 1927

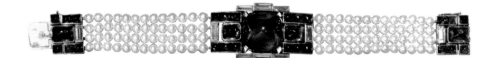

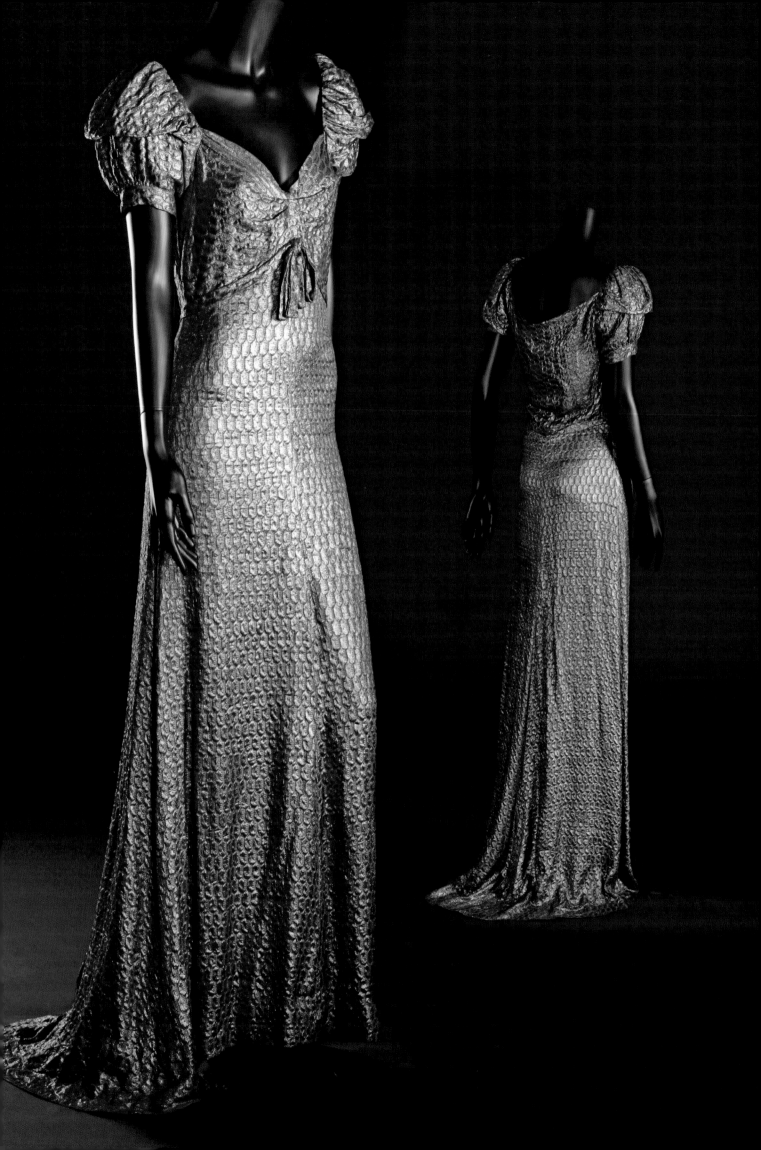

of American designers. Her enormous ego precluded her ability to share the "Hattie Carnegie Originals" label with her in-house designers, such as Norman Norell, Jean Louis, Claire McCardell, and Travis Banton, who went off to start their own labels. Thus, her role was pivotal in launching the solo careers of many of the pre–World War II period's most innovative and influential design personalities.

Department stores and specialty shops were also engaged in this new retail phenomenon of in-house design studios. Along Fifty-seventh Street Bergdorf Goodman, Henri Bendel, Jay-Thorpe, Bonwit Teller, and Saks Fifth Avenue continued to import collections of Parisian models during the Depression while concurrently nurturing their own design studios. Bergdorf Goodman, for example, promoted the work of in-house designers Leslie Morris, Mabel McIlvain Downs, Mark Mooring, and Peggy Morris. Fira Benenson served as chief in-house designer and director for Bonwit Teller's Salon de Couture, which also featured the works of Nettie Rosenstein, Germaine Monteil, Philip Mangone, and Louise Barnes Gallagher.

So great was the appeal of many internally produced designs that, for the first time, the American fashion industry suffered from a problem that had plagued French design houses: fashion piracy. Featuring gowns and *tailleurs* in its Spring 1932 *Harper's Bazaar* ads, Saks Fifth Avenue advertised its "Original Fashions" with a forceful "Reproductions Forbidden" reminder.[16] Leading a campaign against industry infringement, which was rampant by 1931, ready-to-wear designer Maurice Rentner united a representative group of foresighted manufacturers to forge what would become the Fashion Originator's Guild of America. Enlisting the cooperation of retail stores in its crusade to purchase only authentic "originations," the Guild declared it essential to set up a bureau for the registration and labeling of original work "designed to protect the store, and also the customer who wished to purchase individual clothes with the assurance that she would not be cheated by seeing them in cheapened reproductions."[17] Although challenged by subsequent conspiracy in restraint of trade lawsuits by 1936, the creation of the Guild brought about a sense of security, stability, and legitimacy for the 250 manufacturers and affiliates that formed its membership.

America's Depression-era financial straitjacket confirmed the market for thrift-conscious garments, giving America's fashion industry a critical boost. In 1932 Lord & Taylor's prescient vice president and director, Dorothy Shaver, turned away from the increasingly anachronistic remoteness of Eurocentric fashion priorities, taking a strong stand for versatility and stylistic relevance by promoting an innovative roster of American talent. Gambling on the promise of "Young American Designers" like Clare Potter ("painting with fabrics," a window placard

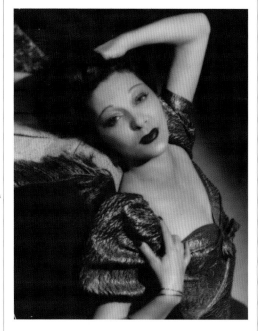

announced, "is her idea of designing"), Ruth Payne, and Alice Smith (whose separates were featured within the store's Fifth Floor Sports Shops), Shaver installed their designs at every turn: in window displays, on platforms, within cases, and hanging on racks throughout the store. Shaver proudly identified these designers by name—a critical step in promoting New York as a fashion center with designers who had individual styles. Adding Muriel King's already-familiar versatile individualism and Elizabeth Hawes's independent classicism to the mix, Shaver gambled on their insiders' understanding "better than any one else could, the type of thing suited to, and desired by, the young New Yorker—a genus almost unknown to the Paris Couture."[18] In 1940 Shaver augmented her staff with Marjorie Griswold, an intuitive buyer and visionary merchandiser who immediately recognized the potential of Claire McCardell as the first in a string of young designers she would "discover." Premiering clothing that would become the backbone of the American sportswear industry, Lord & Taylor continued its advocacy through the war period. In 1945, the year Shaver was elected store president (the first female to hold that office with a major American retail establishment), a subtitle was added to the Lord & Taylor name: "The Signature of American Style."

AN AMERICAN COUTURE

At the same time that retailers were nurturing the American ready-to-wear market, New York–based designers were also challenging Paris's dominance in the field of *haute couture*. The couturière-darling of New York café society, Russian-born Valentina (Valentina Nicolaevna Sanina Schlee) cunningly envisioned her own media campaign from the inaugural days of her independently operated couture salon, Valentina Gowns, Inc., in 1928. Rather than serving as an invisible behind-the-scenes costumer to her

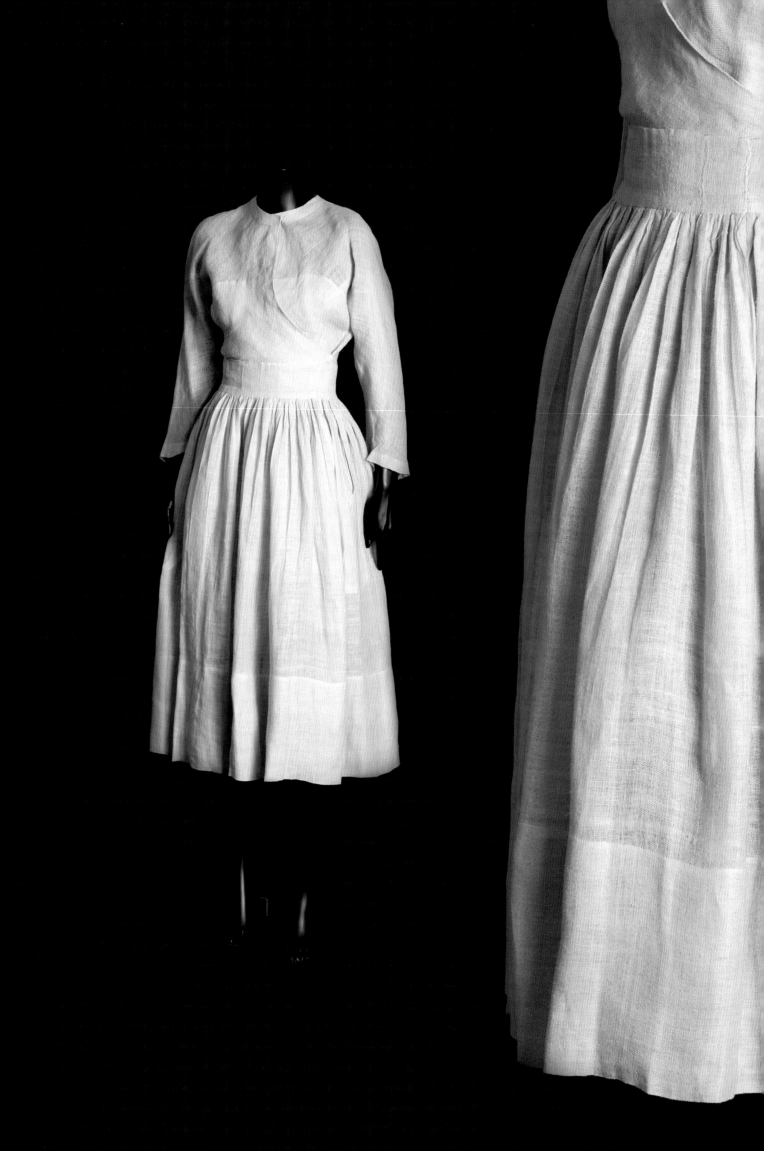

society and theatrical clients, including social-
ite Millicent Rogers and actresses Katharine
Cornell, Greta Garbo, and Gloria Swanson,
Valentina became an increasingly recognizable
figure in fashion editorials. Her first full-page
photographic appearance in a 1936 issue of *Vogue*
identified her as Mrs. George Schlee (her married
name) wearing Valentina. Thereafter, *Vogue* would
cover Valentina's couture work by name, the same
treatment afforded her Parisian counterparts like
Vionnet and Alix.

Another important American couturier, Main-
bocher (born Main Rousseau Bocher in Chicago),
joined French *Vogue* as fashion editor in 1923
and then served as editor-in-chief from 1927 to
1929. A self-described "quiet innovator," Main-
bocher succeeded in breaking through French
couture's exclusivity as the first American to
open his own atelier at 12, Avenue George V in
Paris in 1930. In 1932 *Vogue* featured the collec-
tion of this "new star in the firmament of the Paris
couture."[19] Putting practical American staples
like cotton gingham into a new couture context,
Mainbocher defined his fashion ethos for *Harper's
Bazaar* in 1938: "A good dress has a very long life,
since it contains some past, much present and a
little future."[20] Uncompromisingly committed to
classicism and perfect taste, Mainbocher's dresses
were imported by Hattie Carnegie, I. Magnin
(California), Saks Fifth Avenue's Salon Moderne,
and Jay-Thorpe, distinguishing him as a celeb-
rity on both sides of the Atlantic. In its Septem-
ber 1936 "Glamor from Paris" rotogravure, the
New York Times broke with its editorial policy of
not identifying American designers and noted an
evening gown designed by Mainbocher, as well as
one by another American in Paris, Charles James,

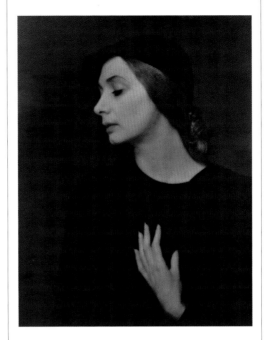

alongside the works of Parisians Jean Patou, Alix,
and Schiaparelli.[21]

The *New York Times* coverage of Mainbocher
indicated the press's increasing acknowledgment
of New York designers in the 1930s. While New
York's fashion industry was rising to the chal-
lenges of the Depression through the efforts of
homegrown couturiers and department stores,
fashion journalism was changing its apologetic
tone to one of giddy optimism about America's
creative prowess. Superlatives formerly reserved
for the artistry of Paris were now lavished on
American designers. A 1930 *Vogue* advertisement
typified this new perspective: "Collaboration of
design and execution . . . The creative genius of

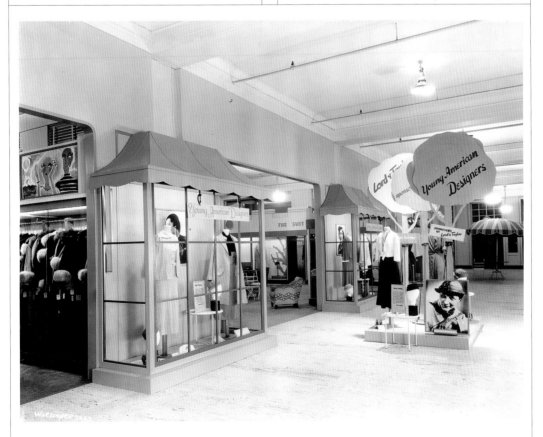

OPPOSITE
Wedding dress sold
by Lord & Taylor, silk
organza, 1934

E.M.A. Steinmetz . . . The interpretive talent of Stein & Blaine . . . Two hands that speak as one in garments that express both."[22] Similarly, a May 1933 *Vogue* article proffered an accolade for American temerity in the face of adverse economic conditions: "We admire courage, especially courage coupled with chic. And when Frances Clyne (6 East 56th Street New York)—right in the midst of the blackest days of current history, during the very week of the hysterical bank holiday—had both the courage to move into bigger and better quarters and the *chic* to do them as she did—we respectfully take off our hat . . . For this unique personality among native dress-makers has an uncanny understanding of what smart women want."[23]

By the mid-1930s editorial copy, as well as word-of-mouth, was supporting the common sentiment that the domestic fashion industry's in-house designers were more empathetic and better suited to design for the daily needs of the American woman than Parisian designers. In 1934 *Harper's Bazaar* awarded a three-page feature to MGM's design mogul Adrian, who was already familiar to the public not only for his screen work, but for the copies of the ultra-feminine ruffled dress worn by Joan Crawford in the 1932 film *Letty Lynton* that were sold in retail stores. (Macy's reportedly sold more than 15,000 of these within three months after the film's release.) In the *Harper's Bazaar* article, titled "Do American Women Want American Clothes," Adrian assessed the differences between the American and French mindsets: "The American wants to look attractive, but she wants to arrive there by a short cut. She hasn't the time to concentrate on being visual all day long, as the French women do . . . She likes to be able to jump into a little dress and look charming without contributing anything herself but slim hips and a pretty face . . . She feels, quite rightly, that the subtle points of couture are lost on the average American man . . . It is only very recently that she has dared to come out openly and admit that she often actually prefers American dress."[24]

That same year *Collier's* observed the insiders' advantage of mold-breaking designers like Clare Potter, Elizabeth Hawes, and Muriel King:

Only an American can understand how a business woman can require a dress that will be suitable for a busy morning at the office, a hasty lunch at the drug store, an unexpected tea date and an informal dinner-theater engagement. Moreover, it must look exactly right for each occasion . . . Of course these are things that can be explained to Paris . . . but it takes time to do that and the chances of misunderstanding are many. The American designer, being on the scene and of it, can evolve a new fashion and have it on the market in less than two weeks, long before an inkling of the change in social life even reaches Paris.[25]

New York designer and importer of French models Frances Clyne acknowledged the place of Paris in her own creative process but was clear about its status as merely a departure point: "One certainly needs to go to Paris for the inspiration to create . . . Half of it is the example of the French designers, half of it the entire change that the trip gives me . . . The dresses that I call American models are models that fulfill American needs. Often, in a New York restaurant observing smart American women, I get an inspiration that sets one of these American modes in motion."[26]

While the Depression put many of the forces transforming fashion into play, it was World War II that marked the turning point in the Parisian-American fashion duel. America's addiction to Parisian couture was a tough habit to break, but it had little choice when the German occupation of Paris shut down the city. Although American designers were practiced creators, the public mindset was not yet prepared to accept them as the sole leaders of fashion. Magazines like *Harper's Bazaar*, however, helped to lead popular opinion to homegrown fashion. Its February 1940 issue was devoted to the "American Fashion Label," presenting "the fashions of America on the march. Yesterday ideas, today realities, by tomorrow they will penetrate to every corner of the land." It delivered an edict to its readership: "As Paquin and Worth stood for a certain civilization, a certain degree of elegance, these names—you'll see them on our cover—stand for American style, and the American way of life . . . The farther you go from New York, the more you'll hear them . . . the names that we use in our magazine are guides to excellence. If you are truly contemporary, they'll be in *your* vocabulary, too."[27]

Similarly, Edna Woolman Chase introduced *Vogue*'s September 1940 "American Fashion Openings" issue, noting, "This is the issue of *Vogue* that, in other years, was called 'Paris Openings.' But this year, the needles of Paris have been suspended, temporarily we hope, by the fortunes of war. And for the first time in memory, an autumn mode is born without the direct inspiration of Paris. For the first time, the fashion centre of the world is here—in America . . . And this, *Vogue's* American Openings issue, brings you the first chapter in the most important fashion openings America has ever held."[28] Represented on the following pages were beautifully depicted designs by Germaine Monteil, Valentina, Hattie Carnegie, Milgrim, and Nettie Rosenstein, plus the anonymously designed products of Henri Bendel's, Bergdorf Goodman's, and Saks Fifth Avenue's custom salons.

More reassuring to America's dependents on the designer star system was the electrifying announcement in November 1940 that Mainbocher had opened his New York salon at 6 East Fifty-seventh Street, ready to satisfy the appetites of "all his decorative clients who used to cross the Atlantic just for the privilege of being dressed by him." Fortuitously, the fame bestowed on Mainbocher by Paris couture's acceptance cast a glow of legitimacy on less-renowned American talent

Sunday,
March 7, 1937
New York Spring Fashions

The New York Times

Rotogravure
Picture Section
In Two Parts

9

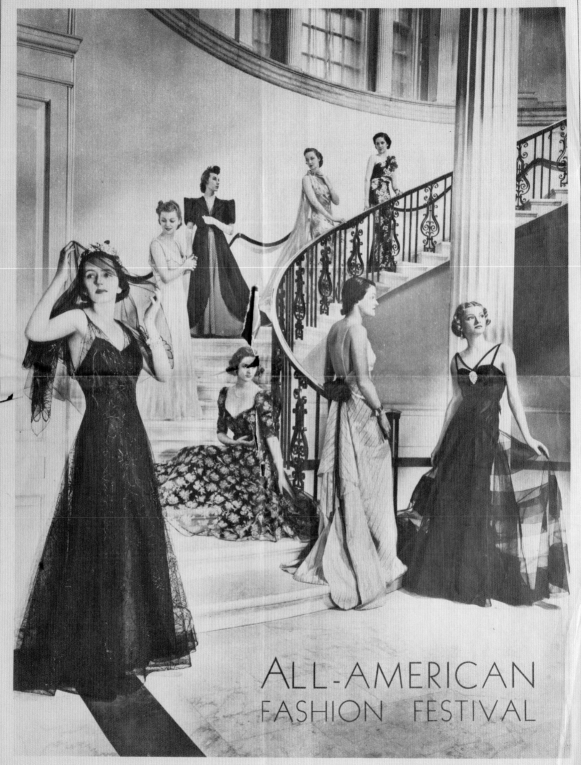

ALL-AMERICAN
FASHION FESTIVAL

Formal evening gowns show great variety in fabric, color and line. At the lower left is a gown of Spanish inspiration in black net with a lacy pattern of lacquer-outlined flowers; its exotic headdress can also be worn as a cape. The seated figure wears lace in an allover design of gray-blue flowers on black. White taffeta with woven stripes of pale green and gold thread makes the gown with cascading back drapery, having two large wine-colored roses at the waist. Against the pillar is an effective bouffant dress combining black silk net and chiffon. The light colored frock low on the staircase is of shell-pink silk net over a slip of matching satin trimmed with disks of the satin encircled with pleated net ruffles. Square shouldered and widely flared is the long wrap of black silk faille which covers a gown of diagonally striped black-and-white taffeta. Second from the top, a long cape of pale green chiffon, held at the throat by a jeweled clasp, forms an airy background for a sheath of off-white printed satin with shaded purple asters and green leaves discreetly embroidered in small matching paillettes. The last figure in closely draped in supple straw cloth woven with huge bouquets of brilliant and pastel red flowers blending with the silk flowers on the shoulder.

[Photographed on the grand staircase of the Museum of the City of New York by The New York Times Studios.]

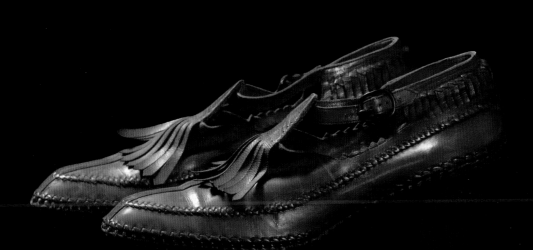

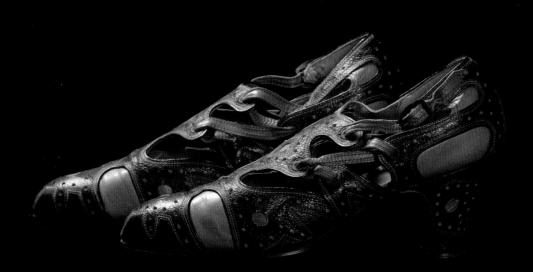

OPPOSITE
"All–American Fashion
Festival," photographed
on the grand stairway of
the Museum of the City
of New York, *New York
Times*, March 7, 1937

LEFT
Shoes designed by
Bob, New York, for
Mrs. George Blumenthal,
mid–1920s
While she focused on Paris
fashion, even Blumenthal
realized the rise of New York as
a new fashion center and bought
from its designers.

FOLLWING PAGE LEFT
New York–made day
ensemble, silk and wool,
c. 1940

FOLLOWING PAGE RIGHT
Evening dress sold by
Bergdorf Goodman's
custom salon to Mrs.
George Blumenthal, silk
and braided floss, c. 1935

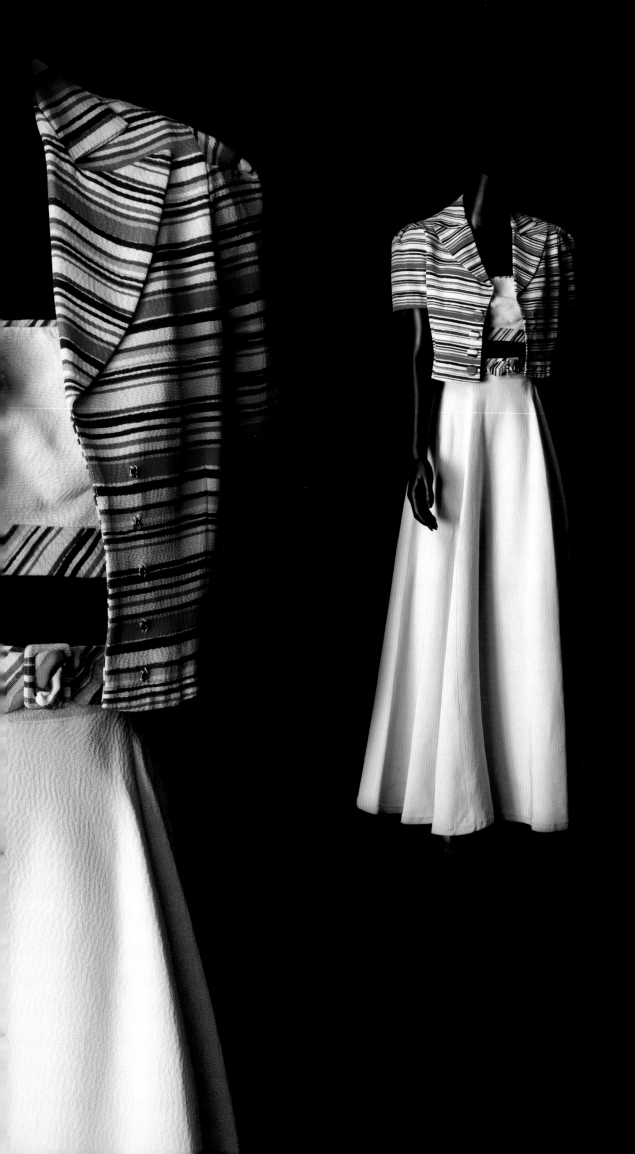

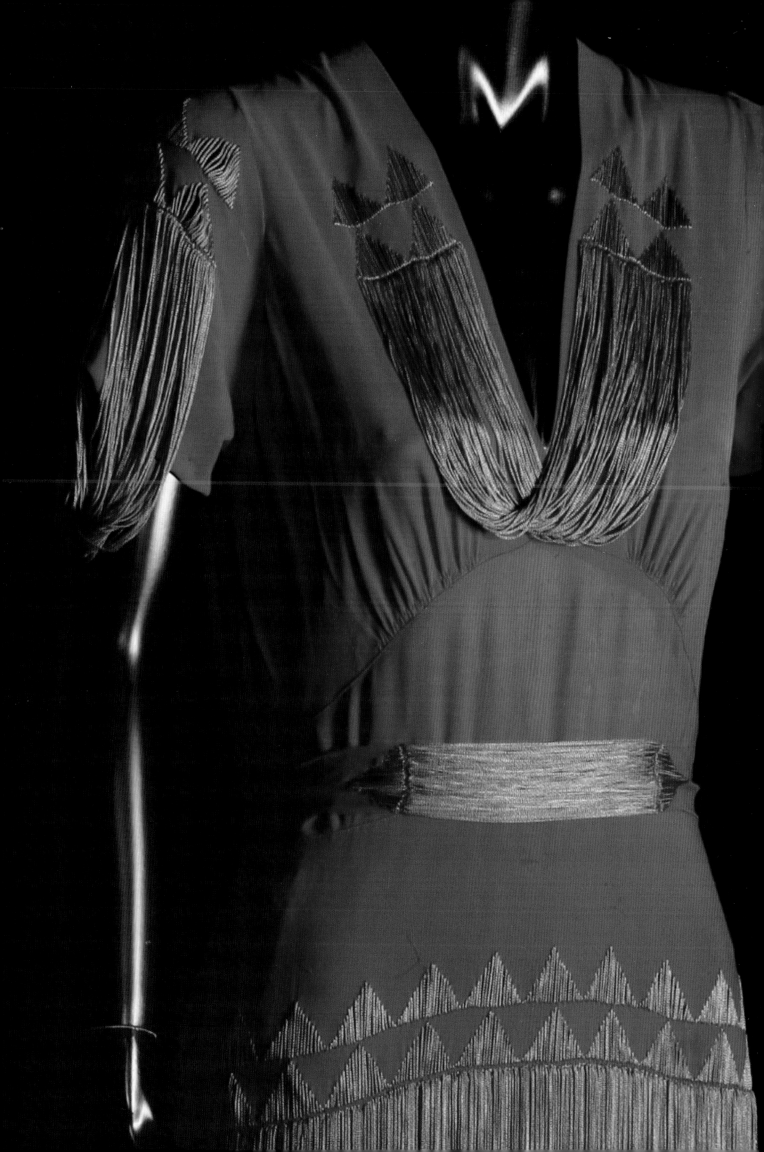

OPPOSITE
Unauthorized copy of a
Norman Norell–designed
cape, spangled velvet,
c. 1944

RIGHT
Evening dress designed by
Sophie Gimbel and sold at
Saks Fifth Avenue's Salon
Moderne, bias–silk satin,
mid–1930s

Dress designed by
Mainbocher, made in
Paris, and sold at Saks
Fifth Avenue's Salon
Moderne, silk satin and
silver lamé, 1935

LEFT
Jewelry designed by
Nina Wolf, gold-plated
metal, 1945

BELOW
Vogue Americana issue,
February 1, 1941

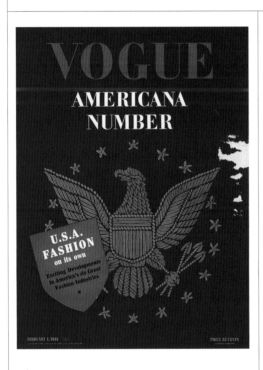

parameters of necessity. As it faced intensifying war constraints, the public's confidence in America's fashion self-sufficiency was boosted in 1943 by the inauguration of the American Fashion Critics' Award. Sponsored by Coty, and conceived and coordinated by fashion publicist Eleanor Lambert, awards and citations were presented by a panel of jurors to recognize outstanding "interpretations of fashion trends under the restrictive influences of 1942."[30] "Coty" awards became a highly anticipated annual showcase for America's burgeoning roster of designers. The first Coty was awarded to former Hattie Carnegie designer Norman Norell, who had presented his first wholesale collection in 1941 and continued in business until retiring in 1970. Other recipients included Claire McCardell (1944) and Pauline Trigère (1949); industry veterans Adrian (1945), Nettie Rosenstein and Nina Wolf (1946), and Adele Simpson (1947); also, innovators Clare Potter (1946), Charles James (1950), and Jane Derby (1951).

while guaranteeing him star stature on his native soil. "This is a collection," *Harper's Bazaar* noted in 1941, "that makes fashion history in America."[29]

February 1941 marked the publication of *Vogue*'s fourth "Americana Number" issue, subtitled "U.S.A. Fashion on its own." A galvanizing political appeal to American women, as well as men, to unify in response to war and threats to freedom, it served equally as a declaration of need to the fashion community for its solidarity. The following year, in compliance with government-imposed L-85 war restrictions delineating manufacturing guidelines, American ingenuity was put to the test and triumphed at what it had always done best—innovating within the

With the Coty Awards as an industry seal of approval that was reinforced by a sympathetic fashion press, American fashion held its own despite Paris's postwar return to full productivity. The 1950s and '60s witnessed a mature and sophisticated American look masterminded by such distinctive personalities as James Galanos, Bonnie Cashin, Oscar de la Renta, Donald Brooks, and Adolfo. Yet, despite enthusiastic support for this formidable creative roster, Paris did not acknowledge America's fashion equivalency easily. It took the American fashion presentation at Versailles in 1973 to finally bring the French to their feet, cheering on those they had so long disdained without surrendering their own honor.

Phyllis Magidson is the Curator of Costumes and Textiles at the Museum of the City of New York, which houses one of the world's premier collections of New York–related fashions. She has organized such exhibitions as *Glamour: New York Style*, *Roaring into the Twenties*, and *Uncommon Threads: Three Hundred Years of New York Style*.

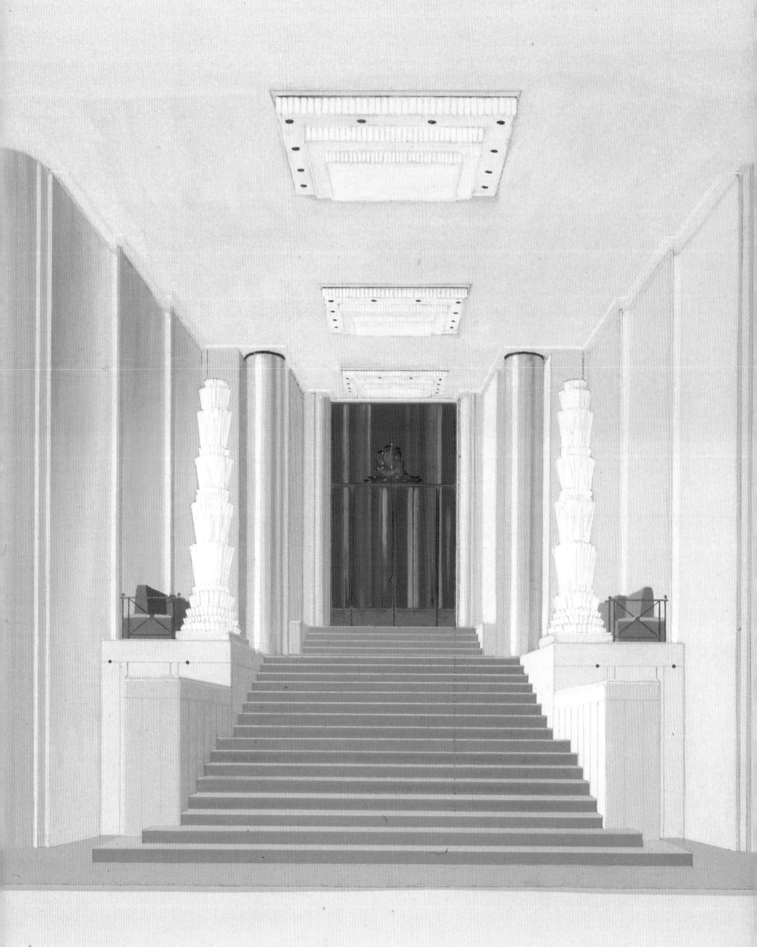

PAQUEBOT T·6
PROJET DE
FUMOIR

LIORA J. COBIN

THE LONGEST GANGPLANK

In the period between World War I and World War II, France made efforts to assert itself as the capital of design, culture, and taste against the artistic visions coming out of Northern Europe, particularly Germany, and the ambitions of the United States. Although France could not ultimately sustain its artistic supremacy through World War II, the energy France put into design in the 1920s and 1930s produced irrefutable proof of its exquisite taste and sophistication. France's design efforts culminated in the Normandie, the lavish, record-setting ocean liner that for half a decade brought the glamour of Paris to the shores of New York.[1]

Commemorative
bronze medallion for
the Normandie, designed
by Jean Vernon
and manufactured by
Paris Mint, 1935

Transatlantic travel gained momentum with the influx of European immigration to the United States in the nineteenth century. The millions of immigrants from Europe who flooded the United States filled the cheapest quarters in steamships, known as steerage. Although they paid the lowest ticket prices and traveled in the worst conditions, by their sheer numbers they generated large profits for ship companies.

The first major ship line was the Cunard Line, a British company founded by Canadian Samuel Cunard in response to a British government request for a plan for mail service between Britain and Canada. Its first voyage was undertaken in 1840. Although conditions on board lacked frills, the Cunard Line's emphasis on safety won it many customers. Ocean liner companies popped up throughout Europe in the 1850s. As immigration increased in the late 1800s, the competition between steamship lines to create the largest, fastest, and most beautiful vessels also increased. National authorities took pride in their countries' ships and subsidized the creation of these increasingly grand liners.

In 1909 the Compagnie Générale Transatlantique, or French Line, began building a new series of flagships. The most famous of these early ships, the France, showcased for the first time the French Line's trademark opulent dining room, a lavishly decorated, three-story room with a grand staircase at one end. These dining rooms and their staircases represented in three elegant dimensions the emphasis the French placed on fine dining and its rituals.

World War I and its aftermath brought great change to the industry. The war decimated Germany's highly regarded fleet, and the economies of the countries involved in the war needed time to recover. In addition, the United States's increasing isolationism, culminating in its immigration restrictions of 1924, took away the major source of income for the passenger lines—the immigrants who filled the low-cost steerage cabins. Soon, however, the United States began providing a new source of income to the ocean liners—the tourist. The booming American economy and curiosity generated by returning soldiers created a new market of middle-class Americans interested in touring Europe. In order to capitalize on this new trend, many ocean liners converted their abandoned steerage quarters to tourist class.

Commissioned in 1927, the French Line's Ile de France was the first of the new liners to be decorated not in traditional period styles but in the pioneering French style that came to be known as Art Deco. German and British companies produced their own new ships of modern design, but the French Line countered with the Normandie, an attempt to establish unequivocally France's supremacy in taste.

As France geared up to build the largest, fastest, and most beautiful ship ever to cross the Atlantic, the project caught the eye of Vladimir Yourkevich, a worker at the Renault automobile factory in Paris. Before fleeing Russia during the 1917 Revolution, Yourkevich had worked as a naval engineer in St. Petersburg, where he designed a new hull that he believed to be the most efficient ship hull ever used. Although the hull had never been tested because of the outbreak of war in Russia, he used fellow Russian émigré contacts to help convince the French Line to test his design in a model. The exterior design proved remarkably efficient, and its striking shape would contribute to the ship's image as a marvel of modern design.

A 1934 French Line advertisement superimposed an image of the ocean liner onto the streets of New York City, emphasizing the ship's size while showing off its unique design, a design which suited the tall buildings and narrow streets of the modern city. A commemorative medallion for the ship also highlighted its unique hull plowing into the future. Stetson designed a "Normandie hat" in honor of the sleek new ocean liner, its "up-to-the-minute chic" marketing slogan echoing the ship's own up-to-the-minute chic.

The Normandie was not only the first ship longer than 1,000 feet, it was the largest ship ever built. Its speed was extraordinary: it set a record for the fastest Atlantic crossing, traveling from Le Havre to New York in four days, three hours, and two minutes on its first trip, in May 1935. The complex of passenger entertainment facilities on board included a swimming pool, a gym, a library, a shooting gallery, a children's playroom, a nightclub, a chapel, and, inspired by Rockefeller Center, a shopping promenade and the first oceangoing movie theater.

extended the length of the ship, beginning with the grand staircase outside the first-class Dining Room and extending through the Smoking Room, the Grand Salon, the Gallery Salon, the Upper Hall, and the theater.

As had been anticipated by previous French Line ships, the first-class Dining Room was the Normandie's showpiece. While the three-deck-high space had no windows, it was lit with 12 freestanding, Lalique-designed chandeliers, enormous Art Deco columns of light that helped earn the ship the moniker "the ship of light." The room's walls were covered with bas–relief sculptures by Alfred Auguste Janniot of Normandy's landscape with topographical features molded in gold on a red marble background. The dining room's opulence also extended to the diner's experience once seated. Normandie passengers were served the finest of French cuisine on dinnerware designed by Jean Luce, with silver by Christofle.

At the ship's center the Grand Salon featured an Aubusson carpet that remains the world's largest hand-woven rug on record. Lavish panels on the Grand Salon's walls were even more striking. One set of gilded glass panels by muralist Jean Dupas illustrated classical mythology: *The Rape of Europa*, *Chariot of Thetis*, and *Chariot of Poseidon*. Dupas also designed the gilded lacquer panels on the sliding walls that led to the Smoking Room. Created by Jean Dunand, the panels were formed out of Dunand's signature one hundred coats of gilded eggshell lacquer and depicted an allegorical history of navigation. Dunand also created the wall decorations — lacquered plaster reliefs of sporting themes — in the adjoining Smoking Room.

dent's wife, Madame Albert LeBrun, Fred Astaire, Marlene Dietrich, the Duke of Windsor, Josephine Baker, Salvador Dalí, Gloria Swanson, Sophie Tucker, and Joseph Kennedy. Many others, however, were intimidated by the ship's lavish decoration and deterred by its high ticket price, and the magnificent ship generally traveled half-empty. Never profitable, the ship continued to operate until World War II only with the support of the French government.

While most New Yorkers never traveled on the Normandie, the ship's glamour captured the city's attention. The success of the French Line's efforts to promote the ship as "Paris afloat" was acknowledged by *Vogue* magazine's special section dedicated to fashions to wear on the Normandie and the lavish merchandising that accompanied the ship's voyages. Commemorative books bound in leather or silver foil showed off the ship's stylish design, and special customers of Jean Dunand received miniature replicas of his lacquer panels for the Smoking Room.

The Normandie was born in the middle of the Great Depression during Hitler's rise in Europe. Although the ship succeeded in distracting both Parisians and New Yorkers from the tumultuous times, it could not escape its circumstances. After Pearl Harbor, the United States seized the ship, which had been resting in the New York harbor since the start of the war, to outfit it for the Navy as the U.S.S. Lafayette. Fortunately for art lovers, the Normandie's lavish interiors had largely been removed from the ship before work began on its conversion. (The art was sent back to France after World War II, used briefly on the Ile de France, and then auctioned off in the 1960s.) The Normandie/Lafayette caught fire in 1942 while a welder was working on refitting it for war use. It burned for four hours until it sank—an ignominious end for a magnificent ambassador of French design.

NORMANDIE

Because of its up-to-the-minute chic . . .
its luxurious felt . . . its trim details, we've
named this hat "Normandie." Like its
namesake, we predict for it an apprecia-
tive following. John B. Stetson Company,
358 Fifth Avenue.

Stetson Hats

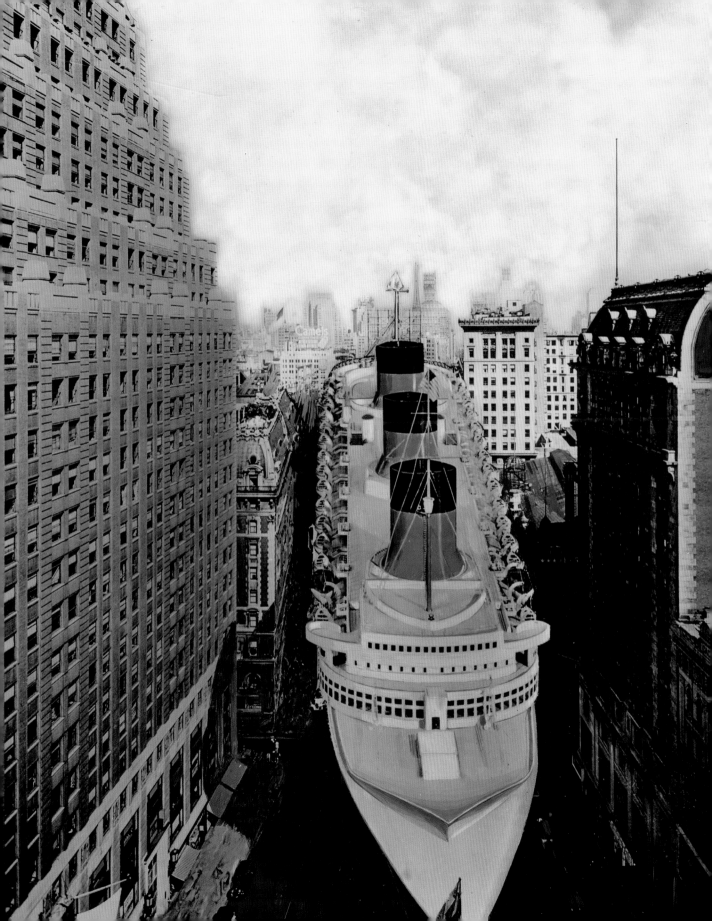

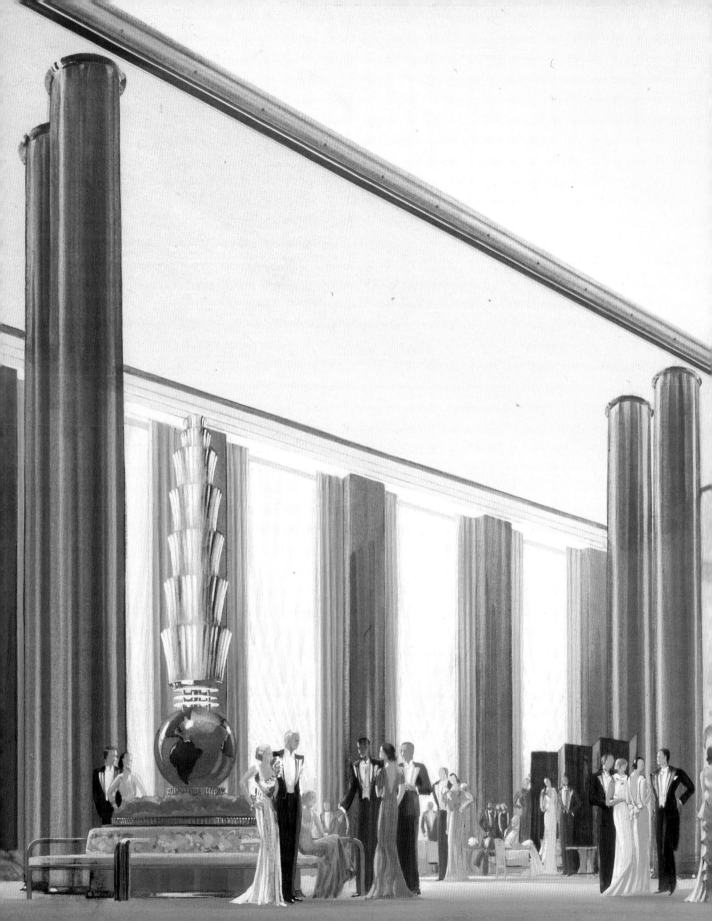

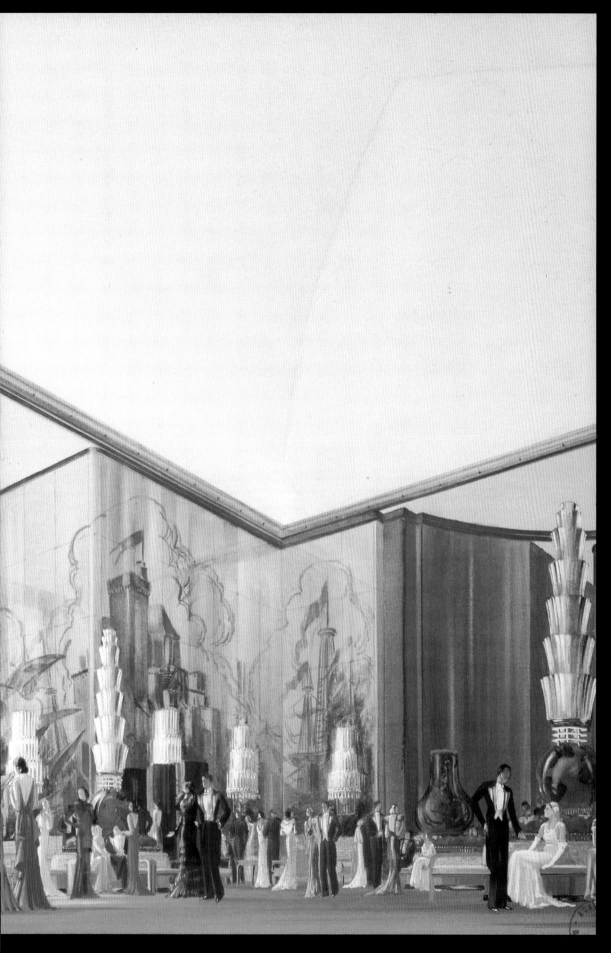

Drawing of the
Grand Salon on the
Normandie, designed
by Richard Bouwens
van der Boijen
and Roger Expert;
ink, watercolor, and
gouache on paper;
c. 1935

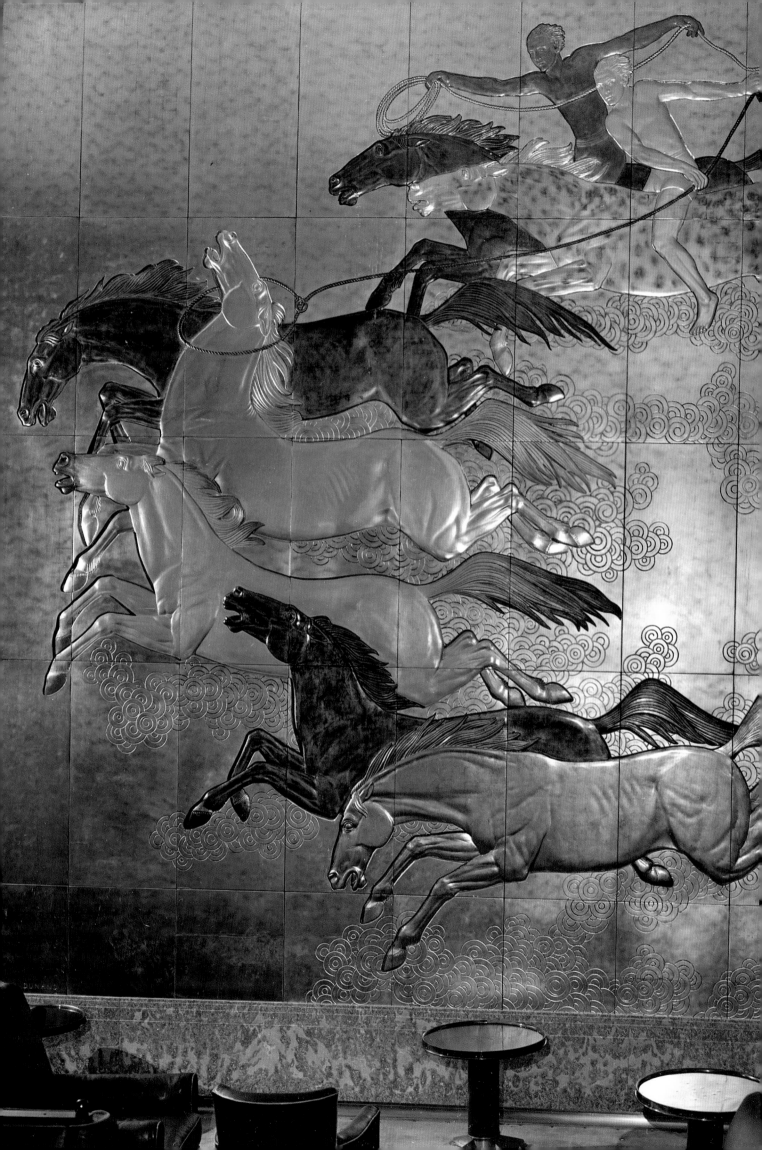

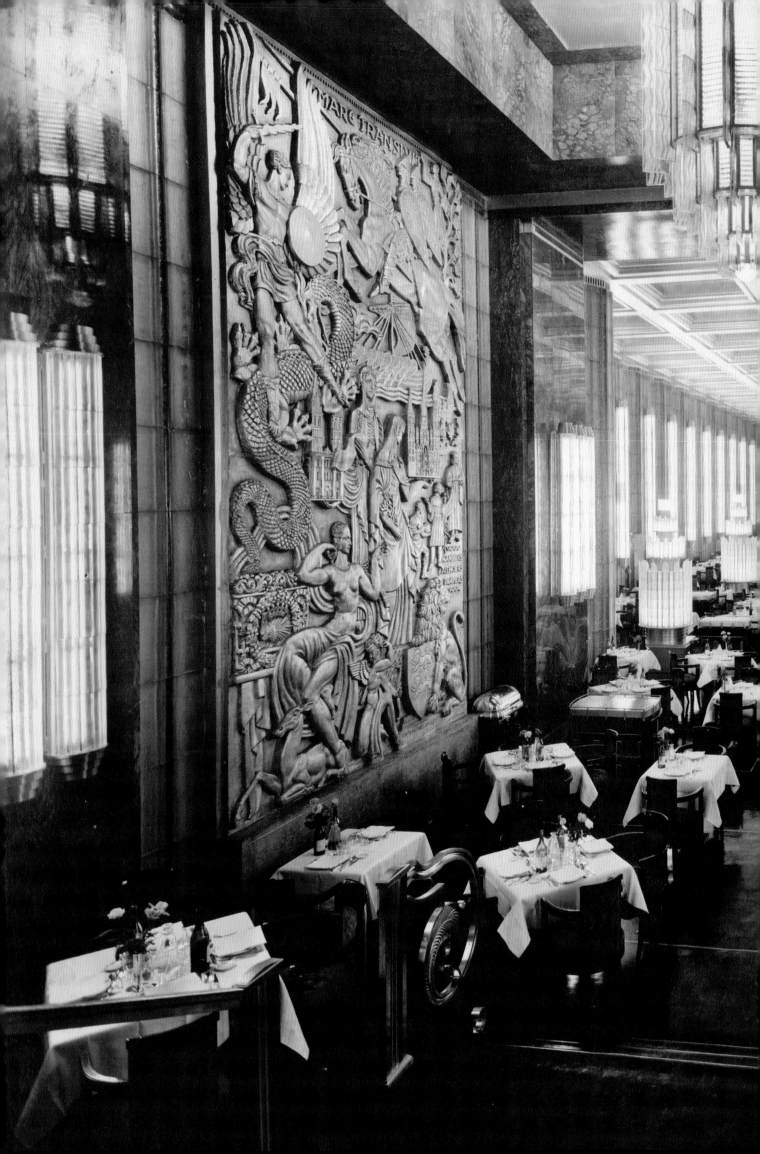

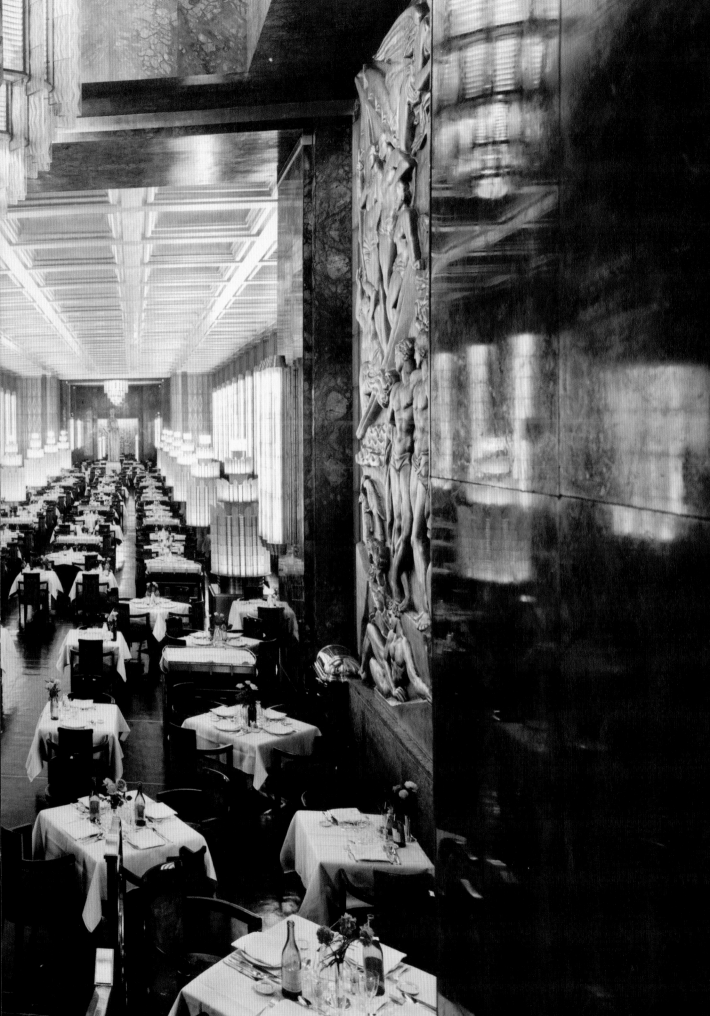

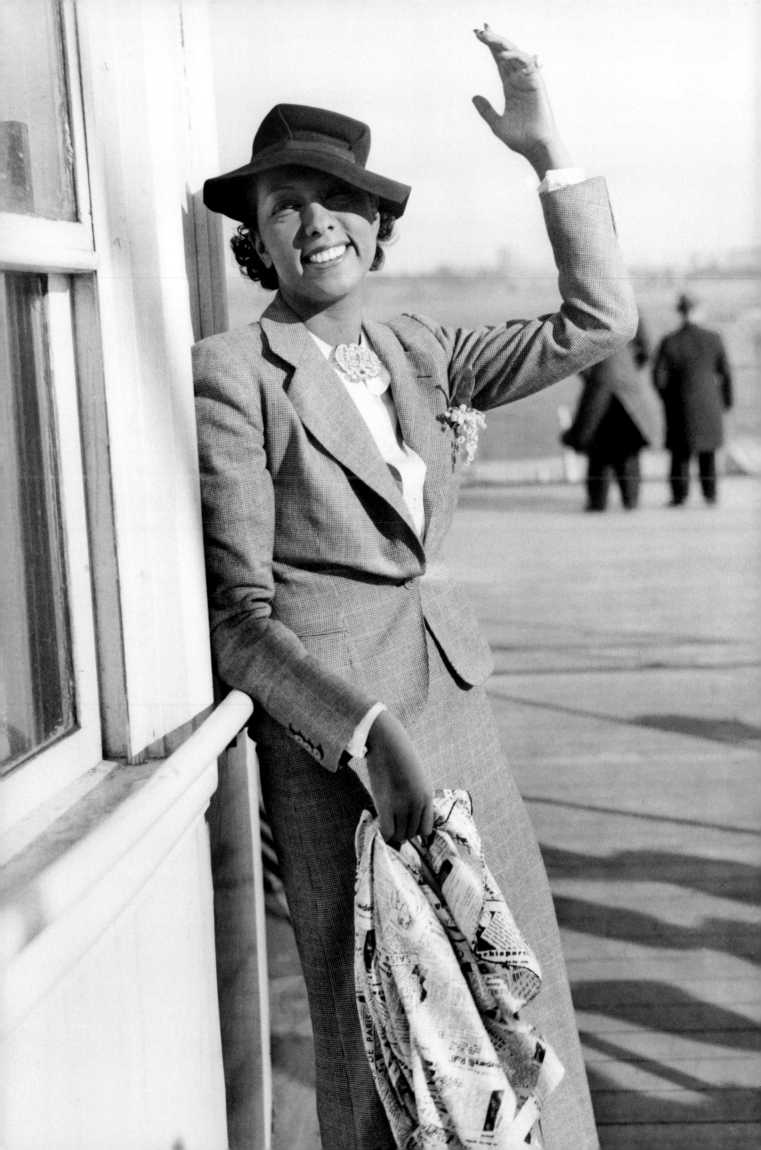

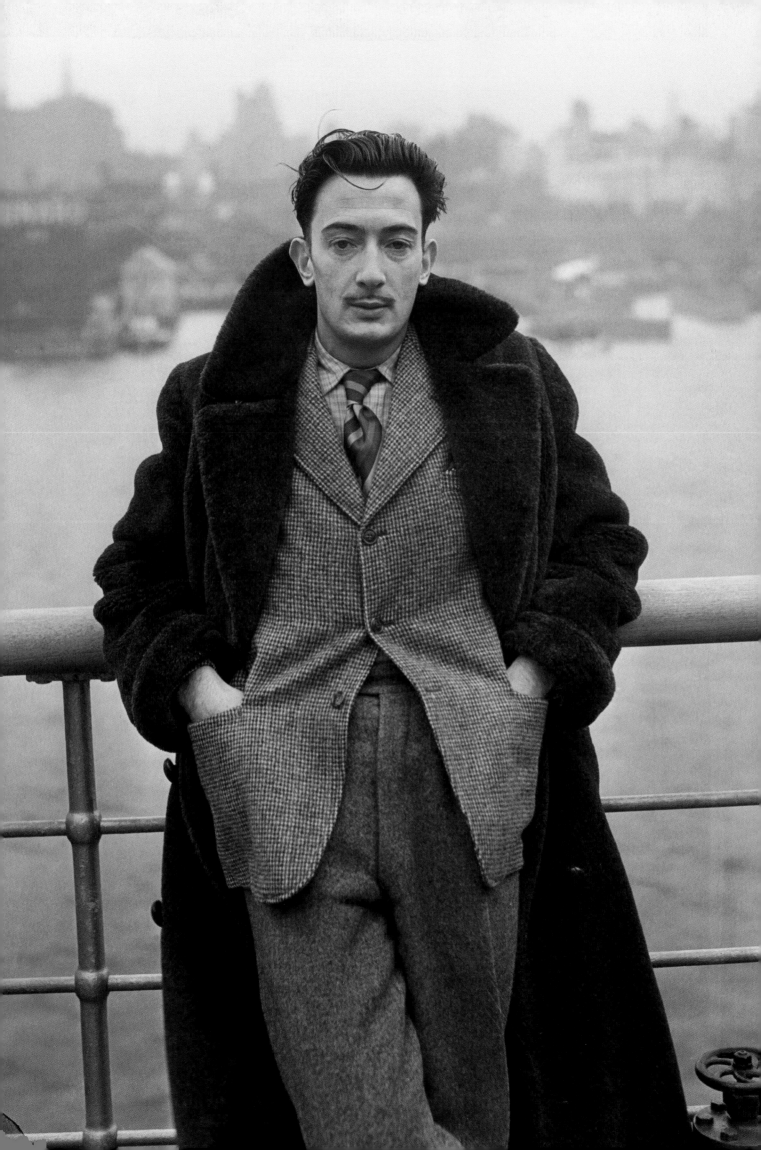

OPPOSITE
Salvador Dalí
arriving in
New York on the
Normandie, 1936

LEFT AND BELOW
Commemorative
Normandie booklet,
published by
Compagnie Générale
Transatlantique,
c. 1937

NORMANDIE

COMPAGNIE GÉNÉRALE TRANSATLANTIQUE

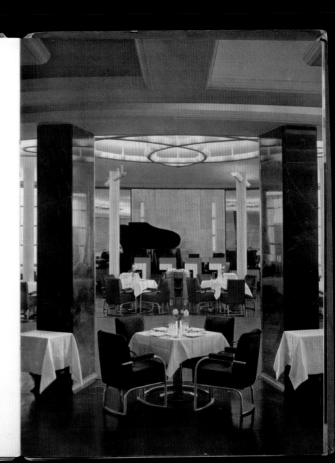

LE GRILL

Le gai rendez-vous des passagers, le « night Club » est ce grill dont les baies immenses s'ouvrent sur la mer. Sa décoration est en peau de porc vernie. Une vaste arabesque et des bandes radiales fixées au plafond diffusent la lumière. Au centre une piste de danse ovale de 50 m2 en marqueterie de chêne aux motifs de palissandre, d'acajou et de noyer.

Un Grill tout noir fait pendant à un Bar tout blanc. L'un est décoré d'une énorme plaque de fonte entourant le four, et que M. Hairon illustra de gravures d'animaux. Pour l'autre, une plaque en verre gravé décorée par M. Max Ingrand, prend pour sujet des bouteilles et des ceps.

Les annexes du grill — bar privé et salle à manger particulière — ont été ornées par M. Gernez.

Cie Gle TRANSATLANTIQUE

French Line

NORMANDIE

LONGITUDINAL SECTION
S/S NORMANDIE

82,799 TONS GROSS REGISTERED

Foldout souvenir booklet
with longitudinal section
of the Normandie,
published by J. Barreau &
Co., no date

ALE TRANSATLANTIQUE

ench Line

MANDIE

OVERALL LENGTH	1.029	Feet
BEAM	119	—
DEPTH from promenade deck	92	—
GROSS TONNAGE	79.280	Tons
HORSE POWER	160.000	H. P.

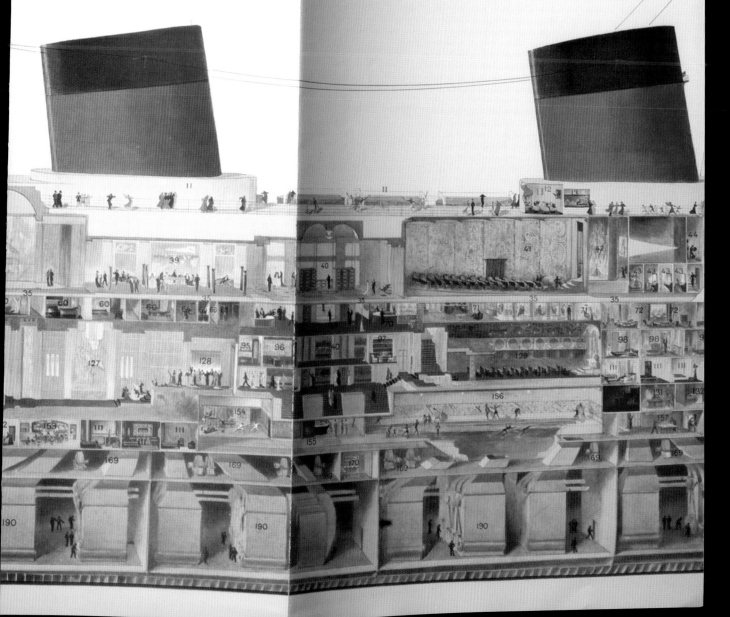

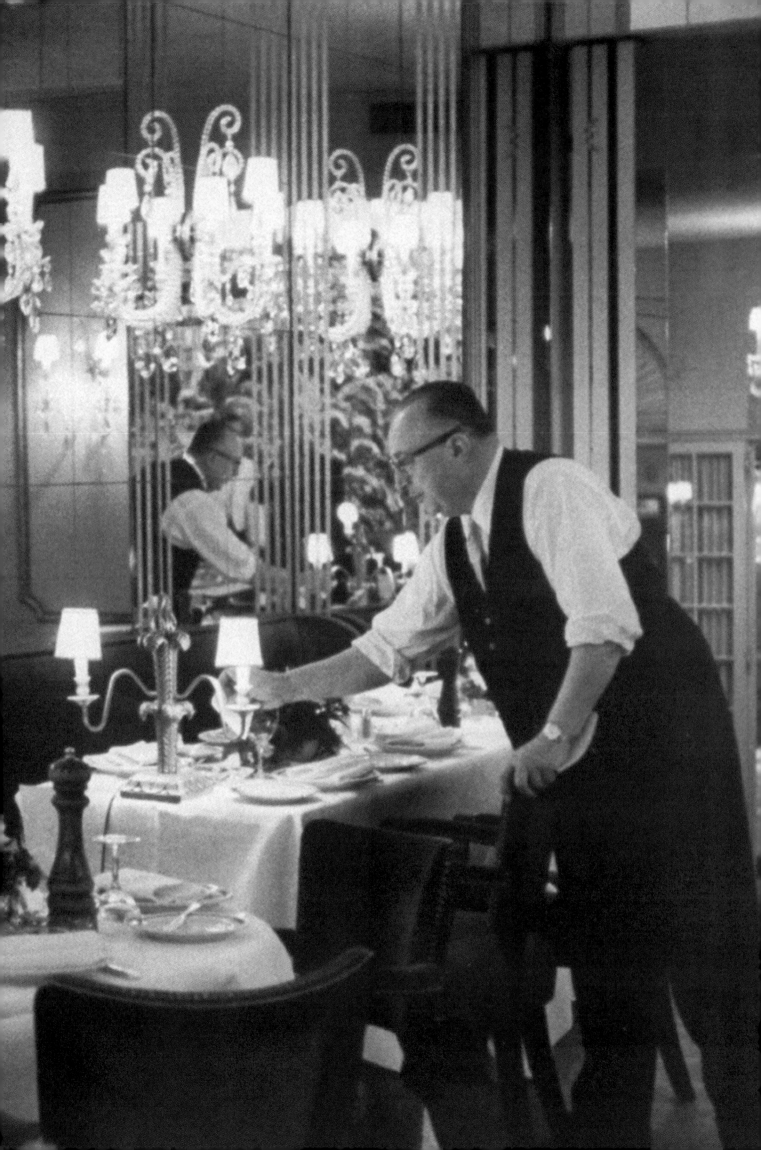

AMY AZZARITO

NEW YORK HAUTE CUISINE

You have traveled the length and breadth of the French Empire within the walls

of two pavilions. You have reviewed the sum and substance of a great civilization in the

space of a few hours. You have seen France today . . . a great democratic culture . . .

recreated on American soil.[1]

On April 26, 1939, ninety-eight Frenchmen sailed from Le Havre, France, on the Normandie. They included chefs, maîtres d'hôtel, waiters, carvers, and wine stewards from the best restaurants in Paris. Their destination was the restaurant at the 1939/40 New York World's Fair French Pavilion in Flushing Meadows, Queens, where they intended

to serve authentic Parisian food to fairgoers. Although restaurants had been serving French food in New York before the World's Fair, this would be the city's first Parisian restaurant on such a large scale. These men would go on to define a new wave of *haute cuisine* in New York and, ultimately, America.

Located in the Government Zone among the pavilions of the fifty-nine other participating nations,[2] the French Pavilion was designed by the architectural firms of Roger Expert and Pierre Patout and built at a cost of nearly four million dollars.[3] The building's curves and huge windows emphasized its vantage point overlooking the Lagoon of Nations. The first two stories of the Pavilion showcased the treasures of France: Gobelins tapestries, Sèvres porcelain, laces, silks, perfumes. A second exhibit, the France-Overseas Pavilion located in the Hall of Nations, displayed goods from French colonies: an incense burner from French Indo-China, Morrocan leather, and bronzes.[4] Since the aim of the Pavilion was to represent French culture and French culture could not be represented without a French dining establishment, a restaurant was built on the top floor.

Refined restaurant cooking was always considered one of France's highest arts. But to establish a great French restaurant on American soil, a great French restaurateur was needed. The man selected for the job, Jean Drouant, owned three renowned Parisian restaurants: Pavillon Royal, Bois de Boulogne, and Drouant Place Gaillon, which was established by his father in 1880 and frequented by Pierre Auguste Renoir, Auguste Rodin, and Camille Pissarro.[5] Specializing in seafood, its menu included dishes like lobster *américaine,* bouillabaisse, *coquilles St-Jacques*, poached turbot, and fluke *au gratin*.[6] Chosen at the height of his influence to organize the restaurant at the World's Fair, Drouant recruited his brother-in-law,

Louis Barraya, who ran the Café de Paris and managed three other restaurants—the Pavillon d'Armenonville, Le Pré Catelan and Fouquet's—to assist. Together, the two men financed the operation and recruited staff from their own establishments as well as from restaurants around the country.

The excitement must have been palpable as the staff, including Drouant; Henri Soulé, former captain of Café de Paris who would become the *maître d'*; and Marius Isnard, the future *chef de cuisine,* set sail on the French Line's Normandie. This ship, the pride of the entire French nation, was capable of making the transatlantic voyage in about four days, compared with the usual seven. The French Line Company was an investor in the World's Fair restaurant operation and, in fact, supplied all of its silverware. Soulé, Isnard, and Drouant traveled in first class, while the rest of the staff bunked in third class. Throughout the five-day voyage, the World's Fair team met in the tourist dining room for briefings. The men were shown a movie on New York City and listened to talks by Soulé and Isnard about how the restaurant would operate.

The Normandie was an ideal choice for transporting the Fair's restaurant staff, since the ship itself was, in many ways, a moving restaurant. The Normandie often served as many as 1,500 people a day—with the utmost elegance. Dinner began with an appetizer, followed by a fish course, a meat course, salad and cheese, and, finally, dessert. In addition to three large meals a day, consommé and fruit were served at 10:00 A.M., tea at 4:00 P.M., and a large buffet at midnight. The Normandie was so dependent on French foods that it carried enough French staples of wine, cheese, fish, frog legs, and even flour for a round-trip journey. This floating restaurant was a precursor to the World's Fair pavilion: proof that the French could deliver great food anywhere.

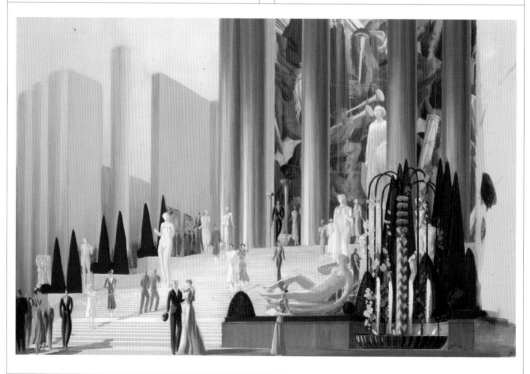

Upon arriving in New York harbor, the entire contingent set off for the Vatel Club in midtown Manhattan. Named for the famous chef of Louis XIV who one day was so distraught at the lateness of the fish delivery that he committed suicide, the Vatel Club was a social club for chefs and also something of an employment agency. Although the World's Fair staff had jobs, they used the Vatel Club as a means of locating housing around the city. (One of the staff members who wandered into the club that day, 18-year-old Pierre Franey, would later become president of the organization.)[7]

Food was such an important aspect of the 1939/40 World's Fair that a separate guide was published, "Food at the Fair: A Gastronomic Tour of the World," that described each national pavilion's restaurant and provided representative recipes. Every foreign pavilion offered its native

dishes. In the Japanese pavilion guests might be served sukiyaki in a typical Japanese garden or in a Shinto shrine by kimono-clad waitresses. Spaghetti was available in the Italian pavilion, or fairgoers could try a traditional Swedish smorgasbord.[8] Food was available for every palate and to suit every budget.

It had been determined that the French Pavilion's restaurant should be as French as possible without catering to American tastes, and "Food at the Fair" made much of this fact. In the pamphlet Governor General Marcel Olivier, Commissioner General of France for the World's Fair and the chairman of the board of the French Line company, described the intention of the restaurant: "The restaurant should be an exact copy of a typical Parisian restaurant of the finest class. That plan has been carried out and the result constitutes a great attraction, for the

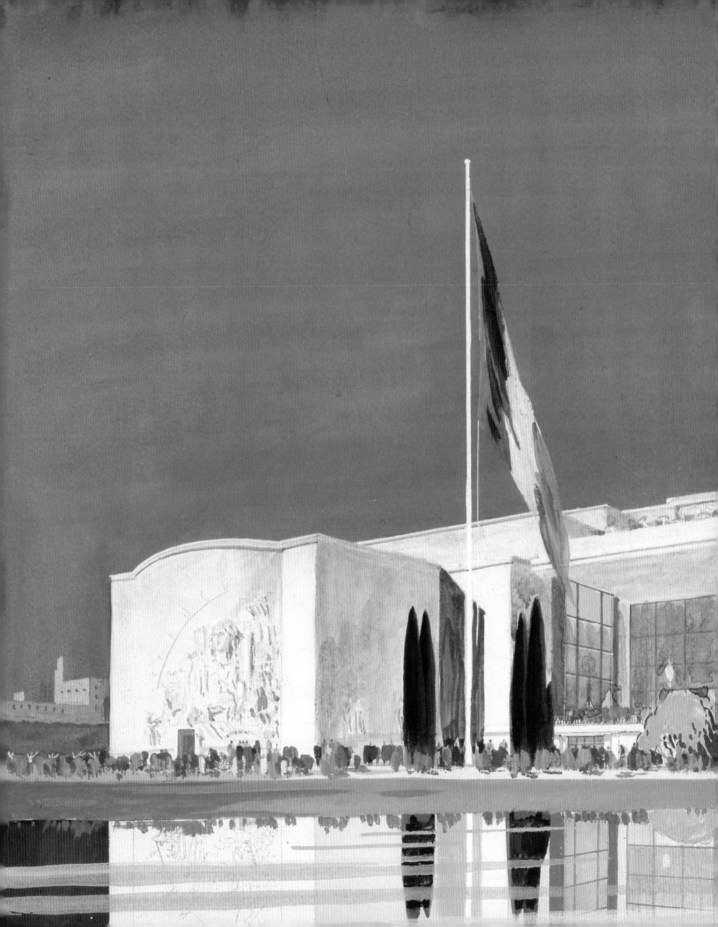

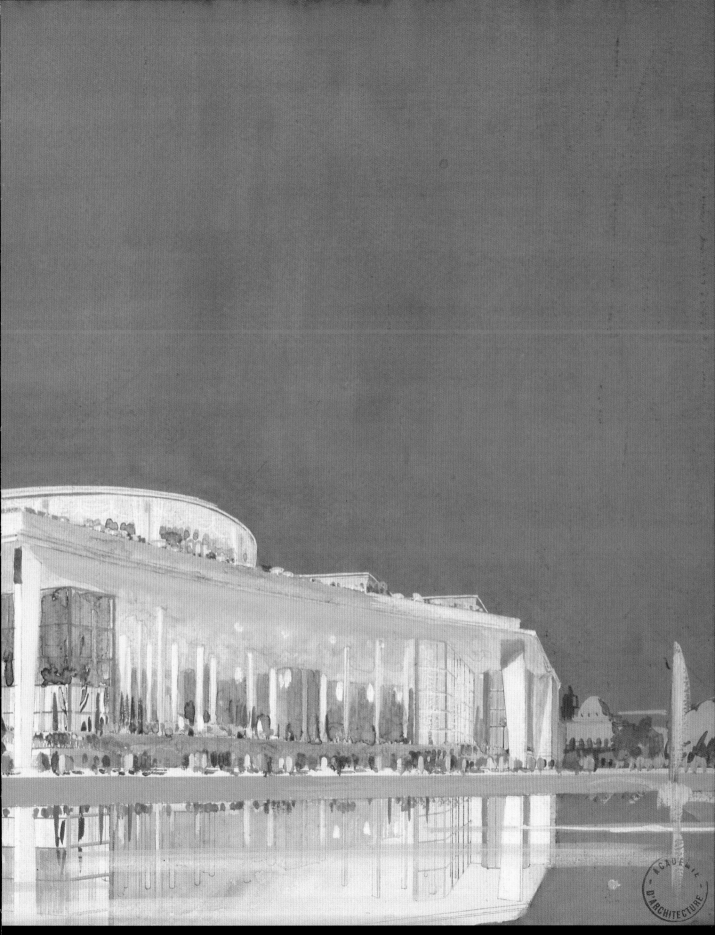

American visitors are able to dine in New York in an atmosphere identical to that found in the restaurants of the Rue Royale or the Avenue de l'Opéra: same cuisine, same wine, same personnel, same charm."[9]

When Le Restaurant du Pavillon de France opened to the public on May 9, 1939, the *New York Times* reported: "375 guests occupied every chair in the five semi-circular tiers of the handsome glass-walled retreat that overlooks the Lagoon of Nations . . . Every gesture of the staff, from the august Jean Drouant, director of the establishment, down to the most unobtrusive waiter signaled the pride of the employees in what was instantly signed, sealed and delivered to the Fairgoing public as a retreat for epicures."[10]

According to Pierre Franey, then an assistant seafood chef at the restaurant, diners on its opening night enjoyed chicken consommé with cheese sticks, lobster *Pavillon* (a version of Drouant's lobster *américaine* with added cream), lamb with potato balls and stuffed artichokes, cold capon in a tarragon aspic, and lettuce with asparagus vinaigrette. The meal was rounded off with strawberries, ice cream, and petits fours.[11]

The restaurant at the French pavilion was by no means the largest at the fair; the British pavilion restaurant sat four hundred people, and the Belgian and Swiss restaurants could seat six hundred. It was, however, one of the fair's more expensive restaurants, with entertainment value that was difficult to replicate. People flocked there in order to experience the exquisite service of a restaurant where whole fish or roasts were brought to the table on silver platters and expertly carved and crêpes Suzettes were flambéed. Also, its view of the Lagoon of Nations was a main attraction, as there was a nightly fireworks display choreographed to live music and an elaborate light show. When the fireworks began, the lights in the restaurant would dim, service would stop, and even kitchen workers would sometimes go onto the roof to watch the display.

The restaurant was a consummate success its first year; when the fair closed for the winter, it had served 136,261 customers. By the time the restaurant staff returned home, however, the climate in France had changed completely. The country was at war, and there was some uncertainty about whether the fair would reopen in 1940, though ultimately it did. The French government issued draft deferments for the World's Fair staff, who returned to New York.

But the fair's second season was not a success. The mood of the country had changed, and fewer fairgoers came to New York. The weather was rainy that summer, which also hurt attendance. Between May 11, when the restaurant opened, and October 31, when it closed, the restaurant served only 85,365 meals—50,000 fewer than it had served in the previous season.

With the fair closed and France at war, some of the staff were at loose ends. France's regions were either occupied outright or under the rule of the Vichy government. In September 1941 President Roosevelt signed into law an immigration bill that allowed the displaced Frenchmen a permanent visa, requiring only that they leave and reenter the country. Together a group of the staff, including Drouant and Soulé, took the train to Buffalo, New York, crossed into Canada, and then walked back across the border into the United States.

The idea of a permanent French restaurant in New York was Drouant's, and he arranged for French businessmen (and, it was rumored, Joseph Kennedy) to finance the enterprise. Together, he and Soulé chose the location—a spot formerly occupied by the defunct Palmer's 711 restaurant at 5 East Fifty-fifth Street, across the street from the St. Regis Hotel. It was the perfect location to attract some of the city's wealthiest visitors. At the last minute, though, Drouant, a homesick, decided to return to France, leaving Soulé to proceed on his own.

Soulé was thirty-eight. He had been working in the hospitality industry since age fourteen, when he left his small village in Saubrigues, France, to become a busboy at the Continental Hotel in Biarritz. By the age of twenty-three he had moved on to Paris to become one of the youngest captains of waiters in the city.[12] He was only thirty-six when he took charge of the restaurant at the World's Fair, but a restaurant of his own in New York City would be an entirely different challenge.

Soulé astutely designed the restaurant to be an extension of the fair. He intended to use virtually the same menu and named the restaurant "Le Pavillon" to evoke the French Pavilion. Of the forty men Soulé employed when the restaurant first opened, twenty of them had been part of the World's Fair team.[13] While there was nowhere in Manhattan where Soulé could reproduce the French Pavilion's architecture or view of the Lagoon of Nations, Soulé did use the Café de Paris, where he had worked in Paris, as a model for his new restaurant. He hired French artist Maurice Chalom, who had designed the Café de Paris, to replicate the classic

French restaurant look with red banquettes, mirrors, and elaborate flower arrangements. There were no round tables, as Soulé believed that round tables belonged in a bistro: "A Frenchman is not really comfortable at a round table. When he goes to a great restaurant, he wants to dine elegantly and peacefully. He wants to sit next to Madam on a banquette. The great classic restaurant always had square tables." Diners sat side by side on red banquettes that ran along the walls. The crystal glasses were manufactured by Baccarat; in his memoirs, Franey describes them as so thin that the glass would actually bend when pressure was put on it.[14] Soulé ordered custom carving carts with built-in chafing dishes and burners from Christofle in Paris for $2,000 each.[15]

The opening of the new restaurant was well timed to make a splash. New York dining had not yet recovered from the devastation of Prohibition and the Depression. As reported by Michael and Ariane Batterberry in *On the Town in New York,* "National events were fatal to the digestion: over a decade of wood alcohol was followed by another decade of soup kitchens."[16] The combination of Prohibition and the Depression ensured that the 1920s and 1930s were two difficult decades for New York's fine restaurants. Sherry's, Martin's, Shanlet's, Bustanoby's, Churchill's, and, most lamented, Delmonico's were forced out of business by the new alcohol restrictions. Established by two Swiss brothers in 1897, Delmonico's had been the premier fine-dining establishment in New York. Once Prohibition was enacted, not only was the restaurant not allowed to serve wine or alcoholic drinks with meals, it also could not cook with alcohol. This rendered most of their menu illegal.[17] Restaurants like Delmonico's sold off their wine cellars to wealthy private citizens, who began to have parties catered in the privacy of their own homes, where they could drink. Speakeasies took over as centers of public entertainment, but they were not known for their

food. By the time Prohibition was repealed in 1933, the Depression was in full swing and few could afford fine restaurants.

The difficult climate for fine dining during the 1920s and 1930s meant that New Yorkers became willing to try anything, and a variety of ethnic restaurants opened throughout the city, including many popular small French restaurants. These, however, were not the high-end establishments of Delmonico's caliber. These were neighborhood places where new food was available inexpensively.

As the economy began to improve in the late 1930s, French restaurants began to emerge as New York's smartest dining establishments. These tended to cluster around Park Avenue and its side streets in the Fifties and included Le Merliton, La Rue, Louis and Armand's, Marguery, L'Aiglon, the Passy, Café Chambord, and Le Voisin (a rare restaurant that managed to survive both Prohibition and the Depression).[18] But none of these restaurants had the star quality of Le Pavillon or were able to bring together Parisian *haute cuisine* with that French *je ne sais quoi* in the way Soulé was somehow able to do. Le Pavillon became the Delmonico's of the twentieth century, at the same time signalling a new wave of *haute cuisine* in New York.

Besides capitalizing on New York's pent-up appetite for good restaurants, especially those that served French cuisine, Soulé also benefited from America's Francophilia. Educated Americans revered French culture and French cuisine. Among the upper classes, Francophilia had been in vogue for some time, and wealthy mothers frequently hired French nannies for their children. "I spoke French before I spoke English," said Dinah Lord, the little sister of Katharine Hepburn's heiress character in the 1940 film *The Philadelphia Story.* The war unleashed a pro-French sentiment that reached all classes of Americans.[19]

French Pavilion terrace and restaurant at the 1939/40 New York World's Fair, reproduced from "Guide to the French Pavilion and to the France–Overseas Pavilion," c. 1940

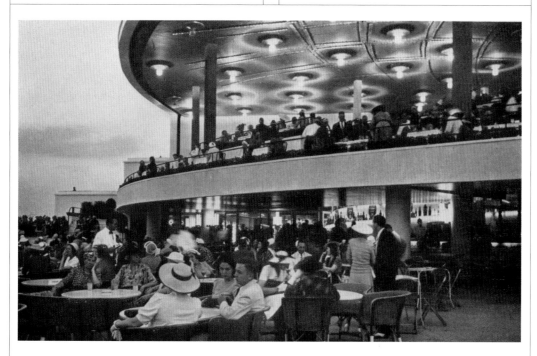

Le Pavillon
MENU — Diner

Caviar Malossol 7.50 Saumon Fumé 2.25 Anguille Fumé 2.00
Jambon de Bayonne 1.75 Foie Gras Truffé 5.00 Grapefruit .80
Little Necks 1.00 Cherrystones 1.00 Melon 1.25
Cocktails: Lobster 2.50 Shrimps 1.75 Crab Meat 2.25

Potages

Petite Marmite Pavillon 1.75 Consommé Double Julienne 1.25 Saint Germain Longchamp 1.00
Bisque de Homard 2.00 Soupe à l'Oignon Gratinée 1.50 Tortue Verte au Madère 1.75
Ox=Tail Clair 1.75 Billi=Bi 2.00 Madrilène en Gelée 1.00 Germiny aux Paillettes 1.50

Poissons

Délices de Sole Polignac 3.50 Timbale de Crab Meat Newburg 3.75 Homard Xavier 5.00
Moules au Chablis 2.75 Suprême de Striped Bass Dugléré 3.50 Grenouilles Provençale 3.75
Goujonnette de Sole, Sauce Moutarde 3.00 Truite de Rivière, Beurre Noisette 3.25

Spécialités: Homard 5.00 Sole Anglaise Moules 2.75

Entrées

LE FILET DE BOEUF FINANCIERE 5.00 **POULARDE POELEE BORDELAISE 4.50**

Suprême de Pintadon Carmen 4.00 Coeur de Filet Duroc 7.50 Pigeonneau aux Olives 4.50
Caneton aux Cerises (Pour 2) 12.00 Médaillon de Veau Smitane 3.50 Ris de Veau Meunière 3.50
Côte de Volaille Pojarsky 3.50 Rognon de Veau Ardennaise 4.25 Foie de Veau à l'Anglaise 3.50

Spécialités: Châteaubriand (Pour 2) 15.00 Volaille (selon grosseur) Ris de Veau 4.50

Rotis

Poularde Reine Grain Poussin Canard Pigeon
Selle d'Agneau Carré d'Agneau

Plats Froids

Poularde à la Gelée à l'Estragon (½ for 2) 6.50 Langue Givrée 2.75 Jambon d'York 2.75
Terrine de Canard 3.00 Boeuf Mode à la Gelée 3.75 Terrine de Volaille 3.00

Légumes

Coeur de Céleri à la Moëlle 1.75 Epinards au Velouté 1.40 Petits Pois aux Laitues 1.50
Courgette Fines Herbes 1.60 Haricots Verts au Beurre 1.40 Choux=Fleurs au Gratin 1.75
Laitue Braisée au Jus 1.60 Champignons Grillés sur Toast 1.75 Artichaut à l'Huile 1.50

Entremets

Patisserie Pavillon 1.25 Soufflés Tous Parfums 2.25 Crêpes Pavillon 2.25
Désir de Roi 1.50 Cerises Jubilée 2.75 Poire Hélène 1.75
Pêche Melba 1.70 Macédoine de Fruits aux Liqueurs 1.75 Coupe aux Marrons 1.50

Glaces: Vanille 1.00 Chocolat (Menier) 1.00 Moka 1.00 Fraise 1.00 Citron 1.00 Framboise 1.00
Café .55 Demi Tasse .45 Bread and Butter .75

On October 15, 1941, Le Pavillon opened with a private, invitation-only gala attended by the wealthiest and best-known society in New York, including the Vanderbilts, the Rockefellers, and the Kennedys. The complicated menu made no concessions to the American palate, and was presented entirely in French.[20] The first year of operation was difficult because the city was focused on the war, but Soulé was adamant that once New Yorkers were given a taste of quality French food, they would come back. *New York Times* food critic Craig Claiborne wrote about Soulé's immeasurable influence on the American restaurant world. Soulé's insistence on perfection was evident not only in his well-orchestrated dining room, but also in the food: "the mousse of sole 'toute Paris,' pilaf of mussels, pheasant with truffle sauce, and the dessert that was almost a trademark of Mr. Soulé, the fantasy of caramel, custard, and meringue called *oeufs à la neige*."[21]

Soulé also seemed to instinctively understand that the restaurant experience itself had to lure diners. As the restaurant's success grew, it became a place to see and be seen, and Soulé was quick to capitalize. He sat the best patrons in a section toward the front that became known as "the *royale*."[22] The rest of the dining room was rated in relation to how close it was to the *royale*. It was Soulé alone who made the decision where one could sit. Because of his high-profile clientele, Soulé never had to employ anyone to handle his press relations, yet he managed to remain constantly in the papers.

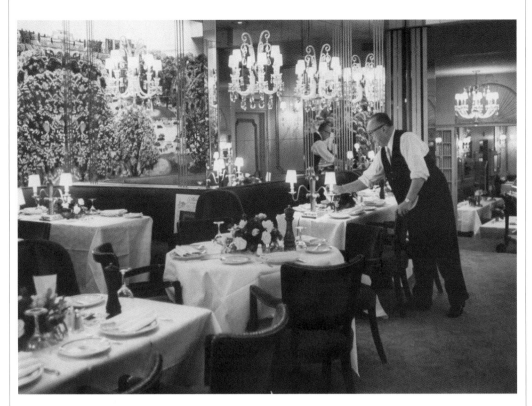

Henri Soulé in
Le Pavillon, New York,
photograph by
Al Fenn, 1962

One privilege of being *royale* and in the know was that one did not have to be constrained by the menu. One could simply order ahead: "A typical special order might begin with beluga caviar, move on to a light consommé with truffles, a lobster soufflé, a roast fillet of beef smothered in truffles with side dishes of pommes Anna and braised lettuce with beets, assorted cheeses and an ice cream bombe with fruit sauce. The meal was often accompanied by champagne to start and then a variety of wines." The special orders were presented to the kitchen on pink slips. This method of dining became so popular that, in a typical evening, nearly one-third of all meals were ordered ahead. For the select few, there was an additional perk. Each day Soulé would choose certain specials, usually simple French dishes, to be prepared by the kitchen. Only Soulé could dispense these specials. He would approach his favored customers and say, "Countess, I have something very special for you." Frequently the customer, flattered to be singled out, would not even ask what the food item was.

While the restaurant at the fair had had the effect of democratizing French *haute cuisine*, the restaurant at Le Pavillon was for the truly elite. Prices at the Pavilion Restaurant, though high for the fair, had been quite moderate for French cuisine, as a means of attracting visitors from many different places and economic backgrounds. In Soulé's quest for perfection, however, he only welcomed visitors he deemed appropriate—the wealthy white Christian elite of the city. This further distinguished Le Pavillon from other French restaurants in New York, primarily little bistros that were exact replicas of places back home, complete with accordion music and dancing on weekends—restaurants that

were part of the ethnic food scene rather than fine dining.

Soulé's frequent displays of favoritism had an ill effect on business when the Cohn brothers, who ran Columbia Pictures, purchased the building that housed the restaurant. The building had changed ownership a few times before, but these new owners would be different. One of the brothers demanded that he be seated in the *royale* and not all the way in the back. Soulé refused. The Cohns warned that if he did not give them a better table, they would raise the rent. When Soulé refused to bend, they raised the rent from $18,000 to $40,000 a year.

There was no way Soulé would relinquish any control in his restaurant. As Franey noted, "He believed in rules. He believed in 'never.' Soulé never went into the kitchen during hours when the service was in progress. His domain was the dining room . . . Soulé also believed in 'always.' He always wore a blue suit with a gray tie at lunch and always wore a tuxedo at dinner." Soulé refused to have his authority questioned. He closed the restaurant and opened a new Pavillon in the Ritz Towers building on Fifty-seventh Street on October 9, 1957. Soulé must have felt some regret at giving up that prime location on Fifty-fifth Street, however, because he opened a new restaurant on the site of the "old" Pavillon just one year later. He named the new restaurant "La Côte Basque," paying the Cohns their $40,000 a year to do so. He had demonstrated his displeasure by removing Le Pavillon, but could not let the old location go to waste.

He hired Bernard Lamotte, the French-American painter, to transform his new restaurant through murals of the Basque coastline. Lamotte painted

Chart from "The Mistral is the Newest Offshoot of Pavillon Tree" by food critic Craig Claiborne, *New York Times*, December 11, 1964

LE PAVILLON
Henri Soulé, proprietor, below
(Former owner, La Côte Basque, The Hedges;
Manager, The French Pavillon Restaurant, World's Fair, 1939)

NEW YORK RESTAURANTS

LA CARAVELLE
Robert Meyzen, proprietor
(Waiter and captain, Le Pavillon; maître d'hôtel, La Côte Basque)
Fred Decré, proprietor
(Waiter, captain and maître d'hôtel, Le Pavillon; maître d'hôtel, The Hedges)
Roger Fessaguet, chef
(Assistant saucier, gardemanger, sous-chef, Le Pavillon; chef, The Hedges)
André Mailhan, maître d'hôtel
(Captain, Le Pavillon)
Yves Legoff, boucher
(Boucher, Le Pavillon; La Côte Basque)
Marc Bonzano, captain
(Entremettier, Le Pavillon)
Claude Uson, waiter
(Waiter, La Côte Basque)
Jacques Nolle, waiter
(Waiter, La Côte Basque)
André Bernard, waiter
(Waiter, La Côte Basque)
Jackie Nolle, waiter
(Waiter, La Côte Basque)
Jean Merlotti, waiter
(Waiter, La Côte Basque)
Max Epper, waiter
(Waiter, La Côte Basque)
Jean Dureuil, waiter
(Waiter, La Côte Basque)

LA POTINIÈRE
LA POTINIÈRE DU SOIR
Pierre Bézin, proprietor
(Waiter, Le Pavillon)

LA TOQUE BLANCHE
François Dantonio, proprietor
(Waiter, Le Pavillon)
Gabriel Jofre, captain
(Captain, Le Pavillon)

EL MOROCCO
François Raynaut, captain, Champagne Room
(Assistant maître d'hôtel, French Pavillon Restaurant, World's Fair, 1939; maître d'hôtel, Le Pavillon)

L'ESCARGOT
Henri Le Troadec, proprietor
(Waiter, Le Pavillon)

CHÂTEAU RICHELIEU
Claude Buvant, saucier
(Entremettier, Le Pavillon)

LE MANOIR
Maurice Bertrand, proprietor
(Waiter, Le Pavillon)
Robert Treboux, proprietor
(Waiter, Le Pavillon)
Guy Cyrona, waiter
(Waiter, Le Pavillon)

ST. REGIS HOTEL
Joseph Castaybert, chef
(Saucier, Le Pavillon)

LUTÈCE
Henri Tisserand, maître d'hôtel
(Waiter, The French Pavillon Restaurant, World's Fair, 1939)

LE VEAU D'OR
George Banatin, co-owner
(Waiter, The French Pavillon Restaurant, World's Fair, 1939)

THE FOUR SEASONS
Roger France, chef
(Saucier, Le Pavillon)

LE MISTRAL
Jean Larriaga, proprietor
(Captain, La Côte Basque; Le Caravelle)
Joseph Lemerdy, proprietor
(Waiter, La Côte Basque; Le Caravelle)

Jean Saint-Cricq, poissonier
(Poissonier, Le Pavillon; La Caravelle)
Pierre Barth, saucier, poissonier
(Saucier, Le Pavillon)
Grégoire Lecane, waiter
(Waiter, Le Pavillon; La Côte Basque)
Louis Colleoc, waiter
(Waiter, Le Pavillon)
André Ascouat, waiter
(Waiter, La Côte Basque)

LA GRENOUILLE
Charles Masson, proprietor
(Waiter, The French Pavillon Restaurant, World's Fair, 1939; captain and maître d'hôtel, Le Pavillon)
Paul Dessibourg, maître d'hôtel
(Captain, Le Pavillon)
Willy Krause, chef
(Saucier, Le Pavillon)
André Jouen, poissonier
(Poissonier, Le Pavillon)

OUT-OF-TOWN RESTAURANTS

LE PARISIEN, MIAMI BEACH
René Seigle, proprietor
(Entremettier, Le Pavillon)

DORAL BEACH, MIAMI BEACH
Louis Hecht, maître d'hôtel, Starlight Roof
(Captain, Le Pavillon)

DORAL COUNTRY CLUB, MIAMI
Fernand Noguès, assistant maître d'hôtel
(Captain, Le Pavillon; La Côte Basque)

GOLDEN DOOR RESTAURANT, KENNEDY INTERNATIONAL AIRPORT
Charles Biles, captain
(Captain, French Pavillon Restaurant, World's Fair, 1939)

LES PYRÉNÉES, QUEECHY LAKE, CANAAN, N. Y.
Louis Chevalier, proprietor
(Captain, French Pavillon, World's Fair, 1939; captain, La Pavillon)

LA CASCADE, HAINES FALL, N. Y.
Lucien Jamet, proprietor
(Waiter, Le Pavillon)

LA CRÉMAILLÈRE, BANKSVILLE, N. Y.
Robert Meyzen, proprietor (see La Caravelle)
Fred Decré, proprietor (see La Caravelle)

L'AUBERGE DES QUATRE SAISONS, SHANDAKEN, N. Y.
Edouard Labeille, proprietor
(Waiter, Le Pavillon)

OTHER FOOD OPERATIONS

HOWARD JOHNSON COMPANY
Pierre Franey, vice president in charge of quality control
(Chef, Le Pavillon; supervising chef, La Côte Basque)
Bernard Valentin, supervising chef for Red Coach Grills, New York
(Chef, La Côte Basque)
Serge David, assistant supervising chef for Red Coach Grills, New York
(Entremettier, Le Pavillon)
Jacques Pépin, research chef
(Saucier, Le Pavillon)
Paul Kieffer, production chef
(Saucier, Le Pavillon)
Santon Curti, assistant production chef
(Gardemanger, Le Pavillon; La Côte Basque)
Mathurin Ferrelles, food supervisor, New Jersey
(Entremettier, Le Pavillon)
Jacques de Chanteloup, chef, Red Coach Grills, New York
(Assistant gardemanger, Le Pavillon)
Victor Vanden, chef, Red Coach Grills, Westbury, L. I.
(Entremettier, La Côte Basque)

THE CAMPBELL SOUP COMPANY
Marcel Theuil, research chef
(Saucier, Le Pavillon)

NESTLÉ COMPANY, SWITZERLAND
Jean Solanon, research chef
(Entremettier, saucier, Le Pavillon)

CULINARY INSTITUTE OF AMERICA
Emile Délorme, instructor in advanced training
(Original chef with Cyrille Christophe, French Pavillon Restaurant, World's Fair, 1939; Le Pavillon)

AIR FRANCE
Michel Bonnettat, saucier
(Saucier, Le Pavillon; La Caravelle)

three floor-to-ceiling murals and several window scenes.[23] When asked, why have two restaurants in the same city, Soulé would say, "The Pavillon is elegant and La Côte Basque is amusing. Some people may find it quite convenient that Henri Soulé has two restaurants in Manhattan. Gives them a chance to take their wife to the La Côte Basque and the other lady to the Pavillon."[24] Soulé was so pleased with the effect of the murals that he had Lamotte paint Parisian scenes of the Rond-Point of the Champs-Elysées on the walls of Le Pavillon in the summer of 1960. In addition to the floor-to-ceiling murals in La Côte Basque, the restaurant was decorated with a basket from the Basque game *pelota*, coats of arms from Basque provinces, iron wall sconces, and a red and gray checkered carpet. Both the lunch and dinner menus at La Côte Basque were *prix fixe*, slightly lower priced than Le Pavillon, and more tailored to the Basque region. In his review of the restaurant, Craig Claiborne complimented his lunch of chopped aspic, braised shoulder of beef in a brown sauce, and crème brûlée, all for six dollars (not including the five-dollar wine).[25]

Soulé ran his restaurant with exacting precision, and his attention to detail was legendary. A florist was employed to spend six hours daily arranging flowers for Le Pavillon's interior, and $15,000

to $20,000 worth of red and white roses were purchased every year to complement the decor.[26] Service was equally attentive. One captain was assigned three or four tables, from which he would take orders and serve. Two waiters staffed each of these sections: one would hover over his assigned tables, replacing rolls and water; the other was the runner, who would go back and forth from the kitchen bringing food and generally orchestrating the meal. The dining room was a model for how an elite *haute cuisine* restaurant should be run. Franey wrote, "When I look back on it, I realize Le Pavillon was running a culinary university training French cooks and dining room staff for service throughout America."[27] Soulé performed all the important tasks of a master restaurateur: he trained chefs, impressed New Yorkers, and produced culinary masterpieces, cementing his and Le Pavillon's status in New York's gastronomic history.[28]

Former Le Pavillon employees moved on to found many restaurants in New York City. One of the best known was La Caravelle. The staff list read like a who's who from Le Pavillon. Founders Robert Meyzen and Fred Decré had both worked their way up at Le Pavillon from waiters to *maîtres d'hôtel* at La Côte Basque and Le Pavillon, respectively. They took with them Roger Fessaguet, sous chef from Le Pavillon, as

well as ten other employees.[29] They also took with them aspects of Le Pavillon's trademark red and white decor. La Caravelle was outfitted with red carpet, mirrors, red velvet banquettes, and wall sconces. Jean Pagès, who designed many *Vogue* magazine covers in the late 1920s and early 1930s, executed three Parisian-themed murals for the restaurant: the Luxembourg gardens; the Tuileries Gardens rendered in red, white, and chartreuse; and the Place du Tertre.[30]

Le Pavillon's reach stretched past New York, across the country, and into all levels of food service—from the White House to Howard Johnson. In 1961, as if to officially acknowledge French cuisine's exalted status in America, René Verdon was appointed chef of the White House under the Kennedy administration. (Verdon had previously worked with Fessaguet.)[31] Le Pavillon's impact also extended as far as the Howard Johnson chain, where Franey and Jacques Pépin worked in the 1960s. Franey, who had resigned from Le Pavillon after a staffing dispute, was put in charge of quality control and was tasked with revamping Howard Johnson's entire menu. Together with Pépin and other chefs who had worked at Le Pavillon, Franey developed recipes that could be frozen and distributed to hundreds of Howard Johnson restaurants. They did not touch the restaurant's ice cream or clam chowder, but they changed everything else. They discovered such fast-food secrets as fresh meat's ability to hold its flavor better than frozen meat, which had to be thawed and refrozen after being added to a recipe.[32] While they did not transform Howard Johnson's menu into French cuisine, they infused French cooking techniques and the French appreciation for quality ingredients into traditional dishes like chicken potpie.[33] This exportation of quality French food to mid-range American eateries proved to be extremely popular. It was in New York City, however, that the cultural impact of restaurateurs like Henri Soulé had the greatest resonance. At the closing of La Côte Basque in March 2004, Adam Gopnik wrote in the *New Yorker*: "it was the restaurant's thorough and even comic Frenchness that had made it so entirely New York. The black banquettes, the lovely red and white striped awning above the bar, the flow of penguined waiters, and above all those murals, showing Basque-harbor scenes—no truly French place could be so resolutely French . . . The colors, the open brushwork and the sea beyond—all of which were intended, in 1962, to make you feel as if you had been transported to southwest France in 1905—now makes you feel, one last time, as if you had been transported to New York in 1962."[34]

The ambiance of La Côte Basque could transport patrons back to old New York because old New York embraced the style of French dining with an enthusiasm almost incomprehensible today. It wasn't just the food that enthralled New Yorkers. They became enchanted by the decor, the style of service, and the formality of Soulé. New York is a powerful force, and Le Pavillon and La Côte Basque ceased to be French restaurants in New York and became, simply, great New York restaurants.

The World's Fair pavilion was seminal in the development of fine French restaurants in New York. Well-trained French chefs, who were in New York because of the World's Fair and loath to leave the city because of the Second World War, aligned with a metropolis that had a new appreciation for taste and class and, more importantly, could pay for it. These elements led to the creation of a restaurant—Le Pavillon —which by 1964 had spawned thirteen restaurants in New York City and eight restaurants in other parts of the country. It had also influenced major food operations, including Howard Johnson, the Campbell Soup Company, and Nestlé.[35] Those New York City restaurants, most of them of the "Le" and "La" variety (La Caravelle, Le Périgord, La Grenouille, Le Cygne, Le Mistral) established New York as a major gastronomic city in the mid-twentieth century.

Amy Azzarito is a librarian at the New York Public Library's Humanities and Social Sciences Library. She is in the process of completing a master's degree in the history of decorative arts and design at Parsons, the New School for Design, Cooper–Hewitt Museum.

MARILYN F. FRIEDMAN

ART DECO
TO AMERICAN
MODERN

AT THE 1929

METROPOLITAN MUSEUM OF ART
INDUSTRIAL ARTS EXHIBITION

In February 1929 the Metropolitan Museum of Art mounted an exhibition of contemporary American design. Titled "The Architect & the Industrial Arts," it was the eleventh in a series of exhibitions at the Metropolitan that began in 1917, each of which was intended to improve the level of design in the United States and encourage its broad dissemination. This exhibition was important in two respects. First, it gave modern interior design the imprimatur of one of the foremost art institutions in the United States. Second, it marked a turning point in the development of an American interpretation of European modernism. In the wake of the Exposition Internationale des Arts Décoratifs et Industriels Modernes, held in Paris in 1925,

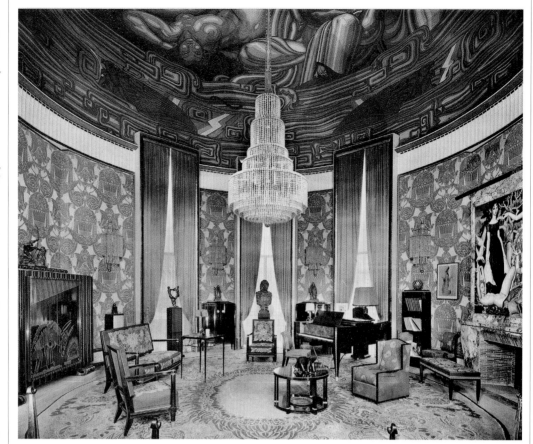

LEFT
Suite of furniture designed
by Emile–Jacques
Ruhlmann in the
exhibition "A Selected
Collection of Objects
from the International
Exposition of Modern
Decorative & Industrial
Art Paris 1925,"
Metropolitan Museum of
Art, New York, 1926

BELOW
"Fumoir" in Une
Ambassade Française at
the 1925 Paris Exposition,
designed by Francis
Jourdain, reproduced in
the folio *Une Ambassade
Française*

American modern design was heavily influenced by the French style featured at the exposition that is referred to today as Art Deco. The model rooms presented at the museum's exhibition signified that by 1929, the influence of the 1925 Paris Exposition's French exhibits had begun to diminish. Instead, there were signs of influence of other European iterations of modernism, such as German functionalist design, as well as a distinctive American response that emphasized comfort, simplicity, and practicality and used industrial materials to help achieve those goals.

The development of an American response to French modernism followed a long-standing pattern: numerous design movements had made their way from France to America with adaptations and modifications suited to American needs and sensibilities. The exuberant curvilinear ornamentation of the French Rococo found expression in the late-eighteenth-century tables and chairs of New York and Philadelphia cabinetmakers, albeit with the restraint mandated by a paucity of experienced craftsmen and limited resources in a country struggling for its existence. The classical rectilinear

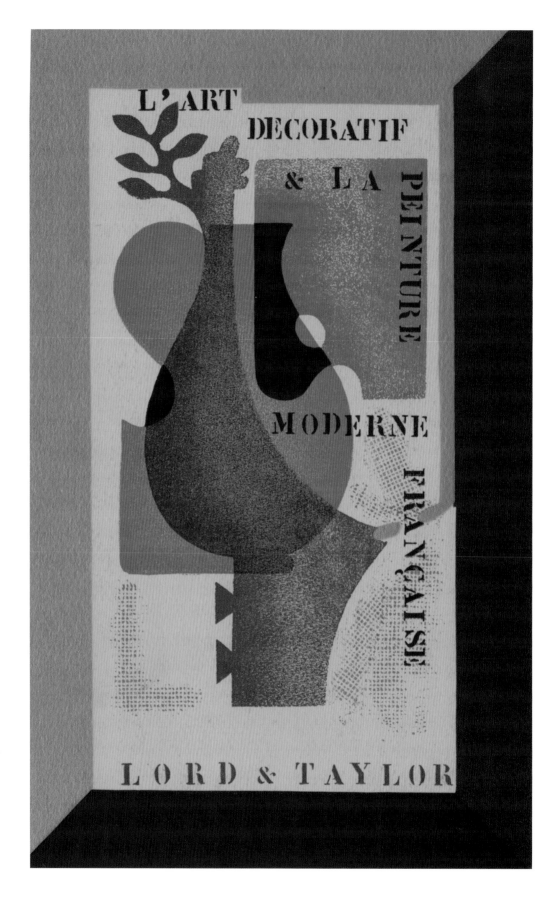

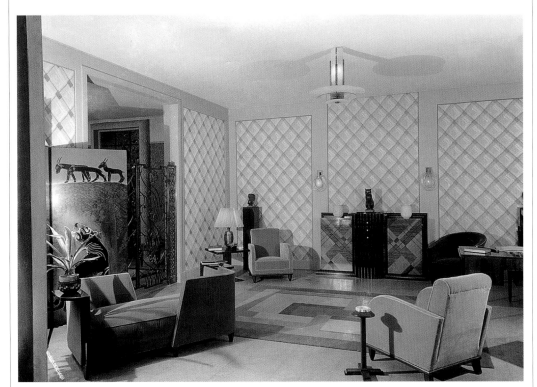

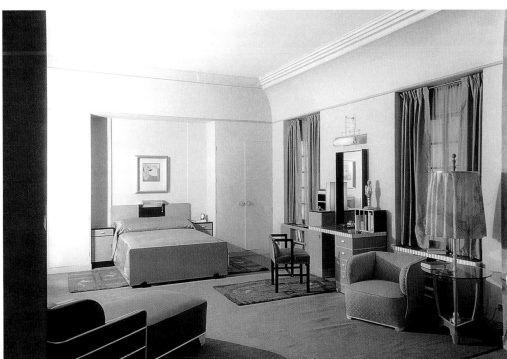

forms favored by the *ébénistes* in the employ of Louis XVI also found their way to America in the early nineteenth century, but with federalist symbols as ornamentation in addition to classical elements. Similarly, the modern design movement, nurtured in Paris throughout the second and third decades of the twentieth century, was brought to America shortly after the 1925 Paris Exposition.

During the four years following the Paris Exposition, New Yorkers were presented with many exhibitions featuring French modern design that were mounted by museums, department stores, and galleries. The earliest of these exhibitions, "A Selected Collection of Objects from the International Exposition of Modern Decorative & Industrial Art Paris 1925," toured eight cities in the United States and opened at the Metropolitan Museum in New York on February 22, 1926.[1] This exhibition included items representative of all the European schools of modernism, such as Swedish glass, Italian ceramics, and Austrian metalwork, but it primarily featured works of a French modernism championed by Emile-Jacques Ruhlmann that updated traditional styles. Like all the modernists, these designers chose geometry over nature as the basis of their designs, but they favored curvilinear forms, used expensive materials, and embellished their furniture with highly polished and exotic wood veneers and rich inlays of mother-of-pearl and ivory.

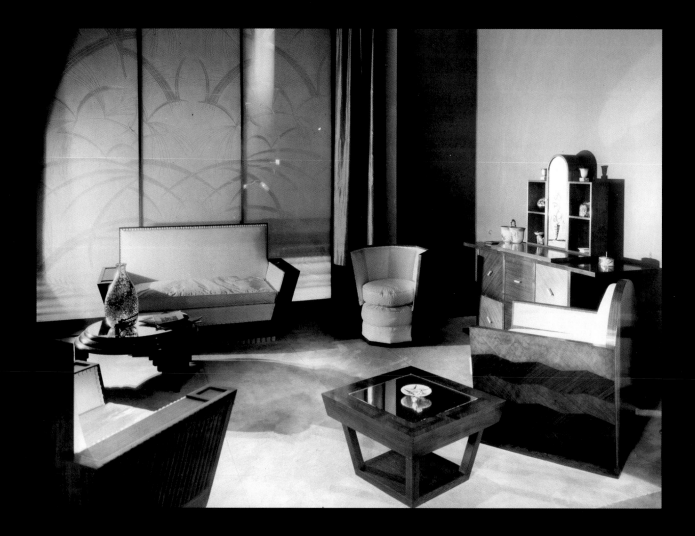

Vestibule designed
by René Gabriel in 1925,
watercolor by Gabriel,
reproduced in the 1926
folio *Intérieurs en
Couleurs France*

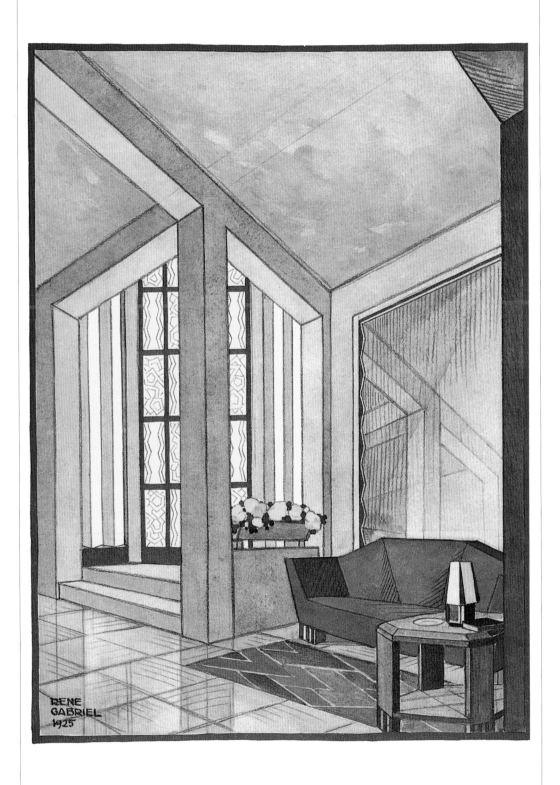

As time went on, department stores and galleries began to exhibit another version of French modernism—today referred to as rationalism, whose proponents included Pierre Chareau, Francis Jourdain, and Robert Mallet-Stevens. The rationalists had a functional approach to design, believing that "a sensitive man" would wish to acquire "forms adapted to his material need and whose purity would satisfy his spiritual needs; that is, his reason."[2] Like the traditionalists, rationalists created furniture that was geometric in form and made of wood, but it was generally rectilinear, simpler than traditionalist furniture, without the expensive inlays, and designed to be practical. Within French modernism, both traditional and rational French design are generally referred to today as Art Deco.

By 1927 department stores were beginning to display the work of American modern designers as well as Europeans. Exhibitions at R. H. Macy & Co. and Wanamaker's featured room settings that had elements of both traditionalist and rationalist French modernism. In March 1928 Lord & Taylor presented "An Exposition of Modern French Decorative Art," which showcased the work of French modernists and also presented five "American" rooms that adhered closely to French designs. In May 1928 Macy's, in collaboration with the Metropolitan Museum, mounted its "International Exposition of Art in Industry," which brought to the public's attention not only the work of French traditionalists but versions of modernism prevalent in Germany, Italy, Austria, and Sweden as well. There were also exhibits at the 1928 Macy's exposition by American designers, and their offerings hinted at a move away from French domination of modern design, toward an American iteration that incorporated various strains of European modernism. The German émigré Kem Weber, for instance, designed a three-room apartment for Macy's that emphasized practicality and simplicity, incorporating German functionalism as well as French design. Although in September 1928 there was another department store exhibition in New York City, this one at B. Altman & Co., that featured traditional French designers and Americans who emulated them, the tide was turning.[3]

In late 1928 two exhibitions opened in New York that were devoted solely to American modern design: one staged by the Art Center and one by the American Designers' Gallery. On October 8, 1928, the Art Center, a union of seven societies in art-related fields, opened a month-long exhibition of products provided by ten American manufacturers seeking to "promote modern art as reflected in American workmanship." The exhibition featured interiors that incorporated furniture, floor coverings, wallpaper, window treatments, tablecloths, and accessories. The American manufacturers demonstrated their debt to Art Deco, favoring geometric patterns and eschewing applied ornament in favor of highly polished figured woods with inlays of ebony and silver.[4]

On November 9, 1928, the American Designers' Gallery, a group of fifteen respected and successful American artists and designers, presented an array of decorative objects and seven model residential rooms that remained on display through February 1929. There were thirty-six exhibitors listed in the exhibition catalog, many of whom were émigrés from central Europe. The displays reflected influences from a broader spectrum of European design than those at the Art Center. Several Gallery members had studied in Europe. Winold Reiss brought with him the emphasis on practicality he had learned at the Munich Werkstätten. Ilonka Karasz adapted the focus on simplicity and folk art patterns she had learned at the Royal School of Arts and Crafts in Hungary.[5] Donald Deskey's work featured the sleekness of Art Deco but brought to it the developing American interest in manufactured materials, using aluminum, linoleum, cork, and Vitrolite (an opaque glass) in the room he developed for the exhibition.

These exhibitions of Americans' work were followed in February 1929 by the Metropolitan Museum of Art's 11th Exhibition, which evidenced further development of Americans' interpretations of modernism. Planning for this exhibition had begun in March 1928 when Henry Kent, Secretary of the Metropolitan Museum, met with Leon V. Solon, who had long been a member of an advisory committee of designers and manufacturers established by the museum to collaborate with its staff in producing the industrial art exhibitions. Solon, a specialist in architectural polychromy, consulted his colleagues at the Architectural League and reported to Kent that they were interested in participating in an exhibition.[6] By early April 1928 a special "Co-öperating Committee" formulated a proposal for an exhibition that would present a broad spectrum of contemporary design in a harmonious manner. The organizers hoped to "show effectively the artistic progress of American craftsmanship and manufacture, to foster original effort and to encourage inspirational study in design, by an exhibition in which all objects are displayed in abstract but concerted arrangement to indicate relationships, unity of style, or in other ways bring out their quality of contemporary design."[7] These requirements are strikingly similar to the standards issued in conjunction with the 1925 Paris Exposition, which excluded objects that did not clearly show artistic and original qualities or were not well adapted to the different uses and conditions of modern life.[8]

The initial members of the Co-öperating Committee were Leon Solon, Eliel Saarinen, Raymond Hood, Eugene Schoen, Ely Jacques Kahn, and Ralph T. Walker. This group met weekly at the Architectural League during the summer of 1928 to assign rooms and develop a plan of the exhibition space while dining in a "homey" atmosphere with "a notable lack of formality."[9] In order to expand the scope of the exhibits, they decided

to add Armistead Fitzhugh, John Wellborn Root, and Joseph Urban to the committee. By September 1928 this group of individuals, well-known for their work in architecture, architectural ornamentation, or landscape architecture, had devised a plan of exhibits, allocated specific spaces among themselves, and secured the cooperation of more than 150 American manufacturers, artists, and craftsmen to assist them by building installations, manufacturing furniture, and providing art and accessories.

The Metropolitan Museum's 11th Exhibition opened to the public on February 12, 1929. Helen Appleton Read, the critic for the *Brooklyn Eagle* and *Vogue*, noted that the term "modern" was not used in the catalog issued in conjunction with the exhibition.[10] Instead, the exhibition was subtitled "11th Exhibition of Contemporary American Design." The participating architects may not have wanted to circumscribe their efforts by choosing among the various terms used to describe contemporary design, such as "modern," "modernistic," or "art moderne." They sought to develop their own iterations of the design mode that would interpret the needs of the public in the twentieth century.

The format of the 11th Exhibition differed significantly from previous industrial arts exhibitions at the Metropolitan Museum. First, it elevated the role of the designer; the preceding shows had focused on manufacturers and quantity production. Second, the 1929 exhibits were presented in room settings; the previous shows had followed a typical museum format of furniture set on platforms and objects displayed in vitrines. Finally, the exhibits were all to be "contemporary." In previous exhibitions at the museum, most of the goods shown were reproductions of period styles. These major shifts can be attributed in large part to the influence of the 1925 Paris Exposition, which featured important designers, displayed objects in room settings, and banished reproductions in favor of original design.

The room settings at the 11th Exhibition indicated a focus on French design as the starting point for many of the participants. Indeed, in writing about the exhibition, the influential critic Henry McBride saw it as "an annex to the French Salon of Decorative Arts." He acknowledged that he got a "whiff here and there of Munich and Vienna," but in his view Paris predominated.[11] It should be noted that the architects selected had ample exposure to modern French design. Raymond Hood had studied at the Ecole des Beaux-Arts in Paris, Ralph Walker had received his degree in architecture from MIT, which was connected to the Ecole in Paris,[12] and Ely Jacques Kahn had visited the 1925 Paris Exposition. For the other participants, not only were folios with photographs and renderings of the exposition exhibits widely available, but hundreds of objects from the exposition toured the United States in 1926, and New York department stores showcased French modern design following the closing of the exposition.

Although French design was the starting point, elements of other European schools of modernism were presented in the twelve interiors that were clustered around a central garden feature designed by Armistead Fitzhugh. The participants did not choose to work in the extremes of modern design. Although some used wood as their main material, none created rooms as sumptuous and extravagant as those designed by Ruhlmann. While some used metal as their base building material, it was not the stark simplicity of Charlotte Perriand and Robert Mallet-Stevens they emulated; rather they created furniture with decorative elements that one critic termed "metallically luxurious."[13] While some paid homage to French and German rationalism, none adopted the uncompromising focus on mass production and standardization that was fundamental to Bauhaus design. As a result, the 11th Exhibition presented a range of modern design based on, but not adhering slavishly to, particular schools of French and other European modernism.

John W. Root's "Woman's Bedroom" was perhaps the closest of all the room settings to the traditionalism of Ruhlmann and his compatriots. It was designed to be a quiet, comfortable, and usable setting for its occupant. The soft color scheme, in shades of gray, blue, and rose, complemented the curvilinear furniture and taffeta upholstery. This room owed a great deal to André Groult's boudoir for the 1925 Paris Exposition. The base of the dressing-table chair in Root's room mimicked the base of the table in Groult's room. In both Groult's and Root's rooms, the bed was placed on a dais and tucked into a niche in the wall. It seemed that Secession, Ltd. of Chicago, which designed the bed, the chaise, and the side table in Root's room, drew heavily on the sensuous curvilinear forms favored by the French traditionalists.

Critics pointed to the etched mirrors and the pewter chair and dressing table as examples of innovations in decoration.[14] The use of pewter may have been a nod to the French rationalists, who used metal extensively in the Salon des Artists Décorateurs held in Paris in the spring of 1928. Root, however, like many of the 11th Exhibition designers, used metal not as the French rationalists and the Bauhaus designers used the material—in new and purely functional ways—but to replicate old decorative forms with new materials.[15] In musing about the functionality of the chair, which had been designed by C. D. Macpherson of Evanston, Illinois, one critic asked why the designer had chosen "this material for that piece of furniture where one sits with little between a state of nature and cold metal?"[16] Also, while the mirrors were a source of the indirect lighting favored by modernists, the hidden bulbs emitted their rays through decorative etchings rather than the simple translucent material favored by French rationalists.

For his "Bath and Dressing Room," Ely Jacques Kahn chose a color scheme of rose, silver, and

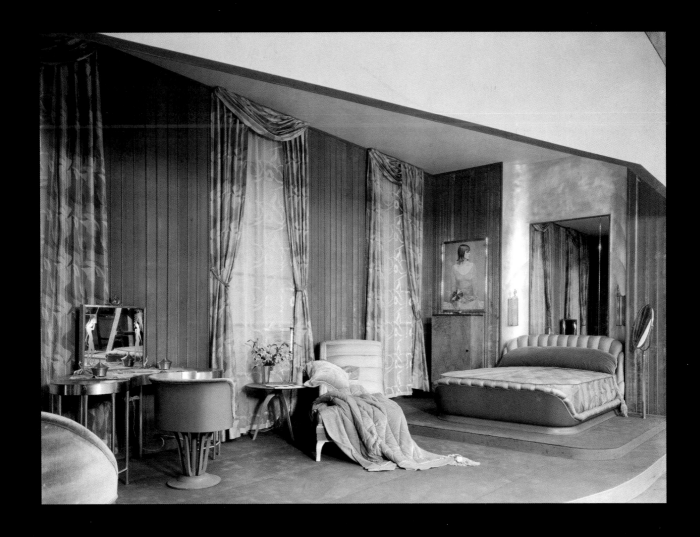

"Woman's Bedroom"
in the exhibition
"The Architect &
The Industrial Arts,"
Metropolitan Museum
of Art, New York,
designed by John
Wellborn Root, 1929

RIGHT
"Bath and Dressing
Room" in the exhibition
"The Architect &
the Industrial Arts,"
Metropolitan Museum of
Art, New York, designed
by Ely Jacques Kahn,
photograph by Richard
Averill Smith, 1929

BELOW
"Business Executive's
Office" in the exhibition
"The Architect &
the Industrial Arts,"
Metropolitan Museum of
Art, New York, designed
by Raymond Hood, 1929

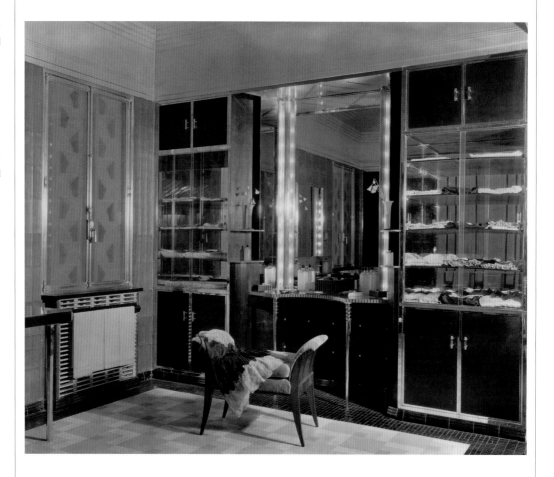

black. In his expansive use of space, silvery ceiling, plush-covered chaise, and glossy surfaces, Kahn's design was close to the luxuriousness of the French traditionalists. Yet Kahn did exhibit some aspects of design favored by the European rationalists: glass walls that could be easily cleaned, a rubber floor that would be soft and welcoming, towel racks in front of the radiators to provide warm towels at any time. This focus on comfort combined with practicality would become a hallmark of the American version of modern design.

Standing at the opposite end of the long gallery from Root's bedroom was Raymond Hood's "Business Executive's Office," which Hood intended to be an expression of the French rationalist credo. It also demonstrated a strong focus on practicality in American design. In his introduction to the exhibition catalog, Hood noted that the "task of the contemporary designer is first to search for the practical solution of his problem, and then to avail himself of every material, every invention, every method that will aid him in its development." He chose his materials with a view to their fitness of purpose, economical upkeep, and sanitary qualities.[17] The furniture, made of aluminum and reddish brown leather, was designed by Hood and executed by Oscar Bach of New York City. Hood stated that he chose aluminum because it was "as strong, light, and adaptable for the purpose as wood, but one that is not subject to shrinking, swelling, warping or the necessity of repeated refinishing."[18] The executive could sit at the L-shaped desk, with his visitors at chairs in front of him or on the sofa to his right, and his secretary to his left in a chair with a built-in armrest for dictation. Two wastebaskets were set into the legs of the desk for convenience, and file cabinets were built into the wall opposite the sofa to save space. The Fabrikoid wall covering produced by E. I. du Pont de Nemours & Company was chosen because it was machine made, durable, and inexpensive.

In this room the structural elements of the furniture formed the decoration. The blocks of color in the brown, red, and cedar rug designed by Arthur Crisp echoed the geometric lines of the furniture. Helen Appleton Read proclaimed the desk, chair, and sofa in the room to be the first successful American interpretation of metal furniture, with the decorative treatment of the furniture "dictated by the capabilities of the machine processes by which it is made."[19] Like Kahn's "Bath and Dressing Room," Hood's "Office" melded comfort with practicality. Hood, however, introduced another aspect that would mark American modern design: materials like aluminum and Fabrikoid that were invented by American industry to make domestic life easier.

Another architect who paid homage to the European rationalist approach was Eugene Schoen. Schoen planned the "Child's Nursery and Bedroom" "to stimulate and meet the need of the growing youngster," with particular attention to sanitation, caretaking, and equipment.[20] In this cheerful room, with walls covered in washable greenish yellow Fabrikoid, a child could experiment with artistic impulses. He or she could draw on the walls or on a blackboard behind the desk. The built-in bins with red interiors, all placed at a child's height, encouraged orderliness, and the lightweight aluminum furniture, with legs that could be adjusted as the child grew, could be moved easily for both activities and cleaning. There were no lamps to knock over; the lighting was recessed behind a molding that went around

"Child's Nursery and Bedroom" in the exhibition "The Architect & the Industrial Arts," Metropolitan Museum of Art, New York, designed by Eugene Schoen, 1929

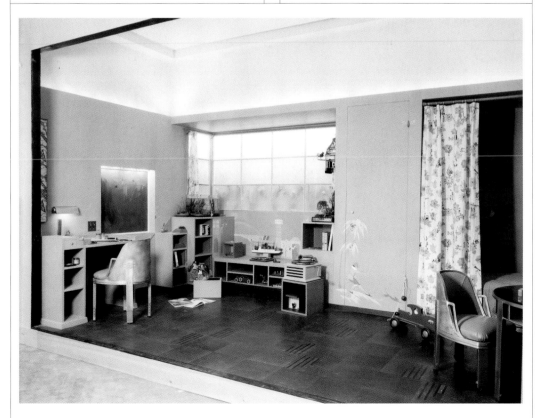

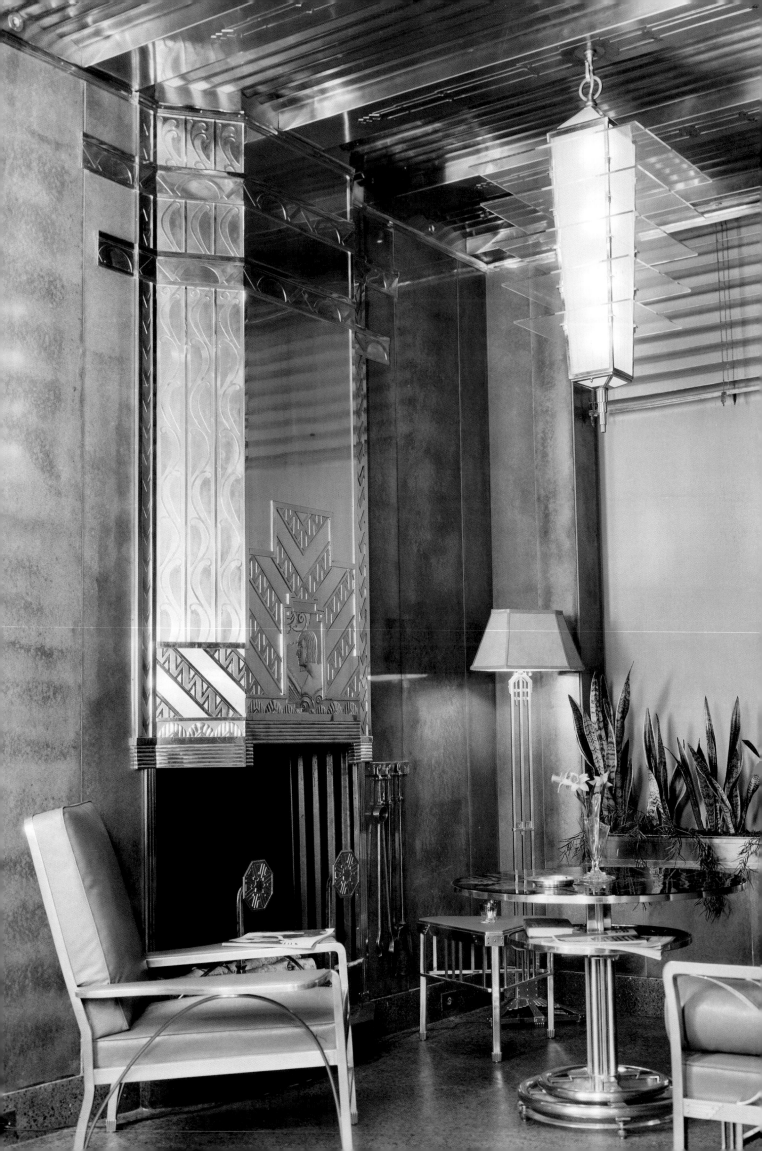

the room. The cork floor was easily cleaned, absorbed sound, and permitted soft landings for active youngsters at play.

As in Hood's "Office," the furniture was unornamented, with the structure providing the decorative element. Walter Rendell Storey of the *New York Times* found the chairs and tables to be suggestive of an age of steel and mechanics. He was impressed by the way in which Schoen had applied "the spirit of research and constructive thought" to arrange the room for "the comfort, happiness and educational and cultural need of the child." Storey saw this rationalist approach as "an important part of good modern decorative art."[21] Schoen's "Child's Nursery and Bedroom" was another example of the marriage of American and European modernism. While many elements could be linked to French and German rationalists such as Robert Mallet-Stevens and Marcel Breuer, the use of cushioned chairs and decorative painting on the walls reflected the American interest in comfort and esthetic appeal, while the use of materials that could be easily cleaned responded to an American focus on hygiene in the early twentieth century.

Metal furniture predominated in two other rooms designed for the 11th Exhibition: the "Apartment House Loggia" designed by Raymond Hood and the "Conservatory" designed by Joseph Urban. Both of these "rooms" were actually semi-outdoor spaces, and the architects selected metals for the furniture that would not rust.

In his "Conservatory" Urban chose to use cadmium-plated steel for the furniture. He admired the highly reflective surface, which could be produced by machine and maintained without continual polishing, even in the semi-outdoor

environment of a conservatory. To assure continuing ease of care, he used glazed tiles and mosaics for decoration and beige Fabrikoid for upholstery. To obviate the need for draperies, he had the window glass etched in large triangular planes, which eliminated glare and provided privacy. The triangular motif appeared in many elements of the room, creating a sense of harmony.

Raymond Hood lined the walls of his "Apartment House Loggia" with reddish brown cast concrete treated to resemble marble and covered the floor with purple terrazzo tiles. He used chromium plate, a noncorrosive metal, for the overmantel, ceiling, and horizontal blinds and designed furniture made of aluminum and upholstered with green Fabrikoid, embellishing the metal with brass accents.[22]

At the time these rooms were designed, the use of metal for furnishing purposes spanned a broad spectrum, from the highly decorative work favored by French traditionalists such as Edgar Brandt's designs for the 1925 Paris Exposition, to the purely functional forms of the French rationalists and the Bauhaus designers. Urban and Hood may have been emulating the latter groups in their furniture designs for these rooms, as they used metals that could be made and shaped by machine. Yet their designs did not project the stark simplicity of René Herbst's furniture. Instead, decorative elements indicated the influence of Brandt, particularly in the overmantel designed by Arthur Crisp for Hood's "Loggia."

Urban's "Conservatory" reflected the state of American modern design in 1929—moving away from blind acceptance of French traditional modernism toward a more balanced approach that incorporated elements of rationalism,

OPPOSITE
"Apartment House Loggia" in the exhibition "The Architect & the Industrial Arts," Metropolitan Museum of Art, New York, designed by Raymond Hood, 1929

BELOW
Ensemble designed by Edgar Brandt for the 1925 Paris Exposition, reproduced in the folio *Ensembles Mobiliers Exposition Internationale 1925*

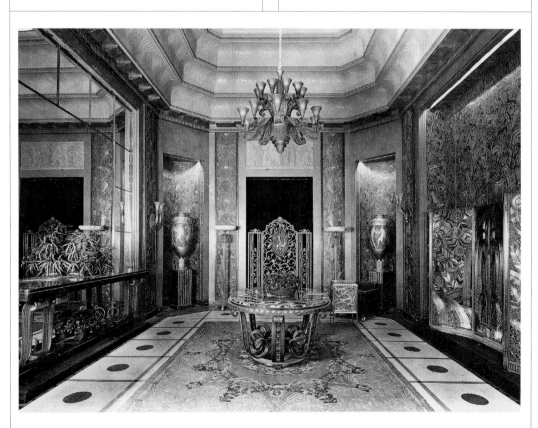

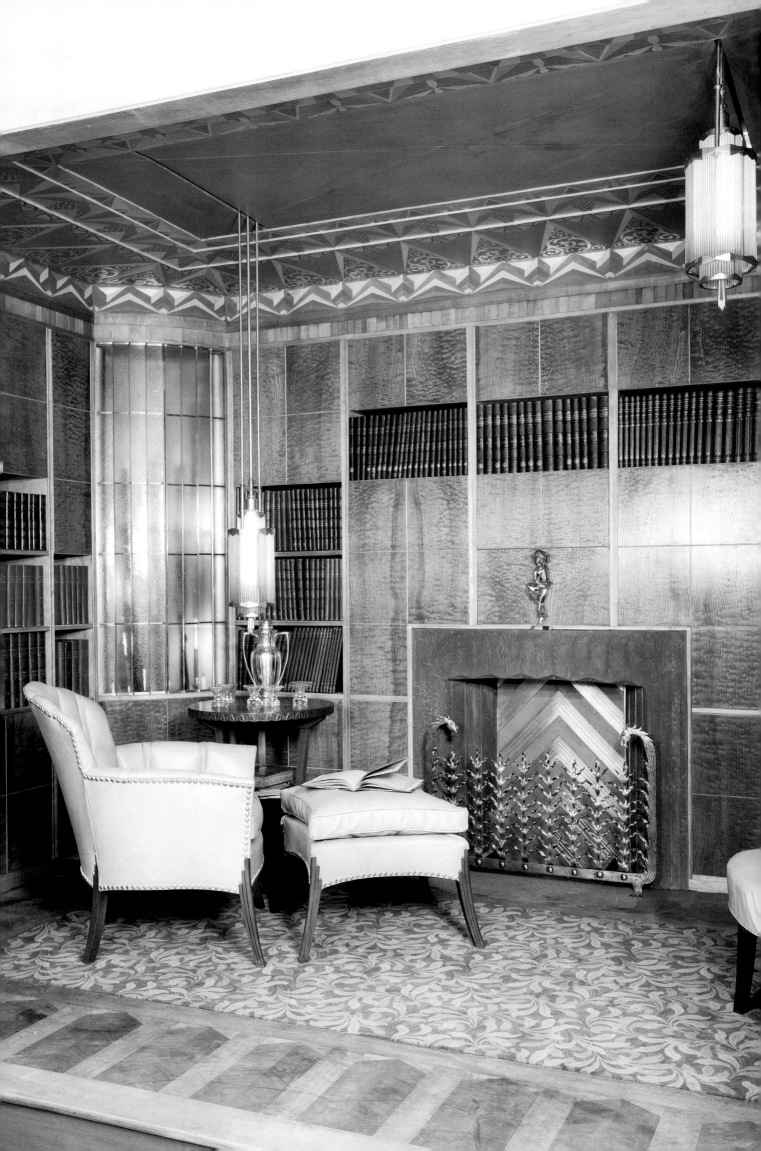

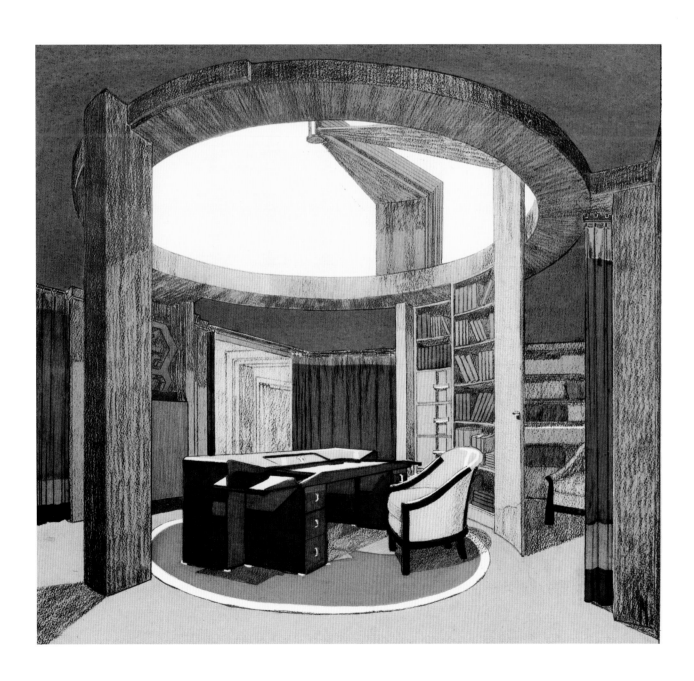

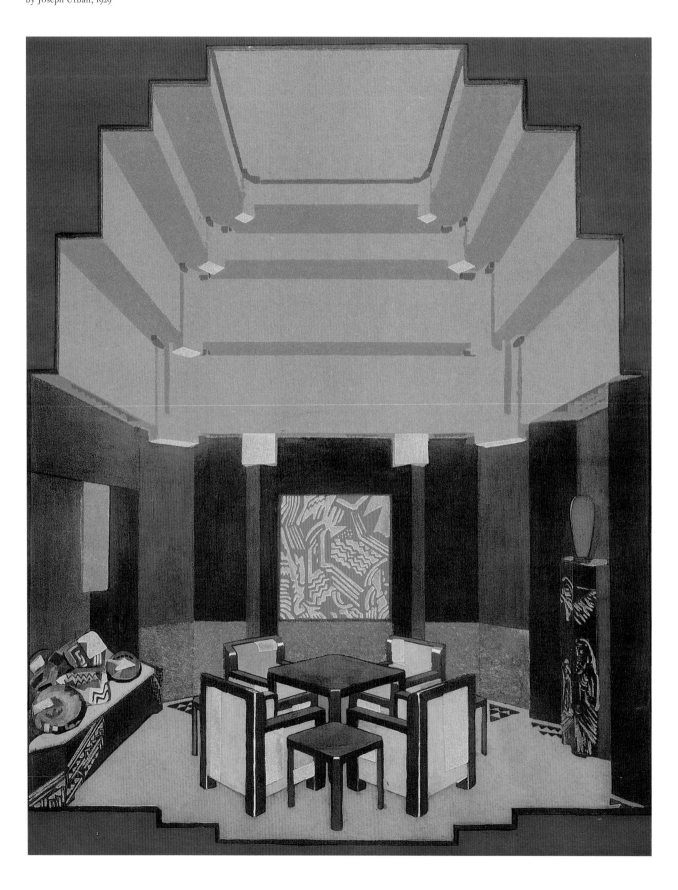

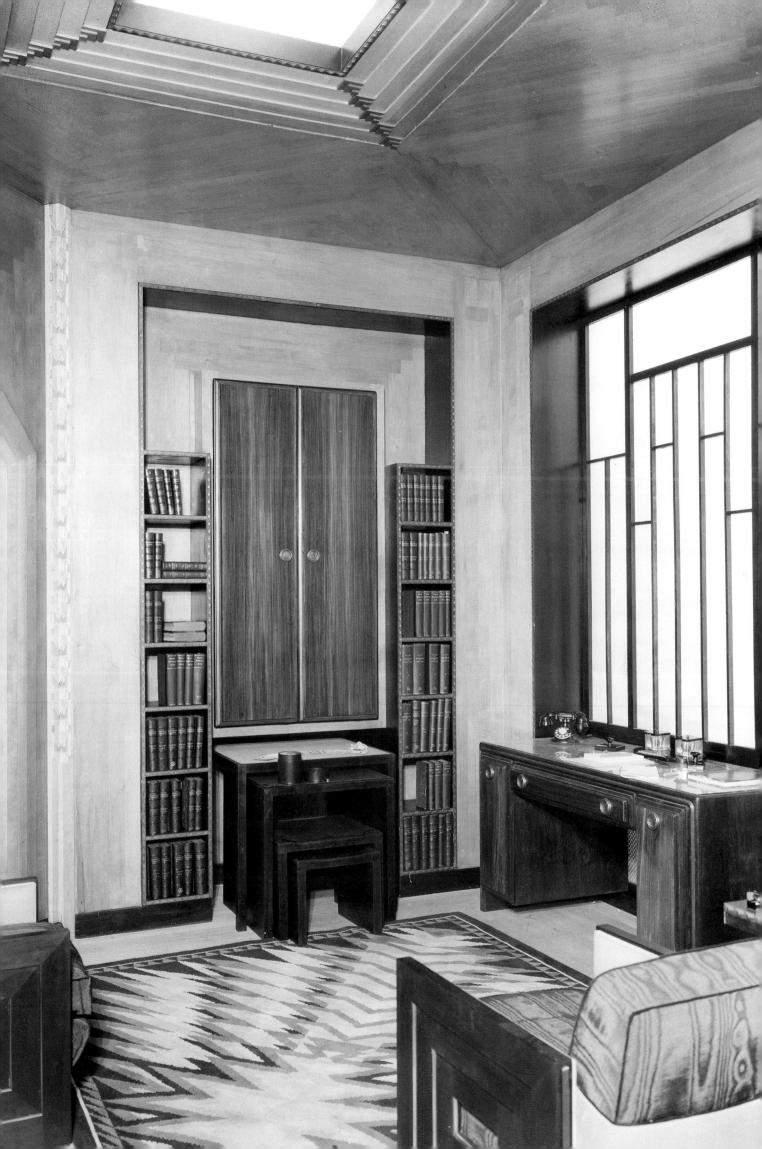

the Bauhaus, and American manufactured materials used for purposes of practicality, comfort, and decoration.

Ralph Walker's "Study" was a distinctive hybrid of the traditionalist and rationalist schools. He designed this "Study" "to inclose and house the body, and then to afford escape for the spirit through the mind."[23] He sought to accomplish this goal by utilizing neutral shades of brown in the upholstered chairs, the rug, and the window treatments to provide a restful background. The paneled walls of Japanese ash actually encased more bookshelves: they were hinged in sections so that as more books were added to the collection, any section could be converted to a bookshelf by removing the paneling.[24] The "Study" was reminiscent of two rooms designed by French rationalists for Une Ambassade Française at the 1925 Paris Exposition: Pierre Chareau's "Bureau-Bibliothèque" and Francis Jourdain's "Fumoir." The extensive use of built-in furniture followed rationalist principles of practicality and economical use of space. The furniture, designed by Walker and W. & T. Sloane in New York City, bore a striking resemblance to the furniture in Chareau's "Bureau-Bibliothèque."

The Walker "Study," however, had certain decorative elements that were associated more with the French traditionalists, including the silvery, stenciled ceiling decorations, the red and gold bindings on the books, the floral carpet, and the elaborate fireback and radiator grille. One critic believed that this room aroused great interest in the public because it provided both a comfortable living environment and "enough interest of itself to occupy the viewer examining it over a space of time."[25] Unlike the French designers of the day, the Americans did not have to choose between the two schools. In France the differences between the traditionalists and the rationalists created such animosity that in 1929, the rationalists split off from the umbrella group, the Société des Artistes Décorateurs, to form the Union des Artistes Moderne. The Americans had the luxury of picking and choosing among the numerous European schools of modernism, as was evident in the final two rooms at the 11th Exhibition. Both Eliel Saarinen's "Dining Room" and Joseph Urban's "Man's Den" demonstrated the interplay among the various schools of modernism and the interest American designers had in melding them to satisfy American tastes.

Eliel Saarinen's "Dining Room" and Joseph Urban's "Man's Den" brought to the exhibition various aspects of central European modernism and French rationalism. The color scheme in Saarinen's "Dining Room" was beige, gray, yellow, and white, with silver and brass embellishments. A number of critics commented favorably on the table, which sat on an octagonal pedestal with triangular niches in which to rest one's feet while dining. Helen Appleton Read saw Eliel Saarinen's "Dining Room" as "essentially Nordic in spirit, if it is no way an attempt to adapt traditional Norge motives." She noted that the room had "the same simple masses, the same use of materials in their natural, unvarnished, unornamented state which characterizes his architecture."[26] This focus on the simple and natural could, however, as easily describe French rationalism as "Nordic" modernism.

Alfred Auerbach of *Retailing* described Joseph Urban's "Man's Den" as a "truly masculine creation," with its extensive use of wood, angular forms, and palette in shades of brown, black, and yellow.[27] Shepard Vogelgesang of *Good Furniture* complimented Urban on his efforts to conserve space by providing a place in the bookcase wall for the nest of tables, one of which also served as a desk chair.[28] The simple, massive forms in Urban's "Den" looked as if they could have been designed at the Wiener Werkstätte, which was not surprising since Urban trained as an architect in Vienna. Even this room, however, betrayed some influence from Paris: the shapes of the chairs and tables and the step motifs on the chairs and the ceiling recalled Jean Dunand's "Fumoir" for the 1925 Paris Exposition.

For the Metropolitan Museum and the moving force behind the 11th Exhibition, Richard Bach, director of industrial relations, any lasting style had to be based in reason, which in turn would be found by interpreting the needs of the people it served.[29] In bringing together a dozen leading designers, each demonstrating his or her own interpretation of design appropriate for the twentieth century, it was hoped that the museum could aid in this process. By most accounts, the exhibition was highly successful: intended to close in March, it was extended until September, and more than 185,000 people had visited it by the time it ended.

A number of commentators, however, criticized the Metropolitan Museum's decision to select architects, rather than interior designers, to mount the exhibition. They argued that in so doing, the museum limited its ability to impact public taste. *Upholsterer and Interior Decorator* noted that architects, who had no ongoing relationships with furniture manufacturers, naturally turned to the building trades for assistance, with the result that the Exhibition contained far too many expensive built-ins and no furniture from existing stock.[30]

Counterbalancing the Metropolitan Museum's exhibition, in March 1929 the American Designers' Gallery mounted its second exhibition on West Fifty-seventh Street in New York City. In this exhibition affordability was a key goal, and thirty-eight exhibitors presented a coherent, unified vision of modern design that was a middle ground between the sumptuous luxury of Art Deco and the stark functionality of Le Corbusier and the Bauhaus.[31] Their designs were characterized by the qualities of affordability, simplicity, and practicality, and they were appropriate for use in traditional interiors as well as modern ones.

Unlike the displays at the March exhibition of the American Designers' Gallery, the Metropolitan Museum exhibits did not satisfy the needs of the middle class for affordable, easily obtainable furniture. Nor did the museum present a coherent vision of modern design; instead, visitors were confronted with disparate versions of modernism, many of which were not congruent with each other or with the traditional interiors of most American homes. The 11th Exhibition did elevate the role of the designer, however, and in so doing set the stage for the industrial design movement in the 1930s, which gave prominence to individuals such as Walter Dorwin Teague, Raymond Loewy, and Russel Wright. Also, the exhibition promoted the qualities of comfort and practicality and demonstrated that manufactured materials like cast stone, Bakelite, and aluminum could replace expensive, difficult-to-maintain natural materials like marble, wood, and silver.

It is useful to view the 1929 exhibitions at the Metropolitan Museum and the American Designers' Gallery as complementary. The American Designers' Gallery brought to American modernism the notion of affordability, which would inform the development of modern design throughout the Depression. The Metropolitan Museum brought credibility to this emerging movement. *Women's Wear Daily* asserted that in mounting this exhibition, the museum had placed "the official stamp of approval" on "modern art" as "a true and worthy expression of our day."[32] In both exhibitions it was clear that by 1929, American modernists had digested the various European iterations of modern design and were ready to present an "American" version. All the designers took elements of the earliest, more traditional, expressions of modern design developed in Paris and married them to modern materials and rationalist principles imported from all of Europe to produce what one critic termed "a soberer and more and more sincere attitude toward our own needs."[33]

Like earlier French design that crossed the Atlantic Ocean in the eighteenth and nineteenth centuries, the sumptuous Art Deco that was exported to New York in 1926 was modified and adapted to American needs and tastes. Simplicity, practicality, comfort, and affordability, all of which were essential elements of French rationalist design, would be the hallmarks of the American modern design developed during the remainder of the twentieth century.

Marilyn F. Friedman is a design historian in New York City. She is the author of *Selling Good Design: Promoting the Modern Interior*, a book about a series of exhibitions at New York department stores that introduced modern design to the American middle class after the 1925 Paris Exposition. She has also written essays that explore the development of modern design in America during the 1920s.

DAVID A. HANKS

FROM

DECO

TO

STREAMLINED:

DONALD DESKEY

AND

RAYMOND LOEWY

In 1920s New York contemporary design didn't roar—it purred, and much of it with a French accent. The U.S. government chose not to participate in the 1925 world's fair that gave "Art Deco" its name, the Exposition Internationale des Arts Décoratifs et Industriels Modernes in Paris,[1] implicitly admitting the superior quality of contemporary French designs. Instead, American industry spent the years immediately after the exposition striving to catch up by importing French decorative arts and exhibiting them,[2] copying them, having U.S. decorative arts fabricated in France, and fostering exchanges between American and French designers.[3] During the 1920s, Americans were experimenting

with designs derived from variations on European modernism. By the early 1930s, however, a trend toward independent, non-European design emerged in the United States that paralleled the rise of the new profession of industrial design. During that time a transition occurred from French Art Deco to American streamlining and from unique decorative designs made by individual craftsmen and small shops to mass-produced industrial designs. In 1930 Paul Frankl noted that the new industrial design had replaced the modernism of the 1920s: "The so-called 'modern' decorative movement was essentially a continuation of the tradition of the past rather than a precursor of the spirit of today . . . Superficially novel as the outward form of this school of decoration might have been, it was indeed no new departure but rather the last step in the old-fashioned way of doing things . . . True modernism is of a radically different nature. It aims to satisfy the needs of modern living and to express the spirit and the flexibility of modern life. It no longer holds aloft the banner of defunct handicrafts and peasant arts, but acknowledges its allegiance to the benevolent despotism of the machine."[4]

The transition from decoration and handicraft to industrial design and mass-production can be traced in the work and careers of two American designers, Donald Deskey and Raymond Loewy. Deskey and Loewy proved their mastery of French Art Deco in the mid-1920s and then evolved as advocates of the streamlined idiom, which took hold in Depression-era America with unprecedented invention and popularity.[5] Although some of the earliest examples of streamlining, such as

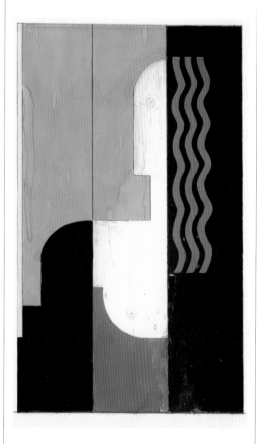

the Zeppelin, were European, the style captured the imagination of American industrial designers like Deskey and Loewy. Streamlining, which was based on the principles of aerodynamic engineering, first appeared in forms of transportation. The ideal form was a teardrop—the shape that offered the least resistance to wind and water. The style that improved the speed and performance of trains, ships, automobiles, and airplanes was then applied to stationary household objects, covering complex machinery with a sleek sheathing that appealed to consumers.

Deskey and Loewy came by their Francophilia by living and studying in Paris. The Minnesota-born Deskey first visited France in 1921–23 as a painting student and attended the Académie de la Grande Chaumière and the Atelier Léger in Paris. When he was in Paris for a second time in 1923–25, Deskey visited the Exposition Internationale des Arts Décoratifs et Industriels Modernes and made sketches of the interiors, furniture, and decorative arts that attracted him. When he returned to the United States, Deskey created advertising illustrations and window displays for department stores, and his training in France is reflected in his Art Deco designs. It is not surprising that the advertisement he drew for Saks Fifth Avenue around 1927 recalls work by Fernand Léger and the French Cubists, but it also combines Parisian and American sources, wittily overlaying books labeled "La Jeunesse" and "La Vie" with sheet music titled "Mammy" and a guitar and palette with a tennis racquet.

Raymond Loewy was born in Paris and received his early training there. After acquiring a degree in engineering from the Ecole de Laneau in 1918, he moved to New York the following year and began work as a freelance window designer for Saks and Bonwit Teller and as a fashion illustrator for *Vogue*, *Vanity Fair*, and *Harper's Bazaar*. His "Metropolis" advertisement for Saks in 1927 illustrates the syncopated angularity of Art Deco in its set-back skyscraper typical of New York, shown silhouetted against a night sky crisscrossed with klieg lights. Both men's adaptation of the jazzy zigzags of popularized Cubism to American fashion marketing suggests the nature of the 1925 Paris Exposition's overall success: its crowd-pleasing pavilions were those of the great Paris department stores and high-end companies, and its impact was felt most in the luxury trades.

In 1926–27 nine American cities were treated to an exhibition of approximately 400 designs from the 1925 Paris show. When this exhibition opened at the Metropolitan Museum of Art, the museum reinforced its impact with a display of modern French designs from its permanent collection, including opulent furniture and decorative arts by Emile-Jacques Ruhlmann, Süe & Mare, Armand Rateau, and Jean Puiforcat. In spring 1928 Lord & Taylor presented "An Exposition of Modern French Decorative Art" and among the twelve contributors were Pierre Chareau and Francis Jourdain (who were advertised as

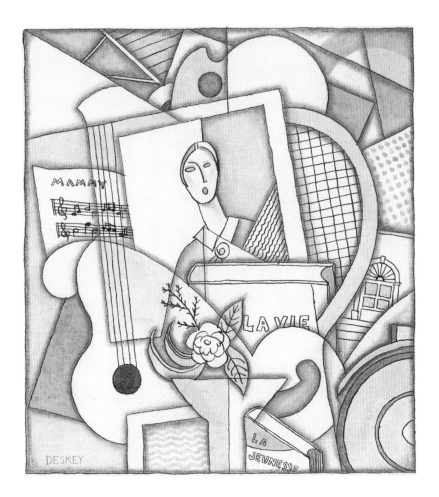

LEFT
Drawing for a Saks
Fifth Avenue advertising
brochure by Donald
Deskey Associates; pen,
ink, wash, and graphite on
board; 1927

BELOW
Advertisement for Saks
Fifth Avenue, New York,
designed by Raymond
Loewy, reproduced in
Vogue, March 15, 1927

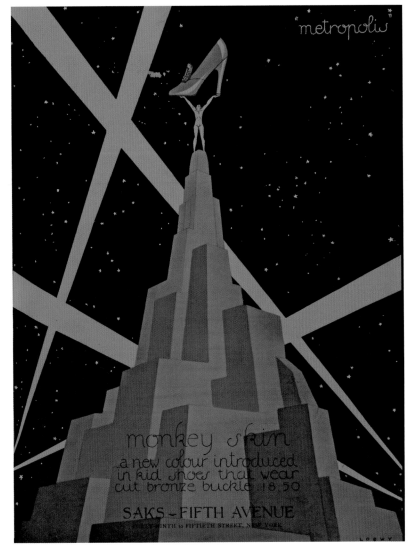

"rationalists"), Lucien Vogel, and Jean Dunand, as well as Ruhlmann and Süe & Mare ("traditionalists"). And in fall 1928 B. Altman & Co.—not to be outdone by its Manhattan rival—compared French and American designs in an "Exhibition of 20th-Century Taste," showing rooms featuring decorative arts and furniture by Ruhlmann with four of his compatriots (to France's advantage). Deskey's and Loewy's advertising illustrations *à la française* represented the Francophiliac spirit of the times.

Although many critics lauded the innovation and craftsmanship visible in the department store- and museum-sponsored shows, more than one columnist viewed prices as extravagant and styles as eccentric. Even before the stock market crash in October 1929, pundits called for simplified, practical designs suited for small apartments, slender wallets, and a shrinking pool of servants in American cities. Deskey's and Loewy's designs for mass production and utilization of new industrial materials were a means to address the diminishing market for deluxe products.

At the same time a group of American designers joined forces to display their own work outside a museum setting and to promote their Americanism by founding the American Designers' Gallery, Inc., in November 1928. Deskey was one of the founding members. This cooperative of fifteen designers intended to show and sell designs produced by members with collaborating manufacturers, in addition to artworks. Many of the members were immigrants schooled and trained in Europe. They were American by citizenship rather than by culture.[6] The exhibition, held at the Chase Bank Building at 145 West Fifty-seventh Street in New York City, included ten rooms, each by a different designer. The exhibition subsequently traveled to other American cities.

Deskey's "Man's (Smoking) Room" was one of the most admired ensembles and offered tables of metal and Vitrolite (a patented glass) produced by his new company, Deskey-Vollmer Associates, as well as a sofa, armchair, and rounded-top desk manufactured by S. Karpen & Bros. of Chicago. Though the dominant forms of the room were rectilinear, representing a machine aesthetic, Deskey's use of shining metal throughout (including cylindrical chair and sofa feet and a reflective aluminum ceiling) and repeated curves in the desk would be expanded through the 1930s. His use of industrial materials—cork, linoleum, Vitrolite, and aluminum—reflected the emerging American style as Deskey moved toward streamlining. Deskey did not consider his work to be Art Deco, which he associated with a more flamboyant style. However, his "Man's Room" can be considered transitional from the French Art Deco seen in his use of luxurious woods, yet the utilization of new materials and geometric forms indicated a new modern style.

That same year, Deskey participated in the establishment of the American Union of Decorative Artists and Craftsmen (AUDAC), which included many of the same designers who participated in the American Designers' Gallery.[7] These two New York–based organizations, both dedicated to promoting contemporary American design, indicated that the country's designers had found a sense of identity and, in their alliance with manufacturers, they set the tone for 1930s applied arts.

Meanwhile, the years 1927–28 marked the ascendancy of the industrial designer in America as Henry Ford introduced his Model A automobile to a rapt media and public. The success of General Motors's automobile designs by Harley Earl had forced Ford's hand, and his $18 million retooling of his Model T was called "the most expensive art lesson in history."[8] Industrial design was a new profession that developed to cope with a saturated, highly competitive mass market. It promised to multiply consumer choices, particularly through rapidly changing surface styling of products, and therefore to multiply sales. Deskey and Loewy recognized that a profitable future lay in American industry, not in one-off or luxury commissions. In 1929 Loewy opened his own industrial design firm, later recalling: "I was in a constant state of admiration for the mass of products resulting from superior American technology and drive . . . The country was flooded with good, inexpensive designs that practically anyone could afford to buy."[9]

The deluxe Art Deco style, however, would make its last appearance in 1929 in the Metropolitan Museum of Art's 11th Exhibition of industrial designs, "The Architect & the Industrial Arts." Among the twelve room settings, which were designed by American architects, one could view both the climax and the swan song of Art Deco in America.[10] John Wellborn Roots's "Woman's Bedroom," with its high ceiling, tall windows, and Art Deco interior design, was particularly reminiscent of the 1925 Paris Exposition.

OPPOSITE
Westinghouse clock–radio in mahogany case, designed by Raymond Loewy, 1930
This clock's use of expensive mahogany stems from Art Deco, while its smooth, rounded forms reveal the influence of streamlining.

LEFT
Exhibition catalog for the American Designers' Gallery, New York, 1928

FOLLOWING PAGES
"Man's (Smoking) Room" at the American Designers' Gallery, New York, designed by Donald Deskey, 1928

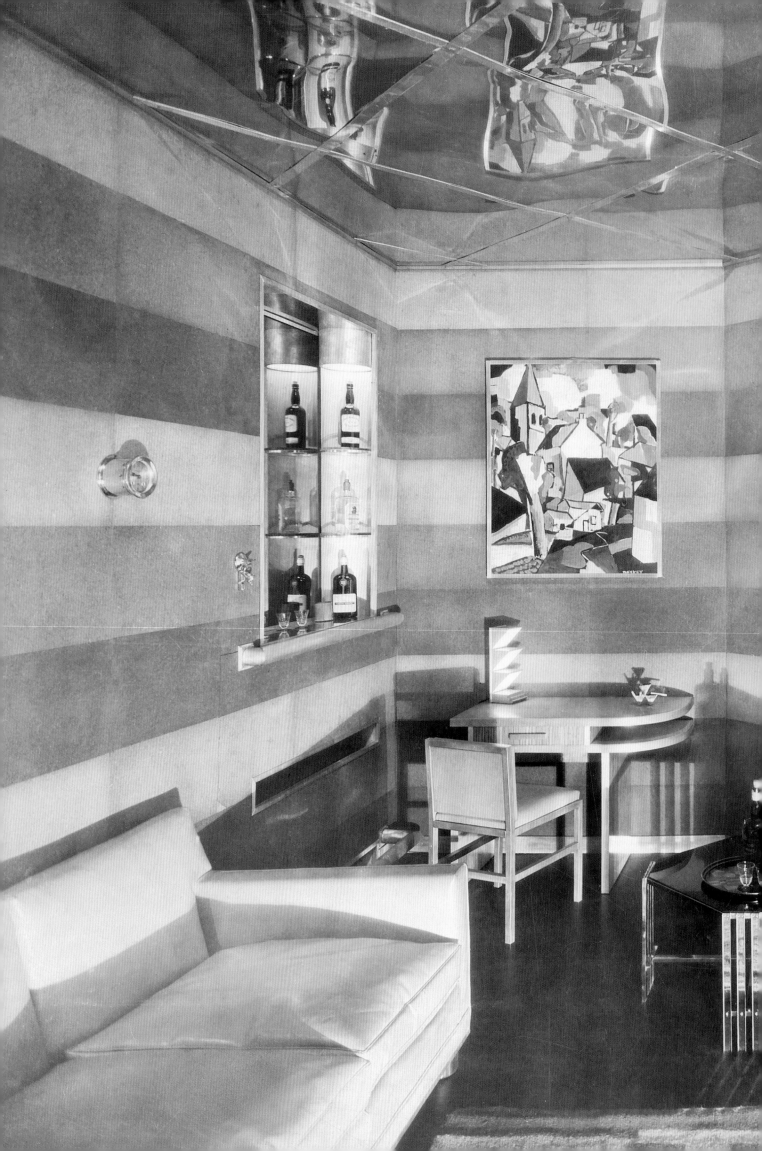

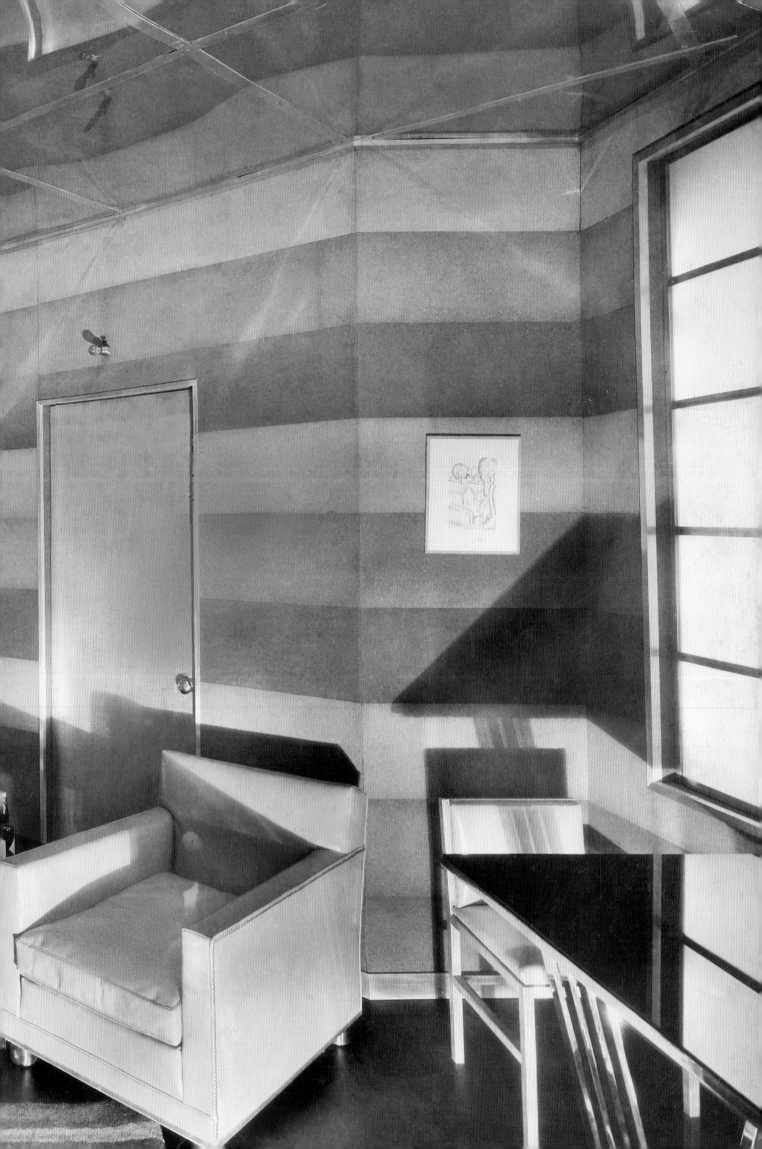

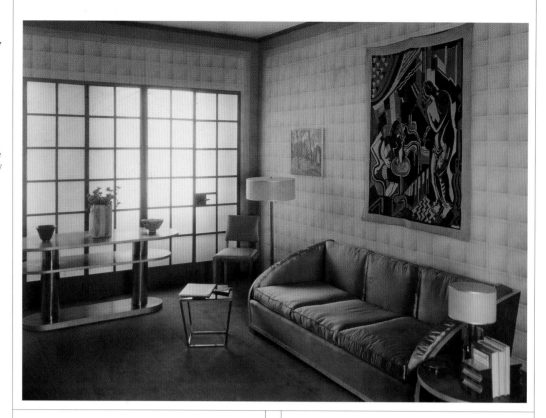

At the Metropolitan Museum's 13th annual exhi-
bition, in 1934, industrial design and the stream-
lined style made the most profound impressions
on observers. The Depression and the 1933/34
Chicago Century of Progress Exposition had made
the aristocratic exquisiteness of French Art Deco
design seem both inappropriate and irrelevant:
America's industries and designers now acknowl-
edged both needing and wanting the mass
market. The 13th Exhibition's designs reflected the
new machine aesthetic. A participating designer
wrote, "The Co-öperating Committee agreed that
in contradistinction to the exhibition held in the
lush period of five years ago, this one was to show
what might be achieved at a low cost . . . While
we may still 'love the garish day' we welcome
any opportunity to try to create a fine thing in a
simple manner." This 13th Exhibition "was the
most widely attended exhibition to have been
held at the Metropolitan Museum."[11]

Deskey's and Loewy's rooms for the 1934
Metropolitan Museum's exhibition demonstrated

LEFT
Drawing of a bedroom
designed by Donald
Deskey; watercolor,
gouache, pen, ink, and
graphite on board, 1930

BELOW
Drawing of a living room
for Mr. and Mrs. Frederick
Gash designed by Donald
Deskey; gouache, pen,
ink, and graphite on
board; 1935
Mrs. Frederick Gash was
professionally known as
Emily Genauer, an important
architecture and design writer.

FOLLOWING PAGES
"Designer's Office and
Studio" for the 13TH
annual exhibition at the
Metropolitan Museum of
Art, New York, designed
by Raymond Loewy and
Lee Simonson, 1934

their enthusiastic championship of streamlined modernism. In his "Living Room" of 1929 for the American Designers' Gallery, Deskey had given his sofa sloping arms to connect back and seat, and he formed a side table of three identical lozenge-shaped horizontals pierced by two columns.[12] In his 1934 "Dining Room" for the museum, glistening planar surfaces, curves, and industrial materials were everywhere: in the two U-shaped supports (a debt to Ruhlmann, but in chromium plating) for the glass-topped table, the curved upholstered cushions and flared rear legs of the chairs, the rounded sides of the sideboard with its three horizontal chromium pulls, and even the two rounded corners of the room display's dais, all characteristic of the streamlined style and representing an American version of French-influenced designs. A full-height wall of glass bricks was reflected in the ceiling-height sideboard mirror. The only remnants of Art Deco angularity appeared in the carpet's patterns of overlapping rectangles and in a cubistic standing sculpture.

In Loewy and Lee Simonson's 1934 "Designer's Office and Studio" (in which the dapper Loewy was photographed presiding), there were almost no right angles at all. Repeated horizontal bands unified the pale walls, and one was extended to form a continuous surface of worktables and shelving. The same metal rods supporting the tables formed lighting fixtures, while the upholstered chairs and high stool were made of similar rods in loops and circles. Here was a showcase for Loewy's sleek transportation designs: renderings of his streamlined Princess Anne ferry on the left

wall, a model of his Hupmobile on a pedestal. With its round-ended horizontal window, the room evoked a spacious and immaculate yacht. It quickly became one of the most celebrated interiors of the 1930s.

Deskey's interiors for Radio City Music Hall and Loewy's iconic design for a streamlined pencil sharpener, both introduced in 1932, remain their best-known, one-of-a-kind works of the decade. But Deskey and Loewy also brought many of their designs to mass production through contracts with manufacturers. Deskey's steel armchair (c. 1939) for the Royal Metal Manufacturing Co. looked mid-century modern in its sharp, linear silhouette and its tapered extremities ending in bright little balls. The extension of the rear legs to form the arms gave the chair a futuristic thrust. In his 1935 Coldspot refrigerator (his first of four) for Sears, Roebuck, Loewy rounded off the legs and corners and bisected the white-enameled door and the drawers and freezing unit inside with horizontal chromium bands. In such ways Loewy, Deskey, and their fellow "streamliners" domesticated the modern, adapted its iconography of machine-tooled efficiency and high velocity to middle-class American tastes, and feminized its austerity with voluptuous forms and shining surfaces, acknowledging the housewife as the nation's dominant consumer.[13] By 1934 streamlining was recognized as an American design language.[14]

The French imports of the mid-to-late 1920s and the Francophile exhibitions of 1926–29 had challenged designers in America to define themselves. By the end of the 1920s they had gained status through their own efforts and won exposure via their collaborative associations and U.S. museum- and department store-sponsored shows. For the first time, American designers created modern alternatives to period revival styles, including the beloved Colonial Revival style, which had typified American homes since the Philadelphia Centennial of 1876. While the 1930s modern styles encompassed a range of expressions, from streamlined design to functionalist modernism (also known as the International Style in architecture, championed by the Museum of Modern Art), they nonetheless represented the emergence of American expressions in the applied arts. After World War II, when designers such as Eero Saarinen and Charles and Ray Eames gained international recognition for themselves and for American design, they and their generation were not working in a vacuum, but were building on the achievements and innovative climate of American design in the 1930s.

OPPOSITE
Armchair designed by Donald Deskey, produced by the Royal Metal Manufacturing Co., Chicago, c. 1939

LEFT
Coldspot refrigerator, designed by Raymond Loewy for Sears, Roebuck; Chicago, 1935

David A. Hanks is an independent curator and Curator of the Stewart Program for Modern Design in Montreal. His exhibitions and books include *American Streamlined Design: The World of Tomorrow.*

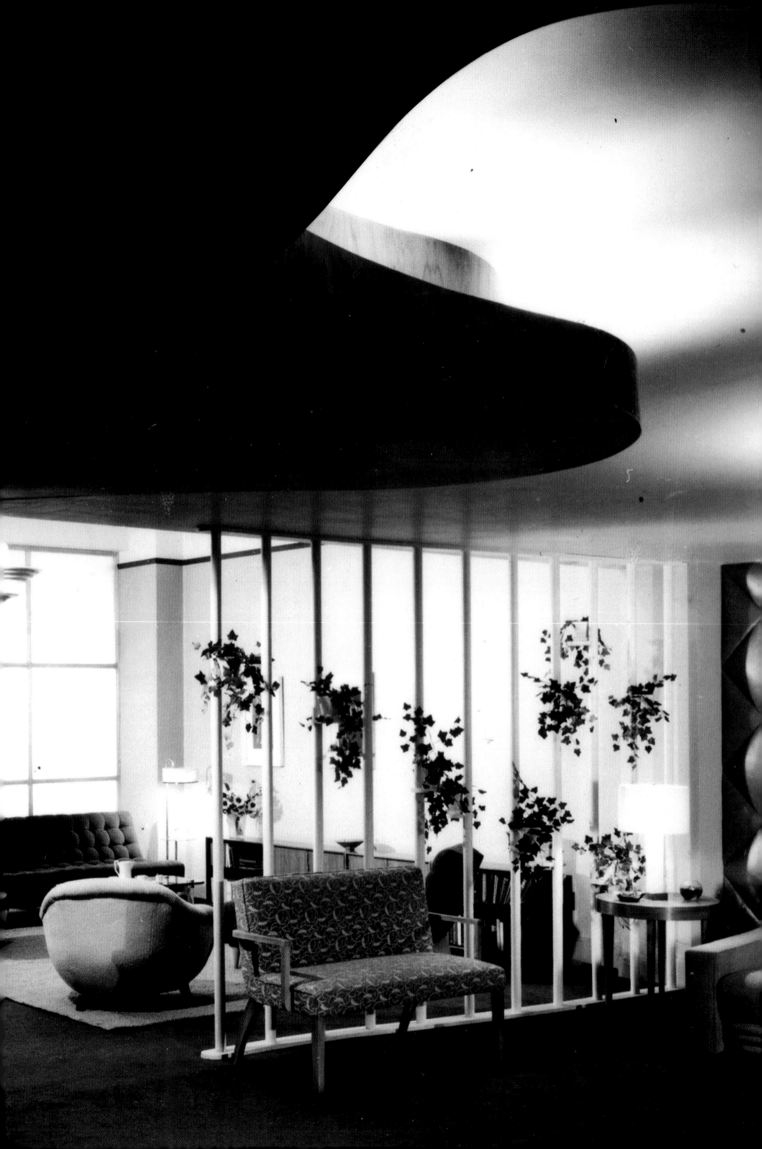

PHYLLIS ROSS

A BRIDGE

TO POSTWAR AMERICAN DESIGN:

GILBERT ROHDE
AND THE
1937 PARIS
EXPOSITION

New York–based furniture and interior designer Gilbert Rohde had a dual mission when he attended the 1937 Paris Exposition Internationale des Arts et Techniques dans la Vie Moderne. With the prospect of designing an exhibit for the 1939/40 New York World's Fair, a visit to Paris offered Rohde an opportunity to gather ideas for his own work. The fair also provided the occasion to survey en masse the latest developments in furniture and interiors shown in the pavilions of the forty-four participating nations, as well as in specialized displays such as the exhibit of the Société Artistes et Décorateurs (SAD), sponsor of an annual Paris salon of decorative arts since 1904. The Paris fair was the impetus for Rohde's new celebration

of luxury and sensuality and the catalyst for incorporating fantastic Surrealist elements into his designs. The fair turned out to be pivotal in both the development of a new aesthetic direction in Rohde's work, and in the emergence of an aesthetic of luxurious materials and biomorphic shapes that would define American modernism after World War II.

Through Rohde's focus on furniture design for mass production, he wielded considerable influence in promoting the cause of modernism during the 1930s and early 1940s. By 1937 he had received commissions from nearly a dozen furniture manufacturers for whom, in most instances, his work inaugurated modern design at the company (most notably at Herman Miller, but also at Heywood-Wakefield, Troy Sunshade, and Widdicomb). In addition to being marketed by trendsetting retailers across the country, Rohde's work was shown in popular fairs such as Chicago's 1933/34 Century of Progress Exposition and in museum exhibitions of industrial art, such as those held at the Metropolitan Museum of Art in New York City.

Rohde's trip to France in 1937 was his third pilgrimage to Paris seeking inspiration and ideas. The first—in 1927, to study French modernism—had been a prerequisite to launching his design career the following year.[1] After graduating from the vocational training program at Stuyvesant High School in New York City, he worked for a few years as a political cartoonist for the *Bronx Home News.* In 1919 he shifted to commercial art, eventually specializing in advertising illustration of furniture and interiors. This experience helped Rohde realize his goal of becoming a furniture designer; his first commercial pieces were small tables sold in specialty shops and at Lord & Taylor. In 1930 Rohde was commissioned by his first manufacturing client, the Heywood-Wakefield Company of Gardner, Massachusetts, to design a large series of coordinated furniture that included seating, tables, and storage pieces. From the beginning Rohde's furniture and interiors combined traditional and industrial materials, and they showed an affinity for the elegance, sophistication, and lushness of materials characteristic of French modernist design. During a second trip to Europe, the focus of which was the 1931 Deutschen Bauausstellung Berlin, he also attended the Exposition Coloniale in Paris, where displays of tubular metal furniture inspired pieces in his 1934 Streamline Metal furniture line for the Troy Sunshade Company of Troy, Ohio.

Prior to 1937, Rohde's aesthetic was characterized by simple, often boxlike, forms, with surfaces that featured rare as well as native wood veneers, inspired by French design ranging from the spare modernism of Pierre Chareau to the more classical moderne work of Emile-Jacques Ruhlmann. At the same time Rohde was a conduit for German ideas such as *typen-möbel,* systems of coordinated furniture that often employed modular units. Through his reinterpretation of European forms for an American market, Rohde's work constituted an important bridge that contributed to the emergence of a truly American modern design expression.

By 1937 Rohde was renowned for his work in furniture design and retail and showroom interiors and as the director of the Design Laboratory, a New York City school for industrial design which he modeled on the Bauhaus. At the Herman Miller Furniture Company headquartered in Zeeland, Michigan, where his work laid the foundation for the company's leadership in modern design, Rohde systematically implemented innovative merchandising strategies, including a retail franchise program at upscale stores around the country. This facet of his consulting work demonstrated an acumen informed by his earlier career in commercial illustration.

He was intrigued with new trends in technology, industrial materials, and even fashion. In a catalog for a 1932 bedroom suite he designed for Herman Miller, Rohde appealed to female consumers using the language of fashion advertising: "'Her suit is plain, her hat is plain, her walk and manner are natural . . . yet this casual young woman is just about the smartest thing you could ever see along Park Avenue.' Thus runs the copy of an advertisement by one of America's foremost dressmakers. If these are the things that should distinguish a modern woman's clothes, will they not also appeal to her in articles for the home?"[2] Several years later, at the instigation of *Vogue,* he designed a costume for "the Man of the Future," a one-piece "solo" suit that anticipated space-age equipment and smart fabrics.

Within a year of Rohde's visit to the 1937 Paris Exposition, he was incorporating new ideas gleaned there into his furniture and interior designs. The exposition had energized Rohde's imagination and liberated his aesthetic boundaries. To his vocabulary of rectilinear and geometric forms he added subtle curvilinear shapes, ultimately experimenting with biomorphic contours, while his restrained approach to texture gave way to a richer and more dramatic mix of materials, with touches of luxury and fantasy. Also, in projects for the 1939/40 New York World's Fair, Rohde drew on Surrealism, evident in several of the Paris pavilions, to dramatize his exhibits.

Although it was only after the 1937 Exposition that Rohde incorporated Surrealist elements in his interiors and exhibit designs, this art movement would undoubtedly already have captured his attention through department store displays, print advertising, and numerous art exhibitions held in New York City. As early as 1926 the Brooklyn Museum's "International Exhibition of Modern Art," sponsored by the Société Anonyme and organized by its founders, Katherine Dreier, Marcel Duchamp, and Man Ray, provided American audiences with their first exposure to the work of the leading Surrealists. An avant-garde movement whose origins in the 1920s were political and literary, Surrealism had by the 1930s

expanded to the visual arts and, ultimately, to design and fashion. Surrealist painting, photography, and, later, design encompassed unexpected juxtapositions of both subjects and materials that were derived from explorations of the unconscious and dream states. Fluid biomorphic forms found in the work of Surrealist artists such as Jean Arp and Joan Miró were appropriated in the design of furniture, interiors, and objects in reaction to the minimalist aesthetic of rational modernism epitomized by the Bauhaus.

Salvador Dalí, whose shocking images and exotic lifestyle had been much publicized by the time he visited New York in 1934, was the movement's best-known artist; two years later, *Time* magazine featured him on its cover.[3] By 1936, when the Museum of Modern Art mounted the exhibition, "Fantastic Art, Dada, Surrealism," which was attended by 50,000 people, one-person shows of all the major Surrealist artists—including Arp, de Chirico, and Miró—had been presented in New York galleries. Among these was the Julien Levy Gallery, which opened in 1931 and was located at the corner opposite Rohde's office at Lexington and Fifty-seventh Streets.[4] Yet it was Rohde's visit to the 1937 Paris Exposition above all that became the catalyst for his own experimentation with Surrealist-inspired design.

Surrealism was manifest at the 1937 Exposition in wall murals, exhibit design, and displays of fine art. Among the displays that Rohde admired in Paris was the Pavillon d'Alimentation (Pavilion of Food), on whose facade three-dimensional posters combined fantasy and wit to promote such food products as biscuits, cognac, and wine. Commenting on these relief posters, he predicted that outdoor advertising in America would soon replicate this clever use of Surrealism.[5] Rohde also visited the Pavillon de l'Elégance, where Surrealism prevailed in a display devoted to French fashion supervised by Jeanne Lanvin, a doyenne of the

industry. Designed by Etienne Kohlmann, the exterior blended geometry with biomorphism. Inside was a fantasy world made entirely of white plaster, with architectural features such as oversized columns, facades reminiscent of images in de Chirico's paintings, and strange trees, as well as shells, musical instruments, and a curtain-sculpture hanging from a rod. The space was populated with faceless, elongated models, dramatically lit to cast exaggerated shadows against nearby walls: the mannequins were like actors in a silent film, their clothes transformed into art objects. Commenting on the choice of Surrealist imagery for the Pavillon de l'Elégance, Lanvin explained that the faceless mannequins were intended to add an air of mystery so that each viewer could see "the face of his dream, with his own imagination."[6]

A series of rooms installed at the fair's Polish Pavilion appears to have directly inspired Rohde's subsequent use of Surrealist elements in his interiors—specifically, the redesign of his office in 1939 and a music listening room conceived for the 1940 contemporary industrial design exhibition at New York's Metropolitan Museum. Described by the New York art critic Emily Genauer as Surrealist-inspired fantasies which drew gasps from visitors, the Polish Pavilion's living room, drawing room, and studio featured unexpected combinations of modern and rustic materials, such as a wall of rough-grained wood set off by an adjacent wall faced with squares of polished, grained marble. In another room string webbing hung from the ceiling. In the studio a couch draped with an oversized thick wool rug cascading from the seat to occupy most of the floor echoed the limpid melting forms of watches in Dalí's paintings.[7]

Another aspect of Rohde's post-Paris design expression—luxuriousness, fluid curves, and the juxtaposition of soft (fabric) and rigid (wood and glass) surfaces—took its inspiration from interiors in the SAD pavilion. Dining rooms, bedrooms, studies, and reception rooms were filled with high-end

LEFT
Gunther Furs advertisement in the article "Surrealism in Overalls," *Scribner's Magazine*, August 1938

BELOW
Container Corporation of America advertisement in the article "Surrealism in Overalls," *Scribner's Magazine*, August 1938

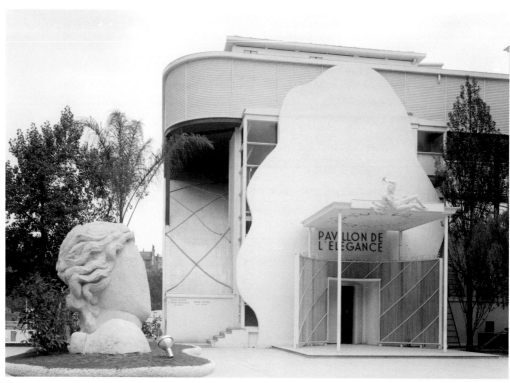

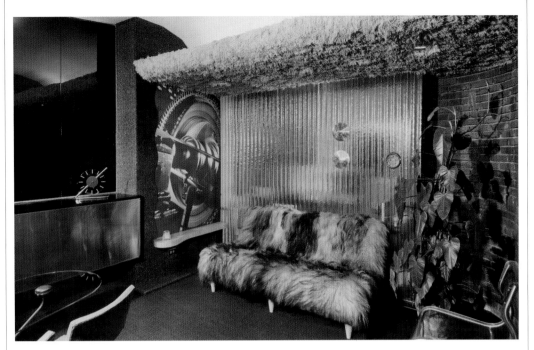

LEFT
Gilbert Rohde's office,
New York, designed by
Rohde, 1939

FOLLOWING PAGES
Living room for the Polish
Pavilion at the 1937 Paris
Exposition

custom furnishings by prominent designers, including Djo-Bourgeois, Jean Royère, Jacques Adnet, and Jules Leleu. With a few exceptions, most of the furniture employed traditional materials, showing a noticeable trend to large-scale pieces, with curved surfaces given prominence, and surfaces of wood veneers combined with rare (sharkskin) and delicate (parchment) materials.

The first application of Rohde's new aesthetic in designs for manufactured furniture appeared in two bedroom suites, No. 3910 and No. 3920, produced by Herman Miller and shown at the January 1939 Grand Rapids Furniture Market. One month later, pieces from the No. 3910 suite, along with new living room furniture, were showcased in a dressing room Rohde conceived for the Decorative Arts Pavilion at San Francisco's Golden Gate Exposition. The bedroom furniture combined paldao and quilted maple, woods with contrasting striped and rippled figures, juxtaposed with industrial materials—plate glass, brushed brass, and Lucite (a clear plastic made by DuPont). Saracen, an imitation leather fabric that was used in lieu of costlier leather or sharkskin, covered the concave drawer fronts—stacked like sliced tubes—in the vanity, chest, and dresser. Plywood was bent sculpturally in several of the bedroom pieces to produce curving vertical planes: in the night table a tight curve held three shelves; the vanity displayed a wide curve that, like the bed footboard, tapered almost imperceptibly to a narrower arc on the bottom edge and served as an armature for a cantilevered pair of drawers.

In Rohde's dressing room interior, strong textural contrasts in the wall treatments evoked the decor of rooms in the Polish Pavilion: opposite the visitor, the rear wall was finished in shiny ceramic tiles shaped like bricks; to the right, a nubby, hand-woven curtain covered the entire expanse; the third wall was upholstered with patent leather quilted in a grid pattern. Added to this palette of textures was plush, deeply tufted upholstery on a couch and rugs with a shaggy, deep pile—a type that had been ubiquitous in the SAD rooms.

The second bedroom suite—the No. 3920, made of East India rosewood and sequoia burl—demonstrated more directly how Rohde was stimulated by designs displayed in the SAD pavilion. For the base support of the chest and dresser Rohde adapted a look shown by several of the French designers: a raised stand in which each end was formed into a whimsical, almost flipperlike, curve. Emily Genauer, reporting on this suite in her *New York World-Telegram* column, noted that the pieces were "obviously an offshoot of the French modern designs" shown at the 1937 Paris Exposition.[8] Where Lucite legs had supplied a distinctive accent in the No. 3910 suite, here Rohde chose another new plastic, Plexiglas, for drawer pulls that caught the light with "the brilliance of diamonds." Brass accents—much in evidence in the Paris displays—provided additional reflective surfaces: pulls were secured by screws of brass; brass tacks were used decoratively to secure upholstered surfaces on the case pieces and on the padded fabric segments of the bed headboard and footboard; and tubular rods supported the triplex of adjustable mirrors of the vanity. The arrangement of drawer pulls on the chest mimicked, intentionally and with a note of humor, the lines of buttons on bellhop jackets.

In parallel to his projects for Herman Miller, Rohde was working out the final plans for his "Focal Exhibit on Community Interests" for the opening year of the 1939/40 New York World's Fair. The exhibit, one of several displays sponsored by the fair administration, presented through a sequence of animated sets the story of American life—from the subsistence living and hardship of Colonial times to the present

RIGHT
Cabinet/desk designed
by Renée Kinsbourg,
reproduced in *Meubles
Nouveaux*, 1937

BELOW
Boudoir in the Pavillon
Société Artistes et
Décorateurs at the 1937
Paris Exposition

LEFT
Herman Miller's 1939
catalog illustrating
Bedroom Group No. 3920,
designed by
Gilbert Rohde

No. 3968 Chair
No. 3920 Dressers

No. 3920 Chest

No. 3954 Bench

No. 3951 Easy Chair

No. 3920 Vanity Base

No. 3920 Vanity Mirror

BEDROOM GROUP

EAST INDIA ROSEWOOD
AND
SEQUOIA BURL

No. 3920 Bed
No. 3920 Bedside Table
No. 3920 Vanity
No. 3951 Chair
No. 3943 Table
No. 3954 Bench

For bedroom Pull-up Chairs see pages 39, 40, 41.
For Easy Chairs for the bedroom see pages 35, 36, 37, 38.

No. 3920 Bedside Table

No. 3920 Dresser Table

No. 3920 Dresser Mirror

No. 3920 Bed

era, transformed by science and technology, in which leisure was available to all. At its conclusion the exhibit emphasized that leisure must be integrated with social values to benefit the entire community, and it posed this final question to the audience: "At last man is freed in time and space. For what?"

Realism was deemed most effective for portraying the eighteenth century: the first set showed a typical Colonial family represented by mechanized wood figures dressed in authentic clothing styles of the period and performing such chores as chopping wood, spinning yarn, and plowing fields. However, for the climax of the Focal exhibit, a message of hope and promise in an idealized community in the twentieth century and beyond, Rohde turned to Surrealism. Like Lanvin, he recognized the power of Surrealist imagery to arouse "the imagination of the spectator."[9] With the imagination engaged, the public would be psychologically more receptive to absorbing the serious message of community ideals. The protagonist in this scene was man, viewed through a biomorphic cutout and set within a Surrealist landscape of earth and sky. An abstract figural construction, both fantastic and humorous, represented the five senses and the character of man. An oversized, free-floating eye, for example, symbolized sight and evoked images conceived by the French Surrealist André Masson. Bits of clothing—overalls above the waist (an American touch), pink-striped pants below—were intended to represent two aspects of man's nature: man as worker and man as perennially beholden to fashion. A vision of the future, the overarching theme of the fair, was revealed in a sequence of

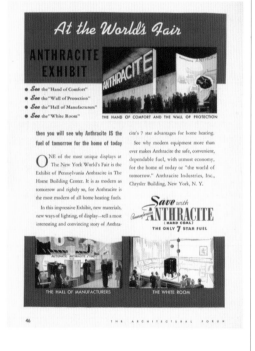

images displayed within Magritte-like clouds. Scenes of housing, factories, and schools represented a world in which society had achieved an integration of industrial, commercial, and social needs appropriate to a democracy, along with recreational options of all types—sports, travel, and entertainment—in a life of expanded leisure. The script, recorded by a male narrator, forecast an optimistic outlook, with the desired feeling of uplift (essential for buoying American spirits in the 1930s as the country struggled to emerge from the Depression) reinforcing the physical ascent of man in the final seconds of the drama to the brightest star, his home.

RIGHT

Armchair designed by
René Coulon for a dining
room by Jacques Adnet,
tempered glass and
leather, 1938

This chair was manufactured
by Saint–Gobain, for whom
Coulon and Adnet had designed
a pavilion at the 1937 Paris
Exposition.

OPPOSITE

Chair designed by Gilbert
Rohde, exhibited at the
1939/40 New York World's
Fair, stainless steel and
Plexiglas, c. 1938

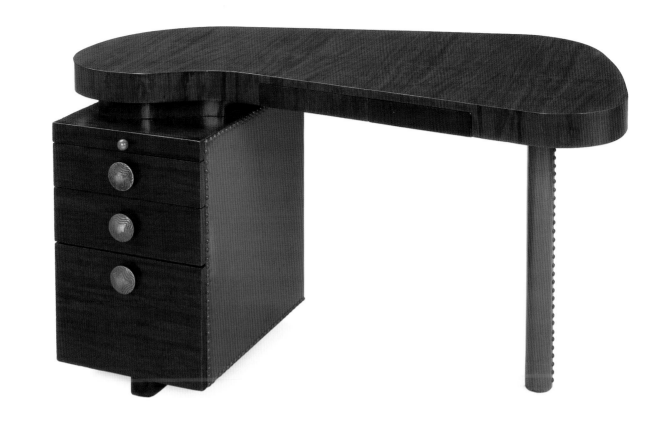

Fantasy played a role in a second New York World's Fair exhibit designed by Rohde, commissioned by the Anthracite Industries of northeastern Pennsylvania, the national center for hard-coal production. The client's goal was to convince the public that anthracite was a modern and, above all, a clean-burning fuel. To that end, Rohde used the color white liberally and dramatically throughout the displays of stokers, burners, and graphics accompanied by industry propaganda.

The focus of the 3,500-square-foot exhibit was a seven-foot-tall white plaster hand holding a lump of coal; set on a raised platform, the hand rose to a height of 13 feet, tall enough to tower over visitors. The hand was that of a woman, designated as "Nature's Gift to Man," its fingernails painted a seductive bright red. (An adjacent section featured the "White Room" with a man's white hand, "The Hand of Comfort," holding a red burner). The 4-foot-diameter chunk of coal was, in reality, hollow. Rigged with hidden lights, it glowed intermittently, starting with a flicker that gradually increased to a bright white light, signifying intense heat. Beyond the hand a wall showed a house that, when illuminated, revealed the anthracite heating system within. All the while, visitors stood on a floor of dark glass that also lit up at regular intervals. In conceiving this display, Rohde may have recalled the striking white interior in the Pavillon de l'Elégance and the clever manipulations of scale used there. In any case, the color, material, size, and sensuality of "Nature's Gift to Man" drew on the mystery and imagination characteristic of Surrealist imagery.

Rohde transposed the showmanship displayed in his fair exhibits to Herman Miller's new Chicago showroom inaugurated in the fall of 1939, incorporating, among other features, dramatic lighting and biomorphic forms. At the showroom entrance, visitors would have been immediately struck by Rohde's innovative design scheme that signaled artistic sophistication and the new note of luxury stimulated by his Paris trip. To the left, the reception area was defined by a free-standing, sweeping curvilinear wall, pierced with a biomorphic cutout. Evocative of Jean Arp's wood relief constructions and similarly shaped floating forms seen in many of Joan Miró's paintings, a window beckoned visitors to explore the room vignettes visible beyond. Modular sectional seating hugged the curving wall, emphasizing its undulating contour. Above, a biomorphic floating wood panel was suspended from the ceiling, its perimeter set aglow by lights concealed above. To the right, a straight wall, covered with patent leather that was padded and quilted in a diamond pattern, served as the backdrop for the receptionist's desk and other furniture displays. A counterpoint to the curvilinear elements, the thickly upholstered wall was flamboyantly luxurious; it reprised the San Francisco installation and reinterpreted, in industrially made fabric, the satin-quilted wall treatments shown in the 1937 SAD pavilion.

Luxury and Surrealism coalesced in Rohde's Paldao living and dining room group for Herman Miller, an eighty-piece series designed in 1940 and marketed the following year. Tables and desks that evoked Arp's work represented the first American instance of manufactured biomorphic designs.[10] At the same time, Rohde transposed the sensual character of his bedroom pieces, with their soft surfaces and sculptural details, to furniture for the more public living rooms and dining rooms. Even the names chosen for the wood finishes were voluptuous—Sable, Mink, Beaver, and Persian Grey—each one an allusion to the softness of fur.

Biomorphism appeared most dramatically in a desk and a coffee table whose planar surfaces featured similar plastic forms. In Herman Miller's catalog the desk was described as having "an ectoplastic shape of constantly varying curves and straight lines," Rohde's memorable nomenclature for these new forms.[11] In both pieces the articulation of parts—planes, legs, and masses—suggested a sculptural assemblage. Raised slightly, the desktop floated above the pedestal, adding to the sculptural effect. Legs wrapped in imitation leather, which was also used to cover one surface of the desk pedestal, lent a tactile quality to these and other pieces in the Paldao group.

Rohde discussed his new aesthetic direction in "Modern and Modern," an article published in fall 1941, explaining that there were several "moderns" according to specific cultural circumstances. (His pluralist perspective is particularly relevant today as modernism is reexamined and reinterpreted by scholars and designers.) While Rohde praised the pioneering work of Gropius and the Bauhaus, he proposed that, with improved economic conditions, it was appropriate and necessary to go beyond strict and spare functionalism and to humanize design: "We are now approaching the point where we can take physical function for granted. We can again relax in our intellectual rationalization and assume that a drawer is the right size, and a table the right height, and begin to think of the psychological needs of human beings. There are certain things that have been experienced by human beings for so many ages that we can say they are functional needs . . . That is why we may now design furniture with some decorative elements that are not needed for physical functioning. It is something unnecessary to the opening of the drawer, but very necessary to the happiness of the soul."[12]

As much as any piece in the Paldao group, the dining table, in which every surface emphasized the sensual and tactile, expressed Rohde's idea of "happiness of the soul." Decorative elements—brass inlays of undulating lines interspersed with tiny stars, an upholstered base, and faceted legs—contributed to a luxurious, handcrafted character. Beneath the tabletop, octagonal-faceted legs that slanted inward from each corner attached to a base upholstered in imitation leather. The overall image, like the desk and coffee table, was of an object that merged function with art.

Rohde's desire to integrate reason and emotion in his own work emulated qualities he had observed at the 1937 Paris Exposition. Shortly after his return, he had told an interviewer, "What really makes the fair so good is the fact that two elements—showmanship and beauty—have been successfully consolidated. The French have merged emotion and reason in such a way that a high aesthetic value is attached to the exhibits and not one iota of dramatic value is lost."[13] To engage audiences in the programmatic ideas of exhibits, Rohde appropriated the visual drama of Surrealist imagery, while in his furniture and interiors he commingled sensuality, fantasy, and functionalism. His blending of fine art and design, especially in the Paldao series, anticipated the sculptural furniture forms that became emblematic of American modernism in the postwar era.

Phyllis Ross, an independent scholar based in New York City, is currently completing the first monograph on Gilbert Rohde, which will be published in 2009.

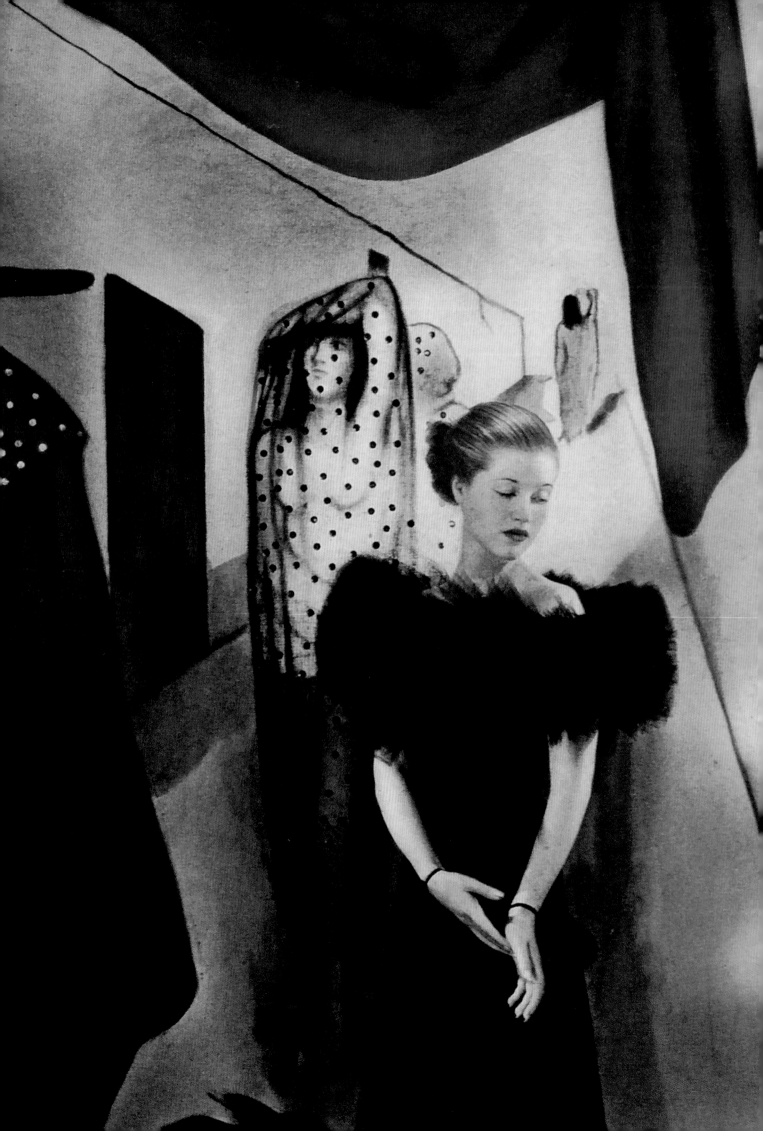

KENNETH E. SILVER

NEO-ROMANTICS

Whether you think that Abstract Expressionist painting triumphed over the Parisian avant-garde or that New York stole modern art from the French, two positions that have been convincingly argued,[1] there is little disagreement that by the time of Jackson Pollock's drip paintings in the late 1940s and '50s, the prestige and power of modern art had been definitively transferred from Paris to New York. But it was not only high modernist abstraction—in the form of those big, ambitious Action Paintings—that clobbered the Gallic product and accounted for the success of the American claim to international avant-garde hegemony by the second half of the twentieth century. Although they are now mostly

Season program for the
Ballet Russe de Monte
Carlo, with stage designs
for *Devil's Holiday* by
Eugene Berman (above)
and *Bacchanale* (below) by
Salvador Dalí, 1939–40

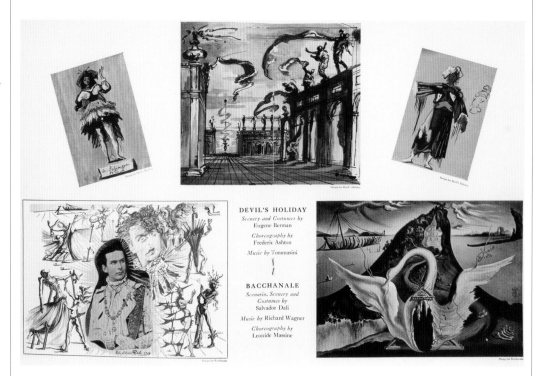

DEVIL'S HOLIDAY
Scenery and Costumes by
Eugene Berman
Choreography by
Frederic Ashton
Music by Tommasini

BACCHANALE
*Scenario, Scenery and
Costumes by*
Salvador Dali
Music by Richard Wagner
Choreography by
Leonide Massine

forgotten, the Neo-romantic painters — including Christian Bérard, Pavel Tchelitchew, Eugene Berman, and his brother, Léonide — were key to the early stages of the seismic Paris–New York cultural shift in the 1930s and in ways that the canonical art historical accounts have ignored.

The expanse of early twentieth-century Parisian art was daunting for anyone on these shores who might have thought of challenging French dominance. Matisse, Derain, Modigliani, Bonnard, Soutine, Braque, Gris, Chagall, Duchamp, Picabia, Utrillo, Lipchitz, Rouault, Léger, Delaunay, Brancusi — these are only the names that come immediately to mind from a list that is headed, of course, by Pablo Picasso, who loomed larger than anyone else in Paris or New York. When it came to collecting contemporary art, France had long dominated American taste.[2] With the establishment of the Museum of Modern Art in New York in 1929, the Parisian bias was made official, leading to the creation of a permanent collection that has remained unrivaled in the world for the richness of its Parisian holdings of the period 1900–50. In New York the Metropolitan Museum also collected modern French art and, at least briefly in the early 1930s, Maud and Chester Dale operated a Museum of French Art on East Sixty-sixth Street.[3]

However, as early as 1915, French artists were starting to follow the trail of contemporary French art to the United States, and several, including Marcel Duchamp, began to spend extended periods in New York. Presciently, Duchamp theorized that the future of modern art lay in the United States rather than in Europe.[4] The first real migration of a contemporary art movement from France to America began in 1934 with the visit of the renowned Neo-romantic painter Pavel Tchelitchew, who resided in the United States for long intervals until his death 1957. Tchelitchew was followed by Eugene Berman, who moved to New York in 1936, and his brother, Léonide, who arrived in the late 1940s. These young painters had already received a good deal of attention at the time of their first Paris exhibition at the Galerie Druet in the winter of 1926.

American galleries and museums heralded the work of Neo-romantic painters with a series of exhibitions beginning in the early 1930s. In 1931 visionary museum director Chick Austin organized an exhibition of the work of Bérard, Berman, Léonide, and Tchelitchew at the Wadsworth Atheneum in Hartford, followed in 1932 by a joint Berman and Tchelitchew exhibition at the Vassar College Art Gallery. That same year, Julien Levy organized an exhibition of Berman's art at his new gallery on Madison Avenue and in the two succeeding years offered exhibitions (first drawings, then paintings) of the work of Tchelitchew. In 1942 the Museum of Modern Art (MoMA) bought Tchelitchew's large, important painting *Hide and Seek* and also gave him a retrospective exhibition. The Institute of Modern Art in Boston gave Berman his first retrospective in 1941, while MoMA organized a show devoted to his sets and costume designs in 1945.

For the movement's supporters, Neo-romanticism offered an appealing alternative to Picasso's domination of modern art. Neo-romantics' work was distinguished by rejection of abstraction generally and of Cubism in particular. Their favored subjects were the human form, including portraiture, and one kind or another of dreamy city or landscape. When James Thrall Soby, the American collector, curator, and critic, published his meditation on contemporary trends, *After Picasso*, in 1935, he was at once respectful of the fifty-four-year-old Spanish artist and quick to suggest that perhaps Picasso's moment had passed: "No matter how revolutionary his most recent painting may be, it is nonetheless the work

of a man who has for thirty years been the great contemporary artist."[5] Soby saw what he believed was a salutary assault on Cubism's abstractions in the "return to sentiment"[6] of the Neo-romantics and, along with the Surrealists, a desire to "touch the emotions rather than to appeal to the intellect."[7] This was an old debate—whether art spoke to the mind or the soul—given renewed vitality, for Soby, in the work of the younger generation: "In place of man's ideas, which the Cubists had painted, the Neo-romantics painted man's spirit."[8]

There is an interesting mix of the old and new, the forward looking and *retardataire*, and, especially, of the elite and popular in the art and critical discourse of the Neo-romantics. This may owe much to the dominance of this eminently Parisian art movement, at least in New York, by two White Russians—Tchelitchew and Berman. Accounts of the period tell us that Tchelitchew's "family belonged to the aristocracy and his education was largely acquired through private tutors,"[9] and that "Berman had arrived in Paris in the early 1920s from his native Russia where, before the Soviet victory, his family had lived in great opulence."[10] A certain "gone with the wind" quality—*à la mode russe*—pervades the Neo-romantic phenomenon in New York. (It is worth keeping in mind that the Russian Tea Room, which opened its doors at 150 West Fifty-seventh Street in 1929, did much to convey this nostalgia for Old Russia to the local population and its tourists.)

Yet, contrarily, there was also an all-American, commercially attuned side to Neo-romanticism. In a 1937 advertisement in the *New York Times* for Wanamaker's department store we learn that, "Eugene Berman's paintings inspired designs of these exclusive sheer linen handkerchiefs. Mysterious landscapes, battlements and flowers mingle in Berman's mellow blues, greens, grays, gold, peach. Street Floor. 50 cents."[11] The Neo-romantic artists also designed photo shoots and covers for *Vogue* and even influenced advertising campaigns for consumer products. In the late 1940s the textile manufacturer William Heller advertised his latest jersey fabric draped over Christian Bérard's sets for "that classic ballet *Seventh Symphony*," as "Mlle Nina Novak, Ballerina of the Ballet Russe de Monte Carlo" modeled a gown of the same fabric, "a miracle of softness, so inspired in its colors."[12]

Indeed, if Parisian taste in New York by the 1930s was of a distinctly Russified kind, this was in large part due to the notoriety surrounding the collaborations between Neo-romantic artists and choreographer George Balanchine. In *After Picasso* Soby commented that Christian Bérard's sketch for the ballet curtain of *Mozartiana* "shows the unpremeditated and fragile record of an impulse" and asserted that Tchelitchew's "genius for the theatre is proved beyond doubt by the forceful dramatics of his *décor* for the ballet *Errante*, recently produced with great success in New York. Indeed, the atmosphere of the theatre," he continued, "may be a necessary supplement to

Tchelitchew's art, giving a warmth and motion which his paintings lack, and its problems a field for his special ingenuity."[13] *Errante,* which Tchelitchew designed for Balanchine's new American Ballet Company (forerunner of the New York City Ballet), brought the two gifted Russians together in New York. Set to an orchestral arrangement of Schubert's *Wanderer* fantasy, the one-act ballet premiered at the Adelphi Theatre on March 11, 1935, two years after it had first been presented at the Théâtre des Champs-Elysées in Paris.[14] In Tchelitchew's book for the ballet, based on the Schmidt von Lübeck poem set to music by Schubert, a female wanderer "seeks love amid phantom dreams; she encounters figures of hope, despair and memory in an atmosphere of dark shadow and diffused light . . . characters were described as Woman in Green, Youths, Shadows, Angels, Revolutionaries."[15] In the colored gouache and ink drawings by Tchelitchew and the black-and-white photos of *Errante* by George Platt Lynes the simplicity, lyricism, and immense *chic* of the costumes are of a piece with the contemporaneous designs for Balanchine's *Mozartiana* by fellow Neo-romantic artist Bérard. In contradistinction to the alternately Cubist, abstract, and primitivist productions which Picasso, Matisse, Léger, and many other contemporary artists had provided for Diaghilev's Ballets Russes and Rolf de Maré's Ballet Suédois productions in Paris, Tchelitchew's, Bérard's, and Berman's ballets look self-consciously and, not surprisingly, "romantic" in their attempts to convey not modern life per se but a timeless realm of high emotions and deep ideas in a modern key. Among the other ballets Tchelitchew designed for Balanchine were *Orpheus and Eurydice* (1936), *Balustrade* (1941), and *Concierto de Mozart* (1942). Berman's collaborations with Balanchine included *Concerto Barocco* (1941), *Danses Concertantes* (1944), and *Le Bourgeois Gentilhomme* (1944).

Edward Alden Jewell discussed Berman's two recent Balanchine collaborations in the *New York Times* in September 1944: "Eugene Berman, like Marc Chagall, seems to me to attain in work for ballet a stature not always—perhaps seldom—realized in easel painting. Berman concocts, with elegance and with no sense of straining for effect, an atmospheric envelope. He makes the ideal collaborator, and nicely integrated collaboration is essential to full, rounded harmoniousness in the realm of ballet, as in the realms of opera and theatre."[16]

In fact Jewell might have added the "realm of war" to his list of activities for which collaborative effort is essential, since that was the context in which he was writing. Just before and after America's entry into World War II, the willingness of foreigners on U.S. soil and even of newly minted citizen-artists like Berman to join in the national effort was much discussed. In his introduction to the catalog for Berman's 1941–42 retrospective at Boston's Institute of Modern Art (which opened just before the bombing at Pearl

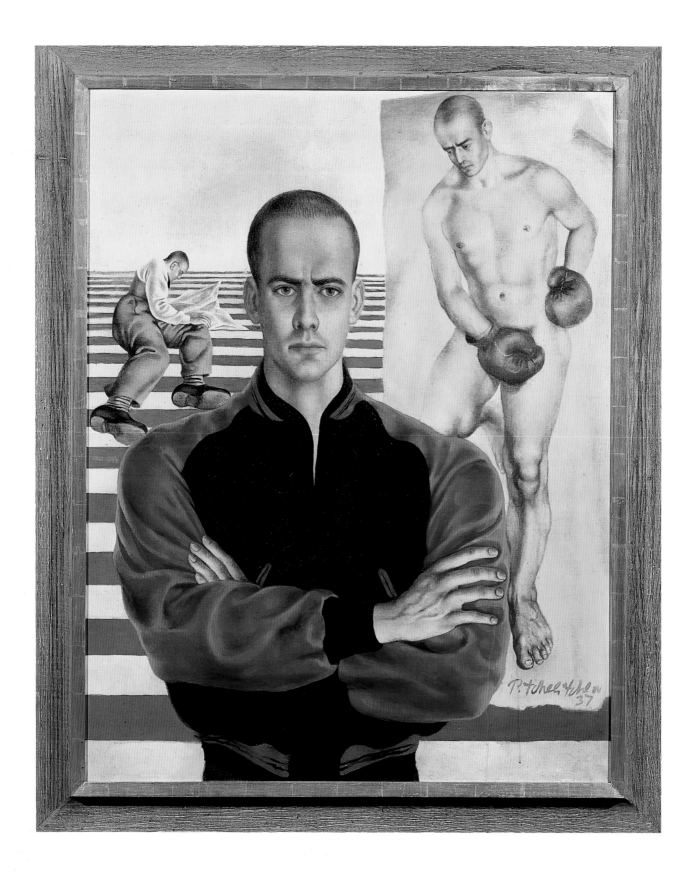

Hide and Seek by Pavel Tchelitchew, oil on canvas, 1940–42

Harbor and traveled to six American cities during the early months of the war), Soby first made a claim for the artist's vision as relevant to current events, refuting charges that, like other Neo-romantics, Berman was out of touch with reality:

For a long time, there were many who, admiring Berman's art, nevertheless found it unrelated to contemporaneity, and confused its mournful mood with that affected by eighteenth century aesthetes. By a tragic irony, they have been proved wrong. For if Berman's melancholy at first seemed personal, or at most national, it has lately come to be almost universal in application. His landscapes in ruin are now reality itself; in real life, his homeless, destitute figures pause wearily in the bare fields of all Europe. He has not, of course, attempted to be either historian or prophet, but like all true artists, he has been sensitive to portents which have escaped the view of laymen.[17]

Having thus vouched for Berman's timeliness and perhaps even his clairvoyant utility, Soby then went on to explain that the finest qualities which foreign artists have to offer must be nurtured, to the eventual benefit of home-grown artistic production: "[Berman's] inspiration has always been basically Old World, and the mark of the New World must be slowly inculcated upon it . . . The permanent adoption of Berman and other refugee artists would surely bring nearer the good age of American painting, so blatantly and prematurely announced in past years."[18]

It was this question—whether foreign artists (read: Parisians) could be made into Americans and whether, in so doing, American art would prosper—that dominated critical discussions of art in New York during World War II. When Pierre Matisse, art-dealer son of Henri Matisse, organized

his "Artists in Exile" exhibition at his gallery at 41 East Fifty-seventh Street in March 1942, these were the issues that James Thrall Soby and Nicolas Calas addressed in the catalog. In his essay "Europe" Soby wrote:

Here are fourteen artists who have come to America to live and work. They are a disparate group, but all belong to the rare company of those who have brought originality and authority to the art of their period. Their presence can mean much or little. It can mean the beginning of a period during which the American traditions of freedom and generosity may implement a new internationalism in art, centered in this country. Or it can mean the reverse; it can mean that American artists and patrons may form a xenophobic circle and wait for such men to go away, leaving our art as it was before.

This last possibility, of course, was to be avoided: "Fortunately, numbers of American artists and interested laymen are aware that a sympathetic relationship with refugee painters and sculptors can have a broadening effect on native tradition, while helping to preserve the cultural impetus of Europe." Soby wanted to be sure that a certain kind of art-world jingoism with which he was familiar would not reappear and that there would be no risk of looking all too much like our fascist enemies: "These Americans reject the isolationist viewpoint which ten years ago sought refuge, and an excuse, in Regionalism and the American Scene movement. They know that art transcends geography. They want American art to have equal voice with that of Europe in the new world, but they check their ambition at this point, knowing that beyond lies the dread bait of imperialism which all men of

LEFT
Program cover drawing
by Pavel Tchelitchew
for the Paris production
of George Balanchine's
Errante, pen and ink wash
on paper, 1933

BELOW
Set design for *Seventh
Symphony*, drawn by
Christian Bérard,
watercolor and gouache on
paper, c. 1938

FOLLOWING PAGES
"Women in Blue" in the
New York production
of George Balanchine's
Errante, drawn by
Pavel Tchelitchew,
watercolor, 1935

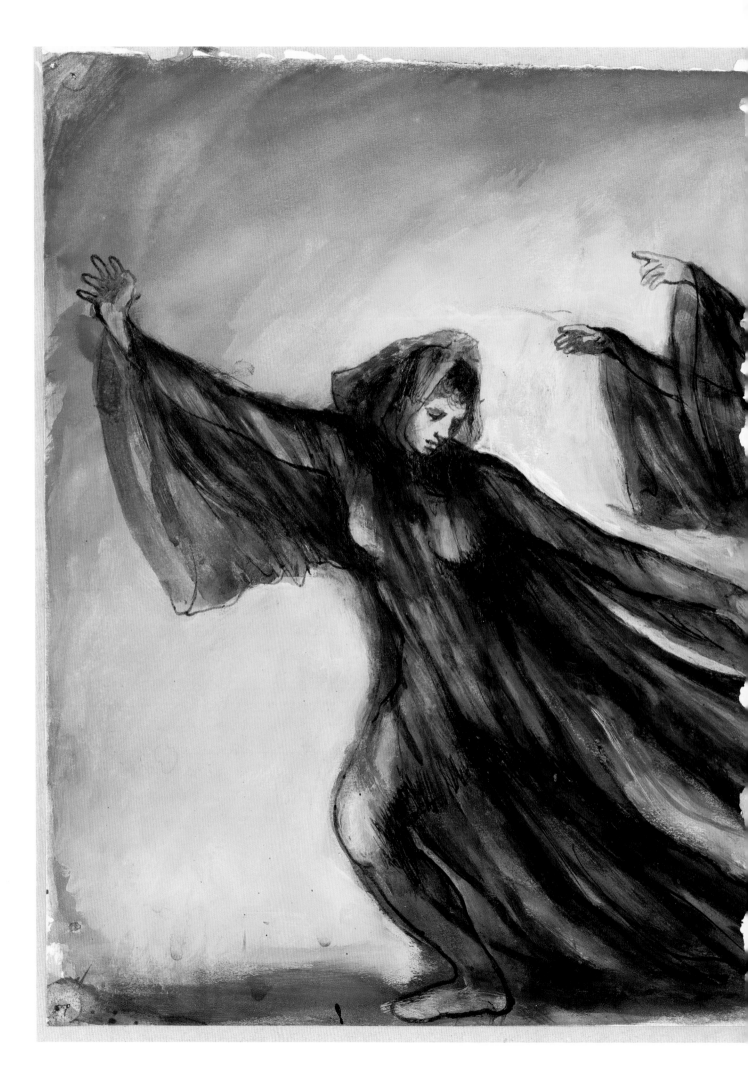

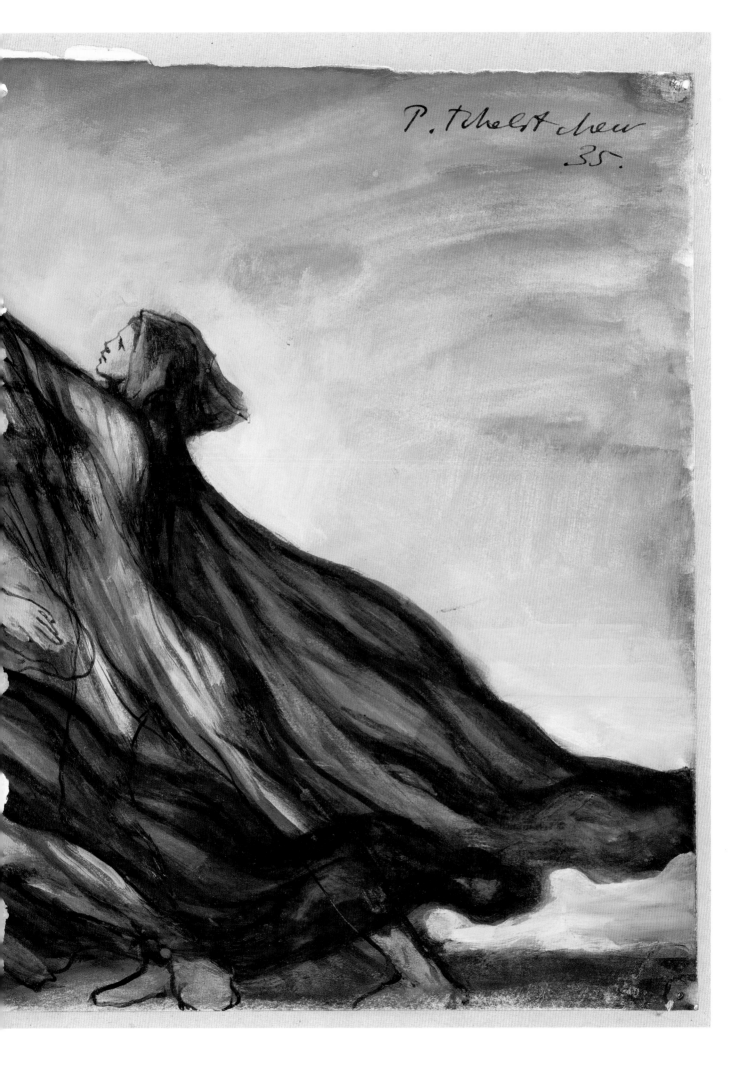

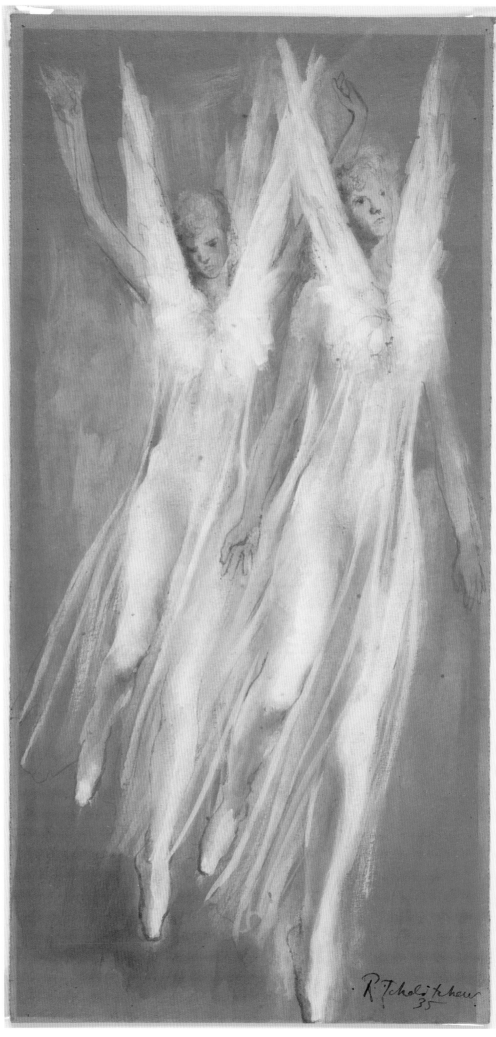

"Angels in White" in the New York production of George Balanchine's *Errante*, drawn by Pavel Tchelitchew, watercolor, 1935

LEFT
"The Funeral" in the
New York production
of George Balanchine's
Errante, drawn by
Pavel Tchelitchew,
gouache and ink on
paper, 1935

BELOW
Drawing of dresses
designed by Pavel
Tchelitchew, inspired by
his costumes for the ballet
Errante, reproduced in
Vogue, July 15, 1935

CLOUDS
of GLORY

● Flowing across the page, like sunset clouds before a night wind, are three figures that seem to come direct from Greek drama. They were drawn by Pavel Tchelitchew and took their inspiration from his ballet, "Errante," the story of a woman pursued by the furies of her own soul. And their immediate function is to clothe, in the strikingly new but age-old Greek tradition, three outstanding women of to-day—a designer, a dancer, and an actress.

● The glimmering, opalescent effect of all three dresses is achieved by the use of diaphanous chiffon in one colour over a satin slip in another colour. The dress farthest left is worn by Miss Muriel King, and its enchanting violet hue is created by pale blue satin seen through a mist of peach-pink chiffon.

● In the centre, Miss Florence Meyer's dress has a turquoise satin sheath under a haze of trailing maroon chiffon. The huge sleeves are lined with chiffon.

● At the right is Princess Nathalie Paley, drifting onward in a swirling cloud of black chiffon that almost obscures the champagne coloured satin beneath. A round, stiff ruff of black grosgrain ribbon, crinkled exactly like a paper Christmas button, runs across the back and around the shoulders, making a point under each arm. The chiffon bar smocking across the front; and below that, it blousès where it breaks. All three dresses from Altman

heart must suspect."[19] Can we blame Soby for wanting to have his cake and eat it too—wanting Europe and the United States to share in artistic glory but, at the same time, dreaming of a "new internationalism in art" whose center would no longer be Paris, but New York?

In his half of the Old World/New World discussion, In his essay "America," Calas wrote: "If the excellence attained by the painters and sculptors of the Paris School is to have a future, the works of the immigrant must be grafted to American life. For this graft to be successful . . . the American should try to understand the European artist's aims; the European should try to grasp the contradiction between the cultural conditions of North America and Europe." In fact, Calas knew of a group of artists that could serve as a model for the kind of transatlantic cultural reconciliation he had in mind: "The Neo-romantics, by a combination of anecdote and essential qualities, use

the American scene as a medium for harmonizing the eternal contradiction between the universal (such elements as sky, water and earth) and the personal (for instance memories of other places)."[20] Although they usually go unnoticed—owing to the dominance of Fernand Léger, Marc Chagall, Max Ernst, Yves Tanguy, André Breton, and Piet Mondrian—Pavel Tchelitchew and Eugene Berman are also present in the famous photograph of the fourteen exiled artists which George Platt Lynes took at Pierre Matisse's request on a late-winter day in 1942. Berman, at the extreme right of the second row, and Tchelitchew, at the very back—two harmonizers of the "eternal contradiction"—assume their place at the edges of this Mount Parnassus of modern art. But marginalized though they seem to be for eternity, they were two of the pioneer Neo-romantic wanderers—*les errants*—who first brought Parisian modernism to New York.

Kenneth E. Silver is Professor of modern art in the Art History Department at New York University and Adjunct Curator at the Bruce Museum, Greenwich, Connecticut. He has curated and written books for numerous exhibitions, most recently *Sarah Bernhardt: The Art of High Drama* (Jewish Museum, with Carol Ockman), and is the author of the critical study of the political impact on culture during the interwar years, *Esprit de Corps: The Art of the Parisian Avant-Garde and the First World War, 1914–1925*.

FURTHER READING AND NOTES

While the literature on Paris and New York is voluminous, a more limited number of books explore the relationship of the two cities, some within the broader context of American and European exchanges. The Museum of the City of New York's exhibition shares its name with a celebrated exhibition, organized by K. G. Pontus Hulten, that inaugurated Paris's Centre National d'Art et de Culture Georges Pompidou in 1977. Spanning the years 1908 through 1968 and focusing on art, it was accompanied by two books, both published by the Centre Pompidou: a massive compendium, *Paris–New York*, edited by Hulten, and the more modest *Paris–New York: Un Album*, for which Hulten wrote a brief introduction. The following books were also particularly helpful in preparing this catalog and its accompanying exhibition:

Bacon, Mardges. *Le Corbusier in America: Travels in the Land of the Timid.* Cambridge, Mass.: MIT Press, 2001.

Clair, Jean. *The 1920s: Age of the Metropolis.* Montreal: Montreal Museum of Fine Arts, 1991.

Cohen, Jean-Louis. *Scenes of the World to Come: European Architecture and the American Challenge, 1893–1960.* Paris: Flammarion, 1995.

Corn, Wanda M. *The Great American Thing: Modern Art and National Identity, 1915–1935.* Berkeley and Los Angeles: University of California Press, 1999.

Guilbaut, Serge. *How New York Stole the Idea of Modern Art: Abstract Expressionism, Freedom, and the Cold War.* Translated by Arthur Goldhammer. Chicago: University of Chicago Press, 1983.

Rodgers, Daniel T. *Atlantic Crossings: Social Politics in a Progressive Age.* Cambridge, Mass.: Belknap Press of Harvard University Press, 1998.

For more specific references on the relationship between Paris and New York, the following notes serve a bibliographic function.

Introduction

1. Sigmund Skard, *The American Myth and the European Mind* (Philadelphia: University of Pennsylvania, 1961), 59. Skard dates the march to December 1918; I am indebted to Jean-Louis Cohen for correcting this.
2. In his book *Paris: Capital of the World* (Cambridge, Mass.: Belknap Press of Harvard University Press, 2002), Patrice Higonnet notes that the myth of Paris as capital of the nineteenth century was a concept originating with Karl Ludwig Börne (1786–1837).
3. Tyler Stovall, "Paris in the Age of Anxiety, 1919–39," in *Anxious Visions: Surrealist Art*, ed. Sidra Stich (New York: Abbeville Press, 1990), 201.
4. Robert J. Young, *Marketing Marianne: French Propaganda in America, 1900–1940* (Piscataway, N.J.: Rutgers University Press, 2004), 84.
5. Secretary of Commerce Herbert Hoover conducted surveys that led to Hughes's decision not to participate. For more information on the subject, see Marilyn F. Friedman, "The United States and the 1925 Paris Exposition: Opportunity Lost and Found," *Studies in the Decorative Arts: The Bard Graduate Center for Studies in the Decorative Arts, Design, and Culture* (Fall–Winter 2005–06): 94–119.
6. Quoted in Joan Kahr, *Edgar Brandt: Master of Art Deco Ironwork* (New York: Harry N. Abrams, 1999), 126. Kahr's book is also the source of my subsequent discussion of Brandt's work in New York.
7. Henry Creange, the Cheney Brothers' art director, was one of the commissioners appointed by Herbert Hoover to organize the tour of the 1925 Paris Exposition.
8. David Garrard Lowe, *Art Deco New York* (New York: Watson-Guptill Publications, 2004), 49.
9. The galleries were designed by architect Ely Jacques Kahn. For this and other information on these exhibitions see Marilyn F. Friedman, *Selling Good Design: Promoting the Early Modern Interior* (New York: Rizzoli, 2003).
10. Wendy Kaplan, "'The Filter of American Taste': Design in the USA in the 1920s," in *Art Deco: 1910–1939*, eds. Charlotte Benton et al. (London: Victoria and Albert Museum, 2003), 336.
11. See Marilyn F. Friedman, "Defining Modernism at the American Designers' Gallery, New York," *Studies in the Decorative Arts* 14, no. 2 (Spring–Summer 2007): 79–116.
12. I am indebted to David A. Hanks's essay in this book, "From Deco to Streamlined: Donald Deskey and Raymond Loewy," for this information.
13. Amy Azzarito provided this material. Her essay "New York Haute Cuisine" appears in this book.
14. This information is contained within the New York World's Fair files of the New York Public Library.
15. Thomas Adams et al., *Regional Plan of New York and Its Environs: Volume 2, The Building of the City* (New York: Committee on Regional Plan of New York and Its Environs, 1931), 58.
16. Ibid., 112.
17. Robert A. M. Stern et al., *New York 1900: Metropolitan Architecture and Urbanism 1890–1915* (1983; repr., New York: Rizzoli, 1992), 145.
18. Carol Herselle Krinsky, *Rockefeller Center* (New York: Oxford University Press, 1978), 66.
19. Edmund Wilson, "The Aesthetic Upheaval in France: The Influence of Jazz in Paris and the Americanization of French Literature and Art," *Vanity Fair*, February 1922, 49, 100; and Jean Cocteau, "Jazz-Band" (1919), reprint in his *Le Rappel à l'ordre* (Paris: Editions Stock, 1926), 140, quoted in Jody Blake's essay in this book, "Africa on the Spiral: Jazz in New York and Paris Between the Wars."
20. From the menu of the 1939/40 New York World's Fair French Restaurant, located in the Miss Frank E. Buttolph American Menu Collection, the New York Public Library.
21. Craig Claiborne, "Le Mistral is the Newest Offshoot of Pavillon Tree," *New York Times*, December 11, 1964.
22. *The French Chef* premiered on February 11, 1963.
23. Nelson Rockefeller's quote and other information on the apartment appear in John Loring, "Nelson Rockefeller's Fifth Avenue Apartment," *Architectural Digest*, April 2001, 102, 106, 110, 114, 118.
24. Peyton Boswell was the *New York Herald* critic, and the comment was later republished in his obituary, *New York Times*, December 19, 1936.
25. "Marketing Modern Art in America: From the Armory Show to the Department Store," on the website "The Virtual Armory Show," http://xroads.virginia.edu/~museum/armory/marketing.html, created by Shelly Staples, American Studies Program, University of Virginia, 2001.
26. The term "experimental museum" was used by Katherine Dreier in a 1926 letter to William Henry Fox and is quoted in Jennifer R. Gross's essay, "An Artists' Museum," in *The Société Anonyme: Modernism for America,* ed. Jennifer R. Gross (New Haven and London: Yale University Press, 2006), 1.
27. Alfred H. Barr, Jr., *Cubism and Abstract Art* (New York: Museum of Modern Art, 1936), 19. Another valuable source was Barbara Hess, *Abstract Expressionism* (Cologne: Taschen, 2006).

Metropolis in the Mirror: Planning Regional New York and Paris

1. No publication has been devoted to the Paris-New York relationship that could be compared to Josef Paul Kleihues and Christina Rathgeber, eds., *Berlin–New York: Like and Unlike; Essays on Architecture and Art from 1870 to the Present* (New York: Rizzoli, 1993). The seminal catalog of the Pompidou Center: K. G. Pontus Hulten, *Paris–New York* (Paris: Centre Georges Pompidou, 1977) doesn't touch on these issues.
2. Préfecture du Département de la Seine, Commission d'Extension de Paris (Louis Bonnier, Marcel Poëte), *Considérations techniques préliminaires: La circulation, les espaces libres* (Paris, Impr. de Chaix, 1913). On the history of Paris planning, see the general considerations of Norma Evenson in *Paris: A Century of Change, 1878–1978* (New Haven: Yale University Press, 1979).
3. Harvey A. Kantor, "Charles Dyer Norton and the Origins of the Regional Plan of New York," *Journal of the American Institute of Planners* 39, no. 3 (1973): 35–41. For Burnham's plan see Carl Smith, *The Plan of Chicago: Daniel Burnham and the Remaking of the American City* (Chicago: University of Chicago Press, 2006).

4. Marc Bédarida, "Compassion et aide américaines: La reconstruction de Reims (1918-1928)," in *Américanisme et modernité, l'idéal américain dans l'architecture,* eds. Jean-Louis Cohen and Hubert Damisch (Paris: Flammarion/Ecole des Hautes Etudes en Sciences Sociales, 1993), 249-66.

5. Joseph Marrast, ed., *L'Œuvre de Henri Prost: Architecture et urbanisme* (Paris: Académie d'architecture, 1960).

6. Geo. [sic] Ford, *L'urbanisme en pratique; Précis de l'urbanisme dans toute son extension; Pratique comparée en Amérique et en Europe* (Paris: E. Leroux, 1920).

7. Henri Sellier, "Charles Dyer Norton," *La Vie urbaine* 5 (1923): 223-30.

8. See, for instance, André Ménabréa, *La réorganisation de Paris et des grandes villes françaises, appel de la ligue urbaine* (Paris: Association française pour le développement des travaux publics, 1928).

9. Jean Claude Nicolas Forestier, *Grandes villes et systèmes de parcs* (Paris: Hachette, 1906).

10. Robert Fishman, "The Regional Plan and the Transformation of the Industrial Metropolis," in *The Landscape of Modernity: Essays on New York City 1900-1940,* eds. David Ward and Olivier Zunz (New York: Russell Sage Foundation, 1992), 106-25; David A. Johnson, *Planning the Great Metropolis: The 1929 Regional Plan of New York and Its Environs* (London, New York: E & FN Spon, 1996); Harvey A. Kantor, "Modern Urban Planning in New York City: Origins and Evolution 1890-1933" (Ph.D. diss., New York University, 1971).

11. "L'aménagement de la région parisienne," special issue, *Urbanisme* 4 (Dec. 1935-Jan. 1936).

12. Three issues of *Paris et la région capitale,* edited by architect and planner Gaston Bardet, were published in 1937.

13. Roger-Henri Guerrand and Christine Moissinac, *Henri Sellier, urbaniste et réformateur social* (Paris: La Découverte, 2005).

14. Albert Guérard, *L'Avenir de Paris* (Paris: Payot, 1929). Guérard discussed the report *From Plan to Reality* (New York: Regional Plan Association, Inc., 1933) in *Urbanisme* and commented on the plan in "L'urbanisme régional aux Etats-Unis," *Urbanisme* 5 (Mar.-Apr. 1936): 140-42. He also wrote "Paris: Yesterday and Tomorrow," *Journal of the American Institute of Planners* 19 (Winter 1953): 10-19.

15. Charles D. Norton, letter to Frederic Delano, August 21, 1922, quoted in Johnson, *Planning the Great Metropolis,* 79.

16. "L'utilisation du sol et les règlements de construction," *L'aménagement de la region parisienne,* 59; Emile Verhaeren, *Les villes tentaculaires* (1895; Paris: Mercure de France, 1920).

17. Alain Cottereau, "L'apparition de l'urbanisme comme action collective: L'agglomération parisienne au début du siècle," *Sociologie du Travail* 12 (Oct.-Dec. 1969): 342-65.

18. Raymond Unwin, "New York and its Environs as a Regional Planning Problem from the European Point of View," in *Plan of New York and Its Environs, Report of Progress* (New York: Plan of New York and Its Environs, 1923), 13-22.

19. Thomas Adams, "Centralization and Decentralization," in *The Graphic Regional Plan* (New York: Regional Plan of New York and Its Environs, 1931), 150.

20. Lewis Mumford, "The Plan of New York," *New Republic,* June 15, 1932, 121-26; 22 June 1932, 146-54.

21. Clarence A. Perry, "The Neighborhood Unit: A Scheme of Arrangement for the Family-Life Community," in *Neighborhood and Community Planning* (New York: Regional Plan of New York and Its Environs, 1929), 22-140.

22. Jean-Louis Cohen, "La porte Maillot ou le Triomphe de la Voirie," in *Les traversées de Paris,* ed. Pierre Pinon (Paris: Éditions du Moniteur, 1988), 177-86. Ville de Paris, Département de la Seine, *Concours pour l'aménagement de la voie triomphale allant de la place de l'Etoile au rond-point de la Défense* (Paris: Editions d'Art Charles Moreau, s.d., 1932).

23. Hilary Ballon and Kenneth T. Jackson, eds., *Robert Moses and the Modern City: The Transformation of New York* (New York: Norton, 2007).

24. Thomas Adams, "Centralization and Decentralization," 272.

25. In 1934 Poëte wrote the screenplay of two films devoted to the history of Paris: see Donatella Calabi, *Marcel Poëte et le Paris des années vingt* (Paris: L'Harmattan, 1997), 96-97. Lewis Mumford wrote the commentary to *The City* (1939), directed by Ralph Steiner and Willard Van Dyke.

26. Regional Plan Association, *From Plan to Reality: Three* (New York: Regional Plan Association, 1942).

27. I remember unearthing as late as 1975 a still-valid Plan Prost document to kill a speculative development in the south of Paris. François Laisney, "Réglementer la banlieue? L'exemple du plan Prost," *Les cahiers de la recherche architecturale* 21 (1st quarter 1997): 117-30.

Modernity and Tradition in Beaux-Arts New York

1. On Art Deco in New York see: Cervin Robinson and Rosemarie Haag Bletter, *Skyscraper Style: Art Deco, New York* (New York: Oxford University Press, 1975); Don Vlack, *Art Deco Architecture in New York, 1920-1940* (New York: Harper & Row, 1974); Robert A. M. Stern, et al., *New York 1930* (New York: Rizzoli, 1987).

2. Le Corbusier, *When the Cathedrals Were White,* trans. F. E. Hyslop (1947; repr., New York: McGraw-Hill, 1964), 60. Wallace K. Harrison, interview with author, March 16, 1981, recounted taking Le Corbusier to see the University Club and his reaction.

3. For background see: Arthur Drexler, ed., *The Architecture of the Ecole des Beaux-Arts* (New York: Museum of Modern Art; Cambridge: MIT Press, 1977); James Philip Noffsinger, *The Influence of the Ecole des Beaux-Arts on the Architects of the United States* (Washington, D.C.: Catholic University of America Press, 1955); Arthur Clason Weatherhead, "The History of Collegiate Education in Architecture in the United States" (Ph.D. diss., Columbia University, 1941).

4. Jean Paul Carlhian, personal communication with author, April 13, 1981.

5. Ernest Flagg, "Influence of the French School on Architecture in the United States," *Architectural Record,* Oct.-Dec. 1894, 210-28; "The Ecole des Beaux-Arts Number" *Architectural Record,* January 1901; A. D. F. Hamlin, "The Influence of the Ecole des Beaux-Arts on our Architectural Education," *Architectural Record,* April 1908, 241-47.

6. *American Architect,* September 3, 1887, 112-14.

7. "Articles of Incorporation," *Yearbook of the Society of Beaux-Arts Architects and of the Beaux-Arts Institute of Design* (New York, 1929).

8. "Constitution," *Yearbook of the Society of Beaux-Arts Architects and of the Beaux-Arts Institute of Design* (New York, 1929).

9. John F. Harbeson, *The Study of Architectural Design, with Special Reference to the Program of the Beaux-Arts Institute of Design* (New York: Pencil Points Press, 1926) was originally published in parts and sent to schools. Another important book written by the founder of MIT's and Columbia's schools of architecture, was William R. Ware, *The American Vignola* (Scranton: International Textbook Co., 1901, 1905, 1906, and later).

10. Otto F. Teegen, "The B.I.A.D.—Its Past and Future," *Journal of the A.I.A.* 20 (Oct. 1953): 184.

11. Isabelle Gournay, "Architecture at the Fontainebleau School of Fine Arts 1923-1939," *Journal of the Society of Architectural Historians* 45 (Sept. 1986): 270-85.

12. Francis Swales, "The Competition Extraordinary for the New Beaux Arts Institute of Design Building," *Pencil Points* IX, no. 1, Jan. 1928, 37-46.

13. Rayne Adams, "Master Draftsmen, XXI Frederic C. Hirons," *Pencil Points* XIII, no. 7, Jul. 1927, 397-410.

14. Elisa Urbanelli, "Beaux-Arts Institute of Design" unpublished designation report, Landmarks Preservation Commission, August 23, 1988.

15. Richard Guy Wilson, "Modernized Classicism and Washington, D.C." in *American Public Architecture: European Roots and Native Expressions.* Craig Zabel and Susan S. Manshower, vol. 5, Papers in Art History (University Park Pennsylvania State University, 1989), 272-303; Richard Oliver, *Bertram Grosvenor Goodhue* (New York: Architectural History Foundation, 1983); Charles H. Whitaker, ed., *Bertram Grosvenor Goodhue, Architect and Master of Many Arts* (New York: American Institute of Architects Press, 1925), 147.

16. Richard Guy Wilson, "International Style: The MoMA Exhibition," *Progressive Architecture,* February 1982, 92-105.

17. Mary Anne Hunting, "Edward Durell Stone: Perception and Criticism" (Ph.D. diss., City University of New York, 2007), 113; see also Herbert Muschamp, "A Wistful Ode to a Museum That Once Was," *New York Times,* June 11, 1989.

18. "Education of the Architect," *Architectural Record,* September 1936, 201-13.

19. This is an area that needs to be studied, but see William Littmann, "Assault on the Ecole: Student Campaigns Against the Beaux Arts, 1925-1950," *Journal of Architectural Education* 53, no. 3 (Feb. 2000): 159-66; Harold Bush-Brown, *Beaux Arts to Bauhaus and Beyond: An Architect's Perspective* (New York: Whitney Library of Design, 1976); Leopold Arnaud, "Columbia Dean Recalls This Century Brought 'Beaux Arts' Schools to United States," *Progressive Architecture,* January 1950, 9; Joseph Esherick, "The Beaux-Arts Experience," *Architectural Education* 1 (1983): 23-51; "Education of the Architect," *Architectural Record,* Sept. 1936, 201-6.

Beyond Metaphor: Skyscrapers Through Parisian Eyes

1. Louis Dimier, "Les Salons," *L'Architecture,* May 25, 1921, 18; Henri Pantz, "La construction des derniers gratte-ciel," *La Construction moderne,* July 1, 1923, 471-72; Louis Gillet, "L'Architecture aux Etats-Unis et l'Influence Française," in *Les Etats-Unis et la France,* ed. Emile Boutroux (Paris: Librairie Felix Alcan, and Bibliothèque France-Amerique, 1914), 65. Both Dimier and Gillet were highly respected art historians.

2. For additional details and citations, see Isabelle Gournay, *France Discovers America, 1917-1939 (French Writings on American Architecture)* (Ph.D. diss., Yale University, 1989).

3. Victor Cambon, *Etats-Unis-France* (Paris: Pierre Roger, 1917), 24, 26.

4. C.D., "Le Woolworth Building et les 'gratte-ciel' de New York," *Le Génie civil,* March 10, 1917, 153; Louis Dimier, "Les Salons," *L'Architecture,* 18.

5. Jules Huret, *L'Amérique moderne* (Paris: Pierre Lafitte, 1910), 8. This travelogue, initially published without illustrations in 1905, was advertised in France until 1930.

6. Charles Cestre, *Les Etats-Unis* (Paris: Larousse, 1927), 106.

7. The giddiness effect is felt by Bardamu, Louis-Ferdinand Céline's protagonist of *Journey to the End of the Night* (New York: New Directions, 1960), 191; first published as *Voyage au bout de la nuit*, 1932.

8. Paul Morand, *New-York* (Paris: Flammarion, 1930); an English translation was published the following year.

9. See, for instance, George de Cuevas, "Les gratte-ciel de New York," *La Renaissance*, Apr.-May 1932, 79-87. (George de Cuevas was a Spanish marquis who had married a Rockefeller heiress in Paris.) Sheeler's skyscraper views were reproduced by the painter Jacques Mauny in his New York chronicles for *L'Art vivant*, January 15, 1926; August 15, 1927. See also "Buildings de New York," *Cahiers d'art*, no. 4-5 (1927): 180-82; Robert Rey, "U.S.A.," *Le Crapouillot*, June 1928, 26; *Arts et métiers graphiques*, March 15, 1930, 30.

10. Lewis Hine's famous "Icarus" photograph was anonymously published in *Vu*, December 1931, and in *L'Illustration*, April 1934.

11. "Immeuble de l'American Radiator à New York," *L'Architecte*, March 1925, 35; Raymond Hood, "The American Radiator Company Building, New York," *The American Architect*, November 19, 1924, 467-73.

12. On American optimistic reactions, see Carol Willis, "Zoning and Zeitgeist," *Journal of the Society of Architectural Historians* 45 (March 1986): 47-59.

13. Louis Thomas, "Les grands blocs: New York se transforme," *L'Intransigeant*, February 19, 1926, 1; reprinted in *L'Architecture*, June 10, 1926, 128; Gaston Rageot, "Une visite aux Etats-Unis: Le building de papier," *L'Illustration*, November 28, 1931, 390-91. The coverage of New York skyscrapers by *The Illustrated London News* was clearly inspired by that of *L'Illustration*.

14. André Maurois, "Premier voyage en Amérique. II Contact," *Les Annales politiques et littéraires* 48 (March 1, 1928): 217; reprinted in *L'Amérique inattendue* (Paris: Mornay, 1931), 41. In the same volume, see Roger Boutet de Monvel, "L'Architecture Américaine," June 13, 1926, 642-43. (Roger Boutet de Movel was brother of the well-known painter Bernard.)

15. J. Effertz, "Le nouveau bâtiment de la compagnie McGraw-Hill," *Le Génie civil*, January 2, 1932, 1-6. In *La Technique des travaux*, see: L.Gain, "Le plus haut gratte-ciel du monde: L'Empire State Building," February 1932, 72-91, and "Le nouvel hôtel Waldorf-Astoria à New York," August 1932, 458-65; R. G. Skerett et L. Gain, "Le Rockefeller Center à New York," June 1934, 344-58; Guy Pison, "Le building de la Radio Corporation of America, à New York," March 1937, 145-58. Henri Descamps, "Gratte-ciel d'Amérique: Panhellenic Tower à New York," *L'Architecture*, January 1, 1931; 29. Illustrations served as precedents for the twin, 19-story residential towers of the Quartier des Gratte-Ciel (completed 1934) in Villeurbanne, a socialist city next to Lyon. I have compared this ambitious project with Rockefeller Center in *Urbanisme* 204 (Oct.-Nov. 1984): 64-7, and established visual parallels in "L'architecture américaine dans la presse professionelle française," *Gazette des beaux-arts* CXVII (April 1991): 196-97.

16. Reproduced in *Plans* 58, July 1931. The Shelton image came from a clipping of a *Vanity Fair* article, October 1924, preserved at the Fondation Le Corbusier. Contrasted with Notre Dame, the Ferriss illustrations were published in Le Corbusier's *The Radiant City* (New York: Orion Press, 1967), 133. The Fondation Le Corbusier has articles from the *New York Times Book Review and Magazine*, March 19, 1922, showing Ferriss's drawings. Ironically, the frontispiece of the 1927 English translation of *Vers une architecture* was illustrated by a photograph of the Barclay-Vesey Building. See also Mardges Bacon, *Le Corbusier in America: Travels in the Land of the Timid* (Cambridge, Mass.: MIT Press, 2001), 127-58 and 205-36.

17. Daniel Okrent, *Great Fortune: The Epic of Rockefeller Center* (New York: Viking, 2003), 275. Architect Wallace K. Harrison was among Rockefeller's representatives introduced by Senator Philip (who had married an American woman) to President Paul Doumer at the Elysées Palace in early May 1932 (see "France May Lease Rockefeller Space," *New York Times*, May 7, 1932). The Maison Française was dedicated by Herriot on April 29, 1933. The French press frequently mentioned the special status of duties deferment granted to French goods sold at Rockefeller Center.

18. *Je sais tout*, December 1931, 496.

19. C.C., "La Cité de la Radio à New York," *Le Miroir du monde*, January 30, 1932, 136.

20. Robert de Beauplan, "Rêve de milliardaire: Une moderne Babel au centre de New York," *L'Illustration*, August 13, 1932, 473; Edouard Weiler, "Urbanisme New-Yorkais," *Urbanisme* 1, (Nov.-Dec. 1932): 247.

21. Edouard Weiler, "Urbanisme New-Yorkais," *Urbanisme* 1, 247.

22. Dexter Morand, "Le Centre Rockefeller à New York," *L'Architecture d'aujourd'hui*, June 1936, 66.

23. Pierre Lyautey, *Révolution américaine* (Paris: Hachette, 1934), 138.

24. In addition to Corbett, Harrison, and Hood, the design team for Rockefeller Center included the French-born and Paris-trained engineer André Fouilhoux, who emigrated to the United States in 1945 and was a reporter for *L'Architecture d'aujourd'hui*. John Mead Howells designed the Panhellenic Tower, Benjamin Wistar Morris designed the American Women's Association Building, and Lloyd Morgan was the principal designer for the Waldorf-Astoria Hotel.

25. Robert de Beauplan, "Rêve de milliardaire," *L'Illustration*, August 13, 1932, 373.

26. See François Loyer, *Henri Sauvage: Les Immeubles à gradins* [Set-back buildings] (Brussels: Mardaga, 1987).

27. Léon Rosenthal, "Notes sur l'architecture aux Etats-Unis," *L'Architecture*, May 15, 1929, 149; Marcel Braunschwig, *La Vie américaine et ses leçons* (Paris: A. Colin, 1931), 338; Jean Porcher, "Les nouveaux gratte-ciel," *L'Architecte*, June 1926, 45.

28. Because the silhouette of skyscrapers was discussed to a much greater extent than were ornamental details, allusions to Parisian Art Deco were unusual in the writings I consulted. Delineated by another architect, Perret's towers and a view of the Municipal Building were both published in Jean Labadié, "Les cathédrales de la cité moderne," *L'Illustration*, August 12, 1922, 131-35. On the genesis of this project and its influence on Le Corbusier, see Francesco Passanti, "The Skyscrapers of the Ville Contemporaine," *Assemblage* 4 (1988), 52-65.

29. See Département de la Seine, *Concours pour l'aménagement de la voie triomphale allant de la place de l'Etoile au rond-point de la Défense* (Paris: Editions d'art Charles Moreau, s.d., 1932). Submissions to the Concours Rosenthal by Le Corbusier, Perret, Sauvage, Mallet-Stevens, and lesser-known architects were exhibited at the Salon d'Automne. Sauvage's proposed pyramids bear a striking resemblance to the Telephone Building in Saint Louis, as reproduced in *L'Illustration*, February 5, 1927, 126.

30. In the *New York Times* see, for instance, "Planning Skyscrapers for the Rue de Rivoli," January 28, 1921; "Girdle of Skyscrapers Is Proposed for Paris," August 14, 1922; "Proposed Park Skyscrapers Disturb Esthetic Parisians," November 30, 1926; and "Immortals May Get Skyscrapers: French Academy Thinking of Building One," May 11, 1935.

31. In the *New York Times* see, "First Skyscraper Planned for Paris," April 17, 1926, and "President Doumergue Rejects Plan for Government Skyscraper in Paris," August 17, 1926. Simon Texier, *Paris contemporain* (Paris: Parigramme, 2005), 98-99, illustrates a high-rise project for a Cité Ministérielle (1930) for Ecole Militaire site designed by Georges-Henri Pingusson and Marcel Rotival.

32. "La Machine à prévoir le temps," *Vu*, March 27, 1929, 227, represented the Pennsylvania Hotel, Ritz Tower, and Irving Trust Building surrounding the Gare de l'Est, accompanied by this caption: "Adopted at too late a date, Le Corbusier's great design was implemented half way on the ruins of old Paris turned into hell." In its Christmas issue of 1933, *Le Miroir du monde* transplanted the familiar silhouette of the Chanin Building to the surroundings of the Arc de Triomphe. Reproductions of polemical photomontages of skyscrapers next to Notre Dame (illustrated in Texier, *Paris contemporain*, 58) and the Place de la Concorde are preserved in the Louis Bonnier archives at the Cité de l'Architecture et du Patrimoine.

33. François Porché, "New York est-il beau?," *L'Illustration*, February 5, 1927, 120.

34. Paul Morand, *New-York*, 263.

35. For instance, the Elysées Building at 56 Faubourg Saint-Honoré and 4 Rue d'Aguesseau (1913-15) was rented to the YMCA. Most publicized was the 8-story Shell Building (1930-34) in the vicinity of the Champs-Elysées, which resembles Chicago's Merchandise Mart. See "Le Building 'Shell,'" *Art et industrie*, June 1932, 37; Gilles Ragot and Mathilde Dion, "La Modernité en Chantiers," *Le Moniteur architecture - AMC*, April 1991, 48-51. The transformation of the Champs-Elysées into a high-density business artery was noted in P. J. Philip, "Step by Step Paris Becomes American," *New York Times*, July 8, 1928.

36. "National City Opens Ornate Paris Branch: $4,000,000 Structure is Most Modern in Europe for Banking," *New York Times*, September 8, 1931, mentions Walker and Gillette as principal designers. However, Parisian architectural reviews exclusively credit Parisian architect André Arfvidson, who took a study trip to New York in 1925 for the design of a U.S.-financed hotel in Paris. See also "Paris Discovers Value of Roof Garden," *New York Times*, September 11, 1927. New York residential roof gardens were illustrated in French editions of *Vogue*, early March 1920, 82-83, and "Les Jardins Suspendus de New York," *Vogue*, June 1931, 56-57.

37. Some of these apartments were built in the *co-propriété* system, which was already well established in Manhattan.

38. Kenneth M. Murchison, "Paris Apartment Houses," *Architectural Forum*, September 1930, 361-64.

39. Frances Mangum, "Bangs Are Still Debated Topic with Coiffeurs. Pro and Con Continues: Antoine Urges Use Only If Suitable," *New York Times*, December 9, 1934. The upscale office and apartment buildings mentioned in this article are illustrated in Bertrand Lemoine and Philippe Rivoirard, *Paris: L'Architecture des années 30* (Paris: Délégation à l'action artistique de la ville de Paris, and Lyon: La Manufacture, 1987).

40. René Millaud, "Deux principes de construction: grande et faible hauteur," *L'Illustration*, February 1929, 115-16, established a visual parallel between the Columbia Presbyterian Medical Center and Jean Walter's apartment group.

41. "Un gratte-ciel de la souffrance: Le Nouvel Hôpital Beaujon," *L'Illustration*, March 16, 1935, 311. See also Clara Simon, "Un hôpital gratte-ciel," *Vu*, February 20, 1935, 223-25.

42. "Housing Experts Differ on Plans," *New York Times*, August 20, 1939. This tower was one of the few examples of French skyscraper projects meant to symbolize collective

rejuvenation. In *Low Cost Housing Here and Abroad*, 1935, 23, a report commissioned by New York's Mayor La Guardia, Macy's heir and future USHA head Nathan Straus decreed that "upon its completion," la Butte Rouge "will be perhaps the finest housing project" he saw in Europe.

43. G. Brunon-Gaurdia, "Gratte-ciel Français," *Le Miroir du monde*, January 1934, 22–23. Towers at Drancy were illustrated in the *New York Times*, May 12, 1935, with the caption, "Skyscrapers for Paris: The towers of a group of low-cost apartment houses," and in "The Vast Red Ring That Girdles Paris," May 3, 1936, which called attention to their connection with communism.

44. At present, the tallest of these high-rise buildings is the 56-story Maine-Montparnasse Tower, completed in 1973. According to Norma Evenson, *Paris: A Century of Change, 1878–1978* (New Haven: Yale University Press, 1979), 194, its "overall construction was in the hands of an American developer Collins, Tuttle and Company of New York."

45. Ada Louise Huxtable, "Paris's La Défense Cluster: Coup of Drawing-Board Style," *New York Times*, June 11, 1978.

Africa on the Spiral: Jazz in New York and Paris Between the Wars

1. George Antheil, "The Negro on the Spiral, or a Method of Negro Music," in *Negro Anthology*, ed. Nancy Cunard (1934; repr. New York: Negro Universities Press, 1969), 215.
2. R. de Givrey, "Aux Champs-Elysées Music-Hall," *Le Soir*, April 8, 1925.
3. Paul Guillaume, "The Discovery and Appreciation of Primitive Negro Sculpture," *Les Arts à Paris*, May 1926, 13. For jazz and the Parisian avant-garde, see Jody Blake, *Le Tumulte noir: Modernist Art and Popular Entertainment in Jazz-Age Paris, 1900–1930* (University Park: University of Pennsylvania Press, 1999).
4. Georges Oudard, "Série noire, "*La Revue française* 21 (November 14, 1926), 547. For the racial politics of jazz in Paris, see Tyler Stovall, *Paris Noir: African Americans in the City of Light* (Boston: Houghton Mifflin, 1996); Brett A. Berliner, *Ambivalent Desire: The Exotic Black Other in Jazz-Age France* (Amherst and Boston: University of Massachusetts Press, 2002).
5. André Rouveyre, "Théâtre: Music-Halls—Jazz-bands noirs—Joséphine Baker aux Folies-Bergère," *Mercure de France,* September 1, 1926, 411–12.
6. Denis Martin and Olivier Roueff, *La France du jazz: musique, modernité et identité dans la première moitié du XXe siècle* (Marseille: Parenthèses, 2002).
7. James Reese Europe, "A Negro Explains 'Jazz'" (1919), reprinted in *Readings in Black American Music*, ed. Eileen Southern (New York: Norton, 1983), 240.
8. For jazz in the Harlem Renaissance, see Samuel A. Floyd, Jr., *The Power of Black Music: Interpreting Its History from Africa to the United States* (New York and Oxford: Oxford University Press, 1995), 100–35; Burton W. Peretti, *The Creation of Jazz: Music, Race, and Culture in Urban America* (Urbana and Chicago: University of Illinois Press, 1992), 39–57.
9. For the history and reception of jazz in Paris, see Ludovic Tournès, *New Orleans sur Seine: Histoire du jazz en France* (Paris: Fayard, 1999); William A. Shack, *Harlem in Montmartre: A Paris Jazz Story Between the Great Wars* (Berkeley and Los Angeles: University of California Press, 2001); Jeffrey H. Jackson, *Making Jazz French: Music and Modern Life in Interwar Paris* (Durham: Duke University Press, 2003).
10. Langston Hughes, *The Big Sea: An Autobiography* (New York: Hill and Wang, 1940), 161–62.
11. Langston Hughes, "The Negro Artist and the Racial Mountain," *The Nation* (1926), reprinted

in *Voices from the Harlem Renaissance*, ed. Nathan Irvin Huggins (New York: Oxford University Press, 1976), 305–9. For African American writers in Paris, see Michel Fabre, *From Harlem to Paris: Black American Writers in France, 1840–1980* (Urbana: University of Illinois Press, 1991), 46–159.
12. For African American visual artists in Paris, see Theresa Leininger-Miller, *New Negro Artists in Paris: African-American Painters and Sculptors in the City of Light, 1922–1934* (New Brunswick, N.J.: Rutgers University Press, 2001).
13. L.H., "Avant la Revue nègre," *Comoedia*, 2 October 1925.
14. Paul Achard, "Tout en noir où la Revue nègre," *Paris Midi*, September 27, 1925.
15. Gustave Fréjaville, "Au Théâtre Music-Hall des Champs-Elysées—La Revue nègre," *Comoedia*, October 8, 1925. For Josephine Baker see also: Henry Louis Gates, Jr. and Karen C. C. Dalton, Introduction, *Josephine Baker & La Revue Nègre: Paul Colin's Lithographs of Le Tumulte Noir in Paris, 1927* (New York: Harry N. Abrams, 1998).
16. Stéphane Manier, *Sous le signe du jazz* (Paris: Edition de l'Epi, 1926), 148–49.
17. Jacques Patin, "Champs-Elysées Music-Hall: Revue nègre en sept tableaux de Louis Douglas," *Le Figaro*, October 7, 1925; Rouveyre, "Théâtre: Music-Halls—Jazz-bands noirs," 412–13.
18. André Levinson, "The Negro Dance under European Eyes," *Theatre Arts Monthly*, April 1927, 288–89.
19. Edmund Wilson, "The Aesthetic Upheaval in France: The Influence of Jazz in Paris and the Americanization of French Literature and Art," *Vanity Fair*, February 1922, 49, 100.
20. Jean Cocteau, "Jazz-Band" (1919), reprinted in his *Le Rappel à l'ordre* (Paris: Editions Stock, 1926), 140. See also Nancy Lynn Perloff, *Art and the Everyday: Popular Entertainment and the Circle of Erik Satie* (Oxford: Oxford University Press, 1991).
21. Albert Gleizes, "Souvenirs," quoted in Daniel Robbins, *The Formation and Maturity of Albert Gleizes: A Biographical and Critical Study, 1881–1920* (Ann Arbor: UMI, 1977), 199.
22. Francis Picabia, "How New York Looks to Me," *New York American*, March 30, 1913. For context for these responses, see Crystel Pinçonnat, *New York, mythe littéraire français* (Geneva: Droz, 2001).
23. For the New York avant-garde and jazz, see Donna M. Cassidy, *Painting the Musical City: Jazz and Cultural Identity in American Art, 1910–1940* (Washington, D.C.: Smithsonian Institution Press, 1997). For white Americans' responses to jazz, see Kathy J. Ogren, *The Jazz Revolution: Twenties America and the Meaning of Jazz* (New York and Oxford: Oxford University Press, 1989), 139–61.
24. For *Parade*, see Olivier Bergruen and Max Gollein, eds., *Picasso und das Theater* [Picasso and the Theater] (Frankfurt: Schirn Kunsthalle, 2006), 42–62; Deborah Menaker Rothschild, *Picasso's "Parade": From Street to Stage* (New York: The Drawing Center, 1991).
25. Lucien Farnoux-Reynaud, "L'époque du jazz-band," *Le Gaulois*, March 6, 1926.
26. For *Within the Quota*, see Wanda M. Corn, *The Great American Thing: Modern Art and National Identity, 1915–1935* (Berkeley and Los Angeles: University of California Press, 1999), 90–133; Robert M. Murdock, "Gerald Murphy, Cole Porter, and the Ballets Suédois Production of *Within the Quota*," in *Paris Modern: The Swedish Ballet, 1920–1925*, ed. Nancy Van Norman Baer (San Francisco: Fine Arts Museums of San Francisco, 1996), 108–27; Deborah Rothschild, ed., *Making It New: The Art and Style of Sara and Gerald Murphy* (Berkeley and Los Angeles: University of California Press, 2007).
27. Darius Milhaud, "Jazz-band et instruments mécaniques: Les ressources nouvelles de la musique," *L'Esprit nouveau*, no. 25 (1924), n.p.
28. Fernand Léger, "The Ballet-Spectacle, the Object-Spectacle" (1925), translated by

Alexandra Anderson in his *Functions of Painting* (New York: Viking, 1973), 72.
29. For *La Création du monde*, see Judi Freeman, "Fernand Léger and the Ballets Suédois: The Convergence of Avant-Garde Ambitions and Collaborative Ideals," in *Paris Modern: The Swedish Ballet, 1920–1925*, ed. Nancy Van Norman Baer (San Francisco: Fine Arts Museums of San Francisco, 1996), 96–102; Francine N'diaye, "La Création du monde et la rencontre de Léger avec l'art africain," and Giovanni Lista, "Léger scénographe et cinéaste," in *Fernand Léger et le Spectacle* (Paris: Réunion des Musées Nationaux, 1995), 21–29, 46–55.
30. Le Corbusier, *When the Cathedrals Were White: A Journey to the Country of Timid People*, trans. Francine E. Hyslop, Jr. (New York: Reynal & Hitchcock, 1947), 161.
31. Olin Downes, "*Skyscrapers* Here with *Jazz* Score," *New York Times*, February 20, 1926. For the creation and reception of *Skyscrapers*, see Howard Pollock, *Skyscraper Lullaby: The Life and Music of John Alden Carpenter* (Washington: Smithsonian Institution Press, 1995), 210–48.
32. Brooks Atkinson, "The Play," *New York Times*, October 26, 1940; "Cabin in the Sky," *New York Times*, November 3, 1940.
33. James Naremore, "Uptown Folk: Blackness and Entertainment in *Cabin in the Sky*," in *Representing Jazz*, ed. Krin Gabbard (Durham: Duke University Press, 1991), 169–92; David Krasner, *A Beautiful Pageant: African American Theatre Drama and Performance in the Harlem Renaissance, 1910–1927* (New York: Palgrave Macmillan, 2002), 239–88.
34. Hughes, *The Big Sea*, 223.
35. Allen Woll, *Black Musical Theatre: From Coontown to Dreamgirls* (New York: Da Capo Press, 1991), 193–209.
36. Quoted in Constance Valis Hill, "Collaborating with Balanchine on *Cabin in the Sky*: Interviews with Katheirne Dunham," in *Kaiso! Writings by and About Katherine Dunham*, eds. Vè Vè A. Clark and Sara E. Johnson (Madison: University of Wisconsin Press, 2005), 240.
37. Langston Hughes, "Jazzonia," in *The New Negro*, ed. Alain Locke (1925; repr. New York: Atheneum, 1992), 226.
38. Alain Locke, "The Legacy of the Ancestral Arts," in *The New Negro*, 254–67. For historical context, see Richard J. Powell and David A. Bailey, *Rhapsodies in Black: Art of the Harlem Renaissance* (Berkeley and Los Angeles: University of California Press in association with the Hayward Gallery, London, 1997).
39. For Pan-African cultural and political organizing in Paris, see Philippe Dewitte, *Les Mouvements nègres en France, 1919–1939* (Paris: L'Harmattan, 1980).
40. Robert de Flers, "La semaine dramatique: Théâtre des Champs-Elysées Music-Hall: La Revue nègre," *Le Figaro*, November 16, 1925.
41. Jean-Philippe Mathy, *L'Extrême-Occident: French Intellectuals and America* (Chicago: University of Chicago Press, 1993).
42. Josephine Baker, "Préface," in Paul Colin, *Le Tumulte noir* (Paris: Editions d'art succès, 1927), n.p.

Fashion Showdown: New York Versus Paris, 1914–1941

1. Wilfred Mark Webb, *The Heritage of Dress* (New York: McClure Company, 1908), 349.
2. "Fashion Fête," program, November 4, 1914.
3. Emily Post, "Where Fashionables and Fashion Met," *Vogue*, December 1, 1914, 36.
4. "Who's Who in the Mode: A Tale of Two Cities," *Vogue*, January 1, 1923, 194.
5. Special Cable to the *New York Times*, March 3, 1931.
6. "The Dressmakers of the U.S.," *Fortune*, December 1933, 37.
7. "Mrs. Harrison Williams, by Cecil Beaton," *Vogue*, February 1, 1938, 94–95.
8. "9,130 Items Presented to City Museum in 1937," *New York Times*, March 6, 1938, 38.

9. "Eye View of the Mode," *Vogue*, November 1, 1932, 25.
10. The majority of products manufactured by New York's vast garment industry (7,000 factories and approximately 200,000 workers generating $1.2 million in New York and $3 million annually in the United States, as published in *Fortune's* July 1939 issue), comprised generic ready-to-wear dresses, outer garments, and suits that only vaguely nodded to original couture or custom designs for inspiration. These were retailed by smaller department stores and neighborhood shops, providing the country's nonelite with serviceable, more attractively priced attire.
11. Store advertisement, *Harper's Bazaar*, September 1922, 124.
12. "Designers in America," *Vogue*, February 1, 1940, 147.
13. Gretta Palmer, *A Shopping Guide to New York* (New York: Robert M. McBride, 1930), 27.
14. Store advertisement, *Vogue*, April 15, 1933, 28.
15. Hulbert Footner, *New York City of Cities* (London: J. B. Lippincott Company, 1937), 85.
16. Store advertisement, *Harper's Bazaar*, April 1932, 46.
17. "The Fashion Originators' Guild of America," *Fashions Art*, Fall 1934, 32-33.
18. "New York Couture," *Vogue*, April 15, 1933, 34.
19. "The Big Parade in Paris," *Vogue*, October 1, 1932, 30.
20. "Mainbocher by Main Bocher," *Harper's Bazaar*, January 1938, 102.
21. "Fall Fashions: Glamor from Paris," *New York Times*, September 13, 1936.
22. Store advertisement, *Vogue*, September 15, 1930, 117.
23. "Chez Frances Clyne," *Vogue*, May 1, 1933, 40.
24. "Do American Women Want American Clothes," *Harper's Bazaar*, February 1934, 37.
25. Selma Robinson, "They Have Your Number," *Collier's*, March 24, 1934, 24.
26. "The Unseen Label,"*Vogue*, October 27, 1930, 102.
27. "The American Fashion Label," *Harper's Bazaar*, February 1940, 42.
28. "*Vogue's*-Eye View of the American Fashion Openings," *Vogue*, September 1940, 41.
29. "Mainbocher Presents a Collection," *Harper's Bazaar*, May 1941, 47.
30. "Citation of Honor, Valentina," American Fashion Critics' Award, 1942.

The Longest Gangplank
1. The following sources were especially valuable in writing this essay: Harvey Ardman, *Normandie: Her Life and Times* (New York: Franklin Watts, 1985); Frank O. Braynard, *Picture History of the Normandie: With 190 Illustrations* (New York: Dover, 1987); James P. Gilroy's review of Pierre-Henri Marin, *Les Paquebots: ambassadeurs des mers, The French Review* (Oct. 1991), 153-54; Arnold Kludas, *Great Passenger Ships of the World, Volume 3* (Wellingborough: Patrick Stephens, 1976); William H. Miller, Jr., *The Great Luxury Liners, 1927-1954* (New York: Dover, 1981); and Ellen T. White, "A Race Among Nations: The Making of the Normandie Panels," www.carnegiemuseums.org.

New York Haute Cuisine
1. "Guide to the French Pavilion and to the France-Overseas Pavilion" (French Government, 1939), n.p. New York Public Library.
2. New York City, *Official Guide Book of the New York World's Fair* (New York: Exposition Publications, 1939).
3. Andrew F. Wood, *New York's 1939-1940 World's Fair* (Charleston, S.C.: Arcadia Publishing, 2004), 33.
4. "Guide to the French Pavilion and to the France-Overseas Pavilion," n.p.
5. Pierre Franey, "Remembering Drouant," *New York Times*, October 30, 1988.

6. Pierre Franey, *A Chef's Tale: A Memoir of Food, France and America* (New York: Alfred A. Knopf, 1994), 43. This book also provided subsequent information on the World's Fair restaurateurs, the Normandie, and the Vatel Club's history, 61, 67, 68.
7. "Franey Dons New Apron for Johnson," *New York Times*, March 24, 1960.
8. Kiley Taylor, "There'll Be All Kinds of Food at the Fair," *New York Times*, January 29, 1939.
9. Crosby Gaige, *Food at the Fair: A Gastronomic Tour of the World* (New York: Exposition Publications, 1939), 31.
10. Kathleen McLaughlin, "Epicures' Retreat Opened by the French," *New York Times*, May 10, 1939.
11. Franey, *A Chef's Tale*, 80. This book also provided subsequent information about the French Pavilion's restaurant and Soulé's decision to stay in America, 76-88.
12. "Henri Soulé of Le Pavillon Dies," *New York Times*, January 28, 1966.
13. Joseph Wechsberg, *Dining at the Pavilion* (Boston: Little, Brown, 1962), 29. This book also provided information about the look of Le Pavillon and artist Maurice Chalom's contribution.
14. Franey, *A Chef's Tale*, 90.
15. Wechsberg, *Dining at the Pavillion*, 46, 51.
16. Michael and Ariane Batterberry, *On the Town in New York from 1776 to the Present* (New York: Charles Scribner's Sons, 1973), 235.
17. "Delmonico's Ends Career of Century," *New York Times*, May 22, 1923.
18. Batterberry, *On the Town in New York*, 196-253.
19. David Kamp, *The United States of Arugula* (New York: Broadway Books, 2006), 39.
20. Franey, *A Chef's Tale*, 92.
21. Craig Claiborne, "In Classic Tradition Henri Soulé Set Towering Standards in Search of Gastronomic Perfection," *New York Times*, January 28, 1966.
22. Franey, *A Chef's Tale*, 94. Franey's book also provided information about Soulé's treatment of his patrons, including the Cohns, his exacting way of dressing, and the story of the creation of La Côte Basque, 90, 95, 110, 111.
23. Craig Claiborne, "Food: A Restaurant for Gastronomes," *New York Times*, November 3, 1958.
24. Wechsberg, *Dining at the Pavillion*, 36.
25. Claiborne, "Food: A Restaurant for Gastronomes."
26. Batterberry, *On the Town in New York*, 269.
27. Franey, *A Chef's Tale*, 96.
28. Batterberry, *On the Town in New York*, 268.
29. Craig Claiborne, "The Mistral Is the Newest Offshoot of Pavillon Tree," *New York Times*, December 11, 1964.
30. Craig Claigborne, "3 City Restaurants Boast Dramatic New Interiors," *New York Times*, September 22, 1960.
31. Claiborne, "Le Mistral."
32. "Vive les Surgelés," *Time*, October 28, 1966, 100.
33. Franey, *A Chef's Tale*, 118-19.
34. Adam Gopnik, "Aftertaste," *New Yorker*, March 22, 2004, 39.
35. Claiborne, "Le Mistral."

Art Deco to American Modern at the 1929 Metropolitan Museum of Art Industrial Arts Exhibition
1. See Marilyn F. Friedman, "The United States and the 1925 Paris Exposition: Opportunity Lost and Found," *Studies in the Decorative Arts* 13, no. 1 (Fall-Winter 2005-2006): 94.
2. Francis Jourdain, *Intérieurs*, (Paris: Editions, Charles Moreau, 1928), Introduction, quoted in Suzanne Tise, "Francis Jourdain," in Arlette Barré-Despond, *Jourdain* (New York, 1991), 328.
3. For a comprehensive review of the New York department store exhibitions of 1927 and 1928, see Marilyn F. Friedman, *Selling Good Design: Promoting the Early Modern Interior* (New York: Rizzoli, 2003). Conspicuously absent from most New York exhibitions was a

third version of French modernism that has come to be known as the International Style. At the 1925 Paris Exposition this most radical form of French modernism could be viewed at the Pavillon de l'Esprit Nouveau, designed by Le Corbusier and Pierre Jeanneret, which showcased tubular steel and other manufactured materials, stark rectilinear forms, and abstract paintings. It was more akin to the modernism of the Bauhaus, which was not represented at the Paris Exposition, than to the other versions of French modernism.
4. "An Exhibit of Modern American Decorative Art," *Upholsterer and Interior Decorator*, November 15, 1928, 129; "American Decorative Art at the Art Center," *Good Furniture*, January 1929, 47.
5. Ashley Callahan, *Enchanting Modern: Ilonka Karasz*, exhibition catalog (Athens: Georgia Museum of Art, 2003), 14.
6. Leon V. Solon, letter to Henry Kent, March 29, 1928. The Archives of the Metropolitan Museum of Art.
7. Statement issued by the Advisory Committee on Industrial Art, April 11, 1928, attached to Memorandum prepared for Executive Committee meeting on June 11, 1928 requesting an appropriation for the work of the Co-öperating Committee-Industrial Art Exhibition. The Archives of the Metropolitan Museum of Art.
8. "International Exhibition of Modern Decorative and Industrial Arts" (Paris: Office of the General Commissioner, n.d.). File 851.607W/3 (Official Translation), State Department Files, National Archives.
9. Leon V. Solon, Acknowledgments, *The Architect & the Industrial Arts: 11th Exhibition of Contemporary American Design*, exhibition catalog (New York: Metropolitan Museum of Art, 1929), 13, 14.
10. Helen Appleton Read, "Moderns Invade Museum," *Brooklyn Eagle*, February 17, 1929.
11. Henry McBride, "Native Designers Make Fine Display That Promises Much," *New York Sun*, February 16, 1929.
12. See Richard Guy Wilson's essay in this book, "Modernity and Tradition in Beaux-Arts New York," for a fuller discussion of the Ecole des Beaux-Arts in New York.
13. William B. McCormick, "Contemporary Designs in Industrial Art Show," *New York American*, February 17, 1929.
14. W. G. Bowdoin, "Store Managers, Window Dressers Can Glean Ideas at Metropolitan," *New York Evening World*, February 11, 1929; Alfred Auerbach, "Fresh Impetus Given Modern Art by Museum Exposition," *Retailing*, February 16, 1929.
15. Douglas Haskell, "Art: Decorative Modernism," *The Nation*, March 20, 1929.
16. Shepard Vogelgesang, "Toward a Contemporary Art," *Good Furniture*, March 1929, 126.
17. Raymond Hood, "Business Executive's Office," *11th Exhibition* catalog, 70.
18. Ibid., 73, 74.
19. Read, "Moderns Invade Museum."
20. Eugene Schoen, "Child's Nursery and Bedroom," *11th Exhibition* catalog, 52.
21. Walter Rendell Storey, "Novel Phases of the Decorator's Art," *New York Times*, February 24, 1929.
22. Raymond Hood, "Apartment House Loggia," *11th Exhibition* catalog, 67, 68.
23. Ralph T. Walker, "Man's Study for the Country House," *11th Exhibition* catalog, 35.
24. Helen Johnson Keyes, "The Architect Extends His Scope," *Christian Science Monitor*. The Archives of the Metropolitan Museum of Art.
25. Vogelgesang, "Toward a Contemporary Art," 126.
26. Read, "Moderns Invade Museum."
27. Auerbach, "Fresh Impetus Given Modern Art by Museum Exposition," 16.
28. Vogelgesang, "Toward a Contemporary Art," 125.

29. Bach served as a member of the Museum Staff Committee for the 11th Exhibition, working with both the Co-öperating Committee and the Advisory Committee.
30. "Comment on the Metropolitan Museum Exhibit," *Upholsterer & Interior Decorator*, March 1929, 93, 106.
31. Marilyn F. Friedman, "Defining Modernism at the American Designers' Gallery, New York," *Studies in the Decorative Arts* 14, no. 2 (Spring–Summer 2007): 79–116.
32. "Metropolitan Plans Modern Art Exhibit," *Women's Wear Daily*, 6 October 1928.
33. Edward Alden Jewell, "Industrial Art Show at the Metropolitan: A New Dawn," *New York Times*, February 17, 1929.

From Deco to Streamlined: Donald Deskey and Raymond Loewy
1. "Art Deco" appears on a headpiece opening each chapter of Le Corbusier's *L'Art décorative d'aujourd'hui* (Paris: G. Cries et Cie, 1925), which attacks the ornamental aesthetic of the 1925 Paris Exposition. But the term only became current with Bevis Hillier's book *Art Deco of the 20s and 30s* (London: Studio Vista, 1968). For the U.S. refusal of the French government's invitation to be represented in Paris, see Marilyn F. Friedman, "The United States and the 1925 Paris Exposition: Opportunity Lost and Found," *Studies in the Decorative Arts* 13, no. 1 (Fall–Winter 2005–2006): 94–119.
2. On Manhattan department stores' exhibitions of "modern design" in the 1920s, see Marilyn F. Friedman, *Selling Good Design: Promoting the Early Modern Interior* (New York: Rizzoli, 2003).
3. Arthur J. Pulos, *American Design Ethic: A History of Industrial Design* (Cambridge, Mass.: MIT Press, 1983), 293, notes that objects winning prizes from America's National Alliance of Art and Industry were sold in Paris and "had also been passed off as coming from Paris to Americans who would not have bought the products otherwise."
4. Paul T. Frankl, "The Home of Yesterday, To-day and To-morrow," in *Modern American Design* (New York: Ives Washburn, 1930), 25.
5. See, most recently, David A. Hanks and Anne Hoy, *American Streamlined Design: The World of Tomorrow* (Paris and Montreal: Flammarion and the Liliane and David M. Stewart Program for Modern Design, 2005).
6. Christopher Long, *Paul T. Frankl and Modern American Design* (New Haven: Yale University Press, 2007).
7. See Marilyn F. Friedman, "Defining Modernism at the American Designers' Gallery, New York," *Studies in the Decorative Arts* 14, no. 2 (Spring–Summer 2007): 79–116.
8. See Jeffrey L. Miekle, *Design in the U.S.A.*, Oxford History of Art series (Oxford: Oxford University Press, 2005), 103.
9. Raymond Loewy, *Never Leave Well Enough Alone* (New York: Simon and Schuster, 1951), 73.
10. R. Craig Miller, *Modern Design in the Metropolitan Museum of Art, 1890–1990* (New York: Metropolitan Museum of Art, 1990), 25, sees the rooms as "illustrating three directions in Art Deco during the late 1920s": "French work" (John Wellborn Root), the "highly geometric" (Eliel Saarinen), and those that "anticipated the moderne with their emphasis on metal and glass" (Raymond Hood).
11. Quoted in Miller, *Modern Design in the Metropolitan Museum of Art*, 27.
12. Illustrated in Friedman, "American Designers' Gallery," 100.
13. For a gendered reading of the streamlined style, see Penny Sparke, *As Long as It's Pink: The Sexual Politics of Taste* (London: Pandora Press, 1995).
14 "Streamlining has captured American imagination to mean modern, efficient, well-organized, sweet, clean and beautiful," the industrial designer Egmont Arens claimed in a telegraph to President Roosevelt in 1934; quoted in David A. Hanks and Anne Hoy, *American Streamlined Design*, 21.

Arens offered to speak on "Streamlining for Recovery" and appealed to the federal government and to businesses to accept "streamlining" as a word.

A Bridge to Postwar American Design: Gilbert Rohde and the 1937 Paris Exposition
1. Rohde returned to New York with a stash of French design magazines and fabric samples. In Rohde's first highly publicized interior and furnishings project, a bachelor's penthouse apartment for Norman Lee, c. 1929, he used a stylized modernist French fabric produced by Rodier.
2. *Modern No. 2185 Group* brochure (Zeeland, Mich.: Herman Miller Furniture Company, c. 1932), n.p. Herman Miller Inc. Archives.
3. Dalí's Dream of Venus pavilion at the New York World's Fair, its most erotic and provocative elements censored, precipitated a new round of publicity in 1939.
4. Keith Eggener, "An Amusing Lack of Logic, Surrealism and Popular Entertainment," *American Art*, Fall 1993, 30–45.
5. In "Saying It Without Words," *Printers' Ink Monthly*, October 10, 1937, which featured Rohde's photographs of the Pavillon d'Alimentation, he endorsed the Surrealist-inspired ads for food, with the quip, "Why shouldn't a biscuit take a ride on a gondola?" a reference to the design for Gondola brand crackers. Gilbert Rohde Collection, Cooper-Hewitt National Design Museum Smithsonian Institution.
6. Amelia Defries, in *Purpose in Design* (London: Methuen, 1938), 38–39, includes an interview with Lanvin.
7. Emily Genauer, *Modern Interiors Today and Tomorrow* (New York: Illustrated Editions Company, 1939), 202–7.
8. Emily Genauer, "East and West Meet in New Furniture Styles," *New York World-Telegram*, February 9, 1939.
9. Gilbert Rohde, letter to Walter Dorwin Teague, April 18, 1938. 1939/40 New York World's Fair Collection, Box 58, New York Public Library Manuscripts Division.
10. Aalto had used biomorphic forms in walls and glass objects; Keisler had designed low, kidney-shaped tables in metal, prototypes that were never serially produced. However, Rohde's irregularly curved tables and desks were apparently the first to be manufactured.
11. Herman Miller, *Catalogue 1940*, 110. The term "ectoplastic," sometimes used to describe Hollywood science-fiction movies, was associated with séances, spirits, and out-of-this-world phenomena.
12. Gilbert Rohde, "Modern and Modern," *Western Arts Association, Annual Report, 1938–41*, September 1941, 82.
13. Quoted in Vivian Vorsanger, "Designers at the Fair," *Printers' Ink Monthly*, September 1937. Gilbert Rohde Collection, Cooper-Hewitt National Design Museum, Smithsonian Institution.

Neo-Romantics
1. See Irving Sandler, *The Triumph of American Painting: The History of Abstract Expressionism* (New York: Harper and Row, 1970); Serge Guilbaut, *How New York Stole the Idea of Modern Art: Abstract Expressionism, Freedom, and the Cold War* (Chicago: The University of Chicago Press, 1983).
2. For the early history of French taste in the United States, see Christopher Riopelle, "American Artists in France/French Art in America," in Kathleen Adler et al., *Americans in Paris 1860–1900*, exhibition catalog (New York: Metropolitan Museum of Art, 2006), 206–21.
3. "Many and varied are Manhattan's 16 museums, ranging from the stately Metropolitan Museum of Art and the Natural History Museum to the more modest

collections of the American Numismatic Society and the Museum of the Peaceful Arts. With little advance publicity and less inaugural fuss, yet another Manhattan museum opened last week. Its name: The Museum of French Art. Its location: the handsome French Institute Building, No. 22 East 60th St. Its donors: Mr. & Mrs. Chester Dale, famed and fervent collectors of modern art." "Lovely Ladies," *Time*, February 2, 1931, 34.
4. For Duchamp and America, see Wanda M. Corn, *The Great American Thing: Modern Art and National Identity, 1915–1935* (Berkeley and Los Angeles: University of California Press, 1999), 54–89.
5. James Thrall Soby, *After Picasso* (Hartford: Edwin Valentine Mitchell; New York: Dodd, Mead, 1935), xi.
6. Ibid., 5.
7. Ibid., 6.
8. Ibid., 12.
9. James Thrall Soby, *Tchelitchew: Paintings, Drawings*, exhibition catalog (New York: Museum of Modern Art, 1942), 9.
10. James Thrall Soby, *Eugene Berman*, exhibition catalog (Boston: Institute of Modern Art, 1942), 11.
11. *New York Times*, April 13, 1937.
12. Jody Blake, "Dance to the Death: Neo-Romanticism, Surrealism, and the Ballet, 1933–1953," in Michael Duncan, *High Drama: Eugene Berman and the Legacy of the Melancholic Sublime*, exhibition catalog (San Antonio, Tex.: Marion Koogler McNay Art Museum, 2004), 42.
13. Soby, *After Picasso*, 6.
14. For discussion of *Errante*, see especially Eric M. Zafran et al., *Ballets Russes to Balanchine: Dance at the Wadsworth Atheneum* (Hartford: Wadsworth Atheneum, 2004).
15. Leslie George Katz et al., *Choreography by George Balanchine: A Catalogue of Works* (New York: Viking Penguin, 1984), 115.
16. Edward Alden Jewell, "Art Season Opens in Early Rush," *New York Times*, September 17, 1944.
17. James Thrall Soby, *Eugene Berman*, 13. The exhibition traveled to Hartford; Chicago; Portland, Oregon; San Francisco; and Kansas City.
18. Ibid., 13.
19. James Thrall Soby, "Europe," *Artists in Exile*, exhibition catalog (New York: Pierre Matisse Gallery, March 3–28, 1942), n.p.
20. Nicolas Calas, "America," *Artists in Exile*, exhibition catalog (New York: Pierre Matisse Gallery, March 3–28, 1942), n.p.

INDEX

PHOTOGRAPHY CREDITS

Page 6: Private collection | **Page 8**: Courtesy Musée des Années 30 | © Boulogne-Billancourt; Musée des Années 30 | Photograph: Philippe Fuzeau | **Page 12**: Courtesy Posters Please, Inc., New York City | **Page 13 (top)**: Private collection | **Page 13 (bottom)**: © LL/Roger Viollet/The Image Works | **Page 14 (top)**: Museum of the City of New York; Gift of Kahn and Jacobs, Architects; | **Page 14 (below left)**: Courtesy Wadsworth Atheneum Museum of Art, Hartford, CT; The J. Herbert Callister Fund (1993.51.2) | **Page 14 (below right)**: Courtesy Wadsworth Atheneum Museum of Art, Hartford, CT | **Page 15 (top)**: Museum of the City of New York; Gift of Kahn and Jacobs, Architects | **Page 16–17**: © Christie's Images, 2006 | **Page 18**: © F. Schumacher & Co; All rights reserved; Used by permission | **Page 19**: Museum of the City of New York; Gift of Kahn and Jacobs, Architects | **Page 20**: Courtesy Marilyn F. Friedman | **Page 21**: Courtesy Cooper-Hewitt, National Design Museum, Smithsonian Institution; Gift of James M. Osborn (1969-97-7a,b) | **Page 22**: Private collection | **Page 23 (top)**: Private collection | **Page 23 (bottom)**: Courtesy Wolfsonian-Florida International University, Miami Beach, Florida; The Mitchell Wolfson, Jr. Collection (86.17.1) | Photograph: Bruce White | **Page 24**: Courtesy Académie d'Architecture/Cité de l'Architecture et du Patrimoine/Archives d'Architecture du XXᵉ Siècle | **Page 25**: Courtesy Académie d'Architecture/Cité de l'Architecture et du Patrimoine/Archives d'Architecture du XXᵉ Siècle | **Page 26 (top)**: Courtesy DAF/Cité de l'Architecture et du Patrimoine/Archives d'Architecture du XXᵉ Siècle; © 2008 Artists Rights Society, New York/ADAGP, Paris | **Page 26 (bottom)**: Museum of the City of New York; World's Fair Collection | **Page 27**: Courtesy Regional Plan Association | **Page 28 (top)**: Courtesy DAF/Cité de l'Architecture et du Patrimoine/Archives d'Architecture du XXᵉ Siècle | **Page 28 (bottom)**: Museum of the City of New York; Gottscho-Schleisner Collection (Neg. #21140) | **Page 29**: Permission courtesy Collection Martin du Louvre, Paris | Photograph courtesy Fonds Janniot | **Page 30 (top)**: Courtesy Posters Please, Inc., New York City | **Page 30 (bottom)**: Photograph © Christie's Images, 2006 | **Page 31**: Museum of the City of New York; Gift of Lord & Taylor | **Page 33 (top)**: Courtesy Bettmann/CORBIS (BE070507) | **Page 33 (bottom)**: Museum of the City of New York; Gottscho-Schleisner Collection (Neg. #28135) | Photograph: Samuel H. Gottscho | **Page 34**: Courtesy Maxwell Davidson Gallery; © 2008 Artists Rights Society, New York/ADAGP, Paris | **Page 35**: Courtesy Rockefeller Archives Center | **Page 36**: Courtesy Pennsylvania State University; Fay S. Lincoln Photograph Collection, Historical Collections and Labor Archives, Special Collections | **Page 37**: Courtesy Chicago History Museum (Neg. #HB-05554-Q) | **Page 38 (top)**: Private collection; © Condé Nast Publications Inc. | **Page 38 (bottom)**: Courtesy Wadsworth Atheneum Museum of Art, Hartford, CT; The Ella Gallup Sumner and Mary Catlin Sumner Collection Fund (1935.49) | **Page 39**: Museum of the City of New York; World's Fair Collection; Courtesy Van Vechten Trust | **Page 42 (top left)**: Courtesy Regional Plan Association | **Page 42 (top right)**: Courtesy Regional Plan Association | **Page 42 (center)**: Courtesy Regional Plan Association | **Page 42 (bottom)**: Courtesy Regional Plan Association | **Page 44**: Courtesy Académie d'Architecture/Cité de l'Architecture et du Patrimoine/Archives d'Architecture du XXᵉ Siècle | **Page 45 (top)**: Courtesy Archives municipales et communautaires de Reims | **Page 45 (bottom)**: Courtesy Cité de l'Architecture et du Patrimoine/Archives d'Architecture du XXᵉ Siècle | **Page 46 (top)**: Private collection | **Page 46 (bottom)**: Private collection | **Page 47**: Courtesy Fondation Le Corbusier (Plan FLC 29723); © FLC/2008 Artists Rights Society, New York/ADAGP, Paris | **Page 48 (top)**: Courtesy Jean-Louis Cohen | **Page 48 (bottom)**: Courtesy Académie d'architecture/Cité de l'Architecture et du Patrimoine/Archives d'Architecture du XXᵉ Siècle | **Page 52**: Courtesy Maison Gerard | **Page 53**: Museum of the City of New York; Gottscho-Schleisner Collection (Neg #17878) | **Page 54**: Courtesy Van Alen Institute: Projects in Public Architecture | **Page 55**: Courtesy Van Alen Institute: Projects in Public Architecture | Photograph: Ali Elai, CamerArts | **Page 56**: Courtesy Van Alen Institute: Projects in Public Architecture | Photograph by Ali Elai, CamerArts | **Page 57**: Courtesy Van Alen Institute: Projects in Public Architecture | Photograph: Ali Elai, CamerArts | **Page 58**: Museum of the City of New York; Gift of the Federal Art Project; Works Progress Administration | **Page 59**: Museum of the City of New York; Gottscho-Schleisner Collection (Neg. #20660) | **Page 60**: Courtesy Wolfsonian-Florida International University, Miami Beach, Florida; Mitchell Wolfson, Jr. Collection (84.21.8); © Scotia W. MacRae | **Page 61**: Courtesy Museum of Modern Art, New York; Given anonymously (743.1966); © Artists Rights Society, New York/ADAGP, Paris; Digital Image © The Museum of Modern Art/Licensed by SCALA/Art Resource, NY | **Page 62**: Museum of the City of New York; Gottscho-Schleisner Collection (Neg. #12864) | **Page 63**: Courtesy Museum of Modern Art, New York; Digital Image © The Museum of Modern Art/Licensed by SCALA/Art Resource, NY | **Page 64**: Courtesy Ezra Stoller © ESTO | **Page 65**: Courtesy Ezra Stoller © ESTO | **Page 68**: Courtesy Isabelle Gournay | **Page 69**: Private Collection | **Page 70 (top)**: Courtesy Isabelle Gournay | **Page 70 (bottom)**: Courtesy Isabelle Gournay | **Page 71**: Museum of the City of New York; Gottscho-Schleisner Collection (Neg. #21691) | **Page 72**: Courtesy Wolfsonian-Florida International University, Miami Beach, Florida; Mitchell Wolfson, Jr. Collection (83.4.43) | Photograph: Silvia Ros | **Page 74–75**: Private collection | **Page 76**: Courtesy DAF/Cité de l'Architecture et du Patrimoine/Archives d'Architecture du XXᵉ Siècle | **Page 77 (top)**: Private collection | **Page 77 (bottom)**: Courtesy Jean-Louis Cohen, © 2008 Estate of Robert Mallet-Stevens/Artists Rights Society (ARS), New York/ADAGP, Paris | **Page 78 (top)**: Private collection | **Page 78 (bottom)**: Museum of the City of New York; Gift of Mrs. Kay Simmon Blumberg, (94.48.366) | **Page 79**: Courtesy l'Association Willy Maywald; © 2008 Artists Rights Society, New York/ADAGP, Paris | **Page 83**: Courtesy National Archives | **Page 84 (top)**: Courtesy National Archives | **Page 84 (bottom)**: Courtesy Metropolitan Museum of Art; Purchase; Gift of the Polaroid Corporation and matching funds from National Endowment for the Arts, 1981 (1981.1043); © Berenice Abbott/Commerce Graphics Ltd. | **Page 85**: Private collection | **Page 87**: Courtesy The New York Public Library; Art and Artifacts Division; Schomburg Center for Research in Black Culture; Astor, Lenox, and Tilden Foundations; © Valerie Gerrard Browne | **Page 88**: Courtesy National Portrait Gallery, Smithsonian Institution | **Page 89**: Courtesy The New York Public Library for the Performing Arts, Jerome Robbins Dance Division, Astor, Lenox and Tilden Foundations | **Pages 90–91**: Courtesy Posters Please, Inc., © 2008 Artists Rights Society, New York/ADAGP, Paris | **Page 93**: Courtesy Solomon R. Guggenheim Museum, New York; Solomon R. Guggenheim Founding Collection (38.817); © Artists Rights Society, New York/ADAGP, Paris | **Page 94**: Courtesy Dansmuseet, Stockholm | **Page 95**: Courtesy The McNay Art Museum; Gift of The Tobin Endowment (TL2001.88.2); © 2008 Artists Rights Society, New York/ADAGP, Paris | **Page 96**: Courtesy The New York Public Library for the Performing Arts; Jerome Robbins Dance Division; Astor, Lenox, and Tilden Foundations | **Page 97**: Courtesy The McNay Art Museum; Gift of Lisa Aronson (TL2001.7.5); © Lisa Aronson | **Pages 98–99**: Courtesy The McNay Art Museum; Gift of Robert L.B. Tobin (TL 1999.116.1) | **Page 100 (top)**: Courtesy Milwaukee Art Museum; Purchase; African American Art Acquisition Fund with matching funds from Suzanne and Richard Pieper, and additional support from Arthur and Dorothy Nelle Sanders (M1993.191) | Photograph: John Glembin | **Page 100 (bottom)**: Courtesy The New York Public Library; Schomburg Center for Research in Black Culture; Art and Artifacts Division; Astor, Lenox, and Tilden Foundations | **Page 101**: Museum of the City of New York | **Page 104 (top)**: Museum of the City of New York | **Page 104 (bottom)**: Museum of the City of New York (57.129.3) | Photograph: John Halpern | **Page 105**: Museum of the City of New York (54.244) | Photograph: John Halpern | **Page 106**: Museum of the City of New York (77.49.143) | **Page 107 (top)**: Museum of the City of New York; Gift of Kahn and Jacobs, Architects | **Page 107 (bottom)**: Museum of the City of New York; Byron Collection (93.1.1.4096) | **Page 108**: Museum of the City of New York (39.202.6) | **Page 110**: Courtesy Filson Historical Society, Louisville, Kentucky (989P C9X27) | **Page 111**: Museum of the City of New York; Archives | **Page 112**: Museum of the City of New York (45.111.3a,b); Image © Metropolitan Museum of Art | **Page 113 (top)**: © Condé Nast Publications Inc. | **Page 113 (bottom)**: Museum of the City of New York (69.123) | **Page 114**: Museum of the City of New York (63.101) | Photograph: John Halpern | **Page 115**: Museum of the City of New York; Theater Collection | **Page 116**: Museum of the City of New York (90.23.3a,b) | Photograph: John Halpern | **Page 117 (top)**: Museum of the City of New York | **Page 117 (bottom)**: Museum of the City of New York (70.139.1a-d) | Photograph: John Halpern | **Page 120**: Museum of the City of New York; from the *The New York Times*, March 7, 1937. © 1937 *The New York Times*. All Rights Reserved. Used by permission and protected by the Copyright Laws of the United States. The printing, copying, redistribution, or retransmission of the Material without express written permission is prohibited. | **Page 121 (top)**: Museum of the City of New York (79.15.59a,b) | Photograph: John Halpern | **Page 121 (bottom)**: Museum of the City of New York (79.15.58a,b) | Photograph: John Halpern | **Page 122**: Museum of the City of New York (84.14.18a-d) | Photograph: John Halpern | **Page 123**: Museum of the City of New York (55.291) | Photograph: John Halpern | **Page 124**: Museum of the City of New York (71.153.78) | Photograph: John Halpern | **Page 125**: Museum of the City of New York (85.69.17a-d) | Photograph: John Halpern | **Page 126**: Museum of the City of New York (44.142.16a-c) | Photograph: John Halpern | **Page 127 (top)**: Museum of the City of New York (88.74.3,.7,.8) | Photograph: John Halpern | **Page 127 (bottom)**: Private collection; © Condé Nast Publications, Inc. | **Page 128**: Courtesy Académie d'Architecture/Cité de l'Architecture et du Patrimoine/Archives d'Architecture du XXᵉ Siècle | **Page 130**: Courtesy Wolfsonian-Florida International University, Miami Beach, Florida; Mitchell Wolfson, Jr. Collection (83.1.56.1, 2) | Photograph: Silvia Ros | **Page 132**: Courtesy John B. Stetson Company | **Page 133**: Museum of the City of New York; Byron Collection (93.1.1.11962) | **Pages 134–35**: Courtesy Académie d'Architecture/Cité de l'Architecture et du Patrimoine/Archives d'Architecture du XXᵉ Siècle | **Pages 136–37**: Museum of the City of New York; Byron Collection (93.1.1.11950) | **Page 138**: Image courtesy Musée des Années 30; © Musée des Années 30, Boulogne-Billancourt; © 2008 Artists Rights Society, New York/ADAGP, Paris | Photograph: Pascal Cadiou | **Page 139**: Image courtesy Musée des Années 30; © Musée des Années 30, Boulogne-Billancourt; © 2008 Artists Rights Society, New York/ADAGP, Paris | Photograph: Pascal Cadiou | **Pages 140–41**: Museum of the City of New York; Byron Collection (93.1.1.11876) | **Pages 142–43**: Courtesy Musée Bouilhet Christofle | **Page 144 (top)**: Private collection | Photograph: John Halpern | **Page 144 (bottom)**: Courtesy Wolfsonian-Florida International University, Miami Beach, Florida; Mitchell Wolfson, Jr. Collection (XB1990.1283) | **Page 145**: Courtesy Bettmann/CORBIS | **Page 146**: Courtesy Bettmann/CORBIS | **Page 147**: Courtesy Stephen Lash | Photograph: John Halpern | **Pages 148–49**: Courtesy Stephen Lash | Photograph: John Halpern | **Page 152**: Courtesy Académie d'Architecture/Cité de l'Architecture et du Patrimoine/Archives d'Architecture du XXᵉ Siècle | **Page 153**: Museum of the City of New York | **Pages 154–55**: Courtesy Académie d'Architecture/Cité de l'Architecture et du Patrimoine/Archives d'Architecture du XXᵉ Siècle | **Page 156**: Museum of the City of New York; Courtesy Van Vechten Trust | **Page 157**: Courtesy The New York Public Library; Science, Industry, and Business Library; Astor, Lenox, and Tilden Foundations | **Page 158**: Courtesy The New York Public Library; Rare Books Division; Astor, Lenox, and Tilden Foundations | **Page 159**: Courtesy Time&Life Pictures/Getty Images | **Page 160**: *The New York Times*, December 11, 1964 | © 1964 *The New York Times*. All rights reserved.

Used by permission and protected by the Copyright Laws of the United States. The printing, copying, redistribution, or retransmission of the Material without express written permission is prohibited. | **Page 164 (top)**: Courtesy Marilyn F. Friedman | **Page 164 (center)**: Courtesy Musée des Années 30; © Boulogne-Billancourt, Musée des Années 30 | Photograph: Philippe Fuzeau | **Page 164 (bottom)**: Courtesy Yale University Art Gallery; Gift of J. Davenport Wheeler, B.A. 1858, by exchange (1997.7.1) | **Page 165 (top)**: Courtesy Metropolitan Museum of Art | Image © Metropolitan Museum of Art | **Page 165 (bottom)**: Courtesy Marilyn F. Friedman | **Page 166**: Courtesy National Museum of American History Archives Center; Behring Center; Smithsonian Institution; Dorothy Shaver Papers | **Page 167 (top)**: Courtesy Library of Congress; Prints and Photographs Division (267 N1) | **Page 167 (bottom)**: Courtesy Library of Congress; Prints and Photographs Division (267 N3) | **Page 168**: Courtesy The Art Institute of Chicago; Twentieth Century Decorative Arts Collection; Ryerson and Burnham Archives | Digital image © The Art Institute of Chicago | **Page 169**: Courtesy Marilyn F. Friedman | **Page 172**: Courtesy Marilyn F. Friedman | **Page 173**: Courtesy Metropolitan Museum of Art | Image © Metropolitan Museum of Art | **Page 174 (top)**: Museum of the City of New York; Gift of Kahn and Jacobs, Architects | **Page 174 (bottom)**: Courtesy Metropolitan Museum of Art | Image © Metropolitan Museum of Art | **Page 175**: Courtesy Metropolitan Museum of Art | Image © Metropolitan Museum of Art | **Page 176**: Courtesy Metropolitan Museum of Art | Image © Metropolitan Museum of Art | **Page 177**: Courtesy Marilyn F. Friedman | **Page 178**: Courtesy Metropolitan Museum of Art | Image © Metropolitan Museum of Art | **Page 179**: Courtesy Marilyn F. Friedman | **Page 180**: Courtesy Marilyn F. Friedman | **Page 181**: Courtesy Metropolitan Museum of Art | Image © Metropolitan Museum of Art | **Page 186**: Courtesy Cooper-Hewitt, National Design Museum, Smithsonian Institution; Gift of Donald Deskey (1975-11-13) | Photograph: Matt Flynn | **Page 187 (top)**: Courtesy Cooper-Hewitt, National Design Museum, Smithsonian Institution; Gift of Donald Deskey (1975-11-59) | Photograph: Matt Flynn | **Page 187 (bottom)**: Courtesy Saks Fifth Avenue | Photograph: Ali Elai, CamerArts | **Page 188**: Courtesy Hagley Museum and Library | **Page 189**: Courtesy Marilyn F. Friedman | **Pages 190–191**: Courtesy Cooper-Hewitt, National Design Museum, Smithsonian Institution; Donald Deskey Collection; Gift of Donald Deskey | **Page 192 (top)**: Courtesy Cooper-Hewitt, National Design Museum, Smithsonian Institution; Donald Deskey Collection; Gift of Donald Deskey | **Page 192 (bottom)**: Courtesy Cooper-Hewitt, National Design Museum, Smithsonian Institution; Gift of Donald Deskey (1975-11-4) | Photograph: Matt Flynn | **Page 193 (top)**: Courtesy Cooper-Hewitt, National Design Museum, Smithsonian Institution; Gift of Donald Deskey (1975-11-12) | Photograph: Matt Flynn | **Page 193 (bottom)**: Courtesy Cooper-Hewitt, National Design Museum, Smithsonian Institution; Gift of Donald Deskey (1975-11-7) | Photograph: Matt Flynn | **Pages 194–195**: Courtesy Hagley Museum and Library | **Page 196**: Courtesy Cooper-Hewitt, National Design Museum, Smithsonian Institution; Donald Deskey Collection; Gift of Donald Deskey | **Page 197**: Courtesy Hagley Museum and Library | **Page 201 (top)**: Private collection | **Page 201 (bottom)**: Private collection | **Page 202 (top)**: Courtesy Museum of Modern Art, New York; Digital image © The Museum of Modern Art/Licensed by SCALA/Art Resource, New York (IN55.68) | **Page 202 (bottom)**: © Ministère de la Culture/Médiathèque du Patrimoine, Dist. RMN/Art Resource, New York | Photograph: Baranger | **Page 203**: Courtesy Cooper-Hewitt, National Design Museum, Smithsonian Institution; Gilbert Rohde Collection; Gift of Lee M. Rohde | **Pages 204–205**: Courtesy Phyllis Ross | **Page 206 (top)**: Courtesy Phyllis Ross | **Page 206 (bottom)**: Courtesy Phyllis Ross | **Page 207**: Courtesy Herman Miller, Inc. | **Page 208 (top)**: Courtesy The New York Public Library; Records, Manuscripts, and Archives Division; New York World's Fair 1939/1940; Astor, Lenox and Tilden Foundations | **Page 208 (bottom)**: Museum of the City of New York; World's Fair Collection | **Page 209**: Courtesy Herman Miller, Inc. | **Page 210**: Courtesy Musée des Arts Décoratifs, Paris | Photograph: Laurent Sully Jaulmes; All rights reserved | **Page 211**: Courtesy Museum of Modern Art, New York; Gift of the Gansevoort Gallery, Jeffrey P. Klein Purchase Fund and John C. Waddell Purchase Fund (1429.2000.vw1) | Digital image © The Museum of Modern Art/Licensed by SCALA/Art Resource, New York | **Pages 212–213 (left)**: Courtesy Victoria and Albert Museum | © Victoria and Albert Museum, London | **Pages 212–213 (right)**: Courtesy of Treadway Gallery, Chicago, Illinois | **Page 214**: Courtesy Herman Miller, Inc. | **Page 218**: Courtesy The McNay Art Museum | **Page 220**: Courtesy The School of American Ballet | Photograph: Jerry L. Thompson | **Page 221**: Courtesy Museum of Modern Art, New York; Mrs. Simon Guggenheim Fund (344.1942) | Digital image © The Museum of Modern Art/Licensed by SCALA/Art Resource, New York | **Page 222 (top)**: © Condé Nast Publications Inc. | **Page 222 (bottom)**: Courtesy The McNay Art Museum | **Page 223 (top)**: Courtesy The New York Public Library for the Performing Arts; Jerome Robbins Dance Division; Astor, Lenox, and Tilden Foundations | **Page 223 (bottom)**: Courtesy The McNay Art Museum; Gift of The Tobin Endowment (TL2002.38) | **Pages 224–225**: Courtesy Wadsworth Atheneum Museum of Art, Hartford, CT; The Ella Gallup Sumner and Mary Catlin Sumner Collection Fund (1935.48) | **Page 226**: Courtesy Wadsworth Atheneum Museum of Art, Hartford, CT; The Ella Gallup Sumner and Mary Catlin Sumner Collection Fund (1935.50) | **Page 227 (top)**: Courtesy Wadsworth Atheneum Museum of Art, Hartford, CT; The Ella Gallup Sumner and Mary Catlin Sumner Collection Fund (1935.47) | **Page 227 (bottom)**: © Condé Nast Publications Inc. | **Page 228**: Courtesy Kinsey Institute for Research in Sex, Gender, and Reproduction, Inc. | © Estate of George Platt Lynes | **Page 229**: Courtesy Museum of Modern Art, New York; Digital image © The Museum of Modern Art/Licensed by SCALA/Art Resource, New York | Image © Estate of George Platt Lynes

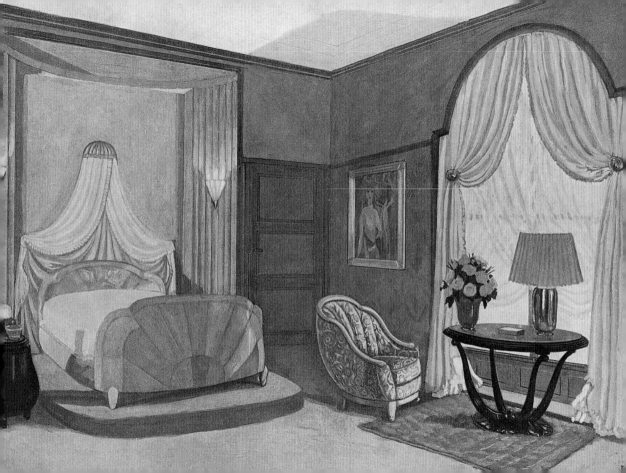